The House of Difference:
Cultural Politics and National Identity in Canada

The unexpected global rise of intolerance ... at the end of the twentieth century has resulted in an alarming increase in racial violence and human rights abuse in recent years. Yet intolerance also manifests itself in more subtle ways, even in nations such as Canada, with its mythologized history of tolerance and its official policies of multiculturalism. Drawing on extensive fieldwork and interviews with white Canadians and government bureaucrats, as well as analysis of national identity and its construction, *The House of Difference* explores ideas of racial and cultural difference, multiculturalism, and pluralism. Eva Mackey argues that official policies and attitudes of multicultural 'tolerance' for 'others' reinforce the dominant Anglo-Canadian culture by abducting the cultures of minority groups, pressing them into the service of nation-building without promoting genuine respect or autonomy.

Mapping the contradictions and ambiguities in the cultural politics of Canadian identity, *The House of Difference* opens up new understandings of the operations of 'tolerance' and western liberalism in a supposedly post-colonial era.

(Anthropological Horizons)

EVA MACKEY is Assistant Professor in the Department of Anthropology at McMaster University.

ANTHROPOLOGICAL HORIZONS

Editor: Michael Lambek, University of Toronto

This series, begun in 1991, focuses on theoretically informed ethnographic works addressing issues of mind and body, knowledge and power, equality and inequality, the individual and the collective. Interdisciplinary in its perspective, the series makes a unique contribution in several other academic disciplines: women's studies, history, philosophy, psychology, political science, and sociology. For a list of the books published in this series see pp. 201–202.

THE HOUSE OF DIFFERENCE

Cultural Politics and National Identity in Canada

Eva Mackey

University of Toronto Press
Toronto Buffalo London

© University of Toronto Press Incorporated 2002
Toronto Buffalo London
First published in hardcover in 1999 by Routledge

Printed in Canada

Reprinted 2005, 2008

ISBN 0-8020-8481-8 (paper)

Printed on acid-free paper

National Library of Canada Cataloguing in Publication Data

Mackey, Eva, 1956–
 The house of difference : cultural politics and national
 identity in Canada / Eva Mackey.

 (Anthropological horizons)
 First published: London : Routledge, 1999.
 Includes bibliographical references and index.
 ISBN 0-8020-8481-8

 1. Multiculturalism – Canada. 2. Canada – Ethnic relations.
 3. Nationalism – Canada. I. Title. II. Series.

 FC105.M8M32 2002 323.1'71 C2002-901248-1
 F1035.A1M33 2002

The University of Toronto Press acknowledges the financial assistance to its
publishing program of the Canada Council for the Arts and the Ontario Arts
Council.

University of Toronto Press acknowledges the financial support for its publishing
activities of the Government of Canada through the Book Publishing Industry
Development Program (BPIDP).

FOR MY PARENTS, ELLY AND DOUG

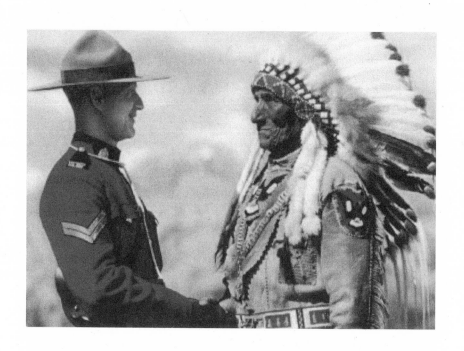

[W]e came to realise that that our place was the very house of difference, rather than the security of any one particular difference.

Audre Lorde

CONTENTS

CONTENTS

CONTENTS

FIGURES

PREFACE TO PAPERBACK EDITION

When I began this project over a decade ago, I was studying in Britain, and a great deal of the critical cultural and race theory I encountered didn't quite apply to the specific Canadian context. Much of the theory focused on demonstrating how powerful forces of nationalism sought to erase cultural differences and create national homogeneity. Such frameworks seemed reasonable in the British or European context. My desire, however, was to understand the workings of Canada's national mythology, a mythology that to me, as a child of Pierre Trudeau's 'multicultural' Canada, appeared to function through representations of 'tolerance,' inclusion, and 'official multiculturalism,' not through the erasure of cultural difference. Further, the 'multiculturalism' of the 'culture wars' in the United States, and the 'multiculturalism' that polarized left and right in Britain, were very different phenomena from the 'official multiculturalism' in Canada, as embodied in its Ministry of Multiculturalism. This project was motivated by a need to understand how such a Canadian mythology worked in forming identities, and to explore if and how state-sanctioned multiculturalism might, in complex ways, actually contribute to intolerance and racism.

As I write this preface to the 2002 paperback edition of the book in mid-September 2001, I think that, on the surface, a great deal has changed in the Canadian political scene in the last decade, at least in terms of party politics. Nevertheless, many of the frameworks of identity, inclusion, and exclusion I explore in this book have stayed remarkably consistent. Today, I read in the *Toronto Star* that the federal Minister of Indian Affairs, Robert Nault, is demanding an apology from the Grand Chief of the Assembly of First Nations, Matthew Coon Come, because, in the Chief's speech at the UN Conference on Racism held in South Africa, he said that Canada is still 'racist' in its 'oppression, marginalization, and dispossession of indigenous peoples.' Coon Come described Canada's 'racist and colonial syndrome of dispossession and discrimination.' The Minister responded by saying that Canadians have a right to be outraged with such statements because there is 'no proof of this in the modern time.'

Mr. Nault's outrage (he says 'people like myself are not just annoyed, we're just beside ourselves') indicates that the mythology of Canada's tolerance is still alive and well, so much so that the *content* of Coon Come's articulate and well-argued speech (available on the AFN web site) is not even addressed. Instead, Nault

responds as if Coon Come has broken a sacred national taboo by even thinking of equating Canada with the word 'racism.' His denial should be surprising, considering that the Canadian government itself has often acknowledged the myriad of structural problems relating to its treatment of Aboriginal people. Further, when the Department of Canadian Heritage consulted NGOs before the World Conference Against Racism, the first point stressed by anti-racism participants in most meetings was that Canada had to begin to admit its own participation in racism. However, for Nault, the problem is that Chief Coon Come went too far with his comments, which were deemed 'not acceptable for any national leader to make in an international forum.' It is ironic that in an international conference on racism, the real issue at stake for Nault seems to be indigenous people's loyalty (in front of other nations) to the nation-state (colonial state) of Canada – the state, which, according to many Aboriginal peoples, continues to oppress and regulate them on a daily basis. Is Nault suggesting that Coon Come should not air Canada's 'dirty laundry' in public? Does he not yet understand that the relationship of Aboriginal peoples to the Canadian state might be informed by their experiences of colonialism and paternalism? Has he never considered that they may not feel loyal to myths of settler nationhood that depend on denial of their rights and their experiences? Nault's response, however, is not surprising, because he, like many before him, uses Canada's myth of tolerance as a weapon to deny the claims and experiences of First Nations people, as I demonstrate throughout this book.

One benefit of writing a new preface in 2001 is the possibility of pointing to a fascinating body of work that has recently been developing on many of the issues addressed in this book. Himani Bannerji's *The Dark Side of the Nation* (Canadian Scholar's Press 2000), Richard Day's *Multiculturalism and the History of Canadian Diversity* (University of Toronto Press 2000), Rinaldo Walcott's *Black Like Who?* (Insomniac Press 1997), and Elizabeth Furniss's *The Burden of History* (UBC Press 1999) are some of the recent books that contribute, all in very different but challenging ways, to an understanding of the complex politics of race, culture, and national identity in a settler nation such as Canada. Ghassan Hage's *White Nation: Fantasies of White Supremacy in a Multicultural Nation* (Pluto Press and Routledge 2000) addresses similar issues in Australia, and offers a particularly insightful analysis of the notion of tolerance.

One commonality in all the books above, and in *House of Difference*, is that they all focus on exploring what we might call 'dominant culture' in Canada or Australia. What do we mean by 'dominant culture'? Furniss's discussion of 'dominant culture' and Hage's discussion of the links between 'good' and 'bad' racists, and between rural and urban expressions of intolerance, raise some points I wish to make more explicit in this second edition.

For example, some people, when reading this book, expect a breakdown and description of all the different possible expressions of Canadianness. Others feel that by talking about dominant culture the book is implicitly essentializing, by suggesting that Canada is monolithic and that all Canadians act and think in the ways I describe. I wish to make it clear that I am in no way describing an essentially static 'culture' of

Canada. Rather, drawing on the work of people such as Raymond Williams and Edward Said, I am describing aspects of the project of the creation and maintenance of a dominant culture over time. In *The Burden of History* Furniss, who also draws on the work of Raymond Williams, provides an account of the dominant Euro-Canadian culture of Williams Lake that is useful here.

Williams suggests that in 'any society, in any period, there is a central system of practices, meanings and values, which we can properly call dominant and effective' (1980: 38). Such a dominant culture infuses multiple domains of everyday life. Its dominance is based, in part, on its ability to become common sense in everyday life. It is continually confirmed and relived in multiple dimensions of ordinary experience. Although a dominant culture infuses everyday life, its dominance is never complete or uncontested. Furniss has shown that not all non-Aboriginal residents of the particular region in British Columbia she studied 'participate in the same way in the dominant culture,' and that 'individuals and groups – Euro-Canadians, Indo-Canadians, men, women, upper- and lower-class families, the employed and the unemployed, the young and the old – are variously positioned within these fields of social and political power' (14). Their positions, of course, often result in 'very different perceptions of reality and lead to different kinds of challenges to dominant culture.' Dominant culture then, is a 'selective worldview that is continually being challenged by alternative systems of meaning and belief. Its dominance lies in its ubiquity and its flexibility; its ability to be continually modified in order to deflect or incorporate challenges to its legitimacy' (15).

It is important to stress that although I explore dominant culture I am not, therefore, presenting Canadian national identity as a bounded, static, essentialized culture defined by a list of uncontested traits and characteristics. Rather, I present and analyse the complex process through which such culture is a long-term project, constantly created by the state and individuals. I am concerned with showing the coherence between, and workings of, a wide body of discourses and practices. However, such a concern with exploring cultural coherence, and with 'highlighting the systemic features of a dominant culture' may, as Furniss suggests, seem 'out of step with dominant academic trends that highlight the heterogeneity and multiplicity of cultural processes and perspectives' (21).

My goal in exploring the coherence of such a system of dominant beliefs is to comprehend the relationship and continuities between the apparent multicultural tolerance of much government ideology developed in the middle and late twentieth century, and the disturbing outpourings of seemingly more racialized and intolerant frameworks of identity that emerged in the early 1990s and still persist today. This exploration of the coherence of such frameworks was necessary in order to make sense of the sentiments of people in small towns I spoke to, people who argued that multiculturalism is great as long as 'Canada is first,' and that there should be 'one set of rules.' It seemed to me that an anthropologist should not simply dismiss such sentiments as aberrant, mistaken, and morally flawed (rural) racisms existing within a generally tolerant national context. Instead, it is important to take such sentiments seriously and attempt to understand their genealogy and rationality, within their con-

text. I, have therefore explored how such frameworks can be seen as logical, in part because they are reinforced constantly in daily life, and in broader historical and contemporary discourses. Understanding and taking such sentiments seriously does not mean agreeing with or legitimating them.

I in no way wish to suggest that all Euro-Canadians participate equally in or experience the dominant culture in the same way. I, like Furniss, do not imagine that all Canadians will recognize themselves equally, or even at all, within most aspects of the cultural processes I describe. I do hope, however, that some people may recognize the processes and intersection of a broad system of meanings and practices that I argue are central to the construction of Canadian national identity. Of course, such processes are not enacted in a hegemonic, fixed, and predictable manner all over Canada, and in all circumstances. The politics of the processes of identity making is, of course, contradictory and contested. For example, after being pressured by some First Nations peoples, the government recently removed the Ottawa statue 'Champlain and Unknown Indian,' which I critique on page 39. Such an action makes it appear that there are official attempts to listen to First Nations peoples on some issues. At the same time, federal policies were being developed that, according to First Nations critics, have the goal of assimilation. The contradictions are multiple. Also, work such as Davina Bhandar's recent doctoral thesis from York University complicate my analysis by showing how such dominant culture is acted out differently in regional contexts such as Victoria, British Columbia, where British colonial roots, rather than multicultural tolerance, are highlighted and celebrated.

In terms of regional differences in the quality of nationalist sentiment, many people see the rise of racism and anti-immigrant and anti-Native sentiment in Canada as a rural or 'Western' phenomenon. I do not intend to suggest that such politics are not located and experienced more powerfully in specific contexts. Rather, my impulse was and is to explore how urban multiculturalism and rural intolerance may exist on a continuum rather than as oppositional forces.

It is also important to stress that although the local aspects of my 1992 fieldwork focused mostly on semi-rural areas in southern Ontario where I encountered fairly pronounced intolerance, my goal was *not* to suggest that these towns are hotbeds of racism, whereas Toronto and other urban areas are not. This book is not intended as an ethnography of national identity in small town Ontario. Some have suggested that because my local ethnographic fieldwork took place in rural environments, the book is therefore really about rural Ontario. On the contrary, the fieldwork in those towns was part of a broader multi-site ethnography of cultural politics and national identity in the nation. Within that broader methodology (discussed in Chapter 1), I focused on those small towns not because I saw them as more authentic versions of Canada, but rather because, as I discuss in the book, the government itself presented such communities as the 'real' Canadians in its public relations programs for the Canada 125 celebrations.

The actual politics of inclusion and whiteness would undoubtedly differ in urban and rural contexts. What I call 'unmarked whiteness' could possibly be more subtle in urban areas. In urban contexts, a wide range of cultural and racial differences are

much more visible, and it is perhaps possible for certain ethnic groups to 'become white' more easily than in rural areas, a process shown brilliantly by Karen Brodkin in her *How Jews Became White Folks and What That Says about Race in America* (Rutgers 2000). Nevertheless, I would argue that such differences are still managed, imagined, and organized hierarchically in very profound ways.

Ghassan Hage's analysis of racial politics in Australia is very helpful in this context. In *White Nation*, he makes a complex argument regarding the similarities between the different forms of intolerance in rural and urban contexts. Like many of their Australian counterparts, urban cosmopolitan Canadians like to imagine that intolerance is characteristic of rural 'rednecks,' and that tolerance is associated with those living in urban areas, who have more opportunity to absorb and celebrate 'otherness.' Hage argues that despite apparent differences, both urban and rural versions of white national belonging are based on the ability to control social space and, ultimately, to decide whether to be tolerant or intolerant: that is, to have the power to decide the *limits of tolerance*. He argues that both urban and rural whites see their nation structured around a white culture, which they control, with Aboriginal people and immigrants as exotic objects. Hage calls this the 'White Nation fantasy.' He suggests that the rise of the new right there (represented by Pauline Hanson's One Nation Party) is a rejection by many of a newer, apparently more tolerant version of cosmopolitan multicultural nationhood – and a new elite – that gained hegemony in the 1980s and 1990s. Yet he demonstrates that, despite differences, both older and newer, urban and rural versions have something in common. They all maintain the fantasy of white settler control over the social space of the nation, only in different ways. In other words, rural intolerance and urban tolerance are not oppositional, but rather exist and are struggled over on a continuum.

Although mapping the realities of urban national identity in Canada could be a project in itself, Hage's work in Australia (where I also spent two years researching and observing such issues) elucidates possible interpretations of this context. Canadians like to congratulate themselves on their tolerance, but under what limits does tolerance exist? Do we use the myth of tolerance to create our own innocence? When does it break down? Finally, is the mythology of multicultural tolerance itself being replaced by something else?

Lately I ask myself whether something new in terms of national identity had begun to develop in the 1990s and is being carried over into the twenty-first century. Is Canada becoming more like Australia? Are we seeing a more overt brutality, as those 'othered' in the nation begin to fight back on their own terms? We already witnessed last summer the Department of Fisheries and Oceans boats ramming small Mi'kmaq fisher boats in Miramichi Bay off the coast of New Brunswick, despite the ruling of the Supreme Court of Canada on Native fishing rights in the Donald Marshall case. Evidence is coming to light that Ontario Premier Mike Harris ordered a heavily aggressive response to the non-violent protests by Native people at Ipperwash Park in 1995, a response that resulted in the death of unarmed protester Dudley George. We have also seen increasingly more social space for the voicing of anti-Aboriginal and

anti-immigrant sentiments with the rise of the Reform and Canadian Alliance parties. The federal Liberals use terms and create programs that are not substantially different from those supported by the Conservatives. The programs now being developed for Aboriginal self-government and land claims – emerging in part from the struggles over the Charlottetown Accord in 1992 (discussed in this book) – are critiqued by Native leaders as attempts to promote the cultural assimilation of First Nations peoples. Ironically, the Indian Act, seen often as a source of immense problems for Aboriginal people – is one of the only protections they have in the context of the new policies, which, some argue, are attempts to eradicate special rights for First Nations peoples and promote assimilation. Finally, with increasing conflict about land and resource rights for Aboriginal peoples, there is constant talk of a potential crisis in Canada about Native rights. How long will official and unofficial tolerance last when land, resources, and real autonomy for First Nations peoples are on the line? When does tolerance shift to intolerance?

For me, one of the key issues is that the boundaries and limits of identity, belonging, and inclusion are a site of constant struggle. But neither the source nor the outcome of that struggle lies only in ideas. Such battles are also integrally connected to much broader, less geographically bounded, economic and political processes. We must remember that national identity is only one aspect of a broader national and global project, a project that is flexible and malleable. For this reason, as I argue in *The House of Difference*, it is useful to look beyond so-called polarizations between left and right, between tolerance and intolerance, inclusion and erasure, and instead explore the power relations that nevertheless inhere through the continuities and flexibilities of projects. It is also important to explore how inclusion and the seeming celebration of multiplicity and difference can also be expressions of power. Finally, such inclusion and tolerance can, as we have seen so often, easily shift to intolerance and backlash, depending on the circumstances – as we are now witnessing in various responses to the events of September 11, 2001.

Since publishing the first version of this book I have benefited from fruitful dialogue with many people. I would like especially to thank Davina Bhandar, Himani Bannerji, Elizabeth Furniss, Mike Ma, my students at York University, and my new colleagues in the Department of Anthropology at McMaster University. Thank you so much for all your support.

EVA MACKEY
September 2001

ACKNOWLEDGEMENTS

When I started this project – which unfolded on three continents over many years – I could not possibly have imagined this moment of completion. With it comes the pleasurable task of thanking all the generous people who have sustained and inspired me throughout. I owe special thanks to many people: Brian Street, for his intellectual guidance and pedagogical skills in helping to tame earlier unruly versions of this project; Susan Wright, whose enthusiasm, careful thinking, and intellectual generosity helped me immeasurably; Julie Marcus, whose incisive comments and unstinting support have greatly improved this manuscript; Rahnuma Ahmed, whose inspiration, patience and encouragement started me and sustained me; Rebecca Garrett, who has listened patiently, read critically, questioned persistently, and made me laugh from the outset; Susan Reinhold, who inspired me, made me think harder, and encouraged through humour; Ann Whitehead, who pushed me to take risks in the beginning; Ruth Bacchus and Barbara Hill for their hard work and comments near the deadline, and for everything else that came with it; Roger Silverstone for his enthusiastic support of this project; Talal Asad, Elspeth Probyn and the anonymous Routledge reviewers for their insightful suggestions which prompted me to say more – and less – and certainly prevented me from making major mistakes; and Rebecca Barden, Alistair Daniel and Mark Ralph at Routledge – and the freelance copy-editor, Susan Dunsmore – for making the publication process so pleasant.

This project benefited enormously from the rigorous and exciting group of graduate students and lecturers at Sussex in the early 1990s, and would like to mention, in particular, Nandinee Bandyopadhyay, Lidia Felix, Ayesha Imam, Farzana Islam, Shin-Yuan Lai, Maitrayee Mukhopadhyay, Jane Cowan, Georgie Wemyss, and Zainab Wahidin. In the UK I was also sustained by the friendship and intellectual stimulation of Andrea Jones and Caroline Freeman. In Toronto I was strengthened by the encouragement and help of Judith Millen, Judi Lederman, Donna Patrick, Elizabeth Wilson, Michael Levin, Jorge Lozano, Carol McBride, Kim Stewart, and of course the Mackey clan – Allison, Clarke, Doug, Eleanor, Paul and Ariel.

Most importantly, this project was made possible by the gift of love and

support so generously given by Mary Millen. Her intellectual and political insights, and her comments and editing skills have improved this book beyond measure. I am deeply indebted to her for her patience with my years of writing and obsession, and for her wisdom throughout.

A number of generous funding sources helped this project through all its stages. A Commonwealth Scholarship gave me the opportunity to study in England and supported me from 1990–94. In particular, I thank Kathleen Roberts at the Association of Commonwealth Universities, as she was always a delight to deal with. The Social Sciences and Humanities Research Council of Canada provided a Doctoral Fellowship from 1992–95. The Royal Anthropological Institute of Great Britain provided fieldwork funding through the Emslie Horniman Anthropological Scholarship Fund. I am especially grateful to Deborah Swallow for her support. The Royal Anthropological Institute also helped during the final days of thesis writing, through the Radcliffe-Brown Trust Fund and the Emslie Horniman Fund. The Wenner-Gren Foundation for Anthropological Research generously awarded me a Richard Carley Hunt Postdoctoral Fellowship to turn the thesis into a book during 1997–98. A Postdoctoral Research Fellowship in the Centre for Cultural Risk Research at Charles Sturt University, Bathurst, NSW, Australia also provided time for the revisions.

A version of Chapter 4 appears in *Social Analysis*, 42(2), 1998, and portions of Chapter 6 were published in Cris Shore and Susan Wright (eds) *Anthropology of Policy* (Routledge 1997). I thank all involved for their comments.

I am grateful to the organisations (and the specific individuals with whom I dealt in those organisations) who gave permission to reproduce the images used throughout. Finally, I am immensely thankful to all the people who were kind enough to speak with me during my fieldwork.

Eva Mackey
April 1998

1

INTRODUCTION

Unsettling differences: origins, methods, frameworks

> Imagine how you as writers from the dominant society might turn over
> some of the rocks in your own garden for examination. Imagine...coura-
> geously questioning and examining the values that allow the
> de-humanizing of peoples through domination...Imagine writing in
> honesty, free of the romantic bias about the courageous 'pioneering
> spirit' of colonialist practise and imperialist process. Imagine interpreting
> for us your own people's thinking towards us, instead of interpreting for
> us our thinking, our lives, our stories. We wish to know, and you need to
> understand, why it is that you want to own our stories, our art...our
> ceremonies.
>
> (Jeanette Armstrong 1990:143–4)

On the postcard, the red-coated Mountie smiles warmly as he reaches out to
shake hands with Chief Sitting Eagle who is dressed in a colourful feather head-
dress, buckskins and beads. The caption reads, 'Here indeed are the symbols of
Canada's glorious past. A Mountie, resplendent in his famed scarlet greets Chief
Sitting Eagle, one of Canada's most colourful Indians.' This image of reconcili-
ation and equality, presented in such a picturesque manner, invokes an older
mythology of Canadian identity which I call the 'Benevolent Mountie Myth', a
myth based on the story of the Westward expansion of the nation at the end of
the nineteenth century. The Royal Canadian Mounted Police, representatives of
British North American justice, are said to have managed the inevitable and
glorious expansion of the nation (and the subjugation of Native peoples) with
much less bloodshed and more benevolence and tolerance than the violent US
expansion to the South. This benevolent gentleness, it was believed, was a result
of naturally superior forms of British justice, and was an important element in
the mythologies of Canadian national identity emerging at the turn of the
century (Francis 1992: 69).

 The image of the Mountie and the 'Indian Chief' places a representative of
the state and a representative of minority culture – coloniser and colonised – in
a friendly, peaceful and collaborative pose. Aboriginal people and the state are
represented as if they are equal: as if the Mountie did not have the force of the

1

crown and the military behind him, shoring up his power. This image of collab-orative cultural contact could be contrasted with a quintessential American frontier image: cowboys chasing and killing 'Indians'. In the American images, the cowboys are presented as rugged *individuals*. In contrast, the Mounties in the Canadian image are symbols and representatives of the kind and benevolent *state* – the state that supposedly treated, and still treats, its minorities more compassionately than the USA.

The Mountie myth is one of many similar stories that utilises the idea of Canada's tolerance and justice towards its minorities to create national identity. From early versions of Canadian history through to the Québec referendums of 1980 and 1995, and the Calgary pact made in September 1997, official defini-tions of English-Canadian history and identity present the past as a 'heritage' of tolerance. During the last three decades, the story of Canada's tolerant nation-hood has often been framed in terms of its policy and mythology of 'multiculturalism', a policy defined in official government ideology as 'a funda-mental characteristic of Canadian heritage and identity'. Canada is often described as a 'cultural mosaic' in order to differentiate it from the American cultural 'melting pot'. In the Canadian 'mosaic', it is said, all the hyphenated cultures – French-Canadian, Native-Canadian, and 'multicultural-Canadian' – are celebrated. One problem with this formulation, as many have pointed out, is that multiculturalism implicitly constructs the idea of a core English-Canadian culture, and that other cultures become 'multicultural' in relation to that unmarked, yet dominant, Anglo-Canadian core culture (Moodley 1983). This book explores the contradictory terrain wherein pluralism as an ideology and mythology intersects with the construction of dominant national identity and culture in Canada.

A nation, Anderson stresses, is an imagined community, and nations are distinguished from each other by the stories they tell about themselves (1991). Although it would be ridiculous to say that this particular 'invented tradition' (Hobsbawm 1983) is uncontested, the Canadian myth of tolerance has gained great authority throughout the nation's history. It offers a 'narrative of nation-hood', and is one of the stories which is closely linked to the images, landscapes, scenarios, historical events, national symbols and rituals which, Stuart Hall argues, 'stand for, or *represent*, the shared experiences, sorrows, and triumphs and disasters which give meaning to the nation' (Hall 1992a: 293).[1] There is no doubt that nationalist narratives of tolerance such as the Mountie myth misrepresent the encounter between cultures and the brutal history of conquest and cultural genocide that Canada is founded upon. However, although the official stories misrepresent the messy and controversial reality of history, they do not, at least overtly, erase the presence of Aboriginal people or deny the existence of cultural differences within the nation. Aboriginal people are necessary players in nationalist myths: they are the colourful recipients of benevolence, the necessary 'others' who reflect back white Canada's self-image of tolerance. Pluralism and tolerance have a key place, and an institutionalised

place, in the cultural politics of national identity in Canada.

This book examines the project of nation-building and the nationalism of dominant peoples within the context of pluralist mythology and 'multicultural' state policies. Nationalism has been the subject of a vast body of inquiry.[2] However, analysts of the cultural politics of national identity often focus on extreme and exclusionary nationalisms, and studies of multiculturalism and cultural pluralism tend to examine the lives of minority groups and their processes of 'adaptation' or 'resistance' to mainstream cultures. In Canada, however, cultural pluralism is institutionalised as a key feature of the mythology of identity of the dominant white Anglophone majority. Multiculturalism, this book contends, has as much to do with the construction of identity for those Canadians who do not conceive of themselves as 'multicultural', as for those who do. It examines the cultural politics of pluralism as it is articulated in colonial and national projects, and in the subjectivities of people who conceive of themselves as 'mainstream' or simply '*Canadian*-Canadians'. As such, it is a contribution to the burgeoning field of studies of 'whiteness'[3] (Dyer 1988, 1997; Frankenberg 1993; Roediger 1991, 1994).

This book maps the contradictions and ambiguities in the cultural politics of Canadian identity and raises a number of key questions. How can we critically understand a cultural politics seemingly based on *inclusion* and *tolerance* rather than erasure and homogeneity? How does 'tolerance' for 'others' work in the construction of an unmarked and yet dominant national identity? What are its effects? Do 'multiculturalism' and pluralism draw on and reinforce racial exclusions and hierarchies of difference? What kinds of conceptual continuities exist between colonial policies, multiculturalism, and the 'white backlash' of the 1990s?

The origins of *The House of Difference* are in the 'crisis' of anthropology that was in full flight when I began to study in the mid-1980s. At that time, feminist and postmodernist critiques of 'scientific objectivity' were shaking up the discipline[4] and post-colonial critiques were inspiring anthropologists to grapple with historical and present-day issues of colonialism, imperialism and power. At the same time, work in feminist theory and cultural studies aimed to bring silenced and subordinated forms of knowledge into relief by exploring the worlds and lives of marginalised peoples. However, it became clear from the study of the politics of cultural differences that it was also necessary to examine the unmarked and yet normative categories such as 'whiteness', heterosexuality, masculinity and Western modernity that were often excluded from analysis.[5] Hazel Carby argues that preserving 'an analysis of gender only for texts about women...or an analysis of racial domination for texts by or directly about black people will not by itself transform our understanding of dominant cultural forms' (1989: 40). It is only through problematising dominant categories – which are often invisible and yet powerfully normative – that we can begin to understand how they are invented and reproduced.

The analysis offered here explores the construction of dominant forms of

3

Canadian national identity, and does so as part of a broader goal: to understand how Western projects of identity function in terms of culture, difference and power. I engage in what Asad calls 'an historical anthropology which takes Western cultural hegemony as its object of inquiry' (1993: 24) and what Chakrabarty (1992) calls 'provincialising Europe' and the West. Such an anthropology interrogates the 'radically altered form and terrain of conflict' – the 'new political languages, new powers, new social groups, new desires and fears, [and] new subjectivities' – that characterise Western modernity (Asad 1991: 322–3).[6] Further, as Chakrabarty argues, the goal of the project of 'provincialising Europe' is not to point out that 'Enlightenment rationalism' is necessarily 'unreasonable in itself', but rather a 'matter of documenting how – through what historical process – its "reason", which was not always self-evident to everyone, has been made to look "obvious" far beyond the ground where it originated' (1992: 351). In this sense I 'critique', in the Foucauldian sense of the term, Canadian nationalism and Western modernity. Foucault argues that:

> a critique is not a matter of saying that things are not right as they are. It is a matter of pointing out on what kinds of assumptions, what kinds of familiar, unchallenged, unconsidered modes of thought the practices we accept rest.
>
> (Foucault 1988 in Corrigan 1990: ix)

Nations have been described as a 'distinctly modern form' and even an 'engine of modernity' (S. Hall 1992b: 292; Hobsbawm 1990: 14). Gellner argues that while 'having a nation is not an inherent attribute of humanity', it has now, in modernity, 'come to appear as such' (1983: 6). Nations are the most universally legitimate, and seemingly natural, political units of our time. In modernity the nation–state 'has been granted universal recognition and validity as the authorised marker of the particular' (Ang and Stratton 1996: 26). Nation-building is a Western project – engendered by structures, narrative forms, desires, and classifying and differentiating practices which are essential to Western modernity[7] – and national identity is 'modernity's fundamental identity' (Greenfeld 1996: 10–11). National identity, therefore, is a useful site through which to examine modern Western processes of identity construction.

Some radical critics of modernity, focusing on extreme forms of colonialism and nationalism, have presented modernity as nearly always destructive of cultural difference. Critics of Western cultural projects often suggest that the Western 'will to power' lies in its construction of a *singular, universal, unified*, and *homogeneous* modern subject. Homi Bhabha contends, for example, that dominant power and political supremacy seek to '*obliterate*' difference (cited in Asad 1993: 262). Thus, resistance and liberation are found through 'resurrecting the virtues of the fragmentary, the local, and the subjugated' (Chatterjee

1993: xi) or in Bhabha's case, the critical 'Third Space' of cultural 'hybridity' (1994: 38).

In Canada, however, power and dominance function through more liberal, inclusionary, pluralistic, multiple and fragmented formulations and practices concerning culture and difference. This study of Canada's 'multicultural' nation-building examines the subtle and less overt powers of liberalism and liberal pluralism. It explores how liberal 'tolerance' is mobilised to manage populations and also to create identities. As a result, this book questions and expands those formulations of the characteristics of Western power that oppose oppressive homogeneity with resistant fragmentation and hybridity. It develops an analysis of culture, identity, difference and power that accounts for liberal and apparently more inclusionary constructions of national identity. It explores how modern Western forms of power and identity have also been enacted through *constructing* forms of difference and *hetero*geneity, and through liberal concepts and practices of pluralism, diversity and tolerance. The powers of 'Western modernity', I argue, work not only through the erasure of difference and the construction of homogeneity, but are endlessly recuperative and mobile, flexible and ambiguous, 'hybrid' as well as totalising.

As such, it should be stated at the outset that this analysis is one slice of a potentially immense topic. It is not a contribution to defining and delineating the *authentic* characteristics of Canadian nationalism or national identity. Neither is it an assessment of the policy of multiculturalism, or a detailed political and economic history of Canadian nation-building. It does not primarily seek to document many of the overtly racial and culturally genocidal state policies and practices applied to cultural minorities, nor the effects upon, or the resistance of, minorities to this process of nation-building. Instead, this book focuses on exploring the subtle and mobile powers of liberal inclusionary forms of national imagining and national culture. Rather than analyse power by examining the erasure of difference and the construction of homogeneity, it explores the cultural politics of the proliferation of difference and the construction of heterogeneity, including the links between discourses of tolerance and the emerging 'white backlash'.

In this mass-media age of *Dancing with Wolves*, of O.J. Simpson and Clarence Thomas, of affirmative action programmes, and of the 'multicultural marketing' seen in Benetton, Microsoft and Coca-Cola ads, taking apart multicultural tolerance is important not just in Canada, but on a broader scale. In the 'global marketplace', television screens, advertising, literature, popular culture and academia are now filled with complex and contradictory images of pluralism, images that do not simply erase difference, but often highlight and celebrate particular forms of diversity. Meanwhile the hegemony of the market becomes stronger, the 'white backlash' grows louder, and marginalised populations have fewer and fewer choices. The important question for me in this context is not 'How does dominant power erase difference?' but rather, 'How might we map the ways in which dominant powers maintain their grip despite

the proliferation of cultural difference?'. Further, it is important to ask how 'threatening' and 'dangerous' differences are contained, controlled, normalised, stereotyped, idealised, marginalised and reified.

A great deal of debate in recent decades on anthropological methods and objects of inquiry has circulated around the question of how the discipline can develop an 'anthropology of the present' (Fox 1991), which would account, both theoretically and methodologically, for the rapid transformations in social and cultural life at the end of the twentieth century (Abu-Lughod 1991; Fox 1991; G. Marcus 1989, 1992; J. Marcus 1990; Wright 1998). Since the closed and bounded localities anthropologists preferred to study in the past no longer exist – if they ever did exist – the issue of linking micro and macro levels of analysis, and of theorising and describing the relationship between global processes and local events and places, has been the subject of debate and argument (Appadurai 1991; Gupta 1992a, 1992b; Marcus 1989, 1992). George Marcus argues for 'event-centred' and 'multi-locale' ethnographies that explore how 'any cultural identity or activity is constructed by multiple agents in varying contexts or places', and he suggests that ethnography must be 'strategically conceived' to represent such multiplicity 'in the network of complex connections within a system of places' (1989).

The House of Difference is a 'multi-site' or 'multi-locale' ethnography. Its methodology accounts for the fact that national identity is produced both in face-to-face encounters in multiple sites, as well as through representations, institutions, and policies. The study of national identity in modern media-saturated nation–states has often been problematic for anthropologists because they focus on single, localised field sites to the exclusion of the broader, multiple sites of national identity production, reception and contest. As a multi-site ethnography, the book combines the use of traditional anthropological methods such as interviews and participant observation in numerous local sites, with an analysis of the construction of national identity in public culture and in state and business policies, both historically and in the present.

The analysis offered here is based on fieldwork carried out in 1992: a year in which highly contested debates about, and versions of, national identity and pluralism were ubiquitous in all forms of Canadian public culture. When I began fieldwork early in the year, my research plan was to examine conflicts over culture, race, nation and representation in Canada. I intended to start with an 'event-centred' approach, by documenting contested representations of history in the Columbus Quincentennial celebrations, an immense multi-national cultural/historic event that was already promising to be controversial. I quickly discovered that while there were innumerable *counter*-Columbus activities, official government celebrations had been all but jettisoned. Some informants in government offices speculated that the Columbus celebrations were simply 'too controversial' largely because of the political activism of Native people and other minorities.

Instead of celebrating the Columbus Quincentenary in 1992, the federal

government decided that Canada would celebrate the 125th anniversary of its formation as a nation – and began plans for the 'Canada 125' celebrations. The celebrations were part of a series of complex political manoeuvres by the federal Progressive Conservative government, including extensive debates on the constitution and, finally, a referendum. The very future of the nation – and the contested place of historically defined cultural, ethnic and racial groups within the nation – were the subject of immense political conflict and debate. Canadian citizens were also the objects and subjects of symbolic intervention by the federal government, in part through the 'Canada 125' celebrations and other 'pedagogies of patriotism' (Mackey 1997). The celebrations, designed to mobilise local people for patriotism and national unity, were excellent sites for ethnographic exploration of the construction of national and local identities. The broader political context provided intriguing and complex examples of contests over national identity in a public culture that is officially 'multicultural'. I documented the contests in public culture, interviewed cultural workers and bureaucratic elites, and did participant observation and interviews at numerous local patriotic celebrations. The 'multi-site' and 'event-centred' methodology allows for an in-depth analysis of the ways in which national political crises – often framed as 'identity crises' – become the conditions of possibility for the production, surveillance, and regulation of identities and difference at national and local levels. This book, therefore, shuttles between micro and macro, between public representations and local discourses, between past and present, and between the global, the national, and the local.

Chapters 2 to 4 explore the representation of cultural difference in official representations of national identity in national histories, national art, tourism, and government discourses and programmes. They also discuss colonial and national cultural and immigration policies and link the processes occurring in Canada to developments happening on a global scale. The end of Chapter 4 is a summary of the arguments made thus far, in preparation for Chapters 5 to 7. They provide a focused and detailed analysis of contests over national identity in local and national sites during the 1990s. Drawing substantially on interviews and participant observation, these chapters are therefore more ethnographic. Chapter 5, for example, explores three of the local patriotic festivals in detail, drawing out some of the broader themes at a local level. Chapter 6 shuttles back and forth between national and local discourses to explore how ideas of an authentic Canadian 'people' were mobilised in official national celebrations and politics, and in local discourses of identity. Chapter 7 examines the 'bottom line' in local discourses of identity, draws together the strands of the book to explore how people mobilised liberalism to bolster and enable intolerance, and assesses some current approaches to culture, power, difference, nation and globalisation in anthropology, postcolonial studies and cultural studies.

Theory/identity: the margins and the metropoles

British and American academics who read earlier versions of this book tended to comment with surprise, perhaps even embarrassment, on how reflection about national identity in Canada seemed so constant, wide-ranging and anxiety-ridden, especially in comparison with their own countries. Australians, on the other hand, found the constant identity crises strikingly familiar. Australia, like Canada, another settler colony of Britain, has also been consistently considered in some sort of 'crisis of identity' (Hage 1996; Lattas 1990), and the 'crisis' at the end of the twentieth century, in both nations, is particularly fierce and brutal.

The different responses by intellectuals to Canadian 'identity crises' raise the important issue of how differently intellectual work may be perceived in particular contexts (see Mani 1990). It also raises the question of whether our theories about identity and nation, coming as they often do from metropoles such as Britain and the United States, are adequate to understand processes of identity formation and contest in colonies such as Canada, Australia and New Zealand. In the early stages, the research for this book was heavily influenced by British work on race and nationhood generated during the Thatcher years which identified the emergence of 'new racism' or 'cultural racism' (Barker 1981; Gilroy 1987; Seidel 1987). This form of racism is new because it has shifted from a focus on crude ideas of biological inferiority and superiority to a language of race that excludes by using concepts of national culture and identity. Gilroy argues that it is a racism that 'avoids being recognised as such' because it links race with nationhood, patriotism and nationalism. It constructs and defends a national culture '*homogeneous* in its whiteness' yet at the same time 'precarious and perpetually vulnerable to attack from enemies from within and without'. Its 'dream-like construction of our sceptred isle as an ethnically purified one', he argues, provides 'special comfort against the ravages of [national] decline' (1990: 196). While his cogent analysis of Thatcherite Britain is compelling, the politics of race and nation in Canada is simply not the same. The exclusions of Canadian nationalist discourse are subtler, less obvious. A settler colony with official policies of multiculturalism and bilingualism, Canada has an official national culture which is not '*homogeneous* in its whiteness' but rather replete with images of Aboriginal people and people of colour. The state-sanctioned proliferation of cultural *difference* (albeit limited to specific forms of allowable difference) seems to be the defining characteristic of Canada.

Therefore, attempting to apply theoretical insights generated from research into contexts such as Britain directly to the Canadian context can be, as Berland notes, 'misguided and misleading' (1995: 514). Recent analyses in post-colonial theory, cultural studies and anthropology stress the importance of countering generalising theories of 'colonialism', 'nationalism', or 'culture' with detailed specific and localised accounts of these processes (McClintock 1995; Thomas 1994). Recent work in Canadian and Australian cultural studies and communi-

cation seeks to map the specific terrain and characteristics of nationalism and cultural difference in settler colonies (Bennett *et al.* 1994; Blundell *et al.* 1993), to engage in the process of what Allor calls 'landing' cultural studies (Allor 1987). National identity in settler colonies such as Canada has a different landscape and genealogy than identity in the older nations of Europe or even in the United States.

Bennett *et al.* argue that new settler societies, unlike traditional European nations, have had to 'undertake the process of nation formation urgently, visibly, defensively'. They are always being 'caught in the act, embarrassed by the process of construction' (1994). Indeed, to speak of culture and identity in Canada is to speak 'not only of a terrain that is fractured and contested, but of a terrain whose identity *as Canadian* is in dispute' (Allor *et al.* 1994, emphasis mine). The chapters that follow demonstrate the sheer quantity of resources and energy that have gone into desiring and creating an identifiable and differentiated Canadian culture. From colonial times to the present, intellectuals, politicians of every hue, activists, state institutions, and businesses have sought to define, defend and differentiate Canadian identity. This book documents only a few of the truly astounding number of initiatives intent on making Canadian identity. The desire for and the necessity for *a* national identity are seen as common sense, it is taken for granted. Yet, if we listen to people, the project of creating identity has also apparently been terribly unsuccessful. Everywhere, Canadian identity is seen as crisis-ridden, as a fragile and weak entity constantly under attack and in need of vigilant defence. Some people say that Canada has no identity at all, or at least not a real one. Even a report from the federal government suggests that Canada is a 'nation without nationality' (Spicer 1991: 1).

Until quite recently it has been generally accepted that it was the state's role to foster national identity in post-Second World War Canada. Perhaps it is therefore not surprising that the 'first texts in Canadian cultural studies were sponsored by royal commissions' (Berland 1995: 515). Canada has produced a 'veritable canon of strategical exploration and description of its ongoing identity crisis', now among the 'most dense bodies of inquiry into culture and nationhood in the industrialised world' (ibid.: 514). A constant theme in debates about Canadian identity, then and now, is the notion that Canada is marginal to and victimised by various forms of colonialism, most recently American cultural imperialism. In this context, the reasoning goes, Canadian identity needs to be protected and produced.

The idea that Canada is a marginal and defenceless victim depends on highly gendered images. Particularly in the feminisation of nationhood, it borrows a key metaphor from one of Canada's internal 'others': Québec nationalists. Elspeth Probyn suggests that within Québec, images of Canada and Québec as a couple in the throes of divorce are 'by now so common' that they need 'little explanation'. The image of Québec as a wife telling her husband to 'shove off' is a metonym for Québec telling Canada that the unhappy 'marriage' of cultures

in the nation is over (Probyn 1996: 80–1). In these gendered and heterosexual images, Québec is constructed as different from and marginal to Canada, and this difference is embodied in the image of the wife, the woman. Probyn argues that marginality itself becomes the basis of Québécois identity, as it creates itself as 'marginal to the majority, as peripheral to the centre, as female to the male' (ibid.: 72–3). The most striking aspect of Probyn's description of the gendering of *Québécois* identity in relation to Canada is that similar images are used by Canadians outside of Québec to define *Canada* in relation to the *USA*. It was not only in the debates about free trade in the late 1980s that the nation (and the land in particular) was constructed as a natural, pure, fertile yet vulnerable woman, constantly defending herself from the more masculine and aggressive hulk of the United States – the southern neighbour who sought to rape her natural resources and colonise her culture. These kinds of gendered metaphors have 'long been a staple of Canadian culture' (Berland 1995: 522). The 'feminised Canadian', Berland argues, has been instrumental in the circulation of 'fictions, metaphors, and interventions which render Canadian culture as closer to nature, aesthetically highbrow, non-violent, uncorrupted, committed to public good but powerless before the masculine figures of (external) authority' (ibid.: 523).

Perhaps the insecurities and anxieties which inspire such productions of identity are more understandable if we consider that traditional European understandings of nationhood 'deny the legitimacy of... post-colonial societies' because these societies do not rest on 'traditions which are the outcomes of long continuous histories' (Bennett *et al.* 1994). Discourses of marginalisation, within this context, are seen as resistance to the universalising features of colonialism. Yet even as they resist dominant forms of *external* colonialism, discourses of marginalisation may reproduce and reinforce particular nationalist assumptions and programmes in a surprisingly unreflective manner. Handler (1988) argues that the problem with much social scientific discourse on nationalism is that it reproduces an axiomatic assumption of nationalist discourse, the idea that nations are bounded territories that should 'have' cultures different from all other cultures. Much work on nationalism in fact seeks to elaborate the comparative differences between nations without having a corresponding critical approach to the historical specificity of the nation–state itself, particularly its status as the most legitimate and naturalised form of identity in western modernity.

Gellner writes that:

> [the] idea of a man [*sic*] without a nation seems to impose a strain on the modern imagination. A man must have a nationality as he must have a nose and two ears. All this seems obvious, though, alas, it is not true.
>
> (1983: 6)

However, that it has come to seem 'so very obviously true' is for Gellner, perhaps the 'very core' of the problem of nationalism. He argues that while 'having a nation is not an inherent attribute of humanity', it has now 'come to appear as such' (1983: 6). Wallerstein contends that national identity is 'the quintessential (albeit not the only) particularism, the one with the widest appeal, the longest staying power, the most political clout, and the heaviest armaments in its support' (cited in Ang and Stratton 1996: 26).

Within modernity a nation must be seen to 'have' a distinct culture in order to be recognised. Handler shows how modern maps embody this axiomatic assumption: they present an image of the world as constituted by multiple distinct and bounded entities, each nation represented by a different colour marking the distinct national territory and culture (1991). The United Nations, too, constructs a 'model for global culture based on interrelations between distinct mutually exclusive, singular national units' (Ang and Stratton 1996: 26). The desire to 'have' an identifiable culture and identity emerges from European models of nation-building, and also to particular historically consti-tuted conceptualisations of personhood. Handler interprets the idea of 'having a culture' and 'having a history' in terms of Macpherson's (1962) idea of 'posses-sive individualism' (Handler 1991). He shows how 'having' – possessing – a culture and a history are historically constituted as essential to the identity of an ethnic group or nation. As a result of these historical processes, it is now axiomatic that a nation or group must have a differentiated (individual) culture and identity in order to be seen to exist, and also to claim rights and powers.

These nationalist views of culture and history are tied to processes of moder-nity and to Western liberal notions of normal personhood, in particular the Enlightenment concept of individual sovereignty and autonomy – a concept that some have argued was the propelling force that set 'modernity' in motion (S. Hall 1992b: 281–2). In this historically specific formulation of selfhood, identity *is* the self. Having a differentiated, bounded and defined identity comes to be an essential feature of 'normal personhood' or normal nationhood, as constituted in a modern Western framework (Asad 1993: 12).

As discussed in later chapters, official and vernacular constructions of identity in Canada often take it for granted that a nation, to be strong, must have a bounded and definable national 'culture' and identity, a culture that is distinct and different from all other national cultures. Nationalism often entails the project of delineating and elaborating that identity in multiple sites from national art and literature, to national histories and 'Canadian studies'. However, as Ang and Stratton argue, the 'politics of nationalism' which is sometimes 'advocated as a strategic essentialism for less powerful nation–states', also entails a 'forgetting of the historical particularity of the nation–state as such, and emphasises only the partial historical and cultural idiosyncrasy of specific nation–state formations' (Ang and Stratton 1996: 26). Studies of Canadian nationalism, whether by royal commissions, popular writers or scholars, have often participated in a similar nation-building project, in that they

often seek to define the characteristics of Canada so that it can be better defended and protected.

I will argue that this kind of 'strategic essentialism' based on particular images of Canada as victim also plays another ambiguous and problematic role. The construction of Canada as a gendered body, victimised by external and more powerful others, creates a fiction of a homogeneous and unified body, an image that elides the way the Canadian nation can victimise internal 'others' on the basis of race, culture, gender or class. It appropriates the identity of marginalisation and victimisation to create national innocence, locating the oppressors safely outside the body politic of the nation: a more compelling and less politically complicated image than that of the nation as a differentiated and non-unified body laden with internal oppressors and victims. As I discuss in the final chapters of the book, key assumptions of the discourse of marginalisation and victimisation used by left–liberal nationalists (for example the idea that Canada needs a 'culture' and that Canadian culture needs to be defended and made strong), were appropriated by the new right and by local people to justify anti-immigrant and anti-multicultural sentiments; a situation that demonstrates the problematic conflation of left and right when it comes to the basis tenets of nationalism. In Canada, although there may not be the overt construction of *national cultural homogeneity* such as that which Gilroy argues exists in Britain, the white Anglophone majority undoubtedly has cultural, economic, and political *dominance*. If Canada is the 'very house of difference', it contains a family with a distinct household head.

Therefore, while theories generated elsewhere do not account for the historically constructed particularities of the sense of marginalisation, victimisation and anxiety associated with Canadian national identity, discussions of identity from within tend to reproduce these kinds of images as part of the project to create and defend national identity. They often do so without a corresponding reflexivity about the specificity of nationalism itself.[8] The production of national identity in settler colonies such as Canada has a specific history and different characteristics from identity in the older nations of Europe or even in the United States. The images that construct Britain as a homogeneous nation with a long history of ethnic purity and imperial glory that Gilroy critiques are simply not possible in 1990s' Canada. Clearly, the project of nation-building does not occur in the same way throughout the world. The problem then is how to explore and account for differences between nations without reifying national culture and reproducing the nationalist project.

Martin Allor discusses how cultural studies has taken to grounding its analyses in concrete local examples of struggle, but argues that the 'risk' of this approach is that it will 'spin out refined conceptions of one site (and model) of mediation without rearticulating the underlying conceptual framework' (1987: 137–8). He argues that a better approach is to 'mine the analysis of specific junctures in order to work over the theoretical first principles' (ibid.: 138). For me this means not only seeking to define the characteristics of a specific

nation–state itself – for example, the identification of the main features of the Canadian nation-building project – thereby constructing 'the nation' as the 'problem-space' (Scott 1995) or object of inquiry. It also requires expanding and problematising the object of inquiry itself. This book therefore analyses a specific national example of contest over national identity and cultural differ- ence in order to re-examine key theoretical assertions about the relationship between identity, power, and Western modernity. As discussed earlier, critics often present modernity as destructive of cultural difference, and suggest that the Western 'will to power' functions by erasing difference to construct a singular, universal, unified, and homogeneous modern subject. These formula- tions of Western power have become what Allor might call 'theoretical first principles'. This book questions and expands these formulations of Western power that oppose oppressive homogeneity with resistant fragmentation and hybridity, and uses a closely textured analysis of a specific national site as a basis on which to re-examine theoretical first principles.

Necessary 'others': the contradictory inclusions of settler national identity

Since Canada, because of its particular history, could not and cannot fit the identity model of European nationhood, it, like other settler colonies, has had to look for alternative models of nationhood and national identity, and has had to do so 'across competing forms of ethnicity and against a history of occupa- tion and dispossession of the original inhabitants' (Bennett et al. 1994). In the chapters that follow I suggest that the development of a pluralist national iden- tity was a flexible strategy developed to manage diverse populations. However, it also emerged, ironically, as a method of creating a common national culture and identity that would differentiate Canada from other nations, specifically the United States. I argue that contrary to the common sense that circulates about national identity and cultural pluralism in Canada, national identity is not so much in a constant state of crisis, but that the reproduction of 'crisis' allows the nation to be a site of a constantly regulated politics of identity. Institutions of the state constantly enact policies to intervene in the production of identity and culture. From the role of museums in the construction of a national identity defined by the state, to the official nationalist celebrations designed to create identity and manage the conflicts of cultural difference, this book travels within the national landscape, exploring the cultural politics of national identity as a form of conscious cultural production, a production with the purpose of creating national subjectivities.

The complex patterns of colonisation and cultural and economic develop- ment that created Canada have resulted in a situation in which the multiple identities which make up the nation are constantly at battle with each other, and in which the boundaries, inclusions and exclusions of identity are unstable and constantly changing. The historical trajectory of nation-building has meant that

identity has never been homogeneous, and cultural differences could never be completely erased. Allor *et al.* (1994) discuss how Canadian myths of origin are based on the reconstruction of British and French colonialism as the acts of Two Founding Peoples, and argue that in the compromise between power blocs at the moment of confederation, the sovereignty and land claims of Aboriginal peoples disappeared. The constitutional recognition of cultural duality created, they argue, a theory of empty land, of *terra nullius*, which erased Canada's First Nations. Yet, if we look closely, the construction of Canada as *terra nullius* is not consistent. As I discuss in more detail in Chapter 2, Canada's mythologised kindness to Aboriginal people was an important element in developing a national identity based on the notion of difference from the USA – a difference that was tied to the idea of Canadian tolerance. The contradiction is that this notion of Canada's tolerance coexisted with brutal policies of extermination and cultural genocide. In a similar vein, while early constructions of national identity such as that of the Canada First Movement were explicitly racially exclusive, these versions of identity were also contradicted by other official representations that highlighted Aboriginal imagery.

Allor suggests that the internal founding division in Canadian identity 'worked to peripheralise other ethnicities and further enact the internal colonisation of the First Nations'. The founding division and its exclusions are still in effect today: Bannerji argues that inhabitants of Canada other than the English and French are 'insider–outsiders', only a minor part of the key 'problematic' of national identity' (1996: 105–6). They are considered *outside* what is commonly seen as the essential conflict of the nation (between the English and the French). Yet they are symbolic *insiders* because the presence of multiculturalism and First Nations people is also necessary for the larger project of building Canadian identity as a whole, and for the strategic management of Canadian politics.

The October 1995 Québec referendum brought definitions of Canadian identity to the fore, and nationalist discourses mobilised the notion of tolerance and pluralism as a central and persistent feature of English Canadian identity. It all began when the Premier of Québec, Jacques Parizeau, gave his speech after the Yes side (Yes to some form of separation or sovereignty for Québec) lost the referendum by an outrageously slim margin on 30 October 1995. The English Canadian press has always enjoyed constructing Québec separatists as intolerant and racist,[9] and Parizeau, in his speech, played right into this view, saying that the Yes side lost because of 'money and the ethnic vote'. This statement created justifiable controversy and scandal, but here I explore how it became an opportunity for English Canada to use multiculturalism to reaffirm its superior tolerance at Québec's expense.

A few days after the referendum an editorial entitled 'Giving voice to the Canadian idea' appeared in Canada's national newspaper, *The Globe and Mail*. It began with a detailed description of all the 'racial' and anti-immigrant comments made by Québec separatists during the campaign. At its 'core', the

editorial stated, 'Quebec separatism is a species of ethnic nationalism, by nature exclusionary, intolerant and, in its worst forms, racist.'

> We are deeply offended. And being offended is the way we learn about ourselves. By showing us what we are against, Mr. Parizeau and Mr. Bouchard and Mr. Landry have given us a rare opportunity to affirm what we are for. Is Canada just a comfortable place to live, a common living space with no common ideal, or is there something more to us? What do we stand for as a nation? What is Canada all about?
>
> (*The Globe and Mail*, 4 November 1995)

And here the editorial describes 'the Canadian idea'.

> Most of us already know in our hearts. We are against the idea that people should be treated differently because of their skin colour, language, religion or background. We are for the idea that all Canadians should be treated as full citizens. We are against the idea that any Canadian is more purely Canadian that any other, no matter how far back his or her Canadian ancestry goes. We are for the idea that everyone should have an equal chance to succeed on his or her merit. We are against ethnic nationalism, in which people of common ethnicity rule themselves – masters in their own house. We are for civic nationalism, in which people of different backgrounds come together under the banner of common citizenship to form a community of equals. Ours is a modern nationalism: liberal, decent, tolerant and colour blind. That is what Canada represents to the millions of people who come here from other countries. That is the idea of Canada...[W]e must show Quebeckers...that Canada and Canada alone waves the banner of pluralism and common humanity.
>
> (ibid.)

Here, the demands of *French* Canada are equated with intolerance and racism, and *English* Canada, in opposition, is constructed as the opposite, a modern tolerant nation. English Canada transcends the particularisms of Francophone 'ethnic nationalism' and becomes a universal model of civic nationhood. Bannerji points out that there is no other way for a 'non-partisan, transcendent Canada to be articulated except in the discourse of multiculturalism' (1996: 108). This means that Canada's 'difference studded unity', its 'multicultural mosaic' becomes an ideological sleight of hand pitted against Québec's presumably greater cultural homogeneity: multiculturalism is therefore mobilised here as 'moral cudgel with which to beat Quebec's separatist aspirations' (ibid.: 108–9). In the same way, Canadians' perception of themselves as less racist and more tolerant of Aboriginal peoples than Québec, is used to justify anti-separatist sentiment. In this way multicultural and

Aboriginal 'others' become necessary weapons in the war between the two 'founding' nations.

In Canada the constant crisis of the nation is therefore not managed through constructing cultural homogeneity and erasing difference as in the British situation Gilroy describes (1987). In Canada, cultural 'others' – and Canada's supposed tolerance – become central pillars of the ideology of nationhood, necessary for managing relations between Québec and Canada and in articulating a national identity which differentiates Canada from the USA. While cultural difference and pluralism may be highlighted to distinguish from *external* 'others', they are also managed *internally* so as to reproduce the structuring of differences around a dominant culture. As an increasing body of work critical of the notion of tolerance points out, tolerance actually reproduces dominance (of those with the power to tolerate), because asking for 'tolerance' always implies the possibility of intolerance. The power and the choice whether to accept or not accept difference, to tolerate it or not, still lies in the hands of the tolerators (Asad 1993; Goldberg 1993; Hage 1994a; Mendus 1993). Hage argues that 'multicultural tolerance' in Australia is an active practice of positioning the Other – the tolerated – in social space, and at the same time limiting and defining the specific limits of tolerable difference (1994a: 28).

Issues of multiculturalism and Aboriginal rights in Canada are most often discussed as a sideline to the real fissure in Canadian society between the 'two solitudes' of Canada and Québec. Debates have tended to focus on integration or separation, on whether Canada can survive as a unified nation. I look more broadly at the issue of the management and regulation of the multiple cultural differences within Canada – including the two 'Founding [sic] Nations' (the English and the French), the 'First Nations' (Aboriginal people), and all the other 'ethnocultural minorities' – to explore the changing characteristics of Western forms of identity construction. In analysing modern forms of identity and nationalism, as I have discussed, many theorists explore the binary oppositions of erasure versus inclusion and homogeneity versus heterogeneity. This approach is not appropriate to analyse the Canadian context because the most consistent features that characterise the intersection of national identity and cultural difference in the nation are inconsistency and contradiction. In order to account for the contradictions I conceptualise nation-building as a 'Western project'.

Nationalism as a Western project

Although project is a 'deceptively simple word', its theoretical implications 'differ significantly from the terms of reference commonly employed in historical, sociological or anthropological inquiry' (Thomas 1994: 105). The idea of a project draws attention neither towards a culture, nor to a time period such as 'colonialism' but rather to a *socially transformative endeavour* that is localised, politicised and partial. This transformative endeavour is also engendered by

larger historical developments and ways of narrating them' (ibid.: 105, emphasis mine). In Canada, for example, the idea of creating a nation was tied to the idea of transforming 'wilderness' into 'civilisation'. The particular way this project of transformation occurred (the forms of resource extraction, the particular way the settlers treated indigenous people, and the specific patterns of immigration) depended, in part, on *local* geographic, cultural, economic and political realities. Yet the project also unfolded in dialogue with larger global processes such as British imperialism and the ways in which it was carried out and imagined. Simply the idea that 'civilisation' was a necessary and progressive transformation of 'wilderness,' or that 'progress' entailed the formation of a nation, indicate particular Western forms of narration and imagining.

Nation-building as a project 'must be understood as a *teleology*' based on Western principles, languages and desires, including notions of progress, liberty, equality, reason, and human rights (Asad 1993: 16). Essential to the project of nation-building, argues Asad, is 'the continuous physical and moral improvement of entire governable populations through flexible strategies' (ibid.: 12). This very dense statement of the project specifies a (Western) *belief system* within which continuous moral and physical 'improvement' – progress – is seen as necessary and natural.[10] The *subject* of this improvement is an 'entire governable population', which implies that diverse peoples must be *made 'governable'*. Finally the process occurs through specific practices: flexible strategies to bring about the desired progress of populations.

The idea of 'flexible strategies' used within broader Western projects, helps to account not only for the erasures but also the inclusions in discourses of Canadian identity. In this framework, the *construction* of culture and difference, and not simply its erasure, is an integral part of flexible Western projects, practices and procedures. Asad suggests that the claim of many 'radical critics' that 'hegemonic power necessarily suppresses difference in favour of unity is quite mistaken', as is their claim that 'power always abhors ambiguity'. He argues that to 'secure its unity' and to 'make its own history', dominant power has 'worked best through differentiating and classifying practices'.

> In this context power is constructive, not repressive. Furthermore, its ability to select (or construct) the differences that serve its purposes has depended on exploiting the dangers and opportunities contained in ambiguous situations. And ambiguity...is precisely one of the things that gives 'Western power' its improvisational quality.
>
> (Asad 1993: 17)

Whereas Homi Bhabha claims that 'political supremacy...seeks to obliterate...difference' (cited in Asad 1993: 264), Asad suggests that political supremacy works specifically through the *institutionalisation* of differences (ibid.: 264, my emphasis). The idea of exploring the institutionalisation of difference is very useful in developing a strategy to understand the relationship

between difference and power in Canada. Consequently, this exploration of the differentiating and classifying practices of an apparently liberal and tolerant official national identity notes erasures and exclusions, yet focuses on the institutionalisation of difference. I use Foucauldian formulations of power and subjectivity that propose that power is not essentially repressive, but rather constructive and constitutive. Power functions not only negatively – as we have often thought – through denying, restricting, repressing, or prohibiting, but also positively, though *producing* 'forms of pleasure, systems of knowledge, goods and discourses' (Abu-Lughod 1990: 42).

Thomas suggests that, within projects, differently located people who carry them out may have various diverse interests, objectives, intentions and aims. Yet, despite the variations, they also share aspects of overall vision concerning the project, presupposing 'a particular imagination of the social situation, with its history and projected future'(Thomas 1994: 106). In terms of nation-building as a Western project, this means that although people and institutions in different contexts may have substantially different visions of what the *content* of the nation should be – whether it should be homogeneously white or multicultural, market-driven or social democratic – they probably share other fundamental and unquestioned beliefs. Some of these beliefs have a long history in modern Western thought; for example, the idea that nations are a necessary and natural form of social life, or that nations must have definable identities, or that nations should progress. Even if definitions of 'identity' and 'progress' might be contested, the shared belief in progressive nation-hood based on Western principles, is not. The project, therefore, has 'essential features', even as articulated in distinct contexts and by different people.

To say that a nation-building project has 'essential features' does not imply that it is always the same, or can never change, but rather to point out that, 'each historical phenomenon is determined by the way it is constituted', and that some of its constitutive elements 'are essential to its historical identity and some are not' (Asad 1993: 18). As Asad argues:

> It is like saying that the constitutive rules of the game define its essence – which is by no means to assert that the game can never be subverted or changed; it is merely to point to what determines its essential historical identity, to imply that certain changes (though not others) will mean the game is no longer the same game.
>
> (ibid.: 18)

One of the essential features of Canadian nation-building is its flexibility and ambiguity. The project of Canadian nation-building is an extremely contradictory, conflicted, contested and incomplete process, as you will see in the chapters that follow. It changes, transforms and reconfigures itself at different moments in different historical contexts. Yet, as I argue, even within and between those contradictions – between the anti-multicultural discourse of

some local peoples and the official multiculturalism of the state; between the British cultural hegemony of Canada before the Second World War and the glorification of Aboriginal cultures in present-day museums – the project has consistent features.

'Ordinary people' and 'Canadian-Canadians'

In the study of nationalism, Hobsbawm suggests the views of 'ordinary people' are 'exceedingly difficult to discover' (1990: 11). Handler also admits that during fieldwork on Québec nationalism, his search for political discussion on nationalism in local citizen's groups or at hockey games was relatively unsuccessful because, except in specific contexts, direct reference to the 'national question' was quite rare (1988: 11). I was immensely fortunate during my fieldwork because, thanks to the projects of the federal government, I had ready-made sites in which to locate and contact Canadians at moments in which national identity was a key concern. The fieldwork was done during a time of perceived 'crisis' in Canadian identity, and the government planned nationalist celebrations to attempt to manage the crisis. As a result, people were thinking about and discussing their ideas about the nation in many informal ways: while watching baseball games, setting up tables for crafts fairs, walking to dances or church suppers, or sitting in bars or coffee shops with televisions turned on, blaring out Canada 125 advertisements and coverage of the constitutional 'crisis'.

This book is based on a year of fieldwork including participant observation and formal and informal interviews with over sixty people. It also draws on archival materials and a large body of written and visual materials from 1992, including television, newspaper and other print sources regarding Canada 125, the referendum campaigns, the Columbus counter-celebrations, and other events concerning national identity. I conducted interviews with high-level government bureaucrats responsible for some of the programmes, employees and spokespeople for Canada 125, counter-Columbus activists, people who had been on government committees, and museum workers and curators. Some interviews were with individuals and others with groups, and some took place over the telephone. Most of the interviews were tape recorded and transcribed by myself afterward, although in some interviews I felt it would be better to simply take notes. For most of these interviews I had written agreements with people that I would maintain their anonymity, although sometimes the agreement was verbal. Many people were not concerned about anonymity and said I could use their names. Throughout, however, I have used pseudonyms for the names of people and places.

The largest group interviewed were organisers or participants at local celebrations in small towns and urban neighbourhoods in Southern Ontario. The research therefore also draws on participant observation at the festivals as well as informal day-to-day observations, conversations and 'small talk' overheard in

shops and restaurants, and discussions observed in museums, meetings, waiting rooms, and classrooms. I accompanied people to church suppers, had tea in their homes, and watched television with them. I discussed the news, peoples' lives, and Canadian identity with 'ordinary Canadians' in many places: over breakfast or a craft table, during a parade, or while watching a rubber duck race at a festival.

But who are these 'ordinary Canadians'? During fieldwork I had one woman angrily declare to me that 'any ethnic group' could get funding from the government: any group, she said, 'except for *ordinary* Canadians... *Canadian*-Canadians' like herself. When multiculturalism was declared as a national policy, it was stated that whereas Canada has two official languages, 'there is no official culture, nor does any ethnic group take precedence over any other' (Multiculturalism and Citizenship Canada 1985: 15). Canada has a proliferation of hyphenated peoples. Many Canadians identify themselves as German-Canadian, Ukrainian-Canadian, Chinese-Canadian, Greek-Canadian, Afro-Canadian, French-Canadian, Native-Canadian, Italian-Canadian, and so on. While all these hyphenated forms all have their own histories of constitution, some groups are widely considered more 'ethnic' than others. Others have the privilege of being simply 'Canadian'. For example, I am white and of mixed British and European ancestry, and my family settled in Canada many generations ago. I most often call myself 'Canadian' with no hyphen attached. This book focuses on the construction of this unmarked, non-ethnic, and usually white, '*Canadian*-Canadian' identity.

The comment about 'Canadian-Canadians' not being able to get funding is also indicative of how the concept of 'ordinary Canadian' is being used by individuals to discount the claims of minorities and so-called 'special interest groups'. One striking consistency in the interviews I did at small-town local festivals was the degree of anti-immigrant sentiment expressed in the language of populism, in a discourse of the oppressed and resistant 'ordinary people'. The striking characteristic of this discourse is that whites like the people I interviewed in small towns, can construct themselves as victims of multiculturalism. Chapters in the second half of the book examine expressions of so-called populist anti-immigrant sentiment, and explore the links between these discourses and the rationale behind multiculturalism itself.

'Ordinary Canadian' is also a key concept of so-called 'populist' neo-liberal discourse now on the rise in Canada and in other nations such as Australia (Johnson 1997). Brodie explores the rise and the political implications of this neo-conservative ideal Canadian citizen: a character defined primarily by what he is not.

The ordinary Canadian is disinterested, neither seeking special status nor treatment from the state. He [sic] is neither raced, nor sexed, nor classed: he transcends difference. So who is he? A close reading of the current conception of the ordinary Canadian reveals that he can be

only a white, heterosexual, middle-class male because in contrast to him everyone is 'special' in some way or another.

(Brodie 1995: 72)

The concept of the 'ordinary people' – now contributing to a white backlash against minorities and 'special interest groups' – was also central to the celebratory policy of the Canada 125 celebrations. The policy was specifically planned to legitimate the government by giving the impression that the celebrations (organised by the government) were organised by and for 'ordinary Canadians'. Since then the kinds of 'ordinary Canadians' addressed by the Canada 125 discourses have become a defined, marked, and increasingly powerful political force. In Chapter 7 I explore how the notion of 'ordinary Canadian' was mobilised politically in a number of co-existing sites, and argue that it was being used to re-define citizenship and to naturalise the exclusion of some citizens from notions of national belonging without direct reference to culture, race, sexual preference and gender.

'Ordinary Canadians' are most often white, and therefore this book examines a particular form of 'whiteness'. To study 'whiteness' is not to suggest that all white people are the same, or that whiteness is a biologically relevant category. Ruth Frankenberg suggests that 'whiteness' has three interlinked dimensions. First, she argues that whiteness is a location of 'structural advantage, of race privilege'. Second, it is a 'standpoint,' a place from which 'white people look at ourselves, at others, and at society'. Finally, whiteness refers to a 'set of cultural practices that are usually unmarked and unnamed' (Frankenberg 1993: 1). The most difficult aspect of pinning down the characteristics of whiteness, is that it is so often unmarked, unnamed and invisible. The power of whiteness is embodied precisely in the way that it becomes normative, in how it 'colonises the definition of normal' (Dyer 1988: 45). Later in the book I argue that a model of 'normal' Canadianness as white and unmarked was being created and reflected in the local Canada 125 festivals. This model is defined not by any particular characteristics, but by its difference from (and often its ability to tolerate) other marked Canadian identities such as multicultural-Canadian, Native-Canadian or French-Canadian. The state of being unmarked (and therefore 'normal' or 'ordinary') is both constitutive of, and an effect of, structural advantage and power, and the cultural authority that that power brings.

Unlike marginal groups, 'whites' are rarely thought of as an homogeneous category, in part because 'whiteness' secures its dominance by 'seeming not to be anything in particular' in a general sense, because the category of whiteness always breaks down into more specific categories. As Dyer points out, discussions of 'whiteness *qua* whiteness' are very difficult to maintain because whiteness is 'always immediately about something more specific'. In discussions of whiteness 'subcategories of whiteness (Irishness, Jewishness, Britishness) take over so that the particularity of whiteness begins to disappear' (Dyer 1988:

44–7). During the process of researching and writing this book, when I told people that I was studying white Canadianness, many automatically assumed I would examine differently located communities of whites and document the differences and similarities between them. Anthropologists also tended to assume I was doing a kind of multi-site 'community study', in order to tease out differences between groups. That is a very different project than the one I engage in here. While it goes without saying that 'white Canadianness' is not monolithic and is crosscut by multiple differences,[11] the primary goal of this book is not to document and highlight distinct versions of white Canadianness based on region, class or other cross-cutting differences. This kind of project, when applied to whiteness, has a number of problems. Anthropologists have traditionally studied marginalised and less powerful communities, groups often constructed in dominant discourses as homogeneous and without agency (Mohanty 1991; Spivak 1990). Therefore, to explore the cross-cutting diversity of marginalised groups can be seen as an attempt to disrupt dominant perceptions of 'the other'. Yet to take this approach with *whiteness*, as distinct from the kinds of marginal groups anthropologists often study, has a deeper problem because of the way that whiteness as an identity differs from other identities. Whiteness sustains its dominance by refusing categorisation as other than just 'normal' and 'human'. Dyer argues that whites have the privilege of being 'just people' and of representing the 'human race' because whites do not represent themselves as raced, or even as white, but always as 'variously gendered, classed, sexualised and abled' (Dyer 1997: 3). Therefore, focusing solely on teasing out differences in the category of 'whiteness' or 'white Canadianness' reinforces rather than challenges historical patterns in the construction of whiteness.

Dyer's description of the construction of whiteness captures a key aspect of its power. Whiteness often comes across as emptiness or absence, and is almost always defined in reference to otherness and to difference, as if 'only non-whiteness can give whiteness any substance'(1988: 44–7). This characteristic of whiteness is also a characteristic of Canadianness, an identity always defined in relation to internal and external 'others'. The dilemma is that in order to begin to focus on white Canadianness it is necessary to explore how it is defined in relation to 'others'. The next chapter therefore examines the historical construction of Canadian national identity through an exploration of how the nation represented and managed its relationship with internal and external 'others' in public culture and social policy.

2

SETTLING DIFFERENCES

Managing and representing people and land in the Canadian national project

Nation-building is a dual process, entailing the management of populations and the creation of national identity. The mythology of *how* Canada managed its different cultural groups (the belief in and representation of itself as tolerant) was one key feature of an emerging national identity believed to differentiate Canada from the USA. This chapter examines this dual process of managing populations and representing difference. It focuses on how, from early colonial times up to the Second World War, white Anglophone settlers in Canada mobilised representations of others and managed non-British cultural groups as part of the project to create a nation and a national identity.

Nationalism often depends upon mythological narratives of a unified nation moving progressively through time – a continuum beginning with a glorious past leading to the present and then onward to an even better future. These mythical stories require that specific versions of history are highlighted, versions that re-affirm the particular characteristics ascribed to the nation. In Canada, nationalist mythmakers draw upon particular versions of national history to explain the nation's 'fairness' and 'justice' today.

A government report on Canadian identity released in 1992 points back to history to argue that certain 'inescapable conditions' set Canadian life in 'an initial pattern' the 'logic' of which has obliged the nation to 'uncover gradually...the requirements of justice in a Canadian setting'. The report argues that two constitutional documents served as 'cornerstones of early Canadian life'. In the Royal Proclamation of 1763 and the Quebec Act of 1774, it suggests, 'much of what was to follow in Canadian life was laid down'. It suggests that the Royal Proclamation of 1763 determined that Canadian governments would treat Aboriginal peoples 'as autonomous and self-governing peoples'. It also claims that the Quebec Act of 1774 established that legal provision would be made for 'a distinctive society in Quebec', in that it could have 'institutions, laws and culture quite different than those of the surrounding English speaking societies'. The report then links history to the present, and *compares* Canadian identity with that of the USA. One of the consequences of the nation's historical trajectory, says the report, was that

Canada could never really embrace what later came to be known in the United States as the concept of the 'melting pot.' Canadians chose instead to support linguistic and cultural diversity...

These initial commitments...led us to discover additional standards of fairness for individuals, for communities, for regions, and cultures within the Canadian family. Thus Canada's social fabric is now interwoven with programmes of income security, social insurance, pensions and old-age security, equalisation, regional development, measures which have made Canada the envy of much of the world, and that have come to define many Canadian's own sense of identity.

(Beaudoin and Dobbie 1992: 5–6)

The report traces Canada's pluralist legacy from its genesis in the late eighteenth century to today's social programmes, thereby reiterating the myth of national tolerance, the central foundational myth of Canadian nationhood and identity. Whereas in Australia the current policy of multiculturalism is represented as a clear break with an overtly racist past (Hage 1994a: 22), in Canada the cultural pluralism of the present is often represented as on a natural continuum with Canada's history, even heritage, of tolerance. A variety of historical work in Canada challenges this mythological version of history, and indeed many people, especially Aboriginal people and Franco-Canadians, legitimately see Canadian history as 'one long confrontation' (Bothwell 1995: 7). Yet myths of tolerant nationhood are ubiquitous, and have a certain kind of authority, as exemplified by their appearance in a government document on national identity.

While this chapter examines the past, it is not intended as 'a history' of Canada. Richard Handler, in his provocative study of nationalism in Québec, refuses to begin with a history, or even a historiography of Québec, because the telling of history 'obliterates any sense of history as story or construct' (1988: 19). In this book I risk looking at history because it is essential to any nationalist mythology, and hope that the idea of history as *construct* will not be lost. I begin, for example, discussing interactions between Native peoples and British and French colonisers. I do not do so in order to understand this *actual lived* relationship in more detail or from a new perspective, but to explore how *representations* of this relationship have been configured in constructions of Canadian national identity. I do not provide a 'history' of Canada, but rather examine particular moments in history, and specific 'telling cases' (Mitchell 1984), in order to explore the contradictory cultural politics of the process of managing and representing difference.

This dual process of management and representation is a complex and contradictory process of inclusion and exclusion, of positive and negative representations of Canada's internal and external others. As Stuart Hall argues, identity is formed in the 'simultaneous vectors of similarity, continuity, and difference' (in Chabram and Fregoso 1990: 206). We can see this at times

24

conflicted process of identity formation, as Aboriginal people and non-British cultural groups are managed, located, let in, excluded, made visible or invisible, represented positively or negatively, assimilated or appropriated, depending on the changing needs of nation-building. The 'heritage of tolerance' is actually a heritage of contradictions, ambiguity, and flexibility.

Allies and others in the colonial encounter

From the early days of Canadian historical writing, historians liked to portray the colonisers of Canada as more generous than those of the USA. According to these histories, while the Americans violently and brutally conquered their 'Indians', the Native peoples of Canada never suffered similar horrors of conquest. English Canadian historians relished comparing the brutal treatment of Aboriginal people by the Americans with the apparently 'generous' treatment they had received from Canadians (Trigger 1986: 321). Yet, these same historians 'expressed gratitude that Providence had sent epidemics and intertribal wars to sweep away the native peoples of Southern Ontario and Quebec', thus leaving the regions for French and English settlers who, 'unlike their American neighbours, had no wrongs against native people for which to atone' (ibid.: 321). In fact, such interpretations, as Trigger suggests, depended on great self-deception and hypocrisy on the part of writers whose governments were 'treating their former allies with much the same mixture of repression and economic neglect as American governments were treating defeated enemies' (ibid.: 321).

Of interest to me in these claims is not so much their truth-value, but rather the way in which they indicate a push to construct a settler national identity perceived as innocent of racism. While it is true that to a certain extent early Canadian historical writing treated Native people 'respectfully', and gave them a prominent role (Trigger 1986: 316), this 'respect' did not result from any natural Canadian form of tolerance. It emerged because of the essential role Native people played in the early years of the colonial project.

The main goal of the early Imperial presence was resource extraction through the fur-trade, an economic activity that absolutely depended on Native people's labour and knowledge. Finley and Sprague argue that '*Without Indian goodwill* there could be *no fur rush, not even a fur trade*' (1979: 22, emphasis mine). Native people were also necessary as allies in battles between successive colonisers (between the French and the British and then between the British and the Americans in the War of 1812) in the fight to stake claims on relatively uninhabited territory (Trigger 1986). The particularities of colonial rule in Canada, therefore, required a certain amount of respect for and the building of alliances with, Native peoples. Although such 'generosity' and 'tolerance' may now be constructed as an early example of a natural characteristic of the nation and its citizens, it was more a matter of expediency, and a response to the specifics of the colonial economic project, especially as it developed in Canada.

These modes of representation also reflect broader trends in Western perceptions of cultural and racial 'others'. In the early centuries of contact between Europe and the 'new world', the 'discovery' of people in the Americas was a 'problem' that needed explaining for the Europeans: how to account for the racial and cultural differences encountered? Were Native people even part of the human race? How did they fit into Christian cosmology? Could 'Indians' be traced back to Adam and Eve? In order to be consistent, orthodox Christian thinkers had to grant Native people souls and humanness because scriptural history dictated God's creation of all humankind at one time in a specific spot (Berkhofer 1978: 35). In this monogenetic interpretation, all people were seen as descendants from Adam and Eve, and all were considered to have the same human potential (Banton 1987; Berkhofer 1978: 42; Curtin 1964: 32–3; S. Hall 1992b; Stocking 1968; Todoróv 1984).

The 1744 writings of the French Jesuit priest, Pierre-François-Xavier de Charlevoix, are a Canadian example of the monogenetic approach. He assumed, like other Enlightenment scholars, that since 'Indians' were human, and therefore potentially as rational and moral as Europeans, they could be improved through education (Trigger 1986: 316–17). Similar European views of others were evident in contemporary representations and perceptions of Africans (Cairns 1965; Curtin 1964). Curtin suggests that in the early years of colonial expansion, when interest in colonial outposts was primarily commercial, there was 'no serious concern with the way men of different cultures should be ruled'. Europeans who had been in Africa expressed xenophobia, yet they were 'free of racial antagonism'. 'Race as such was a *mark* identifying the group – not a *cause* of the group's other characteristics' (Curtin 1964: 33–6).

The manner in which 'others' were represented in Western discourse changed over time, and became a matter of serious contest and debate (Banton 1967, 1987; Goldberg 1993; Stocking 1968). Up to the nineteenth century, dominant interpretations of physical and cultural difference were often based on stereotypes and hierarchies in which Europeans were considered superior (S. Hall 1992b). These interpretations justified conquest and sometimes the genocide and enslavement of humans considered by Europeans to be inferior. However, they were not based on supposedly scientific notions of race as 'type' or 'subspecies', ideas that were to develop in the nineteenth century (discussed later in the chapter). In this sense early representations were *relatively* positive and relations more flexible, in comparison with later 'racial' ideas.

Therefore, the 'positive', 'generous' and 'tolerant' treatment and representations of Native people that historians credited Canadians with must be seen within the contexts both of the specifics of the colonial project in Canada, and also of broader global trends in European representations of others. I would argue that these historical relationships have been interpreted and re-shaped within a national tradition in order to create a mythology of white settler innocence, a mythology that exists in various forms today. Such myths do not simply hide inequalities and oppression, but contribute to a mythology of national identity.

As the context of nation-building changed, so did representations of Aboriginal people, and the policies created to manage populations. By the mid-to late 1700s, the colonial presence increasingly established itself through settlement rather than through resource extraction. Canada's European population increased with an influx of people from the USA during and after the American Revolution in the 1770s. Further, in 1763 the English colonisers conquered the French, and Native people began to rebel against the colonisers (Bumsted 1992a: 141).

At this time, first the Royal Proclamation and then the Québec Act were passed in Britain. Such colonial policies, as discussed in the beginning of this chapter, are today defined as the origins of the Canadian characteristic of tolerance. The Royal Proclamation of 1763 is credited with establishing that Canadian governments would treat Aboriginal peoples as autonomous and self-governing. It was primarily designed, however, as a form of colonial cultural policy for Québec, the French colony the British had conquered. Intended to promote cultural assimilation of the French to the English language and the British legal system (Cook 1963: 4), the policy granted certain land rights in the western areas of North America to Native peoples, with the aim of preventing Westward expansion of the American colonists. The aim was that Americans would instead move into Québec, 'in sufficient numbers to submerge the existing French speaking population' (ibid.: 4). The Proclamation also established English law and representative institutions in the colony, in part to limit the power of Roman Catholicism (McNaught 1970: 46). The British conquerors imagined a situation in which 'a French population, diminished in importance by emigration, would be quickly swallowed by a northward-moving wave of Protestantism' (ibid.: 47). The Royal Proclamation, therefore, played different populations against each other in the interests of the British colonial project, paradoxically giving Native peoples land rights in order to control and assimilate members of another European culture. My point here is that the policy, now appropriated into the idea of Canada's historical 'respect' for Native peoples, did not recognise Aboriginal people in a manner that might threaten the colonial project. Instead, the recognition of difference and the granting of land rights were part of a flexible strategy to manage the colonial project at a difficult and potentially dangerous time.

Despite attempts to manage population movements with the Royal Proclamation, by 1774 it was clear the assimilation policy would not work because the wave of immigrants had not arrived in the numbers expected (Cook 1963: 4–6). Further, there was growing discontent with Britain in the southern colonies (not yet, but soon to become, the United States). The British therefore wanted to secure the loyalty of Québec, and especially the powerful Catholic clergy, in case of trouble (Cook 1963: 4–6; McNaught 1970: 46–7).

This changed situation demanded a different approach to managing cultural difference. The Québec Act of 1774 recognised and guaranteed the position of the Roman Catholic Church, and the French language in Québec. Again, colo-

nial policy was flexible, recognising and enabling certain populations in the interest of controlling others (in this case the French against the southern colonies) as part of the broader project.

Race and settlement

Up to the Confederation of Canada in 1867, a series of rapid changes transformed the relatively unsettled territory of what is now known as Canada, and in the process altered both the lives and the colonial representations of Native peoples. This transformation can be traced, in part, to a shift to colonisation through *settlement* rather than primarily through resource extraction (furs), a process in which Native people had been central. Changing attitudes to Aboriginal people can also be traced to global shifts in beliefs about race, cultural difference, progress and civilisation.

Settlement increased during the late eighteenth and early nineteenth century, and as a result, by the end of the War of 1812, few Native people lived in the southernmost parts of Upper and Lower Canada (now Ontario and Québec), the most populated areas of Canada. Many who did had retreated northward to escape the encroaching settlement (Bumsted 1992a: 229), and those who remained were increasingly isolated on reserves (Trigger 1986: 318). In Nova Scotia, Native people were 'given' land and provisions, but the land was in the form of unsurveyed local reserves on which white settlers would often squat at will (Bumsted 1992a: 229).

As territorial boundaries began to take a more institutionalised form, cultural and racial boundaries began to harden, both in Canada and globally. Marriages between Native women and white men had been common during the fur trade. The frequency of intermarriage declined and the practice became less socially acceptable when, after 1820, the state institutionalised the migration of single white women as prospective wives in a push to settle the country (Van Kirk 1980). Similar processes occurred in other colonial situations such as Sumatra (Stoler 1989: 143–6) and Africa (Cairns 1965: 246), indicating in a broader way that racial ideology and control of sexuality intersected within the colonial project (McClintock 1995; Stoler 1995). As settlement increased, Canadian historical writing began to place Native peoples in a more restricted role. Negative stereotypes began to appear, with greater emphasis given to scalping, torture, massacres, and sexual promiscuity. Whereas earlier it had been assumed Native people could change and develop, they were increasingly presented as incapable of civilisation and therefore doomed to perish in the natural march of 'progress' (Trigger 1986: 318–21). The hardening and sharpening of racial boundaries were consistent with so-called 'scientific' ideas of 'race' developing in the nineteenth century (Banton 1987; Stocking 1968).

Central to theories of evolution and 'race' emerging in the late eighteenth and early nineteenth century was the idea of progress – the notion that societies move through consecutive stages to reach the ultimate pinnacle of evolution:

European-style 'civilisation'. Although the idea of civilisation as the acme of progress had been present in much earlier thought, up to the late eighteenth century it was assumed that 'civilisation' was the potential and destined goal of *all* humankind. In the nineteenth century, more and more people began to see civilisation as only achievable by certain 'races' (Stocking 1968: 35–6). Polygenetic interpretations of human origins began to gain more authority than Christian based monogenetic interpretations (Berkhofer 1978: 56; Stocking 1968), as several trends came together to provide a seemingly scientific explanation for difference (ibid.: 36–7). In Canada these trends were reflected in the near universal belief amongst whites that Native people, as they had existed, were disappearing with the inevitable march of progress (Francis 1992: 53). In tandem with global trends of the late nineteenth century, this assumption meant that Aboriginal cultural artefacts were collected and classified. Aboriginal people were also photographed, painted and written about, in an attempt to document what was perceived as civilisation's picturesque yet less developed past (Dippie 1992; Francis 1992: 11–44; Street 1992).

Emerging national identity

Formed in 1867, the Dominion of Canada was a political unification of the three separate provinces of British North America: Canada (now Ontario and Québec), New Brunswick, and Nova Scotia (Bumsted 1992a: 371). Newfoundland and Prince Edward Island joined the Dominion later, as did the Western provinces and Northern territories.[1] Canada was the product of a political alliance, and the emergence of nationalist sentiment was not guaranteed. From the earliest days, local and provincial loyalties and interests threatened national unity. Like present-day Canadians, not all nineteenth-century Canadians shared the same vision of the nation (ibid.: 382). Despite these divisions, soon after Confederation a search began for a Canadian national identity, resulting in an increase in the production of literature and painting, and the formation of national cultural, educational, and sports institutions (ibid.: 381). At the same time Confederation was seen as fragile, because by the mid-1880s it had been shaken by the Riel Rebellion, a great deal of French resistance to confederation and a depression. The threat of 'continentalism' was also profound, because the Liberal government of the time had committed itself to the policy of freer trade with the United States, a situation that to many meant the inevitable assimilation of Canada into the United States (Berger 1970: 3–4). These challenges to the nation 'galvanise[d] the defenders of Canada and the British connection into action', and brought out into the open 'the ideas and sentiments, traditions and hopes, that constituted their sense of nationality' (ibid.: 4), and resulted in the formation of the Canada First Movement.

Icy white nationalism

The early nationalism of the Canada First Movement was grounded in the belief that Canada was a 'Britain of the North', a 'northern kingdom' whose unique and distinctive character derived from its northern location, its ferociously cold winters, and its heritage of 'northern races' (Berger 1966: 4). This racialised 'Canadianness' was mobilised to create links between Canada and Britain and other northern and 'civilised' nations, to differentiate Northern and Southern peoples (races), and to distinguish Canada from the USA. It also drew on specific forms of racial ideology that had developed on a global scale.

In his 1869 speech, 'We Are the Northmen of the New World', Robert Grant Haliburton, an associate of the Canada First Movement, asserted that the distinct characteristic of the new Dominion was that it was and always should be 'a Northern country inhabited by the descendants of the Northern races' (in Berger 1966: 6). A corollary to the idea of the northern race as superior was the construction of the South as other: inferior, weaker, and also essentially female. While the adjective 'northern' symbolised the masculine virtues of 'energy, strength, self-reliance, health and purity', southern was equated with 'decay and effeminacy, even libertinism and disease' (Berger 1970: 129). The northern (more masculine) races were, in this view, also naturally more oriented towards freedom and liberty, and the southern races with tyranny (Berger 1966: 15). The Canada First Movement believed that the traditions, customs, and unwritten codes which preserve civil and political liberty were 'rooted in the elemental institutions' of the Northmen and all northern nations (ibid.: 7). It was declared, therefore, that Canada was destined to become a pre-eminent power because of its superior racial characteristics.

The Canada First Movement drew upon environmental relativism, a discourse that linked environment and character – an idea proposed by Montesquieu as early as 1748) – and had prominence at the time (Banton 1987: 8, 40–5). What is most interesting, in the context of current thinking, is that the Canada First Movement constructed the *United States*, a nation now often considered the quintessential modern Western nation, as the degenerate and decaying south. Canada was constructed as different from and superior to the United States because of environment, a discourse that functioned through a complex set of ideas which helped to produce Canadian national identity.

One of the most persistent benefits articulated about Canada was that, unlike the United States, its northern climate would keep the country 'uncontaminated' by weaker southern races. Parkin suggested that the northern climate was one of Canada's 'greatest blessings', 'a fundamental political and social advantage which the Dominion enjoys over the United States', because it resulted in a 'persistent process of natural selection'. According to Parkin, Canada's climate would ensure that it would avoid the 'Negro problem', a problem 'which weighs like a troublesome nightmare upon the civilisation of

30

the United States' (in Berger 1970: 131). Canada, he emphasised, would be a nation of the 'sturdy races' of the North (in Berger 1966: 8–9).

The Canada First movement did not consider the United States an Anglo-Saxon country, in part because of the effects of the southern climate and immigration on racial characteristics. They thought the southern climate not only made the northern races of the USA deteriorate, but also attracted ever growing 'multitudes of the weaker races from Southern Europe', and provided a home to 'the large Negro element' (Berger 1966: 14). Canada was considered naturally superior because it had not diluted its northern blood. Canadian or British liberty was also considered 'far superior to the uproarious democracy of the United States' (ibid.: 16). Parkin, when discussing US immigration, suggests that these immigrants from southern climes were 'unaccustomed to political freedom, unaccustomed to self-government' (in Berger 1966: 17).

An important aspect of the imperialists' northern racial discourse was its attempt to include the French in Canada, as they too were seen to share the same northern racial characteristics (Berger 1970: 132). The Canada First Movement was determined to define a distinctive Canadian nationality of 'one people' based on shared traditions and similar racial characteristics. Berger argues they were able to do this through adjusting the French Canadians to their idea of the national character. The idea of the blending of the two races into the new Canadian northern race was built on an invention of shared traits and ideas of complementarity, ideas which inspired some to deny and deliberately minimise the extent of the cultural conflicts between the English and the French (ibid.: 134, 138, 144).

French–English relations were also mobilised to construct a Canadian nationality perceived as essentially different from the United States. This was a process riddled with contradictions. Canada was perceived as superior to the USA because the racial similarities of the English and French made the country *homogeneous,* a racial homogeneity which was supposed to distinguish Canada from the *heterogeneous* and lawless mix of southern races in the USA. Important proof of French Canadian loyalty to Britain was that they had shown their devotion *to* the crown, and *against* the USA, during the American Revolution and the War of 1812. This loyalty was usually credited to the 'beneficence of the British Empire because it was the only world state in which minorities could *retain local traditions.* Compared to it, the United States stood for uniformity and *homogeneity*' (Berger 1970: 138, emphasis mine).

This is an instance of the still current idea that tolerance is a Canadian national characteristic (albeit inherited from the British Empire). Today, as at the turn of the century, the notion of Canada's tolerance is mobilised in a discourse of differentiation that constructs the USA as other. The flexibility of nationalist discourse is apparent, because although cultural pluralism was central to ideas of nationhood, *how* it was constructed was not consistent. French cultural differences were sometimes erased: when Canada, for example, was defined as *homo*geneously northern, unlike the *hetero*geneous USA. At other

31

times the French presence was made paramount, to mark difference from the USA: when it was argued, for example, that Canada allowed the retention of local traditions and *hetero*geneity, unlike the *homo*geneous USA. Yet, as Berger suggests, the Canada First Movement could be tolerant of the French partly because they were convinced of their inevitable decline as a significant proportion of the population. He argues that in fact, 'the more one was convinced of their numerical unimportance, the more one could glorify their character' (1970: 147). Some kinds of differences were valued, as long as there was no threat to the dominance of the Anglo-Saxon, especially, as in the case of the French, if it helped to construct Canada as different from the USA.

One interesting silence in the writings of the Canada First Movement is the absence of a discussion of the way in which Native peoples fit into the idea of the natural superiority of Northern races. If one followed the logic of the 'northern thinking' of the Canada First Movement, wouldn't Native people, having lived in the Northern climates of Canada for longer, be *even more* hardy, superior, and naturally inclined to freedom, liberty and hard work, than Anglo-Saxon immigrants who come from a relatively warmer climate? Perhaps the assumption that Aboriginal people were vanishing (discussed above) meant they did not have to be considered.[2]

The United States was also used as a negative example in the heated debates at the end of the nineteenth century on whether to let in 'southern races', discussions inspired by increased immigration into Canada. One observer, drawing attention to the influx of southern Europeans, queried if there was anything to prevent the nation from becoming entirely Americanised. In 1899 the editor of *Canadian Magazine* feared Canada might become as 'rude, as uncultured, as fickle, as heterogeneous, as careless of law and order and good citizenship as the United States?' (cited in Berger 1970: 148–9).

Nation-building, immigration and national identity

As the discussions above illustrate, immigration policy is more than simply a process of importing the labour needed for nation-building. It is also an 'expression of a political idea of who is, or could be, eligible to receive the entitlements of residence and citizenship' (Smith 1993: 50). One characteristic of the ideal nation–state, as it was characterised in the nineteenth century, was the conception that geographic and cultural boundaries should be synonymous (Anderson 1991; Gellner 1983). Immigration policy is therefore a site that articulates a potential contradiction between the material needs of nation-building and the attempt to create an ideal 'imagined community'. Immigration was essential for nation-building, yet also perceived as potentially dangerous if it threatened the development and maintenance of a national population and a national identity.

Throughout the formative years of Canadian nation-building, immigration policies favoured Britons and northern Europeans. At the same time the need

for labour, especially agricultural labour, often outstripped the supply of preferred 'racial stock'. In the first three decades of Confederation, the westward expansion of the nation was a failure. It was difficult to get British immigrants to come to Canada, and many who did eventually migrated to the United States. The McDonald government of the 1880s tried unsuccessfully to develop immigration schemes with the British government, whose major aim, argues Whitaker (1991: 5), was to remove their 'turbulent Irish subjects at Canada's expense'. Canada simply could not compete with the United States in attracting immigrants until the development of weather-resistant strains of wheat and the exhaustion of the US agricultural frontier lands (Whitaker 1991: 5). Despite Canadian preferences for British immigrants, during the 1890s the Canadian government fulfilled the need for settlers and labour by recruiting Slavs from the Austro-Hungarian Empire. Minister of the Interior, Clifford Sifton, managed to find a place for them in the Canadian imaginary. They became the necessary immigrant of 'good quality', the 'stalwart peasant in sheepskin coat, born on the soil, whose forefathers have been farmers for ten generations, with a stout wife and a half-dozen children' (in Harney 1989: 53).

Immigration laws were therefore flexible as well as racial, exemplified in Canada's treatment of Chinese labourers. The transcontinental railway was built chiefly on the labour of 6,500 Chinese men specifically imported for this job, many of whom died in the process (Bumsted 1992b: 29). In 1883 Prime Minister MacDonald defended Chinese immigration, arguing that it would be 'all very well to exclude Chinese labour when we can replace it with white labour, but until that is done, it is better to have Chinese labour than no labour at all' (in ibid.: 29). The Chinese were not treated as regular immigrants, not being granted even potential citizenship rights (Whitaker 1991: 9). When the railway was finished in 1885, Chinese labour was no longer needed, and between 1878 and 1899 the British Columbia legislature passed over twenty-six bills aimed at preventing or restricting the settlement of Asians (Palmer 1991: 9).

Up until the Second World War, when most immigration ceased, Canada had a strict hierarchy of preferred racial groups for immigration. While Canadians often point to the White Australia Policy as an example of an overt racism which never existed in Canada, Canada had what Hawkins calls a 'White Canada Policy' (1989: 17). This policy drew upon an environmental racism similar to the Canada First Movement, excluding Blacks and Asians on the grounds that they were unsuited to the cold climate of Canada. The notion of 'climactic unsuitability' was enshrined in immigration law as a reason for barring non-whites until 1953 (Kallen cited in Smith 1993: 55). Yet, showing the flexibility of immigration law, notions of race and culture were often interchangeable. While Section 38, Clause c, of the Immigration Act of 1910 focused on Canada's right to exclude races on the basis of climatic unsuitability, amendments to the Act in 1919 expanded these criteria to include cultural elements. Immigrants could then also be excluded if they were 'deemed undesirable

owing to their peculiar customs, habits, modes of life and methods of holding property, and because of their probable inability to become readily assimilated' (cited in Hawkins 1989: 17).

From 1890 to the present, immigration policy has, according to Harney, had several relatively constant goals 'appearing under different flags of convenience and employing different idioms'. Canada has needed immigrants to populate the country so as to discourage American 'expansionary tendencies' and to 'protect the Pacific Rim' from heavy Asian immigration. Immigration was also intended to populate the country enough to create 'economies of scale and a rational East–West axis' to bolster an independent polity and a viable economy. Immigration was also intended to 'combat separatism and maintain British hegemony'. More recently, immigration has been mobilised to create an image of Canada as a land of opportunity, characterised first by the 'fairness of British institutions', and now by the 'civility of state-sponsored pluralism in the form of official multiculturalism' (Harney 1989: 53). Therefore, immigration was an essential, and yet necessarily flexible, aspect of nation-building.[3]

Settling the West: gentle Mounties and picturesque 'Indians'

After Confederation in 1867, the Canadian government promoted agricultural settlement in the North-west of Canada, and as a result needed to push Native people aside as quickly as possible. They negotiated a series of treaties that extinguished Native entitlement to land in exchange for reserves on marginal and unattractive land (Bumsted 1992a: 391–3). The settlement of the west in the late nineteenth century had grave consequences for the lives of Native peoples. It also shaped how they came to be represented in the Canadian national imaginary.

Royal Canadian Mounted Police (or 'The Mounties') and the transnational railway are central and revered symbols of Canada, resonating with romantic notions of national progress and expansion. The formation of the North-west Mounted Police in 1873, to act as a quasi-military agent of the government in Western Canada, is one of the most romanticised events in Canadian popular history. In histories of the RCMP, the west was painted as a lawless and frozen land where both 'Indians'[4] and whites were uncivilised. Into this environment burst the just arm of the Canadian Government, actualised in the red-coated Mounties who would calmly protect uncivilised whites and 'Indians' from each other. In his 1912 history of the Mounted Police, A.L. Haydon writes that they quickly created 'a bloodless revolution' in which over 30,000 Aboriginal people, hostile to the white invasion and at war with each other, were 'transformed into a peaceful community showing every disposition to remain contented and law-abiding' (in Francis 1992: 64). What actually happened, according to some historians, was that Westward expansion did not initially require use of force, because the capitulation of Native land rights was brought

about by disease (smallpox) and loss of subsistence (buffalo) (Finley and Sprague 1979: 216).

In the mythology, however, the frontier – now calmed and civilised by the loyal red-coated representatives of British justice – was then ready for the next stage of what was commonly seen as its inevitable progression from savagery to civilisation: the arrival of thousands of hard-working farmers. This miracle of civilisation was brought about, according to the histories, by the fair and impartial administration of British Justice; a version of history which depends on constructions of Aboriginal people as child-like, trusting, and ultimately friendly to their Canadian government invaders. In both popular and historical literature of the time, a typical scene of confrontation showed Native people like children, easily cowed by a display of authority by an RCMP officer. The classic story had an unarmed officer confronting a band of armed and angry 'braves'. The officer, apparently not noticing the rifles aimed at his head, would coolly dismount and walk up to the leader of the gang. In the story the Aboriginal people would be completely disarmed by the Mountie's reckless courage and self-confidence, and would do meekly as they were told (Francis 1992: 66).

This image of the friendly and meek 'Indian', trusting of the police, was an integral part of an emerging national identity tied to ideas about the distinction between Britain and the USA. According to the legend, the most important thing the Mounties brought to the west was their impartiality, one of the basic elements of British Law. The popular conception was that police were fair and just, and that Native people recognised this impartial justice and were grateful for it. According to Francis, the image of 'the grateful Indian'

> allowed Canadians to nurture a sense of themselves as a just people, unlike the Americans south of the border who were waging a war of extermination against their Indian population. Canadians believed that they treated their natives justly. They negotiated treaties before they occupied the land. They fed the Indians when they were starving and shared with them the great principles of British justice.
>
> (1992: 69)

The story of the Mounted Police had, as Francis argues, a 'powerful influence' on the way Canadians felt themselves to be 'distinct from, and morally superior to', the United States (1992: 69).

However, both US and Canadian methods of expansion and the treatment of Aboriginal people reflect similar Enlightenment assumptions about the inevitable march of progress and civilisation, and the inevitable passing away of the 'Indian' way of life. The main difference with the Canadians was that, with the implementation of British forms of justice, it was believed the inevitable and necessary process would occur peacefully, without hardship, injustice, or violence. The supposedly fairer British/Canadian method of dealing with Native people became institutionalised in the Indian Act of 1876 (Francis 1992:

200–18). The Indian Act encouraged agricultural labour and Christianity and discouraged Aboriginal cultural practices. Over the course of the late eighteenth and early twentieth centuries, for example, governments attempted to ban the making of Totem poles, potlatch, dancing and other ceremonies (ibid.: 98–103, 183–9, 200, 218). There were many contradictions in these processes. The Act, paradoxically, sought to 'civilise' the Native peoples by assimilating them into dominant life and culture, yet at the same time segregated them onto reserves. Further, just as Native people were being prevented from public displays of their cultures, whites increasingly romanticised and appropriated Aboriginal practices by dressing up as 'Indians', by collecting their cultural 'artefacts', and even pretending to be 'Indians', as 'Grey Owl' (Englishman Archie Belaney) did in the 1930s (Francis 1992).

Although the transnational railway was completed in 1885, the expected flood of settlers did not arrive for another decade. In order to make money in the meantime, the Canadian Pacific Railway (the CPR) decided to offer the Rocky Mountains, complete with Aboriginal inhabitants, as a tourist attraction. For many, the thought of seeing 'wild Indians in their natural setting from the safety and convenience of a railway car…was every bit as exotic as visiting the depths of Africa' (Francis 1992: 177–81). This interest in exotica and curiosities was a general trend in British and US society up to the First World War, and was especially evident in events such as world fairs. In these global events, 'exotic' and 'primitive' peoples from around the world would be brought to the metropoles, and yet presented as if inhabiting their 'natural surroundings' (Breckenridge 1989; Hinsley 1991; Street 1992; Stocking 1987).

At the same time the Canadian Pacific Railway was trying to sell images of pure and authentic 'Indians' in feathers and buckskin, the government was enacting, through the Indian Act, a form of cultural genocide on Native peoples, who, as a result, did not necessarily appear as advertised. Many of the visitors were disappointed with the Native people they saw on their tours because they did not look like the romantic and idealised images of 'Indians' they had been promised. Francis suggests that the search to see Native people in their 'uncivilised' and 'natural' state was made all the more urgent and poignant because, in the settler imagination, 'Indians' were soon to vanish with the march of progress (1992: 182).

Assimilation and appropriation

Between the world wars, assimilation policies attempted to destroy Native cultures. The advertisement for War Bonds (see Figure 2.1) epitomises the ideal 'Indian' of the time, because as assimilation policies progressed, the collecting and salvaging of Native artefacts and the romanticising of 'Indians' reached a peak. In combination with tourism, the collection and romanticisation of Native people's artefacts and culture were also now integrated into more official forms

of national identity. Aboriginal peoples' artefacts became national treasures, providing a visible and tangible link with the country's first peoples, a part of the nation's heritage that had to be preserved (Francis 1992: 184–5). The Parliament Buildings of Canada, a symbol of Canadian nationhood, highlight Aboriginal people as part of Canada's heritage. Constructed originally between 1859 and 1866, the Buildings, except the library, were burned to the ground in 1916. Re-completed in Gothic Revival style in 1922, the buildings were purposely built with huge blank stones, to be carved later. The impression one has today is of the incredible diversity of symbols of different cultures, carved into the very walls of the buildings. The symbolic diversity is intentional: a pamphlet put out by the Public Information Office of the House of Commons states that the many images of the Parliament Buildings 'express who we are, where we come from and what we do. Like a mirror, the Parliament Buildings reflect our diversity and uniqueness yet, at the same time, they are an enduring symbol of our unity'.

As early as 1932, the Dominion Memorial Sculpture was placed in the Hall of Honour. Designed by Dr R. Tait McKenzie, the sculpture has images of Native people representing Canada's heritage and past. The official Parliament Buildings Guide Manual describes the first panel of the sculpture.

> In the foreground are four figures. On the left, is Canada enthroned; her right hand on a shield emblazoned with the current Arms of Canada. Her left hand is outstretched to receive the offerings of her children. A youthful figure, Canada wears a headdress of a Caribou mask with antlers, a short chiton and moccasins.
>
> (Parliament Buildings Guide Manual 1994: 202)

The sculpture has the nation beginning its career as a child-like Native person. Aboriginal imagery here represents the early foundations of Canada: its youth, its past. As the narrative moves on, the settlers re-shape, categorise, map and civilise nature itself. The sculpture, as it moves progressively from left to right, shows engineers measuring and cartographers mapping the Canadian wilderness. Lumberjacks and fisherman build and harvest the land. Further back and to the side of one panel is a family, which, according to the Guidebook, represents Canada's pioneers. An 'Iroquois Indian' watches them (Parliament Buildings Guide Manual 1994: 201–2).

Aboriginal people here represent the early foundations of Canada: its youth, its past, and, as is characteristic of a colonising and orientalist aesthetic (S. Hall 1992a), are idealised as nature itself. Pure untouched nature can be constructed as the raw material for the civilising work of settlement; it re-affirms the settlers' sense of themselves as those who transform raw nature into developed civilisation. Indeed, in this image, the early nature/Native roots of Canada are then integrated into a narrative of settlement and progress, as the settlers categorise, map, re-shape and civilise nature itself. In this narrative of Canada's

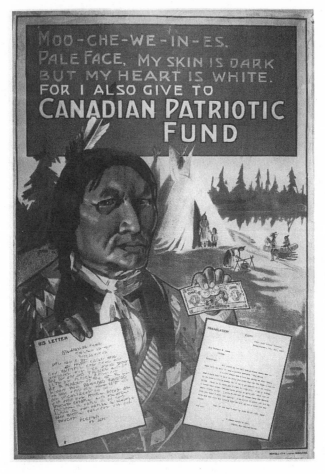

Figure 2.1 'My skin is dark but my heart is white...' Canadian Patriotic Fund poster 1914–18.

Source: Metro Toronto Reference Library

development, inscribed onto the walls of the Parliament Buildings in the 1930s, Aboriginal people are not invisible, erased, or absent. In a similar manner, a monument of one of Canada's earliest explorers, Samuel Champlain, situated in a prominent place in Ottawa, does not erase Native people. In the sculpture Champlain stands tall and heroic on the pedestal, while below him, seated beneath the pedestal, is an unnamed 'Indian' (see Figure 2.2).

As my discussion has shown, from the days of colonialism through to the early days of nation-building, Native people have played important supporting roles in defining Canada. Often images of Aboriginal people have been mobilised to help differentiate Canada from the United States because

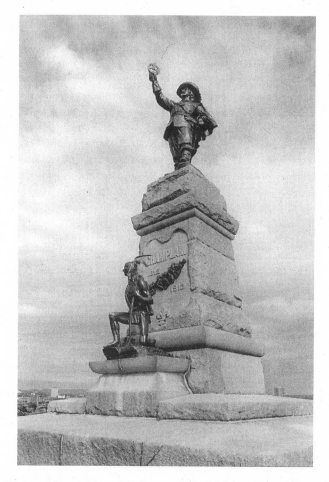

Figure 2.2 'Statue of Champlain and Unknown Indian', Nepean Point, Ottawa, Ontario.

Source: Courtesy of the Canadian Museum of Civilisation. Photo: Harry Foster.

through them British Canada can construct itself as gentle, tolerant, just and impartial. Aboriginal people also represent Canada's heritage and past, providing a link between the settlers and the land and helping to negotiate the rocky terrain of creating Canada as 'Native land' to settlers. Further, although Native people are present in these images of discovery and settlement, their presence is limited: either symbolising Canada's natural beginnings, or as the passive Iroquois *watching* the pioneers or the unnamed Indian at the feet of Samuel Champlain. Canada's Aboriginal peoples were not erased in Canada's nationalist narratives, but were important supporting actors in a story which reaffirms settler progress.

Northern wilderness and settler national identity

In the half-century between Confederation and the end of the First World War, Canada was transformed from a frontier nation to a Western industrial nation. Simultaneous with this 'march of progress' and 'civilisation', the very phenomena which were being destroyed were now invoked to represent Canadian nationhood. Native people, as discussed, began to be integrated into official national iconography. Meanwhile the Northern wilderness would come to represent Canada, in particular through the paintings of the Group of Seven. Northern wilderness and Canada's cold climate remain constant images in public representation and myth in Canada, 'the only sure token...of collective identity' (Berland 1994: 99), although as Margaret Atwood suggests, the 'values ascribed to them have varied considerably' over time (1995: 9).

The wilderness paintings of the Group of Seven represent and embody the origin of Canadian modern art and have a revered place in the symbolic construction of nationhood today. Indeed, it was the work of these artists 'which contributed most to the development of a national identification with a distinctive sense of place' (Osborne 1988: 169). Their work as a whole is characterised by its wild and unpeopled northern landscapes, as their central imagery is the rugged and rocky terrain of the pre-Cambrian shield and the northern woods. Most significant is the way in which they painted the lone and rugged pine trees (see Figures 2.3 and 2.4). The power that this imagery still holds today is borne out by my own experience. When I was in Northern Ontario during fieldwork, I found myself calling the pine trees 'Group of Seven trees', and feeling that their presence confirmed that I was now really in the '*true* Canada', the '*true* North'. The natural world, for me also, was seen through the lens of these quintessential nationalist texts.

Like the Canada First Movement, the Group of Seven saw the north as expression and mirror, essence and root of the Canadian character. And that character was constructed as racial. Lawren Harris, one of the Group, wrote that

> It is only through the deep and vital experience of its total environment that a people identifies itself with its land and gradually a deep and satisfying awareness develops.
>
> We were aware that no virile people could remain subservient to, and dependent upon the creations in art of other peoples...To us there was also the strange brooding sense of another nature fostering a new race and a new age.
>
> (cited in Berger 1966: 21)

Harris's statement involves a complex intersection of ideas about the natural and innate relationship between nature and nation, as well as an expressed desire to foster and construct that essence. Like the Canada First Movement, climate and geography were necessary to express an essential Canadian identity

Figure 2.3 The famous trees of the Group of Seven: *The West Wind* 1917, Tom Thomson (Canadian 1877–1917), oil on canvas, 120.7 × 137.2 cm.

Source: Courtesy of the Art Gallery of Ontario, Toronto. Photo: AGO, Carlo Catenazzi.

in opposition to some form of dominant (even if constructed as inferior) 'other'. Canada as a *virile* nation (also a characteristic of northernness for the Canada First Movement) could not be 'subservient' and 'dependent' on the art of 'other peoples'. McClintock argues that 'all nationalisms are gendered' (1995: 352). The term 'virile' as an ideal term for a nation – in opposition to 'subservient and dependent' – indicates the belief that a nation, to be a proper nation, must have the *male*-gendered characteristic of virility. Further, the idea that a nation must 'have' its own art and possess its own culture in order to be considered a true nation, reflects, as Handler suggests, very specific, modern, Western notions of identity based on 'possessive individualism'. A nation, as seen on a map as geographically bounded, should also have a bounded and identifiable culture and history. The very notion that this form of identity is requisite to 'normal' national identity is based on a highly gendered conception of virile possessive individualism.

Figure 2.4 The wilderness of the Group of Seven: *Beaver Swamp, Algoma* 1920, Lawren Harris (Canadian 1885–1970), oil on canvas, 120.7 × 141.8 cm.

Source: Courtesy of the Art Gallery of Ontario, Toronto. Photo: AGO.

In the discourse of the Canada First Movement, northernness was a way of linking Canada and Britain (and other northern races), to create difference from the USA and other southern places and races. The northern discourse of the Group of Seven, at a later stage of national self-consciousness and differentiation, symbolically differentiates Canada from both the USA and Britain by mobilising a symbolism of unpeopled and rugged wilderness. It is a northernness that is *not American*, and a harsh wildness that is *not European*, or at least not British.

The paintings of the Group of Seven were distinct from the European tradition from which they emerged. In the colonial period, European interpretations of the natural world of North America were more 'projections of European ideas, values, and tastes than reflections of American realities' (Osborne 1988: 163). Early on, this tradition was characterised by an encyclopaedic fascination and a spirit of empiricism, which inspired the recording of flora, fauna, and

Aboriginal peoples 'objectively and accurately'. By the mid-nineteenth century, the empiricist approach shifted to a romantic one, and representations were being moulded into the categories of English landscape painting. This style, in a search for the sublime and the picturesque, combined images of the primitive and archaic landscape with images of bucolic comfort (ibid.: 163–4). A similar shifting between empiricist and romantic images in landscape painting has been documented in European representations of the South Seas (Smith 1960).

In the classical pastoral tradition, picturesque landscapes 'make the viewer think of paintings, in other words where nature imitates art' (Coates 1993: 320–1). That art (which the landscape should mirror) accentuates framed and controlled nature. It shows harmony between human beings and nature, and between people of all classes. The picturesque was 'associated with prosperous, improved landscapes', landscapes which invite the viewer to occupy it or travel through it' (ibid.: 321–3). A.S. MacLaren suggests that the picturesque 'sustained the sojourning Briton's sense of identity when he travelled beyond European civilisation'. It was his 'aesthetic baggage', carried faithfully in the belief that it could 'organise the new world, and sustain his hopes of controlling, governing it and its denizens' (in Coates 1993: 323).

The picturesque aesthetic offered relief from the impenetrable and savage forests, and by creating a vision of civilised and 'improved' nature, it made the new terrain accessible to colonialists (Coates 1993: 323). It, in a sense, invited them in, made them comfortable, and erased conflict, either between humans and nature or between the colonists and the other inhabitants of that landscape. Wilderness areas, on the other hand, were seen as impenetrable.

The paintings of the Group of Seven turn the picturesque invitation on its head in a search for a truly Canadian aesthetic that would differentiate Canadian from European art. These paintings were of impenetrable, and certainly uninviting, *wilderness*. Margaret Atwood, one of Canada's most respected writers, describes the work of the Group of Seven in her story 'Death by Landscape'.

And these paintings are not landscape paintings. Because there aren't any landscapes up there, not in the old, tidy European sense, with a gentle hill, a curving river, a cottage, a mountain in the background, a golden evening sky. Instead there's a tangle, a receding maze, in which you can become lost almost as soon as you step off the path. There are no backgrounds in any of these paintings, no vistas; only a great deal of foreground that goes back and back, endlessly, involving you in its twists and turns of tree and branch and rock. No matter how far back in you go, there will be more. And the trees themselves are hardly trees; they are currents of energy, charged with violent colour.

(Atwood 1991: 121)

In Atwood's description, nature and wilderness are certainly *not* inviting or comfortable to humans. This wilderness – the quintessential Canadian landscape – is overpowering; it is a place in which one can become lost.

The landscape paintings of the Group of Seven do not sustain and construct colonial national identity by *inviting* colonising humans to penetrate nature, as the picturesque tradition does. Instead, their paintings reject the European aesthetic in favour of a construction of a 'Canadian' aesthetic based on the obliterating and overpowering sense of uncontrollable *wilderness*. A central feature that differentiates the wilderness paintings of the Group of Seven from European traditions of painting is that the paintings are unpeopled, not just of human subjects but also of human traces. Bordo suggests that the 'deliberate and systematic absenting of human presence has no consistent precedent in the European landscape tradition' (1992: 109). Further, these nationalistic northern wilderness paintings are specifically empty of signs not just of people, but of *Native people*. The absence of Aboriginal people in this wilderness art constitutes a serious rupture with the nineteenth-century wilderness ethos, in which wilderness was identified with the Native presence (Bordo 1992: 122). In the Group of Seven's paintings, the erasure of Aboriginal presence, and the production of a notion of uninhabited wilderness, were necessary to create 'wilderness landscape' as a signifier of Canada that differentiated Canada's northernness from European northernness.[5]

The obliteration of human presence and the foregrounding of nature as savage and dangerous do not mean, however, that it was not a colonising aesthetic. The aesthetic of the Group of Seven reflects the view of European *settlers*, only in a different way than the Picturesque or the Sublime. Landscape has been described as the 'dreamwork of imperialism', disclosing both 'utopian fantasies of the perfected imperial prospect' and images of 'unresolved ambivalence and unsuppressed resistance' (Mitchell 1994: 10). The paintings of the Group of Seven embody the dreamwork of settler nationalism in Canada. Their wilderness aesthetic articulates some of the contradictory themes in Western concepts of self and other in a language of emergent nationhood. Wilderness as a symbol of Canadianness is polysemic; it can be interpreted in many ways.[6]

The systematic absence of human presence in the Group of Seven paintings can be interpreted as an expression of what I call the 'civilisation versus wilderness' opposition. In the mind of one member of the Group, Canada was 'a long thin strip of civilisation on the southern fringe of a vast expanse of immensely varied, virgin land reaching into the remote north' (in Berger 1966: 21). Bordo makes a link between the absence of people in work of the Group of Seven and the criteria of a wilderness park, a place in which human presence is deliberately erased (Bordo 1992: 114–19). He argues that wilderness is created through rules and regulations that prohibit and control not just human presence, but specifically Aboriginal presence. The 'wilderness' was inhabited for centuries by complex societies of Aboriginal people, and was not a 'wilderness' in the way we think of it today. It was not distinctly and conceptually separated and distinct

from urban life, rural farmland, and human 'civilisation'. It was not, as it is now, a site marked out for leisure, a space of untouched nature in which to recuperate from one's 'real' life. Aboriginal people lived and worked in that so-called emptiness.

Wilderness – unpeopled and savage – can also work as an 'other' to 'civilisation', a comparison within Canada which reinforces the settlers' sense of the difficult struggle to civilise the wilderness and the success they have had in controlling it. If the wilderness park works as a leisure site – a controlled 'precinct' which acts as an 'other space' to modern cosmopolitan lives – the north can be seen as that kind of 'other' to the majority of Canadians who live in 'the long thin strip of civilisation'. Morton, in his 1961 book *The Canadian Identity*, contends that the 'alternate penetration of the wilderness and the return to civilisation is the basic rhythm of Canadian life, and forms the basic elements of Canadian character' (cited in Harris 1966: 28). He also states:

> Canadian life to this day is marked by a northern quality, the strong seasonal rhythm which still governs even academic sessions; the venture now sublimated for most of us to the summer holiday or the autumn shoot; the greatest of joys, the return from the lonely savagery of the wilderness to the peace of the home; the puritanical restraint which masks the psychological tensions set up by the contrast of the wilderness roughness and home discipline. The line which marks off the frontier from the farmstead, the wilderness from the baseland, the hinterland from the metropolis, runs through every Canadian psyche.
>
> (cited in Harcourt 1993: 11)

Morton appropriates the dualism between wilderness and civilisation into a nationalist discourse. Similar to the environmental discourse of the Canada First Movement, environment defines identity. For Morton, however, it is the shifting back and forth, the *contrast between* the roughness and 'lonely savagery' of the wilderness and the peace and discipline of home that defines Canadians.

Margaret Atwood and Northrop Frye, two influential Canadian writers, also use wilderness as a key to articulate the elements and characteristics of Canadian culture. Atwood's *Survival* (1972) and Frye's *The Bush Garden* (1971), are central to the canon of Canadian literature taught in schools and universities. In both works, as in the aesthetic of the Group of Seven, the settler viewpoint of nature – not as 'noble' but as *'ignoble* savage' – plays a key role in defining Canadianness. Historically, in colonial discourse, links have been made between Native peoples and a purer state of nature. Indeed, the construction of Native people as more pure and natural was an important contribution to the creation of a 'civilised' Western identity. Nature was at first idealised and projected upon by early visitors to North America, as were Native people. Part of this idealisation was the construction of stereotypes of Native people, and the splitting of those stereotypical images into the 'noble' and the 'ignoble' savage (S. Hall

1992a). There are striking similarities between the dualism of such images of nature in Canadian nationalist discourse and the historical construction of women as virgins or whores, or blacks as problem or victim (Gilroy 1987).

In the earlier constructions of Canadian northernness by the Canada First Movement, the landscape is noble; it is somehow tamed, mirroring the traits and values of the people who have colonised it. It then produces offspring who (by nature of their northernness) maintain those superior traits. The picturesque landscapes of much of the early painting in Canada construct the relationship between nature and settlers in a similar mode. Nature is tamed; it reflects and reproduces a colonial mindset. The vision of nature is a projection of the viewer and the occupier.

The 'wilderness' aesthetic is the other side, the dark side of this stereotype of nature, which in a different way also re-affirms the viewer's sense of civilisation. This could apply to the paintings of the Group of Seven and to the more recent nationalist work of Atwood and Fry. Atwood's influential book *Survival* has an explicitly nationalist purpose of identifying 'key patterns' in Canadian literature which will help the reader *'distinguish this species'* of literature from all others (1972). In a similar way to the nationalist intention of the Group of Seven, a defined national identity is assumed necessary, and is worked out through a process of differentiation.[7] For Atwood this preoccupation with defining the 'self' of Canada is itself framed within a discourse of victimisation, of being colonised by others. Canadians, according to Atwood, need to build a sense of self because they have been denied full personhood as a result of British colonialism or American cultural imperialism. Outsiders have defined Canadians. Their sense of self is weak, if not non-existent. Atwood's argument becomes tautological when the central image she finds in literature, in order to combat this victimisation and define Canadian identity, *is* victimisation.

In *Survival*, Atwood examines types of landscapes common in Canadian literature and the attitudes they express. The main argument in her chapter 'Nature the Monster' is that in Canadian literature nature is perceived as a 'monster', an evil betrayer. She suggests that this sense of betrayal and distrust of nature emerged because of the disjuncture, during the late eighteenth and early nineteenth century, between expectations imported with the settlers from England about the nature of nature, and the harsh realities of Canadian settlement. In the late eighteenth century the dominant mode in nature poetry, inspired by Edmund Burke, was that of the picturesque and the sublime. This shifted in the first half of the nineteenth century to Wordsworthian Romanticism. Although each movement was distinct, both constructed nature as essentially good, gentle and kind (1972: 50). The themes she describes in literature are similar to those I have discussed in regard to European painting.

Towards the middle of the century, under the influence of Darwinism, literary images of nature began to change. Nature remained female but became 'redder in tooth and claw' (Atwood 1972: 50). However, according to Atwood, most of the English settlers were by that time already in Canada, 'their heads

filled with diluted Burke and Wordsworth, encountering lots and lots of Nature'. If Wordsworth had been right, Canada ought to have been 'the Great Good Place. At first, complaining about the bogs and mosquitoes must have been like criticising the authority of the Bible' (1972: 50).

For Atwood, these writings show a tension between 'what you were officially supposed to feel and what you were actually encountering when you got here' – a sense of being betrayed somehow by the 'divine Mother'. This theme of betrayal has been worked out, according to Atwood, through two central preoccupations in Canadian literature and fiction: victims and survival. A recurring theme is 'hanging on' or 'staying alive'. Canadian stories, according to Atwood, 'are likely to be tales, not of those who made it but of those who made it back, from the awful experience – the North, the snowstorm, the sinking ship – that killed everyone else' (1972: 35). The survivor is not as a hero, but barely alive, aware of the power of nature, and the inevitability of losing at some stage. Later, a constant theme in Canadian literature is what she calls 'Death by Nature' and even 'Death by Bushing' (ibid.: 55–6). In this scenario, if Canada were David and Nature were Goliath, Goliath would win. Submission to, and victimisation by, nature as ignoble, untamed and monstrous savage define Canadianness.

The image of Canadians being lost in the wilderness is also mobilised by Northrop Frye to contrast Canada and the United States. He argues, in *The Bush Garden*, that Canada has, for all practical purposes, 'no Atlantic seaboard'. The traveller from Europe, he suggests, 'edges into it like a tiny Jonah entering an inconceivably large whale'. The traveller slips

> past the straight of Belle Isle into the Gulf of St. Lawrence, where five Canadian provinces surround him, for the most part invisible. Then he goes up the St. Lawrence and the inhabited country comes into view, mainly a French speaking country, with its own cultural traditions. To enter the United States is a matter of crossing an ocean; to enter Canada is a matter of being *silently swallowed by an alien continent.*
>
> (Frye 1971: 217)

Frye's description of 'entering' and 'being swallowed' – a tiny Jonah engulfed by a huge whale – constructs Canada as a devouring, dangerous and alien female, even a *vagina dentata* (toothed vagina). Part of this femaleness is that she is everywhere, unconquerable, and somehow not definite or definable. The USA, on the other hand, is more 'male', more definite and phallic. The Canadian land as alien and female assumes and generalises a male settler's point of view. Such tropes of the colonial landmass as sexualised, as the terrifying female being penetrated by or engulfing male colonisers were also used in Africa during the late nineteenth century (Stott 1989). In Frye's description of Canada, the settlers are uncomfortable because *they* don't *penetrate* and control the (natural/female) foreign space; nature *engulfs* and swallows *them*.

47

In Frye's argument, the frontier – huge, alien, unconquerable and quintessentially Canadian – is different from the USA and again, imagined as essentially female.

> To feel 'Canadian' was to feel part of a no-man's-land with huge rivers, lakes, and islands that very few Canadians had ever seen...One wonders if any other national consciousness has had so large an amount of the unknown, the unrealised, the humanly undigested, so built into it. Rupert Brooke speaks of the 'unseizable virginity' of the Canadian landscape. What is important here, for our purposes, is the position of the frontier in the Canadian imagination. In the United States one could choose to move out to the frontier or retreat from it back to the seaboard. In the Canadas, even in the Maritimes, the frontier was all around one, a part and a condition of one's whole imaginative being...Such a frontier was the immediate datum of his imagination, the thing that had to be dealt with first.
>
> (Frye 1971: 220)

This 'unseizable virginity' – the engulfing and overpowering wilderness – has been 'dealt with' (in Frye's words), in similar ways by the Group of Seven, Margaret Atwood, and Northrop Frye in their shared project of defining and constructing Canadian identity. All utilise the wilderness to distinguish Canada from more powerful external others, such as the USA or Britain, in order to define Canadianness.

The wilderness (with nature as overpowering and hostile) has also been mobilised to affirm a common idea in Canadian nationalist discourse: that a characteristic of Canadianness is its indefiniteness. As in Frye's descriptions, Canadians are often seen as lost, identity-less, engulfed and made invisible by the vastness of nature. Atwood's description of the Group of Seven paintings (quoted earlier) equates the sense of being lost in nature with 'being nowhere at all'. This being 'nowhere', and lost in wilderness defines Canadianness in opposition to European picturesque landscapes. In European landscapes the viewers are invited into a definite 'space' of existence which contributes to the colonisers' sense of solid identity. In contrast, the Group of Seven paintings, which reflect the natural environment, affirm the sense of being lost. For Atwood, being 'nowhere' and identity-less – a victim – defines Canadianness.

Atwood's main thesis is that Canada's essential identity is that of 'the exploited victim' (1972: 35, 36). She suggests that Canada is a colony, and that a partial definition of a colony is 'a place from which a profit is made, but *not by the people who live there*' (ibid.: 36). The notion of being lost in the wilderness – in an undefined and unknown territory – is extremely paradoxical when mobilised in a discourse of victimisation to colonialism or imperialism, since it is itself a perspective of a coloniser, a settler, not one who is colonised. The Canadian literature Atwood examines is, for the most part,[8] written by and

expresses a world-view of those who settled in Canada from other countries. These are people who, although they may have felt lost and victimised by the environment or the Empire, were representatives of the colonial power that victimised Native people. Would being lost in the 'unknown territory' of the wilderness be a central metaphor for Aboriginal Canadian writers? When Frye uses the term 'no-man's land' he must mean European settlers, for it is only to them that Canada could be an 'alien continent'. The versions of northern Canadianness I discuss above utilise a settler point of view (lost in the wilderness) which erases Aboriginal people. Yet, paradoxically, white settlers take up a subject position more appropriate to Native people, in order to construct Canadians as victims of colonialism and US imperialism, and to create Canadian identity.

During the colonial period and in the early decades of nation-building, the dual process of creating Canadian identity and managing diverse populations involved complex and contradictory representations of internal and external others, and of Canada's land itself. Some nationalist narratives and government policies discussed in this chapter are structured through the inclusion of or nominal respect for Native or French peoples. Others are nationalist discourses structured through the erasure of cultural difference. Yet despite their differences, all these versions of national identity mobilise internal differences and similarities (either through erasure, inclusion, or appropriation) in order to differentiate from external others such as the USA and Britain. They all reinforce British or white settler hegemony and construct a settler (usually British) nationalist identity. Paradoxically, often this settler national identity is created through constructing others as friends or allies, or using the culture or subject positions of those others.

The politics of all this flexibility are complex. The important question here is not whether Aboriginal people, French-Canadians, or immigrants are erased in Canadian mythology, or even whether they are represented positively. The central issue is to examine *who* decides *when* and *how* Aboriginal people, French people or more recent immigrants, are or aren't represented, or are or aren't managed, in the interests of the nation-building project. These cultural groups become infinitely manageable populations as well as bit players in the nationalist imaginary, always dancing to someone else's tune. They become helpmates in the project of making a Canadian identity that defines itself as victimised by outsiders and tolerant of insiders. This process became more institutionalised during and after the Second World War, and is epitomised in the emergence of 'multiculturalism' as an official national policy and identity.

3

MANAGING THE HOUSE OF DIFFERENCE

Official multiculturalism

The development of Canada's self-image as a pluralist cultural 'mosaic' at first seems contradictory when compared with earlier immigration and cultural policies that centred on maintaining British cultural hegemony. In this chapter I argue that the introduction of multiculturalism was a response by the elites of Canada to a dangerous and ambiguous situation with regard to the cultural politics of difference in post-war Canada. Here I refer to the emergence of Québec separatism and also the increased politicisation of cultural minorities. Rather than trying to erase difference and construct an imagined community based on assimilation to a singular notion of culture, the state attempted to institutionalise various forms of difference, thereby controlling access to power and simultaneously legitimating the power of the state. Further, the production of a putatively 'pluralist' rather than singular national identity drew on historically constituted discourses of identity discussed in the previous chapter. 'Multiculturalism' was developed as a mode of managing internal differences within the nation and, at the same time, created a form through which the nation could be imagined as distinct and differentiated from external others such as the United States. To understand the contradictory nature of this form of national imagining, it is revealing to look at the way cultural differences were discussed during and after the Second World War.

Culture, 'race' and nation-building during the war

During the Second World War the relatively overt racism that coloured Canadian life came to the fore. After the bombing of Pearl Harbour, Japanese-Canadians were ordered to leave the Pacific Coast, and 22,000 Japanese, many born in Canada, were 're-located' into prison camps. The government also interned German-Canadians and Italian-Canadians (Palmer 1991: 17). At this time, the language of 'race', and a belief in the relationship between 'races', nations, and human characteristics held sway. Yet a method still had to be found to include immigrants, because immigrants were necessary for nation-building. The contradictions in this process are apparent in a 1941 example of the

50

Macmillan War Pamphlets Canadian Series, *The New Canadian Loyalists* (Gibbon 1941). Although its goal is to promote appreciation for 'new Canadians' its language is infused with racialist overtones and assimilationist impulses.

The booklet argues that 'new Canadians', are 'just as loyal to Canada as the United Empire Loyalists were to the British Flag'. Defining each national group in terms of its racial characteristics, and their degree of assimilability, it assures readers that the Scandinavians, of all 'the racial groups' attracted to Canada in the last fifty years...have 'presented the fewest problems in regard to assimilation'. However, the same is not true of the Ukrainians who are used as an example of the problems involved in the 'Canadianization of an alien race from Europe'. The pamphlet describes the characteristics and problems of the Ukrainians in great physical detail, and includes quotes from an ethnologist. Poles are described as 'simple, kindly folk, very affectionate and fond of their barn dances and religious ceremonies', whereas the 'Belgian race' is 'musical and artistic with high standards of education'. Russians are not all 'infiltrated with the germs of Communism', and the Doukhobors 'have been the most indigestible of any racial group admitted into Canada'. The 'Hebrews' appear in a short section that proclaims 'The Hebrew' has a 'natural instinct' for instrumental music, and 'the medical and legal professions in Canada include many brilliant practitioners of Jewish racial origin'. It assures the reader that although 'the Hebrew Canadians have not intermarried much with those of the Aryan races, they are good citizens'. A quote from a prominent German-Canadian military man, Sapper Con Schmidt, proves that the Germans too, are loyal citizens and subjects: 'On behalf of all German-Canadian citizens I salute our King, our Queen, our Britain and our Empire. We pledge our loyalty to them in this, your fight, our fight and my fight' (Gibbon 1941).

The New Canadian Loyalists pamphlet reveals that Canadian dominant culture before the end of the Second World War saw racial character and culture as synonymous, and believed in a hierarchy of races, especially in terms of their assimilability. Assimilation into the mainstream was desired and congratulated. Cultural differences, seen as inherent and fixed in races, were also constructed though the categorisation and description process. Despite its intention to promote understanding and acceptance, the pamphlet reflects and reproduces racial ideologies.[1] It also vividly illustrates the values assumed to be characteristic of Canada and Canadians, and assumptions about how 'new Canadians' were to fit into and contribute to the dominant British society and its project of nation-building.

After the Second World War, public displays of racism and anti-Semitism became less acceptable. However, the idea of northern climate shaping essential characteristics still remained. Vincent Massey, in his 1948 book, *On Being Canadian*, expressed northern racial discourse in a surprisingly unmasked form. While searching for differences between Canadians and Americans, he argued that Canadians' 'air of moderation in...habits' was rooted in climate and race.

Climate plays a great part in giving us our special character, different from that of our southern neighbours...Our racial composition – and this is partly because of our climate – is different, too. A small percentage of our people come from central or southern Europe. The vast majority springs from the British Isles or Northern France, a good many, too, from Scandinavia and Germany, and it is in northwestern Europe that one finds elements of human stability highly developed. Nothing is more characteristic of Canadians than the inclination to be moderate.

(cited in Berger 1966: 23)

Massey's suggestions are infused with many of the assumptions of the Canada First Movement's racial discourse. Published just after the Second World War, it is remarkable that 'moderation', or 'stability' are proposed as racial characteristics of Germans, linking them to other races of northwestern Europe. This discourse must have been at least slightly problematic at that time. Nevertheless, as in the early days of Canadian nation-building, the nationalists' need to differentiate from *external* 'others' – in the case of Massey, the USA – resulted in constantly re-worked, flexible and contradictory inclusions and exclusions of *internal* 'others'.

Post-war transformations

After the Second World War Canada took steps to move from the status of colony to independent nationhood. The government introduced a 1946 Canadian Citizenship Bill which confirmed that 'the British Empire...of which many Canadians felt their country to be an integral part, was itself on the decline and could therefore contribute less to Canadians' sense of collective identity' (Breton 1984 in Smith 1993: 54). Post-war Canada also entered into a period of unequalled prosperity and growth, and therefore increasingly needed immigrants as labour power.

Despite the need for immigrants to fuel prosperity, immigration policy immediately after the war still aimed to maintain British cultural hegemony. In a 1947 speech, Prime Minister Mackenzie King called for the revival of mass migration into Canada, a trend that had slowed during the Second World War. He made it clear, however, that it was of 'utmost importance to relate immigration to *absorptive capacity*'. The 'people of Canada', he continued, 'do not wish to make a fundamental alteration in the character of their population through mass migration' (in Harney 1989: 54). 'Absorptive capacity' and 'fundamental alteration to the character' are racially coded statements. As Harney argues, the 'usual subtext about finding suitable ethnic and racial stock that would be assimilable broke through the text, especially in the explicit call for the exclusion of Asian immigrants' (ibid.: 56). After the war the majority of immigrants came from Europe: Polish army veterans, Jews, Ukrainians and other Eastern

Europeans. Meanwhile, the government pursued recruitment of more desirable immigrants in Holland, Scandinavia, and the UK (ibid.: 57).

At the same time there were periodic moral panics about immigration and its effects on Canada. For example, five years after King's speech, *Maclean's* magazine ran an article on immigration entitled 'What kind of Canadians are we getting?', lamenting the rise in continental European immigration. In addition, reflecting the persistence of racial categories in post-war Canada, it is striking that a poll taken one year after the war found that while 49 per cent of the population were against Jewish immigration, only 34 per cent would have refused Germans (Harney 1989: 58).

By the late 1950s, north-eastern sources of immigrants were dwindling, but the need for labour was not. Canada began to recruit Italians, and although Northern Italians were preferred, at this point racial reasoning could not be made overt. Canada had signed the UN charter in 1944 and one of the effects of the war was that nations gave up talk of the 'right stock' and its racial overtones (Harney 1989: 59; Whitaker 1991: 17). Although the regulations could not go against the UN Charter, they still maintained selectivity through clauses concerning 'unsuitability of climate' and 'inability to become readily assimilated'. Despite these gate-keeping mechanisms, Italian, Portuguese and Greek immigrants 'became the engine of the rapid urbanisation of Southern Ontario', and began to form communities in large cities. As their visibility in Canadian society increased, some panic ensued, and when the number of immigrants from Italy became higher than those from Britain, a minister of immigration toured northern Europe (in 1964) looking for immigrants to 'balance' the flow (Harney 1989: 60).

During the 1960s the government made several attempts to de-racialise the immigration selection process, and yet still maintain control and selectivity. The Conservatives changed the selection criteria, replacing ethnicity and country of origin with questions about skills, education and training (Smith 1993: 57). By 1967 the economic boom was in full swing and the demand for skilled labour was high; yet European sources for that labour were dwindling. Changes were made to immigration law, now to be set up on a point system, which allowed in Asian and other Third World skilled immigrants. By the mid-1970s more immigrants came from the Third World than from Europe (Samuda 1986: 105; Whitaker 1991: 19).

Prosperity and state intervention

Canadian nationalism increased in the three decades after the Second World War, and so did state intervention in economic, social, political and cultural life, as Canada experienced a huge expansion in the public-enterprise and public-service economy. State intervention was itself to become one of the chief characteristics of Canada as a nation. The government took a Keynesian approach to the management of society which involved state support for

industries on a large scale, the formation of crown corporations, the formation of an extensive welfare state, the public support of scientific research and development, and state support of arts and culture (Bumsted 1992b: 274–302). In the post-war period, government at all levels became Canada's largest employer (ibid.: 310–11). At least until the 1970s, the degree of state spending was not a controversial issue (ibid.: 294, 311).

At the same time, post-war Canada renewed its search for a specifically Canadian identity, one that would continue to distinguish it from Britain and the United States. The state became increasingly involved in a project of cultural nationalism, which was most often framed as cultural protectionism. The cultural effects of living beside the USA were considered dangerous to a country emerging from colonial status. In the mid-1950s, the Fowler Commission on radio and television broadcasting argued that:

> No other country is similarly helped and embarrassed by the close proximity of the United States…[A]s a nation we cannot accept, in these powerful and persuasive media, the natural and complete flow of another's culture without danger to our national identity. Can we resist the tidal wave of American cultural activity? Can we retain a Canadian identity, art and culture – a Canadian nationhood?
>
> (cited in Bumsted 1992b: 392)

The sense of danger to Canadian culture was palpable, and increased state funding was explicitly channelled towards developing Canadian culture to protect against US cultural imperialism.[2]

As a result, culture and identity were the basis of four major inquiries in the two decades after the war. The Massey Commission (1949) centred on the arts, letters and sciences; the Fowler Commission (1955) on radio and television broadcasting; the O'Leary Commission (1961) on magazine publishing; and the Laurendeau–Dunton Commission (1963) on bilingualism and biculturalism (more often called the B and B Commission). Canadian culture was also the subject of the 'crucial' opening chapter of the Report of the Québec Royal Commission of Inquiry on Constitutional Problems (the Tremblay Commission 1953). According to Bumsted, the 'disparate subjects of these commissions suggest that culture was virtually all embracing. It was also freighted with political implications' (Bumsted 1992b: 379).

While each of these commissions had different topics, all of them assumed that cultural development was essential for national identity. The commissions were interconnected arms of a broader project to develop, articulate and promote national identity and culture. These programmes represent an unprecedented increase in state intervention, control, and surveillance of culture, and the state-sponsored production of national identity. This identity was defined through the state management of many forms of difference: a concern with defining Canada's difference *from* the United

States, and attempts to define the role of *differences within* Canada in terms of Québec.

During the post-war period a new form of Québec nationalism emerged. Separatist sentiment and the 'Quiet Revolution' made it clear that Québec would no longer accept being treated as a province like any other (Bumsted 1992b: 320–32). Later, other internal differences came to the fore and had to be managed: Canada's Native peoples and the 'ethnic minorities'. The intervention in and management of cultural difference, to protect and develop the nation, were an essential and political aspect of state concern, surveillance and intervention.

Lester B. Pearson, minority Liberal leader from 1963–8, developed a strategy to deal with the increased demands for independence in Québec and the complex demands of nationalism and identity within Canada. He attempted to negotiate the idea of 'cooperative federalism' with Québec: a series of agreements between Ottawa and the provinces that accepted the need for increased consultation and flexibility. In 1963 he introduced the concept of Canada as an 'equal partnership' between French and English Canadians, and enshrined the concepts of 'cultural dualism' and 'two founding races' in an Order-in-Council (Bumsted 1992b: 327–31). Pearson also saw symbolic and ritual aspects of nation-building as essential to national survival. He was committed to establishing a 'distinctive Canadian flag within two years of taking office' (Fraser 1967: 239), and continued working on plans for national celebrations of Canada's centennial in 1967 (Bumsted 1992b: 325–33).

Symbols and survival: the flag debate

According to Fraser, a flag is a 'nation's premier graphic symbol second in importance only to the nation's premier linguistic symbol – its name' (1990–1: 64). Since Confederation in 1867, Canada's official flag had been Britain's Union Jack. The unofficial flag was the Canadian Red Ensign, the flag of the British Merchant Marine with the Canadian coat of arms on one corner. Pearson preferred a flag of three maple leaves joined by a single stem on a white field, an image that had historical and heraldic precedent. Many Anglo-Canadians objected to this design, however, mainly on the basis that it was not sufficiently British (Fraser 1967: 234–40).

In 1964, the battle over the new Canadian flag 'paralysed Parliament and government for six months' (ibid.: 234). It was, as one commentator noted, one of the most controversial, heated, and 'emotion packed issues of our time'.[3] For Fraser, the debate over the flag was a battle between 'disparate cultural views' of the nation itself: between a British imperialist view of the nation, and one which supported a more independent, nationalist, inclusive and pluralistic identity (1990–1: 64, 67). Many saw it as a battle between old and new Canada, between history and future, and between Empire and nation. This battle over identity focused on symbolic aspects of the cultural relationship

between English Canada and its three main protagonists: Britain, the United States, and Québec. The debates also referred to Canadians whose heritage was neither British nor French.

Yet the issue of Québec was primary, as separatism could most threaten Canadian unity. According to John Ross Matheson, a Liberal involved in the flag debate, Prime Minister Pearson's one 'paramount and desperate objective' in introducing the new flag was the 'saving of Confederation' by 'reconciling French Canada to the Canadian Union' (Matheson 1980: xi–xii). He argues that the Canada of the flag debate was not yet a nation.

> There was no common Canadian nationality. By now the ethnocentrism of British Canada, the 'in group' was firmly established and universally recognised. Any sensitive observer of the Canadian scene was aware of the rapidly accelerating isolation of the French, the excessive social distance in Canada and the disturbing lack of interaction. There was an atmosphere of impending crisis. It was a 'moment' in Canadian history with two distinct and two divergent possibilities.
>
> (Matheson 1980: 230)

He suggests that this moment in Canadian history required 'a manifestation of concern...a nobler kinder vision of Canada', which came from Prime Minister Pearson, in part through the provision of a new flag. This new inclusive symbol of Canada would be the 'symbol of Canada's will to survive' (1980: xi–1). He argues that:

> [the] sole motive of this exercise over symbolism...was to bind our divided nation into one. The times shouted loudly for some great act which would make it clear to all Canadians, British and French alike, that Canada was determined to remain united. What was needed was a symbol that would proclaim this oneness to ourselves and to the world.
>
> (1980: 5)

Symbols were therefore important strategic tools in the pan-Canadian nationalist cause. The manipulation of symbols of nationhood was essential for the survival of the project of nation-building in Canada at a moment of perceived crisis.

One of the main issues in the debate was the difference between the British imperialist view of Canada – which saw Canada as part of the British Empire and therefore saw the Red Ensign as the most appropriate flag – and the nationalist view – which perceived Canada as an independent nation and therefore argued that the flag should be 'exclusively Canadian' (in Fraser 1990–1: 67). The pro-Red Ensign faction were convinced that 'the quasi-religious belief in things British served as a talisman to protect Canadians against the quasi-religious belief held by Americans that theirs was the manifest destiny to

overspread the continent'. (ibid.: 66). British symbols were therefore mobilised to protect Canada from an external and threatening 'other' which has consistently been central in the defining of Canadian identity: the United States.

In Winnipeg, Manitoba, on 17 May 1964, Prime Minister Lester B. Pearson gave a speech on the topic of the new Canadian flag to an audience of over one thousand members of the Royal Canadian Legion and at least 700 others. The passion inspired by this debate is apparent in a 1964 television broadcast of the speech (see note 3). The majority of the Members of the Legion, veterans of the First World War and 'fiercely loyal' to the Union Jack and Canadian Red Ensign flag, planned to let Pearson know 'in no uncertain terms' their objections to his maple leaf flag (Fraser 1967: 240).

The television footage of the event shows Pearson beginning his speech to the restless, excited and hostile audience by referring to the Red Ensign and the Union Jack. The audience burst into rowdy cheers and a standing ovation. When Pearson mentioned the maple leaf flag, however, the cheers turned to jeers and heckling by 'an angry mob of Legionnaires, not all of whom appeared to be quite sober' (ibid.: 240–1). Despite the constant interventions by the Chairman, who attempted to quiet the crowd, Pearson continued his speech. He extolled the virtues of the new flag which would represent the 'new Canada', a nation which was home to five million Canadians who were of French descent, and five million others of neither British nor French descent. The maple leaf flag, he explained, would 'bring those other Canadians closer to us of British stock and make us all Canadians'. Pearson thereby constructed the flag as a way of creating unity and similarity between diverse and different cultures, or 'stocks'. It was also presented as a way of differentiating Canada from other nations, and of linking past and future. Pearson proposed in his speech that it was now time, in Canada's 'national evolution' to have a 'truly distinctive flag' which honours 'Canada and only Canada'. The flag would thus mark the nation as evolved – as individual and different from all other nations, drawing on Enlightenment discourses of identity (Handler 1988). The flag would also create continuity, for in Pearson's words it would be 'a flag of the future which honours the past'. The response of the legionnaires to his speech indicates both the extent of passion aroused by the issue, and the degree of active resistance to change mobilised by some Anglo-Canadians. French-Canadians, on the other hand, were generally in favour of the maple leaf flag (Bumsted 1992b).

Finally, after months of heated debate, a new flag was approved by Parliament. It has a single red maple leaf on a white ground, with red bands on the sides. In 1965 it became Canada's official national flag. This shift, to new, more 'inclusive', and future-oriented symbols of Canadian nationhood also resulted in the approval of an official national anthem. Canada had not had a national anthem before 1967, usually singing 'God Save the King or Queen'. Previous anthem suggestions such as 'the Maple Leaf Forever', with its references to the defeat of the French by the English, were rejected because they

would not have appealed to Québec. 'Oh Canada', written originally in French as a *chant nationale* in 1880 and given English lyrics in 1908, was more attractive at this time of intended reconciliation (Bumsted 1992b: 327–9). This was despite the fact that as late as the 1950s 'imperialists' labelled the singing of 'Oh Canada' as 'subversive and unpatriotic' (Fraser 1990–91). The new flag and national anthem were instances of state intervention in cultural politics to ensure the survival of the nation. These primary symbols of a renovated and future-oriented Canadian nation came into prominence in the centennial celebrations of 1967.

Celebrating the 'new Canada'

The centennial celebrations were a high point in Canadian state-produced national sentiment. They were a 'bipartisan extravaganza' (Bumsted 1992b: 329), because the plans were started by Conservative Prime Minister Diefenbaker and continued by Liberal Pierre Trudeau. The main features of this immensely successful celebration were its air of optimism, its incredible expense, the prominence of an emerging bicultural vision of the nation and, finally, the foregrounding of Native people and 'ethnic groups' in the activities. The immense costs of the celebrations indicate how prosperous this era was, and exemplifies the 1960s' philosophy of state spending. My estimate of the total costs of the celebrations (over a billion 1992 dollars)[4] is striking in the context of the comparatively meagre 50 million dollars spent in 1992 on the Canada 125 celebrations.

The celebrations had two arms. The first was a national programme administered by Ottawa, but filtered in part through the provinces and municipalities. It supported, on a dollar-for-dollar basis (if communities could raise one dollar the federal government would match it), the construction of Centennial Monuments and public buildings such as the National Arts Centre in Ottawa, and many other buildings in towns across the nation. The government would support activities judged to be of a 'lasting nature as a permanent memorial to the centennial' (Aykroyd 1992: 77). They also supported other expensive activities: a Confederation Train which toured the country; a Voyageur canoe pageant, theatre festivals; historical re-enactments; and programmes for Youth Travel, Folk Arts, tree planting, and centennial medals. The total cost for this branch of the celebrations, estimated in 1992 dollars, is $359,456,592.00 (ibid.: 197).

The other arm of the programme, and the centrepiece of the celebrations, was the Canadian Universal and International Exhibition at Montreal, familiarly known as 'Expo '67'. The theme of the exhibition was 'Man and his World (*Terre des Hommes*)'. It was a spectacular exhibition that included the participation of 120 governments (Bumsted 1992b: 329). Since the Crystal Palace Exhibition in London in 1851, international exhibitions have been important sites for the production and popularisation of ideas about the relationship

between local, national and global populations, cultures, identities, and the market. In particular, world fairs have been analysed as sites for the elaboration of ideas about Western 'civilisation' and progress in relation to 'uncivilised' and 'savage' others; and often included the exhibiting of those human others (Hinsley 1991; Stocking 1987; Street 1992). They are also sites for the classification, objectification and commodification of exotic cultures through the presentation of collected artefacts and curiosities (Breckenridge 1989; Hinsley 1991). World fairs 'helped shape both the form and the content of public life in respect to global issues', defining metropole and colony, often in the taken-for-granted framework of the cultural specificity of nation–states (Breckenridge 1989: 201, 196). Expo '67 was a site in which Canada could elaborate its emerging national identity: differentiating itself as a nation from external others as well as defining relationships between internal populations. It was a moment in which the nation 'came out' to the world, and to itself, in what was perceived as its new progressive and pluralist form.

The official cost of Expo '67 would translate into an estimated one billion 1992 dollars. Added to the $359 million cost of the other arm of the celebrations, the total cost is breathtaking, at least from the viewpoint of the 1990s. National identity and national unity were obviously important political issues of the day.

Pedagogies of patriotism

The celebrations also offered an opportunity for mass education of Canadian citizens, drawing on a longer history of the role of public spectacle. World fairs in the nineteenth century 'supplied the metropolitan nation–state with an occasion to fulfil one of its unquestioned goals, namely universal education through mass mobilisation' (Breckenridge 1989: 212). McClintock (1995) argues that mass spectacle was and is one of the key modes through which states promote nationalism. In Canada in 1967, the international exhibition and the centennial celebrations played a pedagogical role, providing an opportunity to educate the 'baby boom' generation of citizens about Canada's identity as a nation. I was 10 years old in 1967 and on top of the daily school ritual of singing the new national anthem in front of the new Canadian flag, I remember spending months designing and painting centennial emblems for school competitions. We were carefully instructed to include each province, and to include both French and English languages. Thousands, if not millions, of schoolchildren like myself went on school-sponsored visits to Expo '67, buses packed with children from all areas of Canada converging on Montreal. These trips can be seen as 'pilgrimages of patriotism', that combine the ritual of participation in patriotic performance, with the pedagogical practice of learning about the nation, its relationship to the world, and one's role as a citizen and national subject.

Learning to 'be Canadian' meant being educated about the specific qualities and characteristics being constructed at that time: cultural pluralism and

tolerance. 'Biculturalism' was an important and central theme in the centennial celebrations (Aykroyd 1992: 61) and was reflected in the choice of Montreal, Québec, for Expo. The celebrations also emphasised 'Folk Festivals' and the 'Folk Arts' of 'ethnic minorities', particularly singing, dancing, costumes and food. This emphasis, as articulated before the emergence of official 'multiculturalism', had some unusual expressions. Although the photos in Aykroyd's (1992) book on the centennial has many photographs of the big events and the organisers of the celebrations (mostly white males with French or British sounding names), the book provides one 'ethnic' photo that may reveal current attitudes to cultural pluralism in Canada. Figure 3.1 shows Maitland Steinkopf, Chairman of the Manitoba Centennial Corporation, dressed for the celebrations. Steinkopf's costume seems a little odd because it does not reflect any one ethnic group but bits and pieces of many. The caption describes Mr Steinkopf's 'Indian head-dress, Hungarian shirt and vest, German lederhosen, Ukrainian sash, Dutch klompen and shillelagh' (Aykroyd 1992). The fact that Steinkopf could 'mix-and-match' symbols from different ethnic groups all at the same time, mapping a 'hybrid' version of multiculturalism on his own body, demonstrates that boundaries between ethnicities, were not as closely drawn as they are today. Further, conceptions of cultural property must have been different. In Canada in the 1990s, for example, on ceremonial occasions, members of specific cultural groups tend to wear symbols and costumes defined as their own cultural property. The 'hybrid' mix of cultural symbols, seen in 1967, might indeed be frowned upon today as disrespectful, or as a form of 'cultural appropriation'. Perhaps the differences between then and now may be explained by the fact that the institutionalisation of forms of cultural difference and 'ethnic' identity into national identity were in their early stages in 1967. I discuss the increase in the institutionalisation of cultural difference below.

Making the 'Indians' ethnic

The celebrations of 1967 put great emphasis on the inclusion of Native people. The Commission provided grants to Native communities for travel and athletic programmes, and for projects which focused on 'the rich heritage of native customs, legends, stories, songs and dances...displayed in pow-wows, potlatches, sports meets, pageants, exhibitions and ceremonials' (Aykroyd 1992: 113). This attention also meant that Native people's images and relations with mainstream Canadian society were being constructed along specific and defined lines. A 1964 policy recommendation paper for the centennial, 'Participation in Canada's Centennial by People of Indian Ancestry – Some Policy Considerations' (Courmier 1964), indicates shifts in the way Native people were seen and treated by the state. The document reveals the degree of confusion which reigned amongst managers of Canadian identity at that time: How to define Native peoples within Canadian identity? They were stuck between two conflicting goals and strategies. On one hand, the document claims, 'the

Figure 3.1 Ethnicity at the centennial celebrations. Maitland Steinkopf, chairman of the
Manitoba Centennial Corporation, wearing ethnic costume. Ross Lawrence
admires Mr Steinkopf's Indian head-dress, Hungarian shirt and vest, German
lederhosen, Ukrainian sash, Dutch klompen and shillelagh. Winnipeg,
Manitoba, 1967.

Source: National Archives of Canada (neg. no. PA 185504).

Indians' could not be 'lumped with the rest of the citizenry'. *Not* giving them
special treatment would be politically unacceptable, because of public opinion.
It was also unacceptable because the centennial celebrations needed to
'project the Canadian image in all its aspects' (ibid.: 2). On the other hand,
the report points out, 'it would be *dangerous* for the Commission to declare
the Indian a *special* group' without a good rationale for doing so (ibid.,
emphasis mine).

The report recommends treating Native people as a special group, based on

the recognition of their poverty and marginalisation from mainstream society, and their inability to construct 'a world of their own'. The report makes much about how the lack of a 'cultural rudder' has made 'the Indian' exist 'helplessly and aimlessly'. This failure to define their own cultures means that they do not fit into any group in Canadian society, either of the two 'founding races' of Canada (the French and the English), or the 'third area' (immigrant/ethnic groups). The report suggests that forming an Indian organisation, or assisting an already existing one, was important so that 'the Indians' could 'effectively manage Commission Assistance' (1964: 9).

> They could constitute an ethnic group in the functional sense but they have not reached the level of organisational structure (European style) which would make it possible for government to deal with them through the same approach as would be effective with other ethnic groups.
>
> (Courmier 1964: 3)

It affirms the importance of government intervention to assist Aboriginal people to develop 'European-style' organisational structure. This is a process of trying to transform Native peoples into political clientele, because until that point the 'assistance' of the benevolent state would not be 'managed' by them. Defining Native people, and accounting for their difference and marginalisation, became part of a process of managing them. It is part of the process of prodding them to reach the 'level of *organisational structure* (*European style*) which would make it possible for *government to deal with them*' (Courmier 1964: 3, emphasis mine). Recognising difference, then, was integrally linked to state management of difference.

The state also legitimated itself through constructing these programmes as benevolent. Aykroyd's book on the centennial reinforces this view, because he credits the state, through the celebrations, with building Native peoples' pride and self-confidence, and with creating the powerful Native organisations of today. The activities of the Centennial Commission, writes Aykroyd, brought '*native Canadians together as a unified group...providing them* with increased *confidence and hope for self-determination*'. The organisations formed by this activity, according to Aykroyd, eventually amalgamated into the 'powerful and respected Assembly of First Nations today' (Aykroyd 1992: 113–14, emphasis mine).

In 1992 the Assembly of First Nations was one of the main agents that forced issues of Aboriginal self-government into debates on the constitution. The paradox here is that the state is given credit for forming the very organisation that went on to challenge it. Indeed, the state actively sought the formation of that kind of national representative organisation ('European style'). This paradox can be understood through the framework of the *institutionalisation* of difference. The state, by defining and institutionalising cultural

difference, and constructing Native people as political clientele, not only manages the relationship between the state and potentially threatening minority populations, it legitimates itself as benevolent [5]

As a participant in the 1967 celebrations, I remember being intensely excited and proud of my country. If the goal of the festivities was to ignite pride of nationhood in the population, the government seemed to have been very successful. More than anything there was a sense of national self-congratulation: 'we' Canadians had a kinder, better, more international, more inclusive nation than the United States. Further, there seemed to be no contest over the fact that the state would support and promote national identity. The federal government came out of the centennial celebrations looking very good, both on the domestic and the international scene. Spending money on national identity and culture legitimated it in the eyes of its citizens.

In 1960s Canada, managing and representing forms of difference were central to the creation of national identity, and to the success of the nation-building project. In the 1970s this project continued and became more institutionalised as the state defined even more clearly the boundaries and hierarchies of difference in the Canadian nation. An example is the development of the official policy of 'multiculturalism'.

Creating official 'multiculturalism'

Official 'multiculturalism' emerged from the recommendations of Lester B. Pearson's Bilingualism and Biculturalism Commission. The Commission was given the mandate:

> [to] inquire into and report upon the existing state of bilingualism and biculturalism in Canada and to recommend what steps should be taken to develop the Canadian Confederation on the basis of an equal partnership between the two founding races, taking into account the contributions made by other ethnic groups to the cultural enrichment of Canada and the measures that should be taken to safeguard that contribution.
>
> (cited in Bumsted 1992b: 330)

As part of Pearson's programme to deal with the Québec 'problem' in Canada, the Commission's main focus was bilingualism and biculturalism. Harney suggests that the Bilingualism and Biculturalism Commission (B and B Commission) was 'a state intervention to structure the symbolic order in Canada'. He argues that 'the French–British dualism that had in the past been seen as a tale of mutual antagonism, of exploitation and inequality, as an impediment to the emergence of the Canadian nation, would now be refurbished as a national virtue'. Further, Québec was revived as a key to differentiate Canada from the United States (Harney 1989: 64–5).

In the course of extensive consultations and interviews, the Commission found a certain degree of protest by relatively established 'ethnic groups' such as Ukrainian-Canadians, who rejected the hierarchy of differences implicit in the terms of reference. The Commission, in response to the statements, media coverage, and briefs submitted to it, postponed some of their meetings and slowed down their work. Breton argues that the government, in funding the meetings and conferences, actively promoted the shift from bilingualism and biculturalism towards multiculturalism (1988: 37–8), and book IV of the Commission's Report proposed a form of official multiculturalism. The recommendations were adopted and became official policy on 8 October 1971.

Announced by Prime Minister Pierre Elliot Trudeau, the policy was called 'Multiculturalism within a Bilingual Framework'. The policy asserted that although Canada had two official languages 'there is no official culture, nor does any ethnic group take precedence over any other' (Multiculturalism and Citizenship Canada 1985: 15). The policy identified some eighty different ethnic or cultural groups which could apply for financial support from various ministries, particularly the newly formed Ministry of Multiculturalism, to support programmes for developing and maintaining cultural and linguistic identity (Bagley 1986: 51). The aims of that policy were to 'help minority groups preserve and share their language and culture, and to remove the cultural barriers they face' (Multiculturalism and Citizenship Canada 1985: 15). While it promoted the maintenance of 'ethnic' languages, it also promoted the acquisition of one of the two official languages for immigrants (Multiculturalism and Citizenship Canada 1991).

Breton suggests that the shift to multiculturalism represented an 'attempt to redefine the symbolic system' of Canada (1988: 39–40). As a symbolic intervention, the policy was an attempt to manage a potentially dangerous political situation through the recognition and management of culture. The policy has been criticised as a means to undercut Québec's demands for special recognition by bestowing recognition on other cultural groups (Hutcheon and Richmond 1990: 15; Lewycky 1992; Moodley 1983; Satchewich 1992). In this sense it recalls the Royal Proclamation of 1763, discussed in the previous chapter. The Proclamation, as I argued, played different populations against each other, paradoxically giving Native People's land rights in order to promote the assimilation of Québec. Multicultural policy extends the state recognition of multiple forms of difference, so as to undercut Québec's more threatening difference. According to a study on multiculturalism and education commissioned by the Multiculturalism Directorate, Francophones have an ambivalent response to multiculturalism. Some see it as an invention of the Anglophone-dominated federal government, intended to transform them into just another cultural group. 'Multiculturalism may thus be said to exist outside the Québec Francophone community' (Multiculturalism and Citizenship Canada 1985: 8–9). The state's attempt to manage Québec separatist sentiment by recognising other forms of diversity was not necessarily successful, as we can see in

the continuing debates and strategic moves to deal with the relationship between Québec and Canada over the last two decades. As recently as March 1998, the Canadian government, in a controversial move, asked the Supreme Court of Canada to rule on whether Québec can secede unilaterally from Canada under the Constitution or under international law (Geddes and Branswell 1998; Janigan 1998).

As in the Québec Act of 1774 (discussed in the previous chapter), multicultural policy also gave recognition to powerful minority elites, although this time they were 'ethnic' instead of French Catholics, as they had been in 1774. These 'ethnic' elites, by the 1960s, were seen to represent sizeable constituencies. Breton (1988) and Harney (1989) both indicate that the meanings of 'ethnicity' were changing in the 1960s, as ethnicity was increasingly seen as a permanent political feature of the Canadian landscape. There was also increasing talk of immigrants in terms of their size in the census, and an increase in the assumption that origin (census group) and *interest groups* were necessarily synonymous (Harney 1989: 69). By defining and recognising immigrants as 'ethnocultural groups', the policy provided a means through which cultural difference became politicised, but also politically manageable through the funding of 'cultural programmes', the main function of the early policy. Elite representatives of 'ethnic' groups were being drawn into the institutionalised management of symbolic affairs and inter-group relations. This new institutionalised and recognised difference created new opportunities, new limitations and boundaries, as well as unintended consequences.

The policy also draws on discourses I have discussed which posit the British/Canadian mode of dealing with difference as superior to that of the USA. Through making the 'cultural mosaic' (as opposed to the melting pot of the USA) an official policy, it provides a tangible symbol of that difference from the USA, thereby reinforcing the construction of a differentiated Canadian identity. 'Multiculturalism' replaces Britain as a central symbol of Canada. The construction of tolerance as a national characteristic is on a continuum with earlier forms of British/Canadian identity, for example, the nationalist image of the gentle and tolerant Mounties (being kind to Native People) as a symbol of Britain's superior form of justice.

Limiting diversity

State recognition of diversity also limits diversity. Trudeau's announcement of the policy defined and limited the specific forms of support for multiculturalism that the government would provide.

> First, *resources permitting*, the government will seek to assist all Canadian cultural groups that have *demonstrated a desire and effort* to continue to develop a capacity to grow and *contribute to Canada*...

Second, the government will assist members of all cultural groups *to overcome cultural barriers* to full *participation in Canadian society*.

Third, the government will promote creative encounters and interchange among all Canadian cultural groups *in the interest of national unity*. Fourth, the government will continue to assist immigrants to acquire at least one of Canada's official languages in order to become full *participants in Canadian society*.

(Trudeau 1971: 8545–6, emphasis mine)

Through limiting its support, the policy defines acceptable forms of difference. The support provided by the state is limited to that which will help cultural groups to *participate in* and *contribute to Canadian society* and Canadian *unity*. Therefore, acceptable cultural diversity must buttress the project of nation-building and national unity in Canada. Ethnic groups are thereby mobilised as picturesque and colourful helpmates and allies in the nation-building project. Further, although the tolerance, maintenance, and even encouragement of ethnic cultures and languages were embedded in the policy through language maintenance programmes, neither official linguistic nor political pluralism (other than for the French and the English) was part of the policy. The policy was, after all, called 'multiculturalism within a bilingual framework'. Only the two 'founding nations' have linguistic and political rights as members of their groups. Members of ethnic minorities only have rights as individual citizens. As legally constituted cultural minorities, with rights as individuals only, they cannot authorise political changes to dominant culture, they can only request them. They can request permanent tolerance of their cultural difference, but only as an exception to the rule. They cannot be accorded equality as members of minority groups (Asad 1993: 259). In 1968 Pierre Trudeau suggested, 'in terms of *realpolitik* French and English are equal in Canada because each of these linguistic groups has the power to break the country. And this power cannot yet be claimed by the Iroquois, the Eskimos, or the Ukrainians' (in Francis 1992: 219). The multiculturalism policy, by clearly locating the inclusion and recognition of minorities in *cultural* politics (the state will help them overcome '*cultural* barriers'), attempted to prevent a situation in which *realpolitik* could break the country.

The policy also implicitly mobilises different definitions of 'culture' for minority groups and for national culture. It has been argued that multiculturalism promotes the idea of minority cultures as fragments of cultures, constructed from folkloric and culinary remnants (Smolicz 1985: 455). In the multicultural model of culture the cultural fragments become conceptually divorced from politics and economics, and become commodified cultural possessions. Multiculturalism enacts a process akin to what Handler calls 'cultural objectification' (1988). Kogila Moodley argues that Canadian multiculturalism promotes a 'festive aura of imagined consensus' (1983: 320)', what Mullard calls a 'three Ss' model of culture. This model highlights 'saris,

samosas, and steel bands', in order to diffuse the 'three R's': 'resistance, rebellion and rejection' (1982). However, a much broader definition of 'mainstream' Canadian national culture is also implicit. The policy has been critiqued for maintaining the idea of British Canadians as the 'norm', in relation to 'multicultural' Canadians. In this construction of culture, we have a core Canadian national culture as a 'whole way of life', and the 'multicultures' exist as fragments of culture, only valued for the ways in which they contribute to this 'whole way of life' of the national culture. In this sense, minority cultures in Canada are constructed through a 'discourse of enrichment' similar to Australian multiculturalism (Hage 1994a: 31–2). Multiculturalism still positions Anglo-Canadians or Anglo-Celtic Australians in the centre of the national 'cultural map'; the difference between minority cultures and the dominant cultures is that dominant cultures simply exist, whereas minority cultures '*exist for* the latter' (ibid.: 32).

Rationalising multiculturalism: changes in policy

Since 1971, the official ideology of 'multiculturalism' has, according to government rhetoric, become much more rights-oriented and intent on transforming the dominant society. The discourse of helping remove 'cultural barriers' has been transformed into one of 'race relations'. The 1982 Charter of Rights and Freedoms guaranteed 'equal rights that respect the multicultural heritage of Canadians' and, in 1988, multiculturalism policy was enshrined in Bill C-93. The Act, among other things, 'recognises and promotes' the understanding that multiculturalism is 'a fundamental characteristic of the Canadian heritage and identity'. Further, the Act says it 'promote[s] the full and equitable participation of individuals and communities of all origins in the continuing evolution and shaping of all aspects of Canadian society and assist[s] them in the elimination of any barrier to such participation' (Canadian Multiculturalism Act 1988). A federal department provides programmes such as 'Race Relations and Cross-Cultural Understanding', 'Community Support and Participation', and 'Heritage Cultures and Languages'. According to the Department of Multiculturalism and Citizenship, this new Act, 'addressed to all Canadians...is based on the idea that everyone, including the government, is responsible for changes in our society. This includes the elimination of racism and discrimination' (Multiculturalism and Citizenship Canada 1991: 6).

Angel suggests that the Act focuses more on the combating of racism as a response to the demands of the newer 'visible minority' immigrants who arrived after the 1960s (1988: 26). The Act, despite these changes, is still primarily concerned with mobilising diversity for the project of nation-building, as well as limiting that diversity to symbolic rather than political forms. A 1985 document put out by Multiculturalism and Citizenship Canada makes this reasoning overt, describing multiculturalism as a 'great national bandage' that helps to heal the 'national fabric'.

Multiculturalism can be seen as a great national bandage to bind over all of the divisions, or a philosophy to help individuals develop a self-concept rooted in their unique past and looking toward a united future. It becomes a way of being able to talk about diversity but not divisiveness, unity but not assimilation. In a sociology of knowledge sense, it provides a language with which to talk about problems which are seen as *threatening* to the national fabric.

(Multiculturalism and Citizenship Canada 1985, emphasis mine)

Multiculturalism as 'the great national bandage', allows the state to highlight and manage diversity without endangering the project of nation-building.

Although fundamental aspects of the 1988 Act mirrored earlier multicultural policy, the ways through which the government legitimated the policy changed slightly. One internal government policy document, proposing the multiculturalism strategy that was to become the Multiculturalism Act in 1988, outlines the environment for such a strategy: the usual arguments about Canada's economic need for immigrants and the need for minority groups to feel 'recognised'. However, by the late 1980s, global capitalism enters the picture as a justification for multicultural policy, a policy that will help create economic progress and identity. The policy document presents these rationales for multiculturalism.

The Hawkin Report, the Economic Council, the Asia-Pacific Foundation and numerous business leaders have identified the need to enhance trade and diplomatic links through greater utilisation of the nation's *multicultural resources.*

The Economist (March 1986) identified the reluctance of the political and cultural establishment to grant full recognition to the 'cosmopolitan' nature of society as a *barrier to economic progress* and the emergency [*sic*] of *Canadian identity.*

Important initiatives such as those involving free trade, the Canadian identity, the Official Languages Act and international diplomacy will be strengthened with appropriate recognition and action in respect to Canadian pluralism.

(Multiculturalism and Citizenship Corporate
Policy Branch 1987: 2–3, emphasis mine)

Although this policy document replays many of the earlier themes discussed regarding multiculturalism, this more recent version stresses the links between cultural pluralism, Canadian identity, and new forms of economic competitiveness and prosperity (see also Lewycky 1992). Canada's 'multicultural heritage' is now a 'resource'. The cultural politics of pluralism, it is argued, make good business sense.

However, despite the expediency of cultural diversity for global capitalism,

the limits of diversity must, it appears, also be maintained. Through an Access to Information request, I obtained the *Legislative Briefing Book* given to the Members of Parliament trying to get the Act passed. The document describes the Act clause by clause, and each description is accompanied by potential questions that might be raised by members of the opposition. The book offers suggested replies. Throughout the questions and answers the phrase 'highly symbolic' is frequently repeated.

> Question: What does all this mean? Your policy is *highly symbolic*, lacking practical substance?
> Response: Yes the policy speaks to *symbolic and emotional issues*, as it should.
> (Multiculturalism and Citizenship Corporate Policy Branch 1988: 17, emphasis mine)

The repetition of 'symbolic' begins to appear as a means to reassure opponents that the Act has no political teeth, especially when it is described as non-adversarial.

> Question: If this Bill does not replace the Canadian Human Rights Act or other equality legislation, why have you included this sort of clause. [The clause reads 'ensure that all individuals receive equal treatment and protection under the law, while respecting and valuing their diversity'.]
> Response: This clause again has great *symbolic importance*. It signals our commitment to equal treatment and equal protection. This Bill's approach to *equity is not adversarial*.
> (Multiculturalism and Citizenship Corporate Policy Branch 1988: 21, emphasis mine)

Or non-coercive:

> Question: The Act refers to institutional change. What kind of change does this mean, and how will it be accomplished? How far are you prepared to go to change institutions?
> Response: The Canadian Multiculturalism Act commits the government to – Promote change among Canadians in general through a *non-coercive* approach that emphasises *co-operation, encouragement, awareness, and persuasion*.
> (Multiculturalism and Citizenship Corporate Policy Branch 1988, emphasis mine)

The New Multiculturalism Act, despite the shift to a concern with 'race relations', and the transformation of dominant society, is still primarily a form of

state intervention into the cultural politics of diversity. This intervention not only appropriates and institutionalises diversity for the project of nation-building in the manner of earlier multicultural policy, it now proposes that multiculturalism is a national resource in the context of global capitalism. It still limits multicultural diversity to symbolic rather than political forms, because in the political arena, members of ethnic groups are *individual* members of their groups or the larger society. The government, argues Angel, will not 'establish another power base that might upset the existing balance between French-speaking and English-speaking Canadians' (1988: 27).

The Canadian state, therefore, created the official policy of 'multiculturalism' to respond to a range of complex and potentially dangerous conflicts in the cultural politics of Canadian nationalism, including the threat of Québec separatism, demands for recognition by immigrants and other minorities, and the need for immigrants to fuel prosperity. It also intersected with the need, seen as a natural 'evolution' of nationhood, to construct a unified and distinct national identity to differentiate itself from the USA and Britain. As discussed in the Introduction, a central element of the project of nation-building is the perceived necessity of the creation of a differentiated and defined national culture. This desire, and its integration into projects of nation-building, can be traced to beliefs about personhood dating back to the Enlightenment, which are integral to modern Western conceptualisations of national identity and culture. In the Canadian context, the state did not seek to erase difference but rather attempted to institutionalise, constitute, shape, manage, and control difference. Although 'multiculturalism' could be seen as vastly different from the more overtly racist and assimilationist policies of earlier governments, the institutionalisation of difference and 'tolerance' drew on previously existing patterns which had emerged in colonial and earlier national projects. The key issue here is that despite the proliferation of cultural difference, the power to define, limit and tolerate differences still lies in the hands of the dominant group. Further, the degree and forms of *tolerable* differences are defined by the ever-changing needs of the project of nation-building. The process of flexible inclusion and exclusion that I have traced from the early days of nation-building, becomes even more institutionalised and complex in the 'narratives of nationhood' seen in the 1990s.

4

BECOMING INDIGENOUS

Cultural difference, land and narratives of
nationhood

'Oh Canada, our home and native land'

Canadian national anthem

State, business, and elite interventions in the symbolic representation of Canada
have been seen as necessary for the survival of the nation–state and the building
of national identity. Attempts to define and construct Canadian identity have
changed in tandem with the project of managing the diverse populations of the
country. This chapter explores the cultural politics of the authoritative 'narra-
tives of nationhood' that were officially sanctioned by government institutions
in 1992. These stories of the nation, designed to promote national identity, I
shall call pluralist 'pedagogies of patriotism'. They highlight Canada's pluralism
within a linear narrative of Canada's past, present and future, and they do so
with the goal of building national identity. Whitelaw argues that 'the seeking
out of identity – whether it is defined as singular or plural – continues to under-
score the majority of conceptions of Canadian culture in the public sphere
(1997: 22).

In the late twentieth century national identities are formed through mass
media, spectacles of nationhood, and social institutions. These sites of identity
production – national art and literature, national museums and art galleries,
television and radio programmes, advertising, nationalist festivals and education
programmes – create what Stuart Hall (1992b) calls 'narratives of nationhood'.
These narratives work through a body of stories and myths with which people
identify and which

> stand for, or *represent* the shared experiences, sorrows, and triumphs
> and disasters which give meaning to the nation. As members of such an
> 'imagined community', we see ourselves in our mind's eye, sharing in
> this narrative. It lends significance and importance to our humdrum
> existence, connecting our everyday lives with a national destiny that
> preexisted us and will outlive us.
>
> (Hall 1992b: 293)

From images of England's green and rolling hills, to representations of Australia's outback, to romantic views of the vast expanses of 'The West' in America, these narratives often mobilise images of land – be it homeland, motherland or fatherland – to do the work of constructing a sense of 'oneness' from diverse populations which may never meet face-to-face. The land itself becomes a 'repository of historic memories and associations' (Smith 1991: 9). Thus representations of the land, and the relation between the nation's population and the land, help to define the past, present, future and characteristics of the nation itself.

As I have discussed in earlier chapters, since the formation of the Dominion of Canada in 1867, images of nature, the wilderness, and the north have defined Canadian national identity, often in racialised terms as white settler identity. In 1990s' Canada such images which combine nature and nation remain ubiquitous, although now they are coupled with images of cultural pluralism which do not simply include but highlight Canada's Aboriginal peoples and multiculturalism. Such nature-based pluralist imagery appeared everywhere in 1992: in the imagery of Canada 125, in the constitutional debates, in forms of public culture, and in interviews and discussions. Here I look at such land and nature-based[1] narratives of nationhood in a number of sites, including the design of the Canadian Museum of Civilisation, the story of a nationalist play performed as part of the 125th anniversary celebrations, and an exhibit at the National Gallery co-curated by Aboriginal people.

The relationship between identity and space has recently become an important focus of social inquiry, especially in work that explores cultural aspects of globalisation and 'post-coloniality' (Appadurai 1991, 1993; Bhabha 1994; Clifford 1988, 1992; Gilroy 1987; Gupta 1992a, 1992b; Hall 1991a, 1991b, 1992b, 1992c, 1993; Massey 1994; Wilson and Dissanayake 1996). Discussing the 'apparent deterritorialisation' of identities in the postmodern transnational world, Akhil Gupta (1992a: 9) argues that James Clifford's question is an important one for anthropological inquiry: 'What does it mean at the end of the twentieth century to speak...of a Native land? What processes rather than essences are involved in present experiences of cultural identity?' (1988: 275). As a result of globalisation, many argue, there has been a profound shift in how people conceptualise the local and how they negotiate the link between identities and specific topographical spaces. Some theorists celebrate the radical potential of the mobility, marginality and 'cultural hybridity' they see emerging with globalisation (Bhabha 1994; Gilroy 1987; S. Hall 1991b: 36–9, 1992b: 310).

The reason these critics celebrate transnationalism is that they believe it allows for formulations of identity which disrupt the oppressive features of modernity. Modern identities such as national identity, many argue, function through the erasure of difference and the construction of a singular, unified, homogeneous subject.[2] It is argued that whereas modern identities are based on binary oppositions of self and other and the notion of fixed homogeneous

cultures, some of the identities emerging with transnationalism – defined as fractured, fragmented, mobile, diasporic and hybrid – create a space in which identity can be enunciated outside of, or rather *in between,* modern forms of identity such as national identity. According to Bhabha, this 'Third Space' is one which 'makes it possible to begin envisaging national, anti-nationalist histories of the "people"' (1994: 38–9). These cultural forms are thus seen as essentially radical, because they disrupt the homogeneity of modern identities and allow for the enunciation rather than the erasure of difference.

However, before celebrating the radical potential of the enunciation and proliferation of difference, and to assess claims about the radical nature of cultural hybridity, it is important to account for the ways in which some nation–states such as Canada have taken up issues of pluralism and inclusion in official forms of national public culture such as those I describe in this chapter. A number of controversies about race in Canadian public culture[3] over the last decade have resulted in some of the designers of official national public culture beginning to use imagery of or by historically marginalised groups – especially Aboriginal people and ethnic minorities – in their representations of official 'multicultural' national culture. Do 'multicultural' representations of nationhood emerging at the end of the twentieth century represent a radical break from previous more exclusionary versions of nationhood, or do they re-shape and reinforce older identity discourses? This chapter argues that despite the proliferation of difference in these narratives, the key features of the story of settler nationhood persists, a story which can only recognise limited and unthreatening forms of difference. Even the construction of Native people as active agents of history does not result in the genuine recognition of difference; rather it reinforces and 'legitimates settler meanings' (Marcus 1997) and settler nationalist narratives. This chapter seeks to document how this trick is performed. How do these narratives highlight cultural differences and yet transform and limit them at the same time? What does the inclusion of others do for nationalist mythology? Thus, this chapter explores how cultural difference is highlighted, and at the same time managed, limited, subsumed, and reconfigured within a broader project of national progress.

Narrating the nation: official pedagogies of patriotism

Designed as a sculpture to evoke the 'eroded land forms and stream beds of post-glacial Canada', the Canadian Museum of Civilisation perches on the edge of the Ottawa River. The structure's features are 'drawn directly from the landscape and the forces of nature which shaped the landscape' (MacDonald and Alsford 1989: 1). Much has been made of the fact that Douglas Cardinal, the architect of the museum, is a Native Canadian. The design, which highlights natural and Native imagery, resulted specifically from the 'ritual inspiration', and 'ancestral help' that he found during a sweat lodge ceremony (Boddy 1989; MacDonald and Alsford 1989).

The museum is intended to play a pedagogical role in the creation of national identity, and according to its director, George MacDonald, is part of a 'cultural master-plan' to create a 'cultural pilgrimage centre' in Ottawa, the nation's capital (MacDonald and Alsford 1989: 3). He conceives of the museum as a space of symbolic ritual and pilgrimage – with the task of constructing and disseminating national culture.

> A national museum...helps define cultural identity and the country itself. It stimulates pride amongst Canadians in their own culture. It announces to the world that Canada is a nation with special and unique characteristics. It reflects the ways in which various peoples, bringing their own cultures, have met the challenge of the land, by shaping it and shaping themselves to it.
>
> CMC offers to Canadians and non-Canadians an initiation into the national identity...As a temple of culture CMC is very much a ritual space.
>
> (MacDonald and Alsford 1989: 3)

As a 'ritual space', a 'treasure-house', or a stop on a pilgrimage to discover national identity, the message and symbolism of the Canadian Museum of Civilisation (CMC) are an overt attempt to create a national narrative in which the land and Native people have a central role.

The play, *Spirit of a Nation*, organised by the Canadian Heritage Arts Society and funded by the federal government as part of Canada's 125th anniversary celebrations in 1992, also combines the themes of nature and pluralism to fulfil its pedagogical goal. Some 125 students of diverse cultural backgrounds in 125 performances performed the play over the summer of 1992, as well as at televised Canada Day celebrations. It was explicitly designed as a pedagogical endeavour, and sold to the federal government with the promise to contribute to the task of educating and instilling 'pride of nation-hood' in communities all over the country (Canadian Heritage Arts Society 1992b: 3).[4] Its narrative, similar to that of the Canadian Museum of Civilisation, combines a celebration of cultural diversity, a glorification of Canadian achievement and shaping of the environment, and a message of harmony with the land. A promotional brochure put out to advertise *Spirit of a Nation* centres on the faces of a group of young people of all races, smiling and floating above the Canadian landscape, and surrounded by radiant light. Behind them is a backdrop of Aboriginal masks (Canadian Heritage Arts Society 1992a).

The land as unifier of diversity

The director of the Canadian Museum of Civilisation argues that the national museum 'reflects the ways in which various peoples, bringing their own

cultures, have met the challenge of the land, by shaping it and shaping themselves to it' (MacDonald and Alsford 1989: 3).[5] A key theme, therefore, in the Canadian Museum of Civilisation is the idea of a national population being moulded by 'the challenge' of the land. Douglas Cardinal, the architect of the museum, describes his vision of the museum in a design statement made public shortly after he was chosen as architect.

His proposal takes the form of a narrative, beginning with the emergence of the land from the sea and the creation of 'a culture...entwined with the forces of nature'. Here he is obviously referring to Canada's Aboriginal peoples. Later, people arrive 'from across the oceans...from diverse cultures all over the world, drawn to the beauty and *bounty of this land*'. Although at first, he says they only 'visited and *took from the land* to reinforce their empires', they later stayed and '*gave to the land* their sweat and hardships' (1989: 17, emphasis mine). The story continues with the development and building of the nation, described as if it were a gift to the land. Today, he argues:

> Canadians, with their roots in several different cultures, now are evolving a new culture. Their cultures are merging and a greater understanding and appreciation are becoming part of Canada's national character. Our challenge should be to express the goals and aspirations of our society in our structure so that they will be physical manifestations of the best of our multicultural society.
>
> (Cardinal 1989: 17)

Cardinal's story of the harmonious evolution of Canada from a state of pure nature to multicultural nation, ends with the suggestion that modern technology will now allow Canadians to move from being 'land creatures' to 'star creatures'. The only limit is imagination (ibid.: 17).

In Cardinal's narrative, the land plays a central role in unifying various cultures and peoples, from the First Canadians, to early settlers and later immigrants. In the narrative, cultural diversity is not erased but exceedingly prominent. The image of the land is central here, because it is through meeting 'the challenge of the land' and 'by shaping it and shaping themselves to it' (MacDonald and Alsford 1989) that Aboriginal people, British and French colonisers, and newer immigrants, all *become* Canadian and progress together into the future.

The *Spirit of a Nation* performance tells a similar story. While the stage is filled with the sounds of Aboriginal drumming, rushing wind and water, the narrator tells the audience that 'The people of every nation are nourished by the land. Their spirit and their strength have their roots in the land, and the air, and the sea.' Several female dancers enter the stage and, dressed in natural earth-coloured costumes, express the harmony between humans and nature. Then two actors, coded as Aboriginal by their attire of buckskin and feathers, tell stories about their harmony with and love of the land. Soon the Aboriginal

storytellers appear to know instinctively that their time of living in peace with the land is over, and they disappear while actors dressed as early settlers slowly enter the stage. Sounds of building, work, and progress increase as the stage is transformed into an urban scene, filled with busy lawyers, doctors, pilots, nurses and builders – all the signs of modern life. They sing 'We have built a nation', a song celebrating the industry and energy of Canadian nation-building.

As in Cardinal's museum narrative, the next stage of development is multi-culturalism, and the land is brought into the story again as immigrants and refugees are invited into the land which 'is a garden' if they promise to 'give to the land'. *Spirit of a Nation* differs from Cardinal's harmonious narrative in that the arrival of different cultures creates conflict that results in environmental degradation. However, the conflict is solved, as I discuss in more detail below, by all the diverse peoples of Canada agreeing to give to the land – to take care of the natural beauty bestowed upon them. The Aboriginal people, who had earlier disappeared from the development of the nation, re-appear to help create harmony with the land. The narrative ends with the entire cast, dressed in similar modern suits of differing colours, energetically singing 'The Future Begins with You'.

Again, similar to Cardinal's museum narrative, the land here is also the key to unifying different cultures, and creating a story of nationhood that links past, present and future. Further, these official narratives of nationhood could not be faulted for their erasure of Aboriginal people in history. They are not stories of the conquered land as *terra nullius* (empty, vacant land). On the contrary, Aboriginal peoples' link to the topographic space of Canada is absolutely necessary for the narrative lines. Yet the very highlighting of Aboriginal people and cultural diversity in these narratives contributes to their complex cultural politics.

The Mountie's new clothes: reshaping earlier myths

With the prominence of environmental themes and the highlighting of Aboriginal people and multiculturalism, these narratives are nationalist discourses of the 1990s. They do not erase or exclude Native peoples; in fact, Native peoples are exceedingly prominent in them. Aboriginal imagery is everywhere, and the architect of the museum is a Native person. However, they draw on earlier versions of nationalist mythology. As I have discussed in earlier chapters, Canadian nationalist narratives have a long history of including Aboriginal people and highlighting Canada's tolerance of cultural diversity. For example in Anglo-Canadian historical writing leading up to and immediately after Confederation, patriotic versions of history painted a portrait of the colonisers of Canada as more generous than the colonisers of the USA. A similar view of Canada is reflected in the 'benevolent Mountie myth', which is based on the idea that the process of civilising the frontier occurred in a gentler, less violent, manner in Canada than the USA, because of British

systems of justice, and, in particular, the benevolent and tolerant behaviour of the Mounties. The inclusion of Aboriginal peoples in the Canadian Museum of Civilisation and *Spirit of a Nation* is a 1990s' reshaping of the older 'Mountie myth' because it reaffirms the notion that Canada has a long history of benevolent forms of justice and tolerance.

In both 1990s' narratives of nationhood, as presented in the Canadian Museum of Civilisation and the *Spirit of a Nation* performance, Aboriginal peoples become equated with the land and with nature. In the museum narrative they are described as 'a culture...entwined with the forces of nature', and in *Spirit of a Nation* they dance and tell stories of their harmony with the land. They represent harmony between humans and nature, and the untouched and virgin natural land that comes to represent Canada's beginnings.

Such constructions of Aboriginal peoples are not new in Canada. As discussed in detail in Chapter 2, earlier narratives of nationalism often had Native people representing Canada's heritage and past, and they even appear carved into the walls of the Parliament Buildings in Ottawa, Canada's capital. In the process they are idealised as nature itself, a characteristic of a colonising and orientalist aesthetic (Bordo 1992; S. Hall 1992b; Little 1991; Rosaldo 1989). The representation of Aboriginal people in the museum, like their representation on the walls of the Parliament buildings and in earlier nationalist narratives, provides a link between the settlers and the land. Their presence constructs a historical connection to the land that helps make Canada a 'Native land' to settlers and immigrants.

The Canadian Museum of Civilisation is a hierarchically organised space designed to draw people and control movements in specific ways (MacDonald and Alsford 1989: 24–7), and it locates Aboriginal peoples as Canada's heritage and past through its spatial organisation. The Grand Hall is designed to be one of the first spaces a visitor enters. A breathtaking space of huge proportions filled with totem poles and artefacts of Canada's West Coast peoples, it curves around the central courtyard of the museum with views across the river to the Parliament Buildings. The director of the museum argues that the Grand Hall is made central to the design of the museum in order 'to emphasise the contribution of Native peoples to the heritage of the nation and the world' (ibid.: 25, 78–83).

Heritage is often defined as '*property* that is or can be inherited'; as something 'handed down from one's ancestor or the past'; or as 'a characteristic, a culture, tradition' (*Webster's New World Dictionary* 1988: 631). If Aboriginal culture within the museum, emphasises the 'contribution of Native peoples to the *heritage* of the nation and the world', it is thereby transformed into a form of *cultural property* that the Canadian nation has inherited. Through the cultural property in the national museum, the world also has access to this heritage, and the museum can take a place of global significance, as a 'world class' heritage site.

To claim Aboriginal culture and people as Canada's heritage provides a

longer continuum and tradition of culture for the nationalist cause. Native people and their culture and artefacts have the unique quality of being entirely Canadian in their origin and character. Only Aboriginal people, not the later settlers, are perceived to be actually linked to the land and, as we have seen, the land is a primary symbol of the nation. Yet this construction of Native peoples as heritage also means they are caught in the past. When I visited the museum in 1992, four tepees occupied its centre courtyard, facing the Parliament Buildings, and placed as if embraced by the landscape form of the museum. (see Figure 4.1). The tepees send the signal that Canada recognises its Aboriginal peoples: a contemporary version, we might say, of the Mountie myth. But although Native people are highlighted as Canada's heritage, they are at the same time frozen in the glorious past of tepees and headdresses. Most Aboriginal people in Canada do not live in tepees: as citizens of the twentieth century with a long history of colonisation, many live in poverty in small, unromantic homes on reserves, or in apartments and houses in urban centres. Would homes such as these, if placed in the middle of the Canadian Museum of Civilisation's courtyard, have the same effect?

Figure 4.1 The Canadian Museum of Civilisation with tepees in the courtyard and the Federal Parliament Buildings in the distance.

Source: Courtesy of the Canadian Museum of Civilisation (ref. no. 98-06).

Environmentalism and progress

Central to theories of evolution and race emerging in the late eighteenth and early nineteenth centuries was the idea of progress; societies progress through stages to reach the ultimate pinnacle of evolution – European 'civilisation' – a concept that emerged with its new meaning in the eighteenth century. The narratives of nationalism in the Canadian Museum of Civilisation and in *Spirit of a Nation* are *linear* narratives which pivot on the idea of Canada's progress from a wild and virginal land to a developed, forward-looking, tolerant nation that cares for its environment. In these linear narratives Aboriginal peoples represent nature and the past: they are located in the place of *origin*. Progress, in Western thought, has often been seen as matter of subduing, mastering, and transforming nature – of making wilderness into civilisation (Merchant 1994: 2; 1995). The binary opposition in Western thinking between natural and human life worlds, and the idea that progress entails mastering nature, have been seen to bear some responsibility for the destruction of nature in modern society as well as the destruction of Aboriginal peoples.

The narratives of nationhood discussed here present the Western narrative of progress as if it is natural and inevitable. The designer of the museum, Cardinal, says that the museum should be a celebration of 'man's evolution and achievement' (cited in MacDonald and Alsford 1989: 15–16), and that it should send people away 'optimistic that we are progressing as human individuals and as a nation' (Cardinal 1989: 17). He describes the museum as 'a symbolic form' that will 'show the way in which man first learned to *cope* with the *environment*, then *mastered it* and *shaped it* to the needs of *his own goals* and aspirations' (in MacDonald and Alsford 1989: 15–16, emphasis mine). Here human progress becomes a matter of 'mastering' and 'shaping' nature, a typically Western version of progress. Yet it also has a Canadian nationalist twist, because it begins with Native peoples in harmony with the land and ends with Canadians of all cultures in harmony with the land. This is a story of *tolerant, inclusive, multi-cultural* progress that functions by appropriating Aboriginal people, cultural pluralism, and environmentalism into its plot. This nationalist version of progress only works because it is able to construct Native people as guardians of the land and as helpmates in the project of progressive nation-building.

Helpmates in progress, guardians of the land

A key issue in how Aboriginal people are transformed into guardians of the land and helpmates for national progress is the way in which the museum narrative and the play present the moment of contact between Aboriginal people and colonisers. In Cardinal's museum narrative Native people are first presented as guardians of the land, living in perfect harmony. When the story moves on to the meeting between 'old- and new-world' peoples, he writes that first the colonisers 'visited and *took from the land* to reinforce their empires'. Later,

however, they 'stayed and *gave to the land* their sweat and hardships' (Cardinal 1989, my emphasis)'. This shift constructs the colonisers as people who *share* in the Aboriginal peoples' defined task of 'giving to the land' and living in harmony with it. In doing so it erases the myriad of negative effects colonialism had and has on Native peoples and cultures (and the environment). More importantly, European settlers, history tells us, did not have the well-being of the land and harmony with nature as their goal. However, presenting the story in this way allows the profound differences and deeply asymmetrical relations between Aboriginal and Settler cultures to be transformed. Hence, a mythical narrative of natural, peaceful and tolerant progress is told. 'Giving to the land' is integral to a process of reconciliation between Native people and colonisers – a process of reconciliation in which Aboriginal people forgive the settlers (Marcus 1996), and in which they are still located as an 'absented presence' in the national imaginary, to use Jimmy Durham's phrase (cited in Walcott 1996: 20). This story transforms history, eliding any worries white Canadians might have about the negative effects of colonisation. Its result is a sense of national settler innocence. Native people and the land – and the link between them – play a central role in negotiating the rocky terrain of developing, within a settler nation, a narrative of progress that links colonisers to the specific topographical space, at the same time producing settler innocence regarding the colonial encounter.

In these narratives the process of 'giving to the land' through colonial progress is presented as if it were similar to the pre-colonial relationship between Aboriginal people and the land, and on a continuum with what Native people wanted. It is presented as if settlers and Aboriginal people were really, after all, involved in the same sort of transformative, yet ecologically sound endeavour. This version of history has interesting results for the construction of the relationship between the land and forms of cultural identity. If the settler project of transforming nature into civilisation is framed as 'giving to the land', it re-casts settlers as actually quite similar to Aboriginal peoples. They, too, can see themselves as living in harmony with the land. On the other hand, in this story, Native people become more like settlers. They appear to believe in and work for the shared progressive project of 'caring for the land' through nation-building. In this process Native peoples are transformed into helpmates of the settler project of progress. Finally, in both of these narratives, the land appears to be populated by Canadians of all races and cultures who are desperately 'giving' to it. If the land can be 'given to', it is seen to have a certain amount of agency, even desire. Hence, the conflict-ridden and often devastating realities of colonisation and urbanisation are presented as if the land itself naturally desired to be 'given to' in this particular way. It is presented as if nature wanted its inevitable and glorious transformation into progressive civilisation. Nature therefore plays a central role in constructing a unified story of progressive nationhood that erases conflict.

Nature plays a similar role in the one segment of the *Spirit of a Nation* play

in which conflict breaks out. It begins with a group of war-torn and tired refugees – from 'distant lands where barely a dream of a better life dares to survive' – entering the stage while sounds of war fill the background. A woman refugee from Asia leads them across the stage, singing of her dreams for a brighter future. The tall white male narrator of the play invites them into Canada, the land which 'is a garden', if they promise to 'give to the land'. He invites them to join a celebration of Canada, and the scene is miraculously changed to a joyous multicultural festival in which people from ethnic groups dance and sing in traditional colourful clothes. Yet conflict soon erupts. Near the end of this celebration, two rap singers enter, dressed in black and white street clothes coded as modern and urban. Their song laments the conflict that erupts between people even though the land gives them so much. As the song turns to a searing critique of environmental degradation and all kinds of 'isms', the harmonious pluralism of the multicultural festival begins to dissolve. Everyone on stage begins to fight and argue – until the very set is destroyed.

The Asian refugee woman, who led the refugees in the previous scene, is left forlorn on the stage full of smoke and silence. She pleads that her dream of a better life not be destroyed by the divisions and anger she sees around her. She raises her head and sings of her dream of a safe place, a safe land. Finally the white male Canadian narrator and the two First Nations storytellers join her, and in an example of multi-racial unity, all sing in unison of their shared love of the land.

> There is a land, I believe
> Where one can dream, and see their dreams come true,
> And to this land, I want to give
> I want to be in Canada

Suddenly the stage is transformed as the entire cast – dozens of young Canadians of many races and cultures dressed in similar modern suits of differing colours – energetically enters the stage dancing and singing 'The Future Begins with You'. The hopeful lyrics suggest that if people work side by side they can make their dreams come true.

> We come from many distant countries
> We bring a promise to this land
> That we will honour and protect her
> All her people working hand in hand

The themes of cultural pluralism and respect for the land are still present, although the 'ethnic' costumes and Aboriginal imagery are gone.

This is a story in which the chaos of diversity is resolved, ordered, and unified, through the shared project of caring for the land. The white narrator, the refugee (who shares the Canadian dream of progress), the Aboriginal people (who want to care for the land), unite to save the dream of the nation

through their love of the land. In this ordered nation, all the people are dressed in similar modern outfits, but marked by their different colours. The colour (signifying cultures) may be different, but the goal of working together for the future of the nation makes them unified, and creates order from chaos. Paradoxically, *giving to the land* signifies this environmentally sound and now naturalised process of progress.

The *Spirit of a Nation* segment also limits and defines acceptable forms of difference to those based on different *origins* – differences which may be expressed *within* a unified project. Significantly, the only conflict that does erupt in *Spirit of a Nation* is when the cast is dressed in their 'ethnic' costumes. At first, when they are dancing traditional dances and enjoying each other's 'origins' or 'roots', it is a vision of pluralist exuberance. The note of conflict begins when distinctly modern and urban rappers enter the scene. It is when cultural diversity is not based on 'roots' or 'origins' – assuming the past tense – but in modern life, and in politics (for example, the rap song with all the 'isms') that devastation breaks loose, to the extent that the set is demolished. In this moment, uncontrollable and unmanageable forms of diversity and difference (differences not based on origins but on contemporary politics) threaten the unity and progress of the nation–state. Finally, order is regained through different cultures working together for *the future of the nation*. In this ordered nation, different (but depoliticised) origins are accommodated within the framework of the shared project of nation-building. In a similar way, the Director of the Canadian Museum of Civilisation argues that:

> Unlike the United States' Smithsonian Institution, which tends to focus on the eastern seaboard, as the cradle of the nation, and the myth of the melting pot, CMC has necessarily taken a different position on ethnicity. Canada has never been a true melting pot of culture. CMC *celebrates* the *diverse ethnic origins* of the Canadian people *within the context of a national identity.*
>
> (MacDonald and Alsford 1989: 4–5, emphasis mine)

For MacDonald and Alsford it is the celebration of diverse origins that creates a national identity, which, in turn, makes Canada unique, because a necessary feature of a national culture is that it should be different from all others. Canada's particular form of multicultural pluralism has, historically and in the present, been mobilised to differentiate Canada from the USA. However, the fact that he speaks of origins – yet *within the context of Canadian identity* – limits and defines the kind of cultural diversity that is permissible and celebrated within this model.

This is the nation reshaped for the 1990s, not in the old model of a culturally homogeneous collective, but as collective hybridity engaged in a shared and progress-oriented project. All the individual ethnic identities which, if left to their own devices, are unstable, ambiguous and 'in-between' (in fact so unstable

that they create chaos and destruction), are presented as if they need the project of nation-building (defined as caring for the land) to give them an anchor and a goal, a goal that in turn creates the heterogeneous (hybrid) yet unified nation.[6] This is not liberatory hybridity mobilised to create 'anti-nationalist histories of the people' of the kind Bhabha (1994: 38–9) envisages. Rather, it constructs the *nation itself* as a 'Third Space' of hybridity, a hybrid space which nevertheless reshapes central and well-worn nationalist ideologies in which Aboriginal people are representatives of nature and helpmates to the settlers. Further, in this space, the modern project of progress is still the key to nation-building.

Hybridity and Aboriginal self-representation

The narratives of nationhood discussed above all construct Aboriginal people as guardians of the land, as allies in progress, and as representatives of Canada's heritage. However, in 1992, in part because of the contests over the 500th anniversary of Columbus's arrival in the Americas (discussed in Chapter 1), newer and more critical forms of representing Native peoples had legitimate cultural and political space.[7] The most significant difference between the two was that Native peoples themselves produced these representations. The National Gallery of Canada in Ottawa, which has the mandate of producing and fostering Canada's artistic heritage (Whitelaw 1997: 22), presented *Land, Spirit, Power: First Nations at the National Gallery of Canada*, an exhibition of art by contemporary Aboriginal artists and co-curated by Native curators. I discuss this exhibit in order to examine how officially sanctioned self-representation by Aboriginal people operated in the Canadian imagination. The following argument is not an examination of Native culture, but an exploration of national cultural imaginings about the relationship between whites and Aboriginal people.

In the *Land, Spirit, Power* catalogue, co-curator Diane Nemiroff suggests that the exhibition is an example of the 'new discourses in First Nations art' that emerged in the 1980s, spurred by Aboriginal activism, on the one hand, and the move from modernism to postmodernism, on the other. Nemiroff argues that the new emphasis on identity and difference 'weakened the ethnocentrism of the art establishment' (1992: 36). As a result, in the 1990s, Native people themselves more often controlled exhibits, a situation which she argues resulted in a less totalising and generalising approach to Aboriginal artwork (Nemiroff 1992). But did this approach really change the terms of debate? Metis filmmaker Loretta Todd argues that 'by reducing our cultural expression to simply the question of modernism or postmodernism, art or anthropology', Aboriginal people are 'placed on the edges of the dominant culture, while the dominant culture decides whether *we are allowed* to enter its realm of art' (1992: 75).

Most important to Nemiroff's argument about the changing nature of representation, is the question of Native self-representation and self-definition.

She suggests that the presence of articulate individuals posing and responding to the question 'who shall speak for me?' is:

> an essential step in addressing what Cornel West, writing of African American cultural identity, has termed the 'problematic of invisibility and namelessness', and what has for native peoples, until recently, been their *mythic presence but real absence* in contemporary consciousness. Now...a discourse is emerging in which First Nations individuals are telling it their way.
>
> (Nemiroff 1992: 37, emphasis mine)

But does 'telling it their way' and asking 'who shall speak for me?' challenge deeply felt assumptions and paradigms? In considering just this point, Gayetry Chakravorty Spivak said:

> For me, the question 'Who should speak?' is less crucial than 'Who will listen?' 'I will speak for myself as a Third World person' is an important position for political mobilisation today. But the real demand is that when I speak from that position I should be listened to seriously; not with that benevolent kind of imperialism, really, which simply says that because I happen to be an Indian or whatever...A hundred years ago it was impossible for me to speak, for the precise reason that makes it only too possible for me to speak in certain circles now.
>
> (1990: 59–60)[8]

These are crucial questions. What role does 'speaking' or 'telling it their way', play in this exhibition? If one is to reach an understanding of how identities work in Canada today, one must explore what role Aboriginal self-representation plays, not for the artists,[9] but rather for the consumers and audiences of the exhibition, and in the Canadian nationalist imagination more generally. Who is listening? And how? Is this exhibit an example, as Nemiroff proposes, of a new and better discourse about Native peoples?

Certainly this exhibit was an improvement on discourses about Aboriginal people and Aboriginal art. It did not locate Aboriginal people in the space of 'origins', as many of the representations I have discussed in the book so far do, thereby reinforcing the view of Native people as stuck in a primordial past. Neither did the exhibit promote the 'salvage' paradigm (Minh-ha 1987) of collecting Aboriginal artefacts to use for nationalism, nor white Canadian artists mining Aboriginal art forms. *Land, Spirit, Power* highlighted the artwork of vibrant, dynamic, critical Aboriginal artists in 1992 – 500 years after Columbus' so-called 'discovery' of the 'New World'. The exhibition can be seen as a celebration of Aboriginal survival and resistance to 500 years of colonialism.

Nemiroff suggests that in *Land, Spirit, Power* the artists present their identities as fixed, bounded, and historical, but also as fluid, constructed, dynamic and political. Their identities are embedded in the land and Aboriginality, but also resolutely conjunctural, postmodern, ambiguous, and paradoxical (1992: 37–41). One might say these are indeed 'hybrid' identities. Spivak argues that if a minority person 'speaks as' a representative of a particular group they end up being a token of what is perceived as a homogeneous group (Spivak 1990: 59–60). In this exhibit, however, Aboriginal artists are not presented as a homogeneous group with a fixed identity – they are presented as artists with hybrid, complex and fluid identities. If we were to follow Bhabha's reasoning it would seem that speaking from a position of hybridity – of *non*-homogeneity and cultural *un*boundedness – should challenge the problems of 'speaking as' and being listened to.

However, a closer examination of the reception and presentation of the exhibit suggests that even the discourse of ambiguous, conjunctural and hybrid Native identities can be appropriated and transformed by their location within dominant nationalist imaginings. Hybrid identities can re-affirm *national* history and identity, as well as re-affirm stereotypes. This can be seen in a discussion of *Land, Spirit, Power* by Shirley Thomson (the director of the National Gallery of Canada), in the foreword of the catalogue:

> The organisation and presentation of *Land, Spirit, Power* at the National Gallery of Canada as Canada celebrates its 125th birthday is a particularly welcome occasion. As the first major international exhibition of contemporary art by artists of native ancestry to be held at the National Gallery, it serves to *recognise the contributions* of a remarkable group of artists and marks an important step towards the *openness of spirit* that we hope will characterise the next 125 years.
> (in Nemiroff *et al.* 1992: 7)

Despite Nemiroff's claim that this exhibit represents a 'new stage' in discourses about Native people, Thomson's discourse sounds surprisingly like older patterns in representations of Native peoples; once again their cultures are mobilised to re-affirm *national* identity. Similar to the discourse of 'official multiculturalism', a discourse in which minority groups are valued for their *contributions* to the Canadian nation, Thomson recognises Aboriginal people in this exhibit for their 'contribution' either to art or to the nation. The existence and value of the nation as the primary site of importance are not questioned. She does not ask what Canadian national culture has contributed to Native communities because the value of nation and its progress is normative. Further, she mentions 'openness of spirit', implicitly referring to Canadian tolerance, a nationalist mythology with a long history.

Thomson continues her discussion by affirming the link between Aboriginal people and the land:

> In particular, as *nations search* for *new and compelling visions* to *hold them together*, and the earth is endangered by our carelessness towards the environment, *Land, Spirit, Power* may remind us in a very contemporary way of one of the oldest sources of *unity and sustenance – the land* in all its aspects.
>
> (in Nemiroff *et al.* 1992: 7)

In Thomson's discussion, Native people (hybrid or not) are once again appropriated into national identity to do the work of providing a natural link to the land – a link which gives Canada a 'new and compelling vision', providing 'unity and sustenance' for the Canadian *nation*. Once again Aboriginal people have been invited into Canadian identity to legitimate settler ownership and occupation of the land.

While perhaps not what the artists and curators of the shows had hoped for, Thomson's discussion is an example of the kind of 'listening' that occurred with *Land, Spirit, Power*. The exhibit was appropriated into nationalist imaginings in apparently contradictory ways, yet in ways that follow a nationalist logic. This logic, while on one hand embedded in past patterns of identity construction, also emerges as a new and improvisational response to an ambiguous situation. It is an example of the constitution, recognition, and institutionalisation of a new kind of difference – and in recognising this difference, the nation is recreated as unified, progressive and tolerant.

Since Aboriginal people didn't die out (as it was assumed they would at the end of the nineteenth century), and since they have gained political visibility and strength, these exhibits appropriate images of Native peoples in a manner which reflects this changed situation, and thus constitutes a re-writing of the old Mountie myth in a new and refurbished form for the 1990s. By the Mountie myth I mean the idea that Canadian justice – the Canadian way of dealing with difference and conflict – is more peaceful and friendly than that of the USA. The idea that the Royal Canadian Mounted Police entered the conflicted terrain of the West and, in a very short time, settled all conflicts – almost by magic – is being re-enacted here through the notion of Aboriginal self-representation. For Nemiroff, Native people have, '*until recently*' had to struggle with their '*mythic presence* but *real absence* in contemporary consciousness' (1992: 37). She presents the contemporary situation of Native peoples as if *self*-representation has solved all problems of representation for Native peoples. But does the self-representation of Aboriginal peoples in *Land, Spirit, Power* fundamentally challenge older versions of the construction and institutionalisation of difference? Further, how does self-representation function if it encounters powerful counter-discourses of unifying nationalism that draw on earlier representations of Aboriginal–white relations?

Some of these difficulties are exemplified in reviews of *Land, Spirit, Power*. Lisa Balfour Bowen begins her review suggesting that the exhibit is timely because it takes place in the year of the 500th anniversary of America's

discovery by Columbus (no quotation marks on 'discovery'? no irony intended?). Further, it 'represents a high-profile moment in the constitutional evolution of our country's aboriginal people'. She describes the artwork glowingly, mentions Columbus' 'discovery' a few times (still without irony intended), and writes admiringly of Native peoples' links to the land. As she moves towards the end of the article, she quotes James Luna, a US Native artist who says that '[w]e are held back by the Native art in the US, most of which is cliched and commercial'. He adds that, '*in comparison to Canadian Natives who are very visible*', US Natives are still at the bottom of the social and political heap. 'Certainly,' he argues, 'there hasn't been anything like this show – anything of this scope – in the US, so it *helps confirm the view that your Natives are much further ahead*' (Balfour Bowen, *The Sunday Sun*, 18 October 1992, emphasis mine). The assumption is that visibility and self-representation in themselves answer the problems of power and history. The article implies that the oppression is over – 'we' let 'them' into the Parliament and into the National Gallery – 'we' are good to 'our Natives' – and most importantly we treat them *better than* they do in the United States

Aboriginal peoples' essential link to the land, *and* their 'hybrid' and politicised presence, are here transformed into the mythical tale of Canadian tolerance. Suddenly, by letting Aboriginal people into 'our' institutions, as living and vibrant people – not simply uni-dimensional stereotypes but whole, conflicted, 'hybrid' human beings – Canadians may think that it is time to celebrate the end of the past and the beginning of the future. Canadian nationalism can appropriate Aboriginal people's hybridity and self-representation into its own redemption of its sins; in this redemption, crimes against Native people become conveniently located in the *past*. However, it is too soon to suggest that the past is over and the myth making done. This celebration of Canadian tolerance, and how far *Canada has come* by celebrating how far the nation has let *'them' come*, erases the difficult question of how far the nation still needs to go in order to have genuine justice and equality for Aboriginal people.

The logic suggests that even if Canadians were horrible in the past, the nation is now making up for it. Canadians can see themselves as good and honest and rational, not like those horrible people to the South. Aboriginal peoples' self-representation can produce a conception of a 'white Canadian' that perceives itself innocent of racism. Hybridity, radical critique of dominant culture, and Native self-representation can also be appropriated into a dominant discourse, even if only temporarily.

Official narratives of nationhood, despite the way they include and highlight cultural difference, also reproduce and bolster particular forms of white settler national identity. The Canadian Museum of Civilisation narrative and the *Spirit of a Nation* performance also depend upon key Western concepts such as progress, thereby reinforcing the Western views of nature and human natural relations that justified the destruction of Aboriginal people. Further, Aboriginal people are subtly constructed as if they invited settlement and as if they still

condone the inevitable and glorious progressive development of nationhood – as if they share in this project. Potentially threatening differences are transformed as Native people become colourful helpmates in a narrative of national progress based on Western values and ideals. Thus, the highlighting of Native imagery – even the construction of Native people as active agents of history – does not necessarily result in the genuine recognition of difference nor the acknowledgement of Aboriginal peoples' 'authority and jurisdiction' over their own lives (Todd 1992: 71); rather, it reinforces an existing nationalist narrative. Native imagery is appropriated and foregrounded in the narrative and yet Aboriginal people are subordinate to and subsumed within the project of nation-building. As Loretta Todd argues, Western excursions into Aboriginal cultural territories often ignore 'our cultural autonomy' and 'our cultural uniqueness – our difference – is reduced to playing bit parts in the West's dreams' (1992: 71).

In the narratives I have described in this chapter, cultural difference has been reconfigured and appropriated to strengthen national identity – to create a unified (although hybrid) narrative of national progress. Native peoples' self-representation in *Land, Spirit, Power* is reinterpreted as a story about Canadian tolerance and benevolence. It is through the presence of others, through highlighting the *reconciliation of difference*, that historical and present-day violence is erased and Canadian national character is produced as innocent and 'tolerant'.

Cultures and projects: a summary

So far this book has examined a number of conflicting and sometimes contested constructions of Canadian identity. Rather than proceeding by assuming that a homogeneous national identity is constructed through the exclusion of cultural and racial others, I have explored the institutionalisation of difference in national policy and in national imaginings. I have attempted to account not only for the specificity of each of these versions of national identity, but have also tried to map out the features which they share – their essential 'rules of the game' (Asad 1993: 17–18). Each of these constructions of national identity emerges from, responds to, and reflects their specific social, political and historical context. They may propose different versions of the content of national identity, or the definition of the past, present or future of the nation. However, they are all contributions to a shared and hegemonic project: creating and maintaining Canada as a nation: as an 'integrated totality defined according to progressive principles' (ibid.: 17).

The most fundamental shared assumption we have seen is that a nation needs a strong, bounded, and distinct national identity, a precept about nations and identities that can be traced back to the Western Enlightenment (Handler 1988, 1991). Although the content of that identity may be the subject of dispute and negotiation, the assumption that a nation is, or should be, a

bounded and distinct entity, with an identity that reflects that entitivity, is hege-monic. All of the different versions of identity I discuss – from the overtly exclusionary racial models of national character by the Canada First Movement in the latter part of the last century, to the inclusive models in the Museum of Civilisation or *Spirit of a Nation* in 1992 – have the search for and the articula-tion of that national character, as their goal. The desiring, making and reinforcing of national identity, then, are an essential feature of the Canadian nation-building project, and it has been the site of immense state intervention and funding in the last fifty years.

I have also shown that the project of constructing the Canadian nation and national identity has had a rocky career. Integrating the diverse populations necessary for the furtherance and progress of the project has required 'flexible strategies', both in terms of policy issues such as immigration, and in terms of modes of representing and managing culture. The combination of these flexible strategies, and the desire for a defined and differentiated identity, has produced the particular characteristics of tolerance and cultural pluralism said to define Canadian identity today. In my discussion I have shown that cultural diversity is integrated, assimilated, appropriated, erased, tolerated and managed depending on the needs of the project (including the desire for identity). In this construc-tion, it is the definers of the project – usually white and most often British settlers – who authorise and define similarities and differences. They are the unmarked, unhyphenated, and hence normative, *Canadian*-Canadians who are thus implicitly constructed as the authentic and *real* Canadian people, while all others are hyphenated and marked as *cultural*. For example, if Canadians are said to be defined by their tolerance of or acceptance of 'other cultures', or their 'kindness to Native peoples', the real Canadians are, by definition, not 'Native' or not from those 'other cultures'. Further, it is a white settler construction of *Canadian*-Canadian national identity that sees the land as alien and which needs Aboriginal peoples to help provide heritage and historical links to the land. It is the unmarked and normative *Canadian*-Canadians who 'recognise' other cultural groups primarily for their 'contributions' to Canadian culture, identity, and nation-building, and in doing so help to differentiate the Canadian project of nation-building from that of other nation–states.

How plural, then, is the culture of the Canadian nation? I have shown that in national mythology and cultural policy such as multiculturalism, cultural forms other than the unmarked and dominant British national identity (which defines the project), are limited and defined according to their place within the project of nation-building. The people of other cultures, their artefacts and customs, their *difference* from the unmarked national culture are defined always so that Canada, and the construction of a unified Canadian identity along Western principles of progress, are *first*. As one woman said to me during fieldwork, 'It should be *Canada first*, and then you still get to keep your culture.' In speaking of *other* cultures, 'culture' is defined as fragments of folklore, food, dancing, music, and customs. Yet despite this fragmented diversity, similarities must over-

come differences. The shared *project* defines, limits, and authorises those differences in culture. Yet in speaking of Canadian *national* culture, a different definition of culture is implicit. Here we refer to a construction of culture conceived of as a whole, entire, way of life defined on supposedly universal progressive Western principles. Although 'cultures' (defined in a limited way) may be multiple, the project of nation-building is singular; and that project has the construction of Canadian *culture* and identity (defined as a whole, entire way of life based on principles of Western progress) as a key feature. The limited fragments of cultures may be plural, but the whole cultural and material project is Western.

As we have seen in this chapter, images of land and nature are key symbols used in the task of building national identity. James Clifford asks what it means, at the end of the twentieth century, to speak of 'a Native land' (1988: 275). Canada's national anthem begins with the phrase 'Oh, Canada, our home and native land'. I hope this chapter has raised questions about how narratives of nationhood appropriate Aboriginality and cultural difference to make '*native land*' into what settler Canadians, like myself, can think of as '*our home*'. I now move on to explore how the cultural politics of national identity are played out in the specific cultural politics of 1992, at both national and local levels. It is here that an ethnographic perspective is useful.

5

LOCALISING STRATEGIES
Celebrating Canada

White locality and multicultural nationhood

On a sunny weekend in June 1992 I arrived in Elmford,[1] a prosperous
Southern Ontario town of 100,000 inhabitants, to attend their annual
'Lakefront Festival'. I had come especially for their 'National Neighbourhood
Party' sponsored by Canada 125 Corporation. Planned on a national level but
carried out locally, the 'Neighbourhood Party' event asked participants at local
festivals in towns, villages, and neighbourhoods all over Canada to stop their
activities at 2 p.m. exactly. They would then all simultaneously make a toast 'to
all our neighbours – *à tout nos voisins*' in all parts of the nation. The toasts in
Elmford and across Canada would be made with Canada Dry Ginger Ale
because the events were co-sponsored by a major manufacturer of the drink. In
Elmford itself, the organisers planned that everyone at the celebration would
hold hands along the lakeshore route for their toast, in order to make a several
kilometre-long 'toast to the Nation'.

The well-organised festival, explicitly designed to improve tourism in the
town, had substantial corporate sponsorship, and focused on the themes of
'Harbours and Heritage' and Canada's 125th anniversary. The five-dollar
entrance fee included free bus service and admission to all events taking place
on three stages in two harbours. Events included sailboat races, a '50s and 60s
street dance', a pancake breakfast, barber-shop singers, a town-crier competi-
tion, a water ski show, an ecumenical church service, beer gardens, arts and
crafts displays, musical bands and other entertainers, barbecues, puppeteers, a
picnic in the park (with bands, face painting, pony rides), dance demonstrations
(including Irish, Portuguese, Egyptian and Arab dancing), and a raffle draw for
a new car. The attendance at the festival over the three days was estimated at
over 80,000 people. The organisers had mobilised over 6,000 volunteers, and
sponsors included large corporations such as the Ford Motor Company, Molson
Breweries, a large pharmaceutical company, Ontario Lottery Corporation, Bell
Canada, the Royal Bank of Canada, as well as other smaller local sponsors. The
total budget for the festival, according to one of the organisers, was about
250,000 dollars, with Canada 125 Corporation providing flags and some adver-
tising.

Elmford has an older historic centre ringed with newer development.

According to one of the organisers of the festival, the older areas have more 'WASP' inhabitants, but the town also has what she called an 'interesting ethnic mix', especially in the newer areas. Elmford is home to large Portuguese and Italian communities, and more recently has seen an influx of Vietnamese boat people. Despite the racial and cultural mix in the community, the festival was attended mostly by white middle-class families.

When the moment actually came to hold hands and toast their Canadian neighbours with Canada Dry ginger ale, people were a bit shy. The national anthem, 'Oh Canada', was sung a bit flatly, hands were held tentatively, if at all, and there were many thin spots along the route. Many people stayed seated in the parks. Innumerable small Canada 125 flags and Canadian Maple Leaf flags provided by Canada 125 had been distributed to everyone, and they, as well as big blow-up Canada 125 balloons and large flags, were all on display.

The speech by the federal Member of Parliament for the area, broadcast on the radio and the loudspeaker system, referred not to history but rather to the opportunities Canada offers. He spoke of the constitutional debates, suggesting that the day was a chance to 'stop bickering about the few things that divide us...and celebrate the many things that unite us'. Afterwards, one stage of the festival featured a presentation of *Spirit of a Nation* (discussed in Chapter 4) which was very well attended and very well received.

Approximately two weeks later, on 'Canada Day' (1 July) another festival, organised by the Elmford Multicultural Council,[2] took place in the same park. The differences between the festivals were striking, almost as if they were taking place in different towns. This time one could see the racial and ethnic mix of the area in the participants and the people attending. The themes of the Canada Day festival were the celebration of Canadian citizenship and the appreciation of cultural diversity The entire day was geared to celebrating 'multiculturalism', and the festival presented an infinite variety of ethnic food, dancing, singing, and music. The day began with a citizenship ceremony presided over by a judge with a clearly non-British name.

The single stage had different cultural groups performing dances and songs. The white Canadian Master of Ceremonies introduced one group:

> We have a little change in our programme this afternoon...Canada is a rainbow of colours. If you are into colour then you are in for a real treat because the next two groups are definitely colourful. We are very proud to have them perform for us, however I cannot speak their native tongue so they will introduce themselves. I present Mr [mumble – mumble] from the Hindu Cultural Association of Elmford.

Canada's cultural diversity is presented here as 'colour', a contribution to the Canadian 'rainbow'.

The festival included a multitude of tables selling 'ethnic food' as well as other items of folkloric interest. The performances came from Polish, Croatian,

Irish, Sikh, Portuguese, Dutch, and Hindu ethnic and religious groups. Tables in the 'Ethnic Foods, Arts, and Crafts Market and Community displays' were provided by a much broader range of ethnic groups, as well as organisations as varied as the Liberal Association, the Ontario Provincial Police, and a rape crisis centre. There were also some tables of independent businesses, mostly restaurants and gift shops. The festival displayed many Canada 125 flags. The festival's funding came from local government as well as small local businesses, and was very small in comparison with the Waterfront Festival two weeks earlier.

I define the Waterfront festival as a 'white' festival. Frankenberg suggests that 'whiteness' is characterised by a set of cultural practices that are often 'unmarked and unnamed' (1993: 1). Indeed, the Waterfront Festival was made up of a series of cultural events that were unmarked as either Canadian or white, and were not marked as culturally specific. It did not foreground the cultural heterogeneity of the town. Cultural specificity was not marked out as salient except when the cultural activities were *not* 'just plain Canadian' but were 'other'. The kinds of activities engaged in were conceived simply as 'normal' summer activities that go on in local town festivals in Canada. Within this unmarked 'normality', 'ethnic' performances were clearly marked as cultural and culturally specific. For example, activities such as a 'pancake breakfast', a 'strawberry social', or a 'steak dinner' were not marked as being 'traditional foods' or 'traditional rituals' from any *particular* culture. A '50s and 60s street dance' (although clearly not music from India or China in the 1950s and 1960s, but music mostly from the United States, Britain and maybe Canada), was not labelled a 'Traditional Anglo-American 50s and 60s Dance'. On the other hand, the music or dancing of the 'ethnic' groups was often twinned with their nation's name and labels such as 'traditional', 'cultural' and 'folkloric'. I argue that the unmarked ethnic and racial character of the 'white' activities works through marking difference. Those who are different become located in a distinct conceptual space, as 'other' to that unmarked norm. They are defined by their cultural *difference from* what is simply 'normal'. The Waterfront festival defined white unmarked Canadianness as normative.

It might be possible to do genealogies of the activities or events engaged in these kinds of 'white' festivals – fashion shows, bed-races, rubber duck derbies, nostalgia dances, parades, ring-toss, bowling, pony-rides, log-sawing, and beer tents – in order to understand their 'ethnic' origins. Did strawberry socials originate in England or Ireland? Was rubber duck racing a modern adaptation of something done during the time of Queen Victoria on the River Thames? More important, in my view, is the fact that these events are an amalgamation of a number of possible traditions and transformations, and they now stand as unmarked 'normal', and 'fun', summer activities for groups of people at festivals all over Canada and the United States. They reflect a pan-North American way of celebrating local communities and nations (Lavenda 1983). They are all festival activities that are, most

importantly, *unmarked* as 'ethnic'. Whiteness is normative and ubiquitous, but it is unmarked as culturally specific.

The multicultural Canada Day festival at Elmford, on the other hand, defines an authorised space for representing cultural difference: cultural difference is marked and brought to the foreground. These celebrations probably most directly mirror the nationalist multicultural ideology presented earlier. Differences are pulled out and highlighted in the service of Canadian unity and in selling and celebrating differences. Significantly, the focus is on culture as 'colour', as folk entertainment, and as a product for consumption. We see here a kind of cultural commodification (Handler 1988) of specific facets of difference. 'Multicultural' festivals are an authorised space in which cultural pluralism is recognised, celebrated, and sold. 'White' festivals, are those which unproblematically affirm a conceptualisation of Canadian culture as a normative and unmarked 'white' culture.

The differences between these two festivals also demonstrate a salient distinction between the celebration of *white locality* and celebrations of *multicultural nationhood*. The Waterfront Festival (the white unmarked festival), was primarily a celebration of the *local community* of Elmford. Yet this white locality is projected outward to represent the nation. The Canada 125 theme, for example, was unproblematically added on to the celebration of white locality. The multicultural Canada Day festival, on the other hand, was first and foremost a celebration of the nation (*Canada* Day), and not primarily a celebration of the local town. One celebrated unmarked *white locality as nation*, the other celebrated the Canadian nation as multicultural. Multiculturalism, the celebration of pluralism and cultural difference, inhabits an authorised and defined space of conceptualising the *nation*, on one specific day of the year – Canada Day. Yet white locality is projected outward, without hesitation, to represent nationhood.

At the end of the previous chapter I discussed how, paradoxically, pluralism as a narrative of nationhood can actually reinforce the idea of a core unmarked white settler Canadian national culture. The two festivals in Elmford, occurring only two weeks apart, raise interesting questions in this context. Although pluralism may be an ideology and practice which re-affirms white identities at the level of *nation-building*, overt expressions of pluralism are not always replicated in local white expressions of national belonging. When pluralism is included in these local celebrations, however, it mirrors the forms of limited and managed difference I have discussed in previous chapters.

Re-enacting the past: erasure and appropriation of Aboriginal people

Rockville is a city of approximately 100,000 people situated in Southern Ontario, near the border with the United States. In June 1992 the town celebrated the 25th anniversary of their 'Canada Flag Day'. The day featured a flag

day ceremony and historical re-enactments and 'Tactical Military Scenarios' of the War of 1812, when British troops pushed out invading Americans. These events were part of a ten-day celebration that included activities such as a youth ambassador competition, soccer, soccer-baseball, a dinner theatre, fishing derbies, boat-shows, watercraft races, euchre, a fashion show, a beauty pageant, a strawberry social, a steak dinner, a '50s night with Elvis', bed-races, a pancake breakfast, a parade, a beer garden and dance, a rubber duck derby and a neighbourhood party. The festival began with an historical re-enactment of the War of 1812. Organised by a volunteer re-enactment society, it was well attended, mostly by white people in family groups.

As I walked towards the field of battle I came upon a group of children in front of a historical museum, being trained to hold wooden guns and march in military form. They were the 'Children's Militia' and were scheduled to enact a battle later that day. As I moved towards the open green, now a 'battlefield', I noticed two lines of soldiers shooting at each other, one British, and the other American. They were dressed in uniforms assembled with concern for precise historical detail. Near the battlefield were tents, occupied by white women and children dressed in period clothing cooking and doing domestic work.

The war between the Americans and the British is the only time that Canada has ever been invaded by a foreign military power. Although in some histories, the heroes of these battles are the white Canadians and the British, others credit the Canadian/British success in these battles, in part to the Native People who became their allies and fought on their side. The Americans were apparently terrified of 'Indians'. For example, McNaught's history, on one hand, suggests that 'the Canadas were saved by three decisive factors: the Loyalty of the French-Canadians and "late Loyalists"; the superior training and tactics of the small British regular force; and the almost total incompetence of the American generals' (McNaught 1970: 71). This version does not mention the contribution of Aboriginal peoples. Yet, on the other hand, he also speaks of the small forces of 'British regulars, Indians and fur traders' who were able to win against the larger forces of General Hull, because Hull's force was 'in mortal fear of Brock's Indian allies' (ibid.: 72). Taking account of the different versions of history, I wanted to see how Aboriginal people would figure in the local re-enactment of national history.

As I watched the battle I noticed no Native people on the scene, neither people dressed up as 'Indians' in the battle, nor Native people themselves taking part. Finally, I noticed one man dressed like a fur trader, wearing a buckskin jacket, a breechcloth and leggings. Then, coming up the path behind me, I saw a woman in full 'Indian' attire. They were the only possible 'Indians' I saw that day. I approached the woman, Barbara, and asked her if she was part of the re-enactment. When she said she was, I then queried whom the man dressed in the buckskin was. She said he was representing an 'Indian agent', a soldier attached to the regular British forces, but with the job of negotiating relations with 'the Indians'. Barbara, told me that 'underneath his breechcloth and his leggings he

does have military pants on', and that during battle he would stay with the 'Indians to show that he was supporting them'. So, in order to gain solidarity with their Native allies, soldiers from the British army would cover their own uniform with Native attire.

Barbara told me she was meant to represent an Aboriginal person in the re-enactment: 'Yeah I'm Crow…so I'm a little further West than this but…this is a Crow outfit…and the Moccasins are Woodland but the rest is Crow.' She was well informed about the role of Native people in the battles, and on the situation of Native people in Canada at that time. She named numerous tribes and described the trajectory of many who came to Canada from the USA. She also had ideas about their motives.

> The ones that got pushed from the States [up to] here hated being there just 'cause the Americans destroyed their land. But some did stick to the American side 'cause they would stick to whatever side they thought would win, and whoever they thought they could get the most from in the end. There were some real American haters, though, among the Indians.

Barbara had been a member of her historical re-enactment society since the fall, the end of the previous season. These societies, of which there are many, take their project very seriously. Each group specialises in different time periods or specific battles, and they study the history, work on the costumes, and perform all over the USA and Canada during the summer. Most groups put a great deal of effort into historical accuracy. She said she had spent the winter doing historical reading in order to better understand her role.

Barbara said she got involved in the historical societies partly by coincidence, and partly because she 'looks like an Indian', and might really 'be Indian', although 'nobody's admitting it in the family'.

> There is quite a few in my family that look it. And I have a grandfather who said there was, but my mother didn't like it so I'm not sure…He's dead now so I can't find out…If you had relatives here in the 1700s chances are you are part Indian because there weren't many white women here then. My sister started to trace the family tree but she could only go so far on my Dad's side because they're from England so she stopped at some point. She is wondering because she is the one of us who really looks Indian. There's three of us of six brothers and sisters – three at least – like me – and then the other two sisters look even more Indian than I do.

Barbara said she would like to trace the family history. She has a friend who is studying Native Studies at university. When she went there for a few events with Native people, 'all the Indians' thought she was 'Indian, so if they think so…'.

She became involved with the re-enactment societies because one weekend she drove a friend to an event, 'dressed as a white woman', and an Aboriginal person there said she 'could pass' as a Native person.

> So the next event, my friend and I put together this outfit. And see we knew this was a little too far West, but we knew it was authentic and we could do it fast, and so we did. I've been researching Ojibway through the winter. I'm gonna put Ojibway together now.

As Barbara and I turned to watch the battle, she explained the movements and strategies to me and later we went our separate ways.

I then joined a guided tour of the museum that told the story of the Rockville battle. The guide recounted the story of the battle in simple language, so that the numerous children in the tour could understand. In this description I cannot give the details of the story because they would make the town identifiable and I have agreed to maintain the anonymity of my informants. As the guide came to the end of the story of the battle, he said that the small group of settlers in the area helped in the battle because they 'yelled like Indians'. Afterwards, I approached him and asked him about the phrase 'yelled like Indians'. I said I had heard there were many Aboriginal people in the area at the time and that they were considered important allies. He categorically denied this, saying that it was mainly settlers, 'yelling like Indians' because the Americans 'were scared of Indians and that's why it worked'.

The representation of Aboriginal people at the Rockville festival was contradictory and immensely flexible. On one hand, they were nearly erased from a local version of Canadian history. In the tactical military scenario, for example, Native people did not appear, and in the museum their presence was denied. The one man dressed as an Aboriginal person in the historical re-enactment was not actually playing a 'real' Native, but was re-enacting an historical masquerade.

On the other hand, Aboriginal symbols were appropriated in complex ways. Barbara, the woman dressed as an 'Indian', had immense dedication to her role, ('researching Ojibway all winter') and gained great personal pleasure from it. Her taking on this role could be seen, in part, as a reclaiming and valuing of her Aboriginal ancestry. I suspect that this kind of relationship to playing an 'Indian' is a fairly recent phenomenon. As Barbara herself explained, nobody in her family admits to being 'Indian' although she is fairly sure the background is there. In my family, as well, there has been innuendo and rumour about Metis ancestry, and it has been a source of silence and shame for years. Recently, however, one family member has been trying to reclaim that part of the family history (with some resistance from other relatives). Indeed, in the last decade it has become almost 'trendy' to re-claim one's Native roots. Whereas years ago 'looking Indian' would have been a source of shame, Barbara expressed her pleasure that 'all the Indians think I'm Indian' and that they told her she could

'pass' as an Indian. At one point she even says that she was 'dressed as a white woman', as if being 'white' had now become a masquerade or re-enactment.

However, Barbara's 'taking-on' of Native identity could also be seen as a form of cultural appropriation, [3] in some ways similar to the forms of appropriation of Native culture in the construction of Canadian national identity discussed in earlier chapters. The 'taking-on' of Natives as Canadian 'heritage', I argued, helps to construct a link to the land for the settlers, and contributes to differentiating Canada from other nations, especially the USA. Barbara, herself, talks of the Indians as 'American haters'. Appropriating Native imagery helps give Canada an identity. For Barbara, too, 'going Native' seems to give her a sense of self. However, she has the choice whether to dress as a white woman or dress as an 'Indian'. She can 'pass' in either world, unlike many Aboriginal people. She can choose to take what she wants from Native culture to build her identity, as constructions of Canadian national culture have done with Native culture.

Parts of the Rockville festival also indicate other interesting forms of appropriation. The Indian agent masquerading as an 'Indian' helped the British defend their colonial project, as did having the settlers 'yell like Indians'. Again, Native people and representations of Native people are used in the service of colonial and national projects. In this local example of the relationship between Native culture, and Canadian history and identity, we see similar processes to those in broader national public culture: the paradox of the shifting back-and-forth between the erasure and the appropriation of Native people and culture, in the service of the project of nation-building and identity construction.

'What Canada Means to Me': the flavours and limits of multiculturalism

As I left the museum, the flag-raising ceremony was beginning nearby in a raised bandstand. The sound of children singing the national anthem, 'Oh Canada', drifted across the park. As I approached the bandstand, a blonde, white woman of about 45 years of age, dressed entirely in red and white, the colours of the Canadian flag, got up to introduce the ceremony and the visitors. She was Pam Wallace, the festival organiser I had spoken to on the telephone, and who had agreed to an interview. As rain drizzled down on the very small audience, several local (white) politicians gave short speeches about how the flag day ceremony had begun. Three men and one woman (all white) in full military dress, the Canadian Legion Colour Guard, stood at attention beside the flagpole, ready to raise the flag. Finally, Pam Wallace introduced one of the 'young ambassadors' from the area, to give a speech entitled 'Proud to Be Canadian'.

Ernie Ferguson, a grade nine student at a local school, began his very long discussion of Canada with images of himself at home watching cartoons on television. He described how suddenly, his cartoon fantasy was ruined as he was

woken by 'the horrendous and monstrous sounds of the news: "Quebec wants to separate", "constitutional conference going down the drain", "government can't agree with Aboriginals", "federal government selling country to the United States".' [4]

Ernie's speech described how he threw his sandwich at the television in fury. He continued, to express a sentiment that was to grow more and more common in my interviews with people as the year went on: anger at politicians and people who complain about the country.

> For the life of me I can't figure out what people are complaining about. I've heard more bickering and complaining about this country...Each and every day, hundreds and hundreds of politicians go to fancy hotels and convention halls to have their so-called conferences. And what's really accomplished at those conferences? Not too much at all! A typical day would start off with a two-hour breakfast, end with a four-hour dinner, have twenty minutes of serious conversation, and six hours of bickering and whining sandwiched in!

As the organisers and politicians on the stage began to look slightly uncomfortable, Ernie continued: 'When are people going to take off their pyjamas, rub their eyes, and see the light? As Canada's one hundred and twenty-fifth birthday approaches, are we going to dwell about the things that we don't have in this great land of ours? So many people take this country for granted.'

Ernie then proceeded to describe in great detail his reasons for loving Canada. First, he compared Canada's prosperity with all the troubled countries in the world, countries stricken by 'famine, hunger and starvation'. He then outlined Canada's superiority over other countries in which 'a child can't even get a decent education' or proper health care. This superiority, Ernie argued, is something people don't appreciate. He then described how people in other parts of the world, without Canada's 'freedom of speech', feel 'trapped...in a deep, dark, damp, dungeonous [sic] hole, where screams for help only go as far as their minds'. In Canada, however, 'people are free to speak their minds and contribute their ideas. Nobody is ignored or left out in Canada. Everybody has a say in what happens in their homeland.'

He then described his version of cultural pluralism in Canada. In Canada, he argued, 'people aren't persecuted because they're black or white',

> or because they speak a different language, or because their parents came from a different country. Being the builders of our creativity and our innovations, we welcome different and unique people. In many parts of the world governments feel that people should be the same, because they think that unique people will be the ones to question their dictatorships, unreasonable rules, and communistic [sic] regulations.

In this part of the speech it appears as if Ernie has been well schooled in Cold War anti-Communist propaganda. The freedom the West offers is individual freedom to choose to be 'unique'. It is interesting that the difference is described as uniqueness. 'Unique' tends to describe *individual* and solitary difference. Indeed, as Ernie, continued, difference and freedom are implicitly defined as a series of individual consumer and lifestyle choices.

> Different cultures and backgrounds, different languages and tongues, different customs and traditions, different hairstyles and hairdues [*sic*], different food tastes and preferences, and different hobbies and professions, all contribute to Canada's uniquely distinguishable flavour – a flavour that's sweet, not sour or bitter.

As in much multicultural discourse, Canada's diversity is described in terms of flavour. He also describes Canada as a canvas of colour that holds all the diverse people together and at the same time distinguishes the nation from other countries.

> From coast to coast, from the cold Arctic north to the lusciously warm southern Banana belt [this was intended as a joke], fishermen and women, farmers, lawyers and librarians, miners, teachers and steelmakers and doctors, can all feel truly proud in knowing that when they hold hands they can't be ignored by any other country in the world...In Canada individual personalities are welcome. From adventurous to zany, people from all walks of life find that Canada is the canvas on which they can paint their personal imprints and cultural mosaics.

However, again as in official 'multicultural' discourse, diversity is about '*individual personalities*' and painting '*personal imprints*'. Finally, Ernie closed his speech by returning to his anger at people who make the country fall apart because they bicker and whine. He used the image of Canada as a family.

> Canada mustn't fall apart...[N]ot enough time is spent on being a family and exploring what we have in common. We are looked up to by billions of people around the world. Let's not damage our reputation with all this bickering and complaining. I hope that the young generation will carry on Canada's great traditions, without the bickering and whining that's evident in today's society.

Ernie finished to a smattering of applause. His speech had gone on for almost one half-hour.

Ernie's speech is a telling example of a discourse about pluralism and national identity that was very common in my field sites during 1992. In this

discourse, diversity is often considered one of Canada's defining characteristics, a characteristic that distinguishes it from all other nations. Diversity of cultures, lifestyles, professions and hobbies is constantly referred to. These differences are often, however, framed as freedom of *individual* choice. Diversity, while celebrated, is also carefully defined and limited. In Ernie's speech, as in the 'ethnic' dancing segment from *Spirit of a Nation* (described in Chapter 4), the acceptance of diversity is limited to those who peacefully celebrate their differences. When people begin to fight and get 'political', as in *Spirit of a Nation*, or when they, in Ernie's words, begin to 'bicker', 'complain', and 'whine', they will not be tolerated. The *political* manipulations and 'bickering' threatens the unity of the country. Conflict threatens the naturalised Canadian 'family'. The tolerance for difference and uniqueness, in 1992, began to stop right at that line. The sense that patriotism should be 'non-political', and anger at the divisive 'political' 'bickering' of politicians and those described as 'special interest groups' in 1992, is a theme I will return to in more detail in the next chapter.

Back at the bandstand in Rockville, the flag was raised and a children's choir made up of '44 children from 20 different ethnic backgrounds' sang a song called 'Celebrate Canada'. One of the organisers closed the ceremony by thanking Canada 125, thanking everyone involved, and acknowledging the 'family orientation' of the festival. Another organiser stood up and read a letter she had received saying 'Thank God we are Canadians'. Afterwards I spoke to Pam Wallace and some of the other organisers up on the bandstand.

Shifting ground: tolerance turns to 'rubble'

As the people on the bandstand were clearing off the stage and discussing the ceremony, Pam introduced me as a PhD student doing work on Canadian identity. People immediately begin to chat about Canada. A man clearing the stage said '*This* is what Canada's all about', and gestured to the bandstand and the flag. Another man, carrying a speaker, piped up that he had been on a trip to Scotland and that everyone there wanted to come to Canada. 'If we ever opened up immigration the place would be flooded…Sure there's problems all over the world but it's the best place in the world' he said. Pam responded, 'It's true though – if the United Nations had voted the US as the best country in the world they'd still be partying. They'd be wild.'

Within five minutes of conversation, Canada was set up as a place *other people* want to come to and as a place *different from the United States*. Again, comparison with and opposition to the United States was a conceptual tool used to define Canada. Pam, for example, spoke at length about the characteristics that differentiate Canada from the United States. The first issue she brought up was patriotism and 'flag-waving'. In a discourse that recalls the debates about the Canadian flag twenty-five years earlier (discussed in Chapter 3), she said, 'We aren't as obnoxiously proud or quite as flag-waving as the Americans, but we are still slightly – politely – proud.' She defined Canadians as more reasonable,

less emotive, and less jingoistic (flag-waving) than Americans. These specific characteristics of Canadians, when brought up in the debates about the flag twenty-five years earlier, had meant more *British*. Pam continued to define Canada through comparison with the United States.

> We have as much of the best things that the States have without nearly any of the worst things. I heard an excellent commentary on New York City...And it was personifying the best and the worst of American culture. You will find the Philharmonic and the homeless – you know – both extremes. I don't think you can find the down-side of the extremes in this country. We have all the perks, all of the lovely things, we have the architecture, the culture, the education, the universities and then some. We have health care and social services second to none, we have better and more geography than they do, we have huge natural resources. We have more of the best and not nearly as much of the worst. I think that that doesn't come by accident. We have been very very careful in the past and maintained laws towards civil liberties and freedom. One of the big issues I think is firearms...[W]e don't have the crime rate that the States do. We don't have people getting shot in the drive-byes. It just doesn't happen.[5]

Pam presented a mythologised and heroic version of the benefits of the welfare state. Through comparison with the USA, Pam's rhetoric completely denied the poverty that does exist in Canada and totally overlooked the dismantling of the social safety net carried out by the, then Conservative, government. Her argument is similar to nationalist discourse we have seen repeated since Confederation – from the Canada First Movement, to the myth of the gentle Mounties and superior British justice. In this discourse Canada is seen as more reasonable, more rational, more ordered, more balanced, less extreme, and finally bigger and more natural ('we have better and more geography than they do') than the United States.

Eventually, Pam gave her views on cultural pluralism and race relations, and argued that although 'morale' about race relations in Toronto is 'extremely poor':

> it's *nothing* compared to the States. *Absolutely nothing*. We've had diffi-culties in certain communities, but I think part of the reason we don't have nearly as much trouble is the fact that we tend to recognise and appreciate our particular ethnic groups.[6]

The language of 'we' (Canadians) not having trouble with *'our'* ethnic groups betrays a form of patronising possessiveness. Indeed, possessing 'our' ethnic groups, which 'we' (Canadians) 'recognise and appreciate' provides Canadians with the necessary differentiating characteristics that draw a distinction from the

USA and construct national identity. Pam again drew on an historically constituted discourse of national identity which defines one of the major differences between Canada and the United States as Canada's tolerance for minorities. But how do Canadians, in Pam's words, 'recognise and appreciate' what she called 'our particular ethnic groups'?

> We don't try to push them off into a corner, in fact we take a lot of pride in their particular identity, and incorporate that into the whole flavour of the community.

Here, as an example of this incorporation, Pam described two 'ethnic' or 'multicultural' festivals that took place in her area (not coincidentally, both were important tourist attractions).

Integrating the 'flavour' of ethnic groups into the 'community' was, however, limited. Although 'flavour' was incorporated into festivals that were specifically marked as 'ethnic', cultural pluralism did not appear in the Rockville festival at all. There were no ethnic dancing or singing presentations, and not even any ethnic food advertised. The festival's events were all activities I have defined as 'white' activities. Ethnicity is unmarked, and hence these events have normative status as simply 'Canadian' summer festival activities. The 'appreciation and recognition' of difference, consistent with the forms of multiculturalism I have discussed, are about allowing ethnic groups to represent and sell their particular cultural artefacts. Even this form of pluralism occupies a distinct conceptual space outside of the local community. Further, in a similar vein to Ernie's speech, her description of the ways in which ethnic groups are integrated uses the term 'flavour', as if cultural pluralism was akin to a menu in a restaurant.

As my conversation with Pam proceeded, most of the men disappeared. Several women were left on stage, and they joined the discussion. Pam and I were talking about constitutional politics and the situation of Québec. Someone mentioned that Canada seemed so culturally 'fragmented'. A woman in her early forties, Jan, described the strength of ethnic communities in the Western provinces. She felt that ethnic strength is a drawback, because people who have 'lived in Canada for ten centuries' still tend to say they are 'Irish-Canadian and Scottish-Canadian and Icelandic-Canadian....' People aren't 'just Canadian'.

Marcia, the public relations person for the festival, burst in passionately with her ideas on the issue.

> Do you guys have any idea what that does to a family that's been in this country...? Well we've been in North America since 1580 something or other – they came north after the revolution, and we have intermarried with every group that has arrived on this continent. But you ask me what I am [and] I say 'I am Canadian'. And they say 'What kind?' EXCUSE ME!!! I'm pissed at a response like that.

Jan supported Marcia's point, 'and then people say "where're you from?" – "Canada...I was born in Montreal." – "Oh you're French-Canadian" [they say]. – [I say,] "No, *I'm Canadian*."' The discussion began to lose its politeness. Everyone began interrupting and talking at the same time, as if all sharing a similar experience of anger at Canada's fragmented identity. It was also the moment in which the discourse of tolerance to difference began to shift to a discourse that defined the limits of 'allowable' differences. Pam cut in loudly, and, playing her role as the spokesperson for the festival, tried to speak reasonably,

> Somewhere there's a *fine line* between acknowledging our *uniqueness* – and it's nice to acknowledge and celebrate those differences because, the festivals, especially with the food and the culture and the traditional dancing, is a wonderful way to celebrate, where we're from – *but* when you start into...*granting special privileges* and *special rights* to *special groups* that is *no way* to promote *national unity*. Because then somebody feels left out. Someone's better than they are.
>
> (emphasis mine)

Pam's 'fine line' distinguishes between cultural differences in terms of food and dancing, and differences in terms of special privileges or 'special rights to special groups'. As in official discourses of multiculturalism, the fine line between those two forms of difference is what can threaten 'national unity'. And *national unity*, the *project* of nation-building, is key.

Jan continued along Pam's line of thought. In her case, she said that special cultural status is not such a good thing. However, taking a less authoritative tone than Pam, she expressed her ideas about cultural difference by projecting her feelings on to immigrants.

> If I was from another country I'd like to be considered...if I came to this country to make it my country, and I took citizenship, I'd like someone to say to me, 'It doesn't matter that you originated from China or Japan, you are now a Canadian.' I think that's what we should say: 'Congratulations – we are glad you are now Canadian.'

She thereby naturalised her denial of ethnic status by defining what she would want if she were in their shoes. Marcia burst in again angrily, 'Do you know that you can get multicultural funding for absolutely every nationality except Canadian? *Canadian*-Canadian?'

The conversation went wild again here, everyone interrupting and agreeing. It became a full-blooded defence of a vision of Canada in which *Canadian*-Canadians should have priority. Finally, the discussion turned to a comparison between the United States' 'melting pot' philosophy and Canada's 'cultural mosaic' policy. Although earlier Pam had described Canada's tolerance to

minorities as a major feature that distinguished Canada positively from the United States, here the celebration of difference began to become a problem. The United States' model began to seem more attractive. Jan said that if you are American and

> • you try to take your citizenship somewhere else, whoa – you are American first.... I think it's probably good because then you have more of a unity. People from three generations back who are from Japan, they are no longer from Japan they are now...American.

The unity provided by having the nation come first ('American first'), for these women, was better than Canada's fragmented mosaic. Finally, Marcia described her version of the cultural mosaic:

> A cultural mosaic results in a picture, and it's not...We've got the squares of the mosaic without having a picture...Mosaics, individually, one piece at a time – if you see a mosaic in the process of going up, I got to actually see one because they did one in high school where I was – But until that picture was completely formed you have a pile of rubble. That's all you've got. Any individual piece, any chunk, doesn't do anything. So I don't like the mosaic analogy because when we get to it – well what does the picture look like? *We haven't got one.* In which case, it's *not a mosaic, but ...a pile of rubble.*

Representing Canada as unfinished mosaic, a mosaic with no picture, implies that Canada has no culture and no identity ('we haven't got one'). Both the earlier discussion of their lack of status as *Canadian*-Canadians and this discussion are examples of the profound threat many white people were beginning to feel as the 'identity crisis' in 1992 worsened. More importantly, these discussions illustrate the ways in which tolerance can and does shift easily into intolerance and a defence of white unmarked Canadian identity. In the process, the unmarked and normative status of white Canadians becomes increasingly marked and articulated as '*Canadian*-Canadian'. The shift occurred when a 'fine line' was crossed. The line was drawn when others, whose cultural differences had previously been celebrated because of their contribution to Canadian culture, begin to demand political rights ('*special* privileges and *special* rights for *special* groups') as they were doing in 1992. Or, as in Marcia's example of the mosaic, the line was drawn when the celebration of cultural difference prevented or threatened the emergence of a unified and whole Canadian identity. In these constructions of Canadian identity, the project of having and defending a unified nation was primary. The cultural differences of others are allowed or refused on the basis of those criteria.

As the discussion continued, the park slowly emptied of people. Finally, the group on the stage went over to their cars, walking past the people from the

historical re-enactment as they pulled down their tents and packed up their costumes. The Canadian flag fluttered in the breeze. The celebrations in Rockville were over for the day.

This chapter has described several local celebrations of Canadian identity. The two festivals in Elmford illustrate how white unmarked and normative Canadian identity was actualised on the ground. The historical re-enactment and flag-raising ceremony in Rockville showed that many of the contradictory themes of identity construction we have seen in national public culture and policy were also apparent at a local level.

As in official nationalist discourse, local identity practices simultaneously erased Aboriginal people and appropriated Native imagery. In addition, despite the proliferation of 'multicultural' imagery and rhetoric, the limits of difference were also very tightly drawn in terms of colour, flavour, and individual uniqueness. Ernie drew the boundaries of proper Canadian behaviour through the notion of 'bickering and whining'. The women on the bandstand in Rockville limited difference by defending *Canadian*-Canadian identity, and through anger at those who demand 'special rights and privileges'. At both national and the local level, Canadians constantly compared Canada to the United States. Whereas in the discussion on the bandstand at Rockville, people initially defined Canada as better than the USA because it is more tolerant, over the course of the conversation, the comparisons shifted. The USA eventually became a model of unified identity. Canada's 'multicultural mosaic', which Marcia presented as a 'pile of rubble', was seen to prevent the kind of whole, unified, identity that Americans have.

As in historical and present-day public discourses of Canadianness, the contradictory construction of Canadian identity paradoxically includes cultural difference, and at the same time constructs a notion of Canadianness in which the real and authoritative Canadian people are defined as white, culturally unmarked and assimilated *Canadian*-Canadians. Ernie's 'Proud to be Canadian' speech, gestured towards the emergence of so called 'populist', anti-government and anti-political patriotism. Notions of non-political and populist patriotism were mobilised to good effect in the political and cultural struggles of 1992, at both local and national levels.

6

CRISIS IN THE HOUSE

The constitution, celebrations and 'populism'

This chapter traces the link between national political crisis over the constitution (which represented an attempt to manage *historical differences*), and policies that seek to produce and manage *identity* through cultural events such as national celebrations. It shows, through analysis of the build-up to the constitutional crisis and nationalist celebrations of 1992, that the constant reproduction of 'identity crisis' makes possible the regulation and state intervention in identity at national as well as local levels. This chapter also traces the mechanisms through which, as a response to the perceived 'crisis', a new form of 'populism' and new definitions of 'the people' began to gain legitimacy. It explores how representing itself as 'populist' became a primary goal of the government in numerous sites, and how 'the people' became a key contested metaphor at both national and local levels.

The emergence of so-called 'populism' is part of a global shift in which many nation–states are witnessing an increase in movements of an intolerant and 'populist' majoritarian Right as well as the assertive identity politics of minorities. Within this conflicted field, as Chatterjee points out, some of the fundamental tenets of Western liberalism are being questioned (1995: 11). For example, in India, as well as in Ontario, Canada, the Right have gained power through mobilising precisely the key concepts and images of populism and the 'people' thought to be the prerogative of the Left.

National identity is what Greenfeld calls modernity's 'fundamental identity'. She argues that:

> the specificity of nationalism derives from the fact that in its framework the source of identity, whether individual or collective, is located within a 'people' which is seen as the bearer of sovereignty, the central object of loyalty, and the basis of collective solidarity.
>
> (1996: 10–11)

Perhaps, therefore, it is not surprising that the term 'the people' evokes powerful and emotive, yet also ambiguous and contested images.[1] Whereas in traditional leftist thought 'the people' call up images of a politicised popular

107

class struggling for freedom and equality against an exploitative ruling class and its state apparatus, in new-Right discourse 'the people' are constructed as a natural and non-political category of authentic citizens who resist the 'political correctness' of radicalised minorities and the meddlesome 'nanny state'.

In fact, when I arrived home to do fieldwork, Canada had become much more racialised than previously, and the term 'politically correct' was being used regularly in the press and in day-to-day discourse, as a way to discount politicised minorities. More legitimate social and political space had opened for 'populist' expressions of anti-immigrant and anti-multicultural sentiment. Sometimes these sentiments were overt, as in the discourse of the increasingly popular Reform Party, a 'populist' Right-wing Western-Canadian based party which emerged on Canada's political scene in the late 1980s (Manning 1992). Often, however, especially for liberal Canadians, debates on pluralism in Canada revolved around defining the right *limits* for forms of pluralism, debates focusing on how some members of minority communities, or some policies of affirmative action, were *going too far*. The limits of tolerance were being carefully debated and drawn. I was surprised when even close friends spoke this way. In Canada in 1992, it appeared the belief in a 'multicultural consensus' was beginning to fray at the seams. At the same time, economic recession was peaking.

As I discussed in Chapter 1, when I arrived for fieldwork my plan was to examine contests over the 500th anniversary celebrations of Columbus's encounter with the 'New World'. As I searched for official government-sanctioned celebrations, I noted that the press was dominated by coverage of Canada's newest version of 'identity crisis' on the constitution. At the same time, advertisements appeared on television announcing the government's programme for Canada's 125th anniversary celebrations. At first, these events seemed disconnected. However, as I was to discover, the programmes were intricately connected. They were all enactments of policies devised to promote the Conservative government's political programme. Shore and Wright argue that if policy is a tool of government, if approached anthropologically it can also equally be 'a tool for *studying* government' and broader society, because policies 'codify social norms and values' and 'articulate fundamental organising principles of society' (1997: 7). An exploration of the government's celebratory policy and its links to the constitutional debates and programmes, therefore, can help us to understand how axiomatic assumptions and key concepts such as 'populism' and 'the people' began to function, through policy, as 'organising principle[s] of society' (Mackey 1997; Wright and Shore 1995: 30).

Constitutions and celebrations

Many nations planned to celebrate the 1992 Columbus quincentenary by sponsoring extravagant celebratory displays to promote nationalism and stimulate international trade and global tourism. At the same time Aboriginal and black

North and South Americans sought to use the occasion instead to mark 500 years of *resistance* to European imperialism (Harvey 1992). As early as 1988 the Canadian government set up a 'Columbus Committee', made up of representatives from 'ethnocultural groups', Native people, and Québeckers, to make proposals on how to celebrate Columbus (Special Committee 1989). However, official Columbus celebrations were jettisoned by the government in the early stages of planning, because the government decided to celebrate the 125th anniversary of Canada's formation as a nation – the 'Canada 125 celebrations'. As I was to discover, the shift from Columbus to Canada 125 was part of a complex web of political manoeuvring by the federal Progressive Conservative government linked to their political programme, in particular the constitutional changes that they were trying to initiate.

An employee of the government's National Identity and Special Events Task Force, Ronald Dagleish, told me in an interview that the government had never had any intention of having Columbus celebrations. He admitted they had formed the Columbus Committee only so they 'could say' they had 'studied the sucker', even though they had never seriously intended to go through with the celebrations. Celebrations of Columbus, even critical ones, were simply too controversial. In fact, the report by the government's 'Columbus Committee' took account of the controversial nature of the issue and proposed celebrations that were informed, to a certain extent, by revisionist or critical approaches to history (Special Committee 1989). Dagleish said that in the specific political context of Canada's crisis (and the fact that 1992 could be an election year), forging and reinforcing national unity was a much more important issue, and therefore it 'made more sense' to celebrate Canada's anniversary. Indeed, the language of forging national unity and building identity appeared in the Throne Speech of the Conservatives in April 1989.[2] One of the four themes in the programme for their term was to 'Foster a confident sense of Canada's *cultural* and *national uniqueness* in which Canadians may have a greater sense of their *common values* and *common citizenship*'. The Throne Speech made the first public mention of planned celebrations for 'Canada's 125th birthday in 1992'.

Planned at the highest levels of government, the celebration of the Canadian nation was an intensely political strategy, imbricated in a web of political events and repercussions. Further, the plans themselves changed as the political context shifted. Each day and each week, as the complex political situation in Canada developed, the National Identity and Special Events Task Force, Dagleish told me, responded by inventing new and different plans for the celebrations. By June 1990, the Meech Lake Accord had failed, and Canada was officially in a recession. This did not bode well for the Conservative Party. According to Dagleish this was certainly not a context in which the federal government could announce a 'big birthday bash'. It was imperative to have some celebrations, he said, although the political climate made it 'dangerous'.

According to Dagleish, there was 'no way out' of celebrating, despite the 'shifting sands' of the political situation. The celebrations had to go on, but he

was desperately trying not to 'create a political minefield of extraordinary proportions'. Because, he said, during the summer of 1990 the government was trying to 'get off the mat'. Finally, during that same summer the federal government was seen to mishandle the 'Oka Crisis' (discussed in more detail on p. 112). He admitted that the situation at Oka as well as the Gulf crisis were important in the government's deliberations on how to announce and carry out the celebrations. Dagleish describes this stage (the autumn of 1990) as the time when constitutional deliberations were 'limping along covered with the blood of Oka', and with the recriminations about Meech Lake. He said that, between 1989 and early 1992, the National Identity Task Force developed at least twenty-seven versions of 'identity and unity related projects'.[3] As the Conservative Party's popularity began to plummet in public opinion polls, the most important strategic issue was to make the government appear legitimate. Dagleish said there was finally a 'turn of the tide', linked to the development of a populist and participatory approach. The shift to 'populism' was also apparent in government management of the Constitutional conflicts.

Constitutional context and background

To understand the government's shift to a 'populist' approach and therefore the context of the celebrations, it is important to have at least a cursory understanding of the history of Canada's Constitutional conflict. The 'crisis' in 1992 had its source in the historical conflict between the French and the British, going back to the conquest of the French by the British in 1760 (McNaught 1970: 42–5). Until 1982, the Constitution of 1867 had not been changed drastically. However, starting with the 'quiet revolution' in Québec, governments made numerous attempts to change Canada's constitution to respond to the demands of Québec for a distinct status within Canada. Soon after the 1980 referendum in Québec, which the federalists won, Prime Minister Pierre Trudeau negotiated amendments to the Canadian Constitution, including the Canadian Charter of Rights and Freedoms. While this agreement finally meant Canada was able to change its own constitution without applying to the British Parliament, it also triggered a series of complex changes that strongly influenced the political context of 1992 (Bumsted 1992b; Cairns 1991; Cameron and Smith 1992; Milne 1991; Vipond 1993; Webber 1994). The separatist Québec provincial government of René Levesque 'disassociated' itself from the 1982 changes, a symbolic gesture, as by law Québec's approval was not required (Martin 1993: 199). However, the fact that this major constitutional change was passed without Québec's approval has had long-standing repercussions.

In 1984, Canada elected a majority Progressive Conservative federal government, led by Brian Mulroney. As with other Conservative governments, such as those of Margaret Thatcher and Ronald Reagan, their central projects were the severe reduction of state power, spending, and intervention, and the related aim of a more market-oriented, less protectionist, capitalism (Bashevkin 1991: 107–8;

Feaver 1993; McBride 1993; Simeon 1988). The Progressive Conservatives, 'set out to dismantle those products of Liberal policy'

> that most offended them and their supporters. In the area of federal–provincial relations, the Mulroney government set out to secure Quebec's participation in constitutional renewal, an initiative that resulted in the 1987 signing of the Meech Lake Accord. Jurisdictional decentralisation was thus wedded to market-oriented economics in the first Conservative government – a combination in direct contrast to the centralism and interventionism of the nationalist worldview.
>
> (Bashevkin 1991: 107–8)

Mulroney's government entrusted itself with the mission of 'the "reconstruction" of Canadian society and politics' (Gollner and Salee 1988: 21). The lines of 'reconstruction' are clear in this quote by Mulroney prior to his election in 1984.

> The tragic process of swedenizing of Canada must come to a halt...I am a Canadian and I want to be free...of government intrusion and direction and regimentation and bureaucratic overkill...
>
> As we contemplate the sad state of this splendid nation, we search for reasons why things are as they are. One major reason is that we have a federal government committed to a social democratic collectivist philosophy...It is absolutely clear that the private sector is and must continue to be a driving force in the economy...The role and purpose of government policy will relate primarily to how we can nurture and stimulate the private sector. A Progressive Conservative government will create an overall economic environment which provides exactly this kind of support.
>
> (cited in Gollner and Salee 1988: 14)

In a 1984 speech on free trade in New York city in which he declared Canada 'open for business', he also 'spoke of the need to limit both nationalist and bureaucratic influences on government decision making' (Bashevkin 1991: 126). Brian Mulroney's first Constitutional endeavour was the Meech Lake Accord. It, and the constitutional negotiations of 1992, were designed to 'heal the wounds' of Québec's 1982 exclusion.

The Meech Lake Accord left crucial elements of the proposal undefined and ambiguous, and under the 1982 formula, it had to be ratified by each provincial legislature within three years, before it became part of the constitution. This process would prove to be its undoing, the Accord finally defeated in a dramatic scene in the Manitoba legislature, in which Elijah Harper, an Aboriginal Member of the Provincial Parliament, used procedural tactics (also

called a 'filibuster') to delay its approval until the deadline had passed (Milne 1991: 252). He argued that if Québec was to be recognised as a 'distinct society', the claims of Aboriginal people must be dealt with first. Further, despite promises to the contrary, Native people had been left out of the constitutional consulting process (Milne 1991; Webber 1994). Elijah Harper became a hero to Native people in Canada. His speech gave a high profile to the claims of Native peoples in the context of the Canadian constitution, a profile that was to continue.

After the defeat of the Meech Lake Accord, it was generally agreed that the process, in part because of Prime Minister Mulroney's approach of 'elite accommodation', had left an intensely bitter taste in the mouths of the Canadian public. The idea of a constitutional deal made by eleven white men in a room with closed doors did not meet with some of the new demands by the Canadian public for more participation. Furthermore, the failure of Meech was said to have fuelled Québec's anger at the rest of Canada. Québec's representatives refused to sit at further constitutional negotiating tables until their demands for recognition as a 'distinct society' had been met (Cameron and Smith 1992: 8–9).

Then, over the summer of 1990, the government had to deal with what became known as the 'Oka crisis'. Native people, tired of waiting peacefully for governments to listen to and respond to their demands, began to take direct action. A peaceful vigil by the Mohawks of Kanehsatake to protest the municipality of Oka's plans to expand a golf course, turned into an armed confrontation between the Quebec Provincial Police Force and Mohawk warriors. One member of a SWAT team that attacked the Mohawks was killed (Regroupment de Solidarité avec les Autochtones 1992: 101). The Oka events brought the historical oppression of Native people to the forefront of Canadian politics, and also received international attention as national and international media were filled with images of masked Mohawk warriors carrying automatic weapons, under the surveillance of the Canadian army. Canadian and international Human Rights groups condemned the government's inaction as an abdication of responsibility. They called for the appointment of a mediator and the recall of Parliament. Canada, which sees itself as an international peacekeeper, was now on the international stage as unable to handle its own peacekeeping. Parliament was never recalled. Jeffrey suggests that few Aboriginal Canadians 'failed to conclude that their concerns mattered little to the federal government' (1993: 39).

The failure of the Meech Lake Accord and the political context made the Conservatives change their strategy to one that appeared more inclusive. Designed to counter some of the discontent and anti-government sentiment unleashed by the deliberations on the Meech Lake Accord and Mulroney's approach of 'elite accommodation', the Spicer Task Force was set up to appear more populist. Formally called 'Citizen's Forum on Canada's Future', it was not, in the Forum's own words, a 'traditional royal commission'.

Instead of asking citizens to come to the Forum, the Forum would *go
to the people* – in their living rooms and kitchens, schools and universi-
ties, church basements and temples, farms and reserves, boardrooms
and chambers of commerce, YM/YWCAs, union halls, parks, theatres
– even trains, prisons, street shelters.

(Spicer 1991:16, emphasis mine)

The Forum organised a phone line (which took over 75,000 calls) and devised
special kits for groups to use in order to 'make the Forum a grassroots, do-it-
yourself commission of inquiry' (ibid.: 18). They organised student forums, and
over 7,681 discussion groups and televised Electronic Town Meetings. The
mandate of the Forum was to promote discussion and dialogue on the 'values
and characteristics fundamental to the well-being of Canada' (ibid.: 149).

One of the Forum's most significant findings was the high level of distrust
for and disillusionment with the government, particularly the Prime Minister. In
the Introduction to the final report, Spicer admits that the Final Report 'does
not adequately echo' the anger and the 'fury in the land' they found directed at
the Prime Minister (ibid.: 6–7). The Forum itself, although named as 'indepen-
dent', 'faced entrenched cynicism as suspected stooges of an unpopular
government'. The Forum became an 'instant lighting rod' for the distrust and
anger directed at politicians, governments, bureaucrats and the media (ibid.:
25).

In response to the final report of the Spicer Commission which was released
in June 1991 (Spicer 1991), the federal government began a new round of
constitutional debates and a Special Joint Committee on Renewed Canada (the
Beaudoin–Dobbie Commission) in order to make recommendations to
Parliament about Constitutional reform. Following an approach that gave the
appearance of inclusion, they received 3,000 submissions, listened to testimony
from 700 individuals, and held 78 meetings totalling 227 hours (Beaudoin and
Dobbie 1992).

The changes begun by Trudeau in 1982, had resulted, by Brian Mulroney's
second term of office, in 'a kind of eruptive riot of constitution making' (Feaver
1993: 464). Mulroney's view of constitutional change, as well as his style, drew
upon his background as a labour lawyer who represented management, and as
president of an American Iron Ore Company in Québec (McQuaig 1995:
96–7). He spoke of 'rolling the dice', and 'making deals'. Jeffrey suggested he
treated constitution making as 'just any business' (Jeffrey 1992: 6). Feaver
points out that the 'rhetorical mood had shifted over the years; the emphasis
now seemed to be on the urgency of the new, the contrived, the political
problem solving and the future oriented in Canadian constitutional design'
(1993: 465). Feaver captures the sense of urgency and crisis over the constitu-
tion which was ubiquitous in 1992, Mulroney's peak of 'reinventing Canada'
(Feaver 1993).

When I arrived in Toronto for my fieldwork, the televised conferences of the

Beaudoin–Dobbie Commission on the Constitution of Canada were taking place. The debates were immensely wide-ranging and confusing, as they dealt with major changes to levels of government, the Canada Clause, economic issues, Aboriginal self-government, senate reform, guarantees of seats in the House of Commons for provinces, and Québec as a distinct society. Near the end of the summer, the sense of crisis increased. The press was full of talk of deadlines and 'pushing through a deal' in time for the Québec referendum. Finally, at the very last moment, on 28 August 1992 the negotiators came up with the constitutional agreement known as the 'Charlottetown Accord', named after the city in which it was negotiated. Soon a referendum was called and the fight for the hearts and minds of the Canadian public was on. At the same time the Canada 125 celebrations were going full steam ahead. In the referendum campaigns and the celebrations, 'populism' was a key metaphor.

Designing populist nationalism

The attempt to make the celebrations appear populist had been part of the government's policy from the outset. Their populist celebratory approach had two facets. The first concerned *who* would appear to sponsor the celebrations. Dagleish, from the National Identity and Special Events Task Force, said the government felt that the idea of celebrations 'brought to you by the government' would not 'go down well', due to the recession Canada was experiencing and because of the sinking popularity of the Conservative Party. Therefore, rather than have government, through a crown corporation, run the celebrations, they formed the 'Canada 125 Corporation'. This was a private corporation, at 'arm's length' from the government, and with no legal ties to the crown. The government gave money to the corporation to spend on the festivities. However, the celebrations were explicitly designed so that people would perceive them as *not* organised *by the government*. This privatised version of celebrations was seen by Dagleish to be on the 'cutting edge' of 'event marketing'.

The move to private sponsorship, and private/public 'partnership' based on the model of 'event marketing' in big sporting events such as the Olympics, is a reflection of neo-Conservative ideologies of privatisation and government 'down-sizing'. In the final celebratory plan, the government intended that businesses would facilitate this apparently non-political patriotism, through their sponsorship of activities. The federal government supplied only 50 million dollars, a minuscule amount compared to the immense government investment in the Centennial celebrations in 1967, which I estimate at almost a billion and a half 1992 dollars (Mackey 1996: 112). The rest of the funding was to be raised through corporate sponsorship. If companies donated funds, goods, or services, their logos would appear on advertising materials and Canada 125 merchandise, and their names would be associated with the good feelings the celebrations were expected to arouse. These activities included companies such

as Avis Rent-a-car contributing free car rentals for one of the programmes, and a bus line or airline donating free trips for regional exchange programmes. It also included Canada Dry supplying ginger ale for a National Neighbourhood Party discussed in the previous chapter.

Corporate sponsorship was also intended to help create a fiction of 'non-political' and populist nationalist celebrations, not 'brought to you' by the (political) government, but created through a combination of business sponsorship and 'grass-roots' activities. In the celebratory plans, therefore, the government was constructed as 'political', and the celebratory policy was intended to erase their presence. Canada 125, on the other hand, presented business interests, as 'non-political' and non-partisan. An early advertisement for 'Canada 125' announced that any activity, to receive Canada 125 sponsorship, had to be 'non-controversial, non-partisan, and apolitical'. It described Imperial Oil (Esso) Canada as the sponsor of Canada's national celebrations (Canada 125 Corporation 1992a, see Figure 6.1). The federal government had privatised the country's national celebrations in order to appear non-political, non-partisan, and populist.

In tandem with business sponsorship, the second facet of the 'populist' approach was that 'Canada 125' would focus on *local* celebrations of nationhood – creating or piggybacking on existing local festivals and community events. If a small town regularly held a summer community festival, Canada 125 hoped to have them register as a Canada 125 activity. The Canada 125 Corporation would not directly give funds to local communities, although they might donate flags and banners. They promised, however, that they would 'facilitate' links between corporate sponsors and local communities. If a small-town wished to have a beer tent in their festival, for example, Canada 125 promised to help link the local community with a potential corporate sponsor, such as Molson Breweries. The local community might get a discount, or even a donation, and the corporation would have its name associated with the local community, and with celebrations of the nation. The idea of 'piggybacking' on local events was not only a means of reducing spending, but also a way to bolster the appearance of celebrations of 'the people' as opposed to 'the government'.

Bill Sunfield, a spokesperson for Canada 125 Corporation whom I interviewed, said that the celebrations were intended to promote a political agenda of patriotism and unity to support the federal proposals in the referendum on the constitution, while presenting itself in the 'voice of the people'. It could only work, in Sunfield's words, if it could 'be unity without even being unity'. From the early planning stages, Canada 125 Corporation mobilised a conceptual division between political and non-political patriotism, and between politicians/government/the state and 'the people'. From the outset, according to Ronald Dagleish, the corporation would not support anything seen as 'political'. 'Political' was anything promoting divisions or controversy. He mentioned that they would not support political or controversial issues such as euthanasia,

CANADA 125 invites you and members of your community to consider what you might do throughout 1992 as your personal contribution to our country. Your event or activity should be non-controversial, non-partisan and apolitical and reflect one or more of the CANADA 125 themes listed below.

While CANADA 125 does not offer financial support for community events, we encourage partnerships between local businesses and community organizations to help fund and organize events. We are communicating with the corporate sector in order to facilitate partnerships that can be a positive legacy for the future. We also want to learn about the events and the activities you plan for your community so that we can share your ideas and experience with other Canadians.

Perhaps you already have or are planning an activity that fits the CANADA 125 objectives. We are offering you the opportunity to register your activity to become part of the program of CANADA 125 events and projects that will be taking place across the country in 1992.

Celebrating The Country – Ideas From Other Canadians

When we asked Canadians across the country for their thoughts on our 125th birthday we received a wide variety of responses. Those thoughts can be divided into five common themes which express what Canadians value most about our country:

1. the freedom, opportunity and personal security we enjoy as citizens;
2. a common concern for the environment;
3. the desire to help one another;
4. our wish to get to know one another better;
5. our many achievements as Canadians.

We suggest that CANADA 125 activities and events planned for 1992 use one or more of these themes as their focus.

We also received many suggestions for specific types of events that could take place. Some of these ideas, outlined below, may be applicable to your group or community.

• Plan a celebration to recognize the services we often take for granted i.e. police and fire protection, hospital and ambulance teams.

• With the involvement of your local newspaper, organize an essay writing contest for all ages on one or more of the CANADA 125 themes listed above.

• Celebrate the achievements of the generations of immigrant Canadians who have contributed to our present communities.

• Plan a tree planting project in your municipality, clean up the shoreline of the local river or lake, start a recycling program.

• Set up a volunteer support group to help seniors who are living alone at home.

• Plan a "Walk of Fame" featuring hand and foot prints of significant contributors from the arts, sports, cultural and business communities.

• Open a toy recycling centre for the benefit of children.

• Hold a native heritage festival with an open invitation for all to attend.

• Plan a student exchange visit between your school and a similar one in another community, province or territory.

• Stage a multi-cultural street party with an ethnic foods buffet and everyone dressed according to their own cultural traditions.

• Hold a Flag Day honouring Canada's world-wide contributions to the preservation of freedom.

• Plan a community heritage festival paying tribute to the historical milestones in your home town over the past 125 years.

Figure 6.1 Non-controversial, non-partisan, apolitical patriotism. Early public relations material from Canada 125 Corporation, 1992.

Source: Courtesy of Canada 125 Corporation.

abortion, capital punishment, Oka warriors, or Lesbian and Gay Pride Day. The idea was to make the celebrations something to 'bring Canadians together' in a more 'personal' way by promoting 'person-to-person contact' and community activities. Indeed, in my discussions with planners and strategists in the Canada 125 campaign, the phrases 'non-political', 'grassroots', 'people focus', 'face-to-face' 'real Canadians', recurred with striking frequency. The celebrations, according to Dagleish, were intended to make people see that 'we [Canadians] are *nice* people', and that 'we have something in common'. They were designed to make people remember that in 'our neighbourhoods' and families we are good people – 'it is *politicians* who fight, not *us*'.

A key feature, therefore, of the Canada 125 celebratory policy was the conceptual opposition between 'the government' and 'the people'. 'The people' are presented as the site of authentic and non-political patriotism, whereas government involvement must be erased because people might perceive it as divisive, political, and manipulative. Ironically, it was the government itself that used this opposition to try to legitimate its own actions.

'Diagnostics of power': non-political patriotism and civil society

The reason why the government was denying its role in the Canada 125 cele-brations and why it was conspiring in the seemingly contradictory populist attacks on the 'meddlesome government' was because of the symbolic weight attached to popular conceptions of nation and state. As Handler (1988: 7) points out, 'the state' usually has negative connotations, associated with rational, instrumental organisation, whereas 'the nation' is conceived of as something inherently wholesome, sentimental, and less calculating. The former is typically regarded in pejorative terms as a necessary evil, whereas the latter, like the idea of 'community' is always deemed to be something natural, good, and authentic. In nationalist logic the source of authentic nationhood is seen to originate in 'a people', and ideally the state should reflect this authentic and natural 'nation'.

When conservatives mobilise the idea of nation as the realm of 'the people', they draw on historical conceptions of 'civil society', as well as the notion of the 'public'. These interlinked concepts are central to European political thought and practice, to the development of modern liberal nation–states, to ideas of democracy, and to European political traditions (Taylor 1990). Civil society is usually considered to include areas of social life which are 'organised by private or voluntary arrangements between individuals and groups outside of the *direct* control of the state' (Held 1992: 73). As originated by Locke, the concept of civil society developed into 'a picture of human social life in which much that is valuable is seen as coming about in a *pre- or non-political realm*, at best under the protection of political authority, but by no means under its direction' (Taylor 1990: 105). Taylor contends that the later development of the idea of a

self-regulating economy and the notion of an autonomous 'public' with an opinion, gave body to the Lockean idea that society has 'its own *identity* outside of the *political* dimension' (ibid.: 107–9, emphasis mine). The connected language of 'the people', as in the phrase 'We, the People' (epitomised in the United States War of Independence and the doctrine of Thomas Paine) takes the notion of civil society and links it to nationhood and self-determination. It draws on the idea that

> the people have an *identity*, they have a purpose, even (one might say) a will, *outside of any political structure*. In the name of this identity, following this will, they have the right to make and unmake these structures...This has become a commonplace of modern thought.
>
> (ibid.: 111, emphasis mine)

Yet, as Foucault's work on governmentality (1991) and subjectivity (1986) reminds us, the conception of civil society as an 'autonomous order which confronts and experiences the state as an alien, incursive force' is implausible (see Gordon 1991: 34). As Chatterjee points out, Foucault's concept of governmentality allows us to see this opposition between the state (as a domain of coercion) and civil society (as a zone of freedom) as in fact a 'liberal doctrine' (1995: 32). 'The people' is a political, and hence contested, discursive construct (S. Hall 1981). Using Foucaultian notions of governmentality and subjectivity, I suggest that rather than take the opposition between these realms as 'common sense', it is more useful to explore how the conceptual distinction between them is mobilised and crossed over. We should explore these categories as 'diagnostics of power' (Abu-Lughod 1990: 42) integral to the formation of subjectivities and identity.

Indeed, as I have discussed, these categories which construct civil society as a non-political realm of naturalised national identity opposed to the manipulative and political state were used by the government itself in a bid to legitimate its political programme and transform notions of national identity. It draws on common-sense liberal axioms, thereby naturalising a particular view of national identity and attempting to reinforce particular forms of power.

Celebratory 'taboos' and naturalising imagery

Indeed, in much political discourse (Right or Left), it is an axiomatic assumption that in theory, if not in practice, it should be 'the people' – defined here as 'civil society' and as a non-political realm – who should define and legitimate political authority. It is common sense that 'society has its own *pre-political life* and *unity* which the political structure must serve' (Taylor 1990: 111, emphasis mine).

The nation, therefore, is often constructed with naturalising imagery. As Anderson points out, the nation is often described

either in the vocabulary of kinship (motherland, *Vaterland, patria*) or that of home (*heimat...*). Both idioms denote something to which one is naturally tied. As we have seen earlier, in everything 'natural' there is always something unchosen...And in these 'natural ties' one senses what one might call 'the beauty of *gemeinschaft*'. To put it another way, precisely because such ties are not chosen, they have about them a halo of disinterestedness.

(1991: 143)

Indeed, the recurring images of families, local celebrations, 'face-to-face' and 'grass-roots', in the Canada 125 strategy were an attempt to make Canadian unity and patriotism natural, common-sensical, and non-political.

In an effort to naturalise the idea of unity and patriotism as a non-political, non-governmental, (and hence legitimate) phenomenon, Canada 125 carefully strategised around their celebratory policy. First, they avoided using 'political' language and national symbols of the state. Unity, as a key word in political debate, and therefore a 'political' term, was literally erased from the language and programming of Canada 125. Bill Sunfield, a spokesperson for Canada 125 Corporation, said that words such as unity 'were *taboo* words for us'. Other Canadian symbols such as Canadian flags or maple leaves were also 'taboo' because people might see them as 'political'.

Further, these designers of patriotic policy consciously manipulated and created new patriotic symbols, strategically designed to distance commemoration from politics, and to present the celebrations as 'grass-roots'. Sunfield explained that Canada 125 created its own logo, a 'new Canadian symbol' that had 'it's own symbolic meaning'. He said there was 'a conscious attempt' to stay away from traditional Canadian symbols such as the Canadian flag, in order 'to fulfil the mandate that we were asked to fulfil'. Although Canada 125 Corporations produced a lot of public relations materials (Canada 125 Corporation 1992f, 1992g, 1992h, 1992i, 1992j), the most important 'media vehicles' invented and used by the Canada 125 Corporation were 'tabloid' information pamphlets that were put in almost all Canadian homes in five editions over the spring, summer and fall of 1992 (Canada 125 Corporation 1992b, 1992c, 1992d, 1992e). Compared to some of the very glossy and highly produced patriotic advertising put out by governments and corporations during 1992, the tabloids, printed on newsprint, had a more gritty, less expensive, feel to them (see Figures 6.2 and 6.3). They were designed to show what 'ordinary Canadians' were doing to celebrate the nation. On top of advertising Canada 125 merchandise, they provided listings of local, regional and national events. Sunfield said the tabloids were important because they listed local events that were very important to the corporation because they gave it '*credibility*', they were

proof that Canadians were doing something. And we felt the *most credible* thing that we could do in this tabloid is to have *Canadians tell Canadians* what they are doing. *Nothing* from the *top down.* These are all *real Canadians,* and these were all real things that were happening. And again it was Canadians telling Canadians.

The tabloids had an opening section in which descriptions of patriotic activities were described in 'the voice of the people', these 'human interest' stories about 'real Canadians' were specifically designed to inspire sentimental and naturalised feelings of patriotism.

Figure 6.2 Canada 125 tabloid information pamphlet. Front cover, Volume 1, Number 1, April 1992.

Source: Courtesy of Canada 125 Corporation.

National Activities

Throughout our land, THE CELEBRATIONS ARE IN FULL SWING!

4 *Memories are in the making to share and remember forever, be a part of them. It's all yours to enjoy.*

Here's just a few examples.

Chevrolet
OFFICIAL VEHICLE · VÉHICULE OFFICIEL

Canadian
THE OFFICIAL AIRLINE
of CANADA 125.

CANADA 125 salutes these two companies for helping Canadians rejoice in our people, our land and our future.

The Great Canadian Video Challenge

Video cameras are a part of life for many Canadians so here's a contest to contribute to the celebration of Canada in a very video way.

The spokespersons of the Canadian Video Challenge, Kathleen, the young recording sensation from Québec, and Pat Mastroianni, the young star from the "Degrassi" TV series, invite you to produce a video of 5 minutes or less on any one of the following six categories: community and special events; sports and recreation; arts and culture; environment; community services and business; history and heritage.

You can produce it in any medium you prefer, puppet show, talk show, cartoon, commercial, drama or music video. It's open to your imagination and your own video view. There will be prizes awarded for each category and a grand prize winner. And to make sure you have a fair chance, this contest is not open to professional TV/film makers.

The winning videos will be featured on a major bilingual television special to be broadcast in December 1992. All you have to do is produce your video by September 30, 1992.

CANADA 125 is proud to be associated with the 'Canadian

Video Challenge', a production of Forevergreen Television and Film Productions Inc. of Toronto and Jean-Pierre Laurendeau of Montréal, both in association with CHCH-TV, in Hamilton, the host broadcaster.

To find out the rules and regulations, and get a list of the prizes, call 1-800-361-1992.

Have Camera, will travel

What happens when you put state of the art camcorders in the hands of talented young Canadians and hit the road for 4 months? It's Road Movies, a concept in television programming that will capture Canada as never before.

Eight adventurous, inquisitive videographers, between the ages of 19 and 25, have been selected from a demanding national competition involving hundreds of participants from journalism programs, film schools, colleges and universities across the country. They were chosen because they have passion, a point of view and plenty to say. In late May, armed with camcorders, the videographers visited outposts along the Labrador coast, the far North, the Queen Charlotte Islands, and the cities, towns and villages between. Their video stories of 4 minutes in length will reflect their own experiences

and the life and times of Canada.

The stories, packaged to include a studio component with a young Canadian host, will create a 13 week half-hour television series to be seen on CBC Television. The show will premiere Monday, June 29 at 8:30 pm.

Road Movies will be exciting, original and sometimes provocative television. Produced by Why Not Productions and CBC Television, the series is sponsored by CANADA 125 Corporation and Multiculturalism and Citizenship Canada.

Witness the Power of Kashtin

Canada's rich native culture is making its musical mark in the pop music world through the talents of two singer-songwriter-performers. Claude McKenzie and Florent Vollant are "Montagnais" from the Maliotenam Reserve near Sept-Îles Québec. Known as Kashtin (tornado in Montagnais), their music gives Canadians, and the world, a new sound insight into the traditions and artistry of Canada's native peoples.

Figure 6.3 'The celebrations are in full swing.' Canada 125 tabloid inside page, 1992.
Source: Courtesy of Canada 125 Corporation.

Which 'people'?

The inconsistencies in the government's approach to the politics of celebration, at times verged on the absurd, yet they still reveal modes of inclusion and exclusion in definitions of 'the people'. For example, the Secretary of State's theme song for the 125th anniversary was 'For Love of This Country'. It was played innumerable times on television advertisements celebrating Canada's 125 anniversary, sung by a girl who looked suspiciously like Mila Mulroney, the Prime Minister's wife. This song was originally commissioned by the Conservative Party and first presented at a fundraiser in Montreal in December of 1991 (Winsor 1992a). It is difficult to maintain the fiction of non-partisan celebrations in this context.

Further, Canada 125 corporation refused to give official recognition and rights to use the Canada 125 logo to a publication focusing on gays and lesbians entitled *A Family Portrait: Gay and Lesbian Canada 1992*. Canada 125 told David Roman, who initiated the lesbian and gay project, that they routinely refuse outside use of the logo. One of the other members of the project, Sandra Pate, tested the decision by sending in a fictional application. Pate, owner of a toy poodle named Butch, entitled her proposal 'The Joy of Toys: Toy Poodle Owners of Canada'. It was quickly approved by Canada 125 (Swainson 1992). When interviewed, Brian Barrett, a spokesperson for Canada 125, said the poodle approval would be rescinded as soon as possible. 'We're not infallible. This isn't the Vatican, you know. We're celebrating the country, we're not trying to tear it apart...anything controversial we're staying away from' (Swainson 1992).

Canada 125, in trying to be non-political, also implicitly constructed multi-culturalism as *political*, and therefore not of the *real Canadian people*. In government rhetoric and programmes, and in the Canadian Charter of Rights and Freedoms, multiculturalism is defined as an inherent characteristic of Canadian national identity. Sunfield said that Canada 125 always made an effort to present Canada in a 'representative' way, ('you never saw a tabloid without an Asiatic [sic] person or a black person'). They did not, however, make any effort to *'promote'* multiculturalism because 'that would have been a *political* stand, and we didn't want to have any political connotations'. Canada 125 also refused to support a project for a new 'multicultural' version of the national anthem because it might be seen as too 'political'. Other insiders from Canada 125 spoke about the internal politics of the organisation. They suggested that even people hired with the mandate to include diverse populations in the cele-brations were 'stonewalled' within the organisation and excluded from major decisions. They were seen as too 'political'.

Back to the constitution

While local and national celebrations of Canada 125 were taking place, the constitutional negotiations were dominating all forms of media, and both the extent of the media coverage, and the focus on 'populism' within it, increased during the lead up to the referendum on the Charlottetown Accord on 26 October 1992.

Even before the agreement was reached and the referendum date declared, the government drew together what one journalist called the 'sinews of a powerful communications organisation', a 'propaganda machine', under order of the Communications Committee of the Cabinet (Winsor 1992a, 1992b). All government departments had been ordered to use their communications divi-sions to 'reinforce national unity' (Winsor 1992a, 1992b). With a combined budget for television advertising expected to be over $100 million, the federal Department of the Secretary of State, the Ministry of Multiculturalism and

Citizenship, the Department of Industry, and the Department of Tourism created television advertising campaigns intended to promote national identity and unity. Winsor describes the 'feel-good' campaigns with war-like images: 'a major build-up of capacity to use communications and research as major artillery in the battle for Canadian (especially French-Canadian) hearts and minds' (Winsor 1992a, 1992b).

Further, during this time many businesses took it upon themselves to engage in what I call 'corporate nationalism', using advertising to make statements about the necessity of unity in the country and referring to Canada's 125th anniversary and the constitutional debates (see Figures 6.4, 6.5 and 6.6). The Bank of Montreal put out a special full-colour eighteen-page insert for newspapers and magazines, entitled 'A Portrait of Canada', to celebrate Canada's 125th anniversary and the bank's 175th anniversary (Bank of Montreal 1992). The 'Canada Day' edition of *Maclean's*, Canada's national newsmagazine, had several examples of 'corporate nationalism'. On the inside cover, the Chairman of the Board of the Investors Group, spoke of his commitment to Canada as the son of immigrants, and the need to 'stand up...on behalf of Canada' (Investors Group 1992). The Canadian Imperial Bank of Commerce paid to have a sixteen-page discussion of the Constitution placed in the centre of this Canada Day edition of *Maclean's*, entitled 'The Constitutional Debates: A Straight Talking Guide for Canadians' (Canadian Imperial Bank of Commerce 1992, see Figure 6.4). Imperial Oil (Esso) placed an advertisement in which Arden R. Haynes, Chairman and CEO of Imperial Oil, outlined the risks of constitutional uncertainty, and urged Canadians to 'seize the opportunity to build a new constitutional consensus', and 'apply our hearts, as well as our minds, to the ongoing process of nation building' (Imperial Oil (Esso) 1992, see Figure 6.5). Advertisements either celebrating Canada's 125th anniversary or making comment on the constitution were also put out by the Aerospace Industries Association (1992), London Life Insurance (1992), Tim Donuts (1992), Bell Canada (1992), Noranda (1992) and Maclean-Hunter (1992, see Figure 6.6).

The question to be asked all Canadians of voting age on the same day, 26 October 1992, was: 'Do you agree that the Constitution of Canada should be renewed on the basis of the agreement reached on August 28, 1992?'. Although a detailed analysis of the Accord is not possible here, it proposed, in more than sixty clauses, changes to approximately one-third of the existing Constitution, including, *inter alia*, the definition of Québec as a 'distinct society', renewed commitment to official language minorities, reform of the House of Commons and Senate, a new division of powers between regional and federal governments, recognition of the inherent right of Canada's aboriginal peoples to self-government and amendments to the formula enabling constitutional changes to be passed (Jeffrey 1993; Mackey 1996).[4] The immense scope and sheer number of changes proposed in this Accord are striking. On a comparative note, the United States attempted to make a single amendment to the constitution with the Equal Rights Amendment, and even that was not

The Constitutional Debate

A Straight Talking Guide for Canadians

The mood of Canadians in late 1991 was described by pollsters in a variety of ways, almost all of them negative. Canadians were said to be sour over the economic outlook, intolerant of the regional concerns of other citizens and distrustful of political leaders at all levels of government.

A dangerous cycle, it seems, is now under way in Canada. It begins with the grave doubts people have about Canada's prospects. These doubts often encourage suspicion, prompting Canadians in one region of the country to grow sceptical of the views held by other regions. Suspicion, in turn, leads to an unwillingness to compromise on important issues — an attitude that is fast becoming the most serious stumbling block to resolving our national unity problem. Finally, doubt and anxiety over our ability to achieve lasting national unity contributes to additional economic uncertainty, causing the cycle to repeat itself.

We have the opportunity to break this cycle. The federal government's proposals, released in late September, received close scrutiny before the Special Joint Committee on a Renewed Canada. To assess all these proposals, a series of regional meetings were held across the country in early 1992. Their purpose was to provide Canadians with a forum to express their views on such key constitutional issues as strengthening the economic union, Senate reform, the division of powers and the distinct society clause. Following these meetings, the Special Joint Committee filed its report on February 28.

Recent public polls have suggested that a small majority of Canadians wants an acceptable compromise that will break the current unity deadlock. Indeed, there is the opportunity for a "win/win" outcome to this painful debate. Long-standing constitutional issues are up for discussion, as well as a broad package of economic reforms – reforms that would strengthen the way in which the Canadian economy operates and performs.

The fact that many of these reforms received little initial support among participants at the regional constitutional conferences in no way lessens their importance. Nor does it eliminate the pressing need to continue to work toward their implementation. If even some of them are agreed upon, all Canadians will be better positioned for stronger economic growth in the coming years.

This CIBC publication is a straightforward examination of Canada's constitutional debate. It was produced for CIBC employees to encourage informed discussion.

Figure 6.4 Corporate nationalism 1. Front page of a 16-page section on the constitutional debates inserted into *Maclean's* magazine, 6 July 1992, sponsored by Canadian Imperial Bank of Commerce.

Source: Courtesy of the Canadian Imperial Bank of Commerce.

The Globe and Mail, Friday, May 1, 1992

Nation Building...
An Exercise of the Heart.

From an address by Arden R. Haynes Chairman and Chief Executive Officer, Imperial Oil Limited

The Annual Meeting of Shareholders Toronto, Ontario April 21, 1992

Like many other business leaders, I have been asked from time to time to offer some thoughts on the current search for constitutional reform. I will address this issue from two perspectives. The first, as you would expect, is as chairman of Imperial Oil.

There can be few Canadians who do not realize the magnitude of the economic issues at stake. We often fail to appreciate how fortunate we are and are perceived to be by the rest of the world. Independent studies by the United Nations, O.E.C.D. and the World Competitiveness Report, among others, clearly indicate the achievements enjoyed by the vast majority of our citizens. Only last week, Canada took first place among 160 nations as the best place in the world to live according to the United Nations latest ranking in human development, which rates countries according to factors such as life expectancy, literacy and standard of living.

The very thought that we would risk all that we have accomplished together simply defies understanding. Look at the facts. The dissolution of Canada would result in significant economic dislocation for all citizens. The resulting jurisdictions would be saddled with significant debt, diminished trade and investment prospects, weakened currencies, smaller markets, increased bureaucracy and administrative waste. The structural costs of doing business in Canada are already unacceptably high. This situation will only be compounded for each of us, federalist and separatist alike, if we fail to reconcile our differences.

Nation building truly is an example of the whole being greater than the sum of its parts. Creating smaller countries from the present Canada would destroy rather than create. It would reduce rather than increase our ability to produce and share wealth. It would reduce rather than increase our ability to compete in an increasingly global and unforgiving economy. And it would reduce rather than increase our standard of living and the opportunities available to our children.

In pure economic terms, there is everything to lose and nothing to gain from the willful destruction of one of the most envied nations in the world. If the future of Canada is to be resolved by appeals to the mind, then surely the cause of reformed federalism can, must, and shall prevail.

The second perspective is that of someone who has lived and worked in every part of a united Canada and who wants this country to endure for the sake of his grandchildren.

The bonds of nationhood consist of more than economic convenience or the triumph of reason over emotion. Nation building is also an exercise of the heart. A national heartbeat, evidenced by shared goodwill, tolerance, vision and hope creates the invisible ties from which countries are forged and maintained. After all, the plaque commemorating the 1864 Constitutional Conference in Charlottetown honours the hearts as well as the minds of those who brought about our confederation.

The importance of the heart is the subject of a story called "The Little Prince" written by Antoine de Saint-Exupery. In it, a little prince from a distant planet travels to other worlds in search of meaning for his life. On the planet earth a simple fox at last provides him with the secret: "It is only with the heart that one can see rightly; what is essential is invisible to the eye."

The same secret applies to the process of nation building. One hundred and twenty seven years ago, on April 20, 1865, the Fathers of Confederation set sail for a crucial round of constitutional discussions in the United Kingdom. Like the little prince, they sought a better life for the land from which they sailed. Like the little prince, the answer to that quest lay elsewhere. And, like the little prince, they came to realize that the secret lay in more than tangible terms. They became bound by shared yet invisible dreams and hopes. The resulting vision, often flying in the face of conventional wisdom, became the heartbeat of a new nation.

The words of the 19th century writer Edward Bulwer-Lytton provide sound advice to those involved in the current process of constitutional reform: "A good heart is better than all the heads in the world." This guidance should be applied to the issues now under discussion.

For example, is it fair to include a definition of the distinct society for Quebec that was first recognized under law in 1774 and again in 1867, and in reality exists today? I say yes.

Is it fair to enable Canadians from all regions to participate more equitably in their national institutions and in the exercise of responsibility? I say yes.

And is it fair to maintain a central government with the ability to exercise leadership on a national scale in the interest of all Canadians? I say yes.

To these and other questions I say yes to reform, yes to our national heartbeat and yes to a renewed and united Canada.

However, reform will not be achieved without give and take on the part of our political leaders. I urge them to set to one side areas of narrow self-interest for the good of the country. And I ask Canadians to take active steps to ensure that they do – this is not the time to follow political leadership that is insensitive to the realities necessary to forge our nation.

And so I urge our political leaders and all Canadians of goodwill to seize this opportunity to build a new constitutional consensus. Let us apply our hearts, as well as our minds, to the ongoing process of nation building. And let us create a solution based on one country in which all Canadians, wherever they might be, feel welcome, secure and confident in their future together.

Imperial Oil

Figure 6.5 Corporate nationalism 2. 'Nation-building…an exercise of the heart.' Advertisement sponsored by Imperial Oil.

Source: Courtesy of Imperial Oil Limited.

We believe in one Canada.

Maclean Hunter was founded in Canada in 1887.
During the life of the Corporation, Canada has survived a number of serious social and political challenges.
The current constitutional debate is perhaps among the most significant. As a company that publishes in both of Canada's
official languages, we are particularly sensitive to the fact that there are diverse interests
that need to be accommodated, but our growing presence beyond our borders also gives us an international perspective.
We will not find constitutional harmony unless the cultural distinctiveness of Quebec is acknowledged and
allowed to flourish. We elect politicians across our many jurisdictions to represent us and,
at critical times, to act as statesmen, finding the right balance between legitimate regional concerns and the
longer term national interest of all Canadians. This is clearly the challenge that faces our federal and provincial politicians.
Undoubtedly models can be generated to show that Quebec can exist economically outside Canada, and
that the balance of Canada can exist without Quebec. We believe, however, that all regions of Canada, including Quebec,
will be the poorer for failing to find a constitutional and economic union within which all regions may prosper.
The initial costs of separation, as divisive and often bitter divorce proceedings unfold, would be followed by a
longer term reduction in the standard of living and cultural fabric enjoyed by Canadians.
It is in the interests of all Canadians to find a prompt and workable solution to constitutional,
economic and cultural differences and to show to Canadians and foreigners alike that Canada remains a country of great
economic potential, a safe haven for investment with the prospect for significant and fair returns.
We take seriously the role of the media in this national debate and will endeavour to ensure
a balanced editorial approach to the options facing Canadians. But as a corporate citizen, Maclean Hunter Limited
will champion its view that a renewed federalism, respectful of the rights and aspirations
of all Canadians, is the best option for all of us.

Figure 6.6 Corporate nationalism 3. 'We believe in one Canada.' Advertisment
sponsored by Maclean Hunter.

Source: Courtesy of *Maclean's*.

successful. A journalist invoked Machiavelli's warning: 'It should be borne in mind that there is nothing more difficult to arrange, more doubtful of success, and more dangerous to carry through than initiating change to a State's constitution' (cited in Jeffrey 1993). The Charlottetown Accord, called the 'Charlatan Accord' by some of its critics, proposed innumerable changes, many of which were ill-defined and unclear in their potential effects, in either the long or short term. During the fall of 1992 the media was a battleground of contested visions of Canada, and explicit attempts to influence voters.

When the agreement was first announced, polls showed it held substantial support, and so the government called a referendum, rather than going through the usual amending process, because they were, according to Jeffrey, 'hesitant to proceed once more without the appearance of public consultation' (Jeffrey 1993: 14). The longer the Accord was public, the more contradictory it seemed, reflecting no one political agenda but rather pieces of many. Webber calls the Accord a 'set of largely ad-hoc trade-offs, unsupported by a clear vision of the country as a whole' (1994: 175). The contradictory nature of the agreement was reflected in the debates about it, and the campaigns in the referendum to follow.[5] Each of the constitutional changes proposed by the Accord was highly controversial, and interpreted in very different ways by different people and groups. However, on voting day eight weeks later, the Charlottetown Accord was rejected in the referendum. To many commentators it seemed 'the people' had risen from the flames and shown the great distance between the 'elites' and 'ordinary Canadians'. The rejection was considered by many to reflect 'an underlying current of popular rebellion', and was called a 'popular uprising' (Jeffrey 1993).

The campaigns were very different. Elites and corporate interests supported the centralised and high profile Yes side. The No campaign, dispersed and under-funded, was described as 'Guerrilla warfare' (Jeffrey 1993). The Yes side was characterised as having a 'top-down' strategy and the No side having a 'bottom-up' strategy, coming from the 'grassroots' (Delacourt 1992b). In fact, in a manner similar to the celebratory policy, both sides of the referendum campaigns tried to present themselves as populist and of 'the people'. The Yes campaign, for example, attempted to erase government involvement in the campaign and have it endorsed by 'ordinary Canadians'. Further they prioritised business sponsorship, assuming this would be seen as non-political.

The 'people', and their opposition to 'the politicians' and the 'government', became the main storyline in most versions of the referendum narrative. Jeffrey calls this the theme of ' "the little people" against the elites' (1992: 11). Many articles in the press, supported by authoritative graphs of poll results, showed the weakening of the Yes side ('the elites' who supported the Accord) and the strengthening of the No side ('the people' who rejected the Accord). Articles spoke of the 'Loss of Faith' in Canada's politicians and elites, and 'The Deep Divide' in Canadian society (Delacourt 1992a).[6] Others argued 'Canadians are lashing out at the elites' (Underwood 1992). Many saw the rejection of the

Accord as a massive rebuttal of the Conservative Party and politicians, and a moment in which 'the Canadian people' found their unified and true democratic voice. Others saw the campaign result as the 'harbinger of a new kind of democracy for Canada' (Gwyn 1992).

The Yes side tried very hard to present itself as representative, credible and populist, as a *consensus* that emerged from immense consultation with 'the people'. Their approach was a kind of numerical populism that was ultimately ineffectual and unconvincing. The government, for example, put out full-page advertisements that declared that the 'public consultation' on the accord had been the broadest in history (see Figures 6.7 and 6.8). Readers were told that '*Thousands of people*' were consulted to make this '*unanimous*' agreement that would '*include all parts of Canada*'. The advertisement, released two days before the referendum, when their legitimacy was truly at stake, asked, in bold letters over an inch high that took up half the page: 'WERE CANADIANS CONSULTED ABOUT THE CONSTITUTION?'. The advertisement documented in detail how many people were consulted, and listed all the commissions, joint committees, and policy conferences going back as far as the Spicer Commission. It gave detailed counts of exactly how many individuals and briefs and witnesses were heard. The advertisement also asserted, in more familiar language, that the Charlottetown Agreement is the 'result of federal, provincial, territorial and Aboriginal representatives listening to the input of Canadians *just like you*' (see Figure 6.7).

During the campaign the term 'special interest groups' was commonly used as a derogatory term by both sides. The Yes side presented opponents of the Accord first as 'enemies of Canada'. Later they became 'special interest groups'. This began when the NAC was accused of being just a feminist 'interest group' by Bob Rae, when they publicly announced they would not support the Accord. Finally, later in the campaign, as authoritative polls came out almost daily showing that 'the people' were furious at politicians and would vote No to the Accord, Prime Minister Brian Mulroney argued

> What's happened to this country is that it has been captured by special interest groups. Special interest groups have captured the media and the only people left to speak not for special interests, but for national interests, are the national political parties.
>
> The evolution – I'm sorry, the explosion – of this whole panoply of special interest groups…has made it much more difficult for a government seeking to bring important changes to ensure the legitimacy of those changes.
>
> (cited in Delacourt 1992a)

In this example of unbridled hubris, Mulroney constructed the entire Canadian body politic, except for federal politicians, as a 'special interest group' infested by the Charter.

THE CONSTITUTIONAL PROCESS

WERE CANADIANS CONSULTED ABOUT THE CONSTITUTION?

The Charlottetown Agreement is the result of one of the broadest public consultations in Canadian history.

• Over 700,000 Canadians from all walks of life and representatives of hundreds of concerned groups were listened to and heard.

• National and regional Aboriginal groups consulted Aboriginal peoples.

• In every province and territory, hundreds of public hearings were held.

• Numerous forums and think tanks were organized by universities across the country.

Key Public Forums and the extent of participation by Canadians

Citizens' Forum on Canada's Future (the Spicer Commission):
approximately 700,000 individuals contributed their input to the Forum.

Special Joint Committee on the Amending Process (Beaudoin-Edwards):
209 witnesses were heard and over 500 briefs were submitted by approximately 450 individuals and groups.

Special Joint Committee on a Renewed Canada (Beaudoin-Dobbie):
over 700 witnesses were heard and nearly 3,000 written submissions were received.

Federal Policy Conferences:
1,500 participants included interest groups, academics and Canadians. Conferences were held in Halifax, Calgary, Montreal, Toronto, Vancouver and Ottawa.

Letters responding to individuals and groups from the Minister responsible for Constitutional Affairs:
10,000 letters were sent in response.

Hundreds of thousands of Canadians have participated in these forums since 1990.

The Charlottetown Agreement is the result of federal, provincial, territorial and Aboriginal representatives listening to the input of Canadians just like you. It represents a unanimous agreement to change Canada's Constitution in a way that would include all parts of Canada and chart a course for our future together. These Constitutional proposals are designed to equip Canada with the structures and means to meet the economic and social challenges faced by us today and by those in generations to come.

Figure 6.7 Government populism 1: 'Were Canadians Consulted about the Constitution?' Full-page advertisement placed in *The Globe and Mail*, 24 October 1992.

Source: Privy Council Office. Reproduced with the permission of the Minister of Public Works and Government Services Canada, 1998.

HIGHLIGHTS OF THE CONSTITUTIONAL AGREEMENT

WHAT'S IN THE AGREEMENT?

A social & economic union

The Charlottetown Agreement proposes that the new Constitution contain what most Canadians would agree to be the key economic and social objectives that distinguish us as a country. These social objectives include universal, publicly-administered health care, adequate social services and benefits, quality education, collective bargaining rights and a commitment to protecting the environment.

In a world where trade barriers between countries are falling, another important consideration is to reduce internal barriers within Canada. One of Agreement's key economic objectives would be to promote the free movement of people, goods, services and capital within Canada.

Avoiding overlap & duplication

As things currently stand in Canada, there is some overlap of government services. The Agreement proposes making governments work more efficiently by transferring more control from the federal government to the provinces in areas such as forestry, mining, tourism, housing, recreation, municipal affairs, cultural matters within the province and labour market development and training. The Agreement also proposes to harmonize federal-provincial activity in the areas of immigration, regional development and telecommunications.

Aboriginal self-government

The Agreement recognizes that Aboriginal peoples have an inherent right to self-government. The new Constitution would enable them to develop self-government arrangements and to take their place in the Canadian federation. The proposals would recognize Aboriginal governments as one of the three Constitutional orders of government in Canada. The recognition of the inherent right to self-government would not create any new rights to land nor dilute existing rights.

Parliamentary reform

The Charlottetown Agreement proposes modernizing our democratic institutions. The existing Senate would be replaced by an elected, equal and effective chamber. The new Senate would reflect the equality of the provinces by having an equal number of Senators from each province. Its powers would significantly increase the role of the elected Senators in the policy process. The House of Commons would be based more on the principle of representation by population: the number of seats would vary according to the size of the population. As well, various provinces would be assured a minimum number of seats in the House.

Distinct society

. The new Canadian Constitution would recognize the distinct nature of Quebec based on its French language, unique culture and civil law tradition. Like all other provinces, Quebec would have greater control over immigration and cultural matters within its territory, giving it the means to preserve its heritage.

These are key points in the Agreement. They are the result of bringing thousands of Canadians from all walks of life to the table – a first in Canadian history. The Charlottetown Agreement is now before the people of Canada. It is for you to decide if the proposed new Constitution will equip Canada to meet the economic and social challenges of tomorrow.

It's up to you to think about it and to vote on October 26.
It's important...
to you and to your country.

For more information, call toll-free:
1-800-561-1188

Deaf or hearing impaired:
1-800-465-7735 (TTY/TDD)

Canada

Figure 6.8 Government populism 2: 'What's in the agreement?' Full-page advertisement placed in *The Globe and Mail*, 24 October 1992.

Source: Privy Council Office. Reproduced with the permission of the Minister of Public Works and Government Services Canada, 1998.

In the referendum coverage 'Canadians' were also increasingly defined as particularly unfriendly to immigrants or minorities. Susan Delacourt writes

> The final, big-ticket event of the Yes campaign takes place this weekend with a rally in Calgary. A Chinese cultural festival will be turned into a Yes rally, attended by a rainbow of other ethnic and immigrant groups. It is curious and almost fitting that the Yes campaign should turn to immigrant groups to symbolize itself. Immigrants and politicians have a lot in common in the way Canadians react to them. One-on-one, Canadians are generally kind, helpful and welcoming to immigrants – but they are not as big on the concept of immigration. So, too are they ambivalent about their politicians.
>
> (Delacourt 1992a)

The image of the 'big ticket' event of the Yes side equates politicians and immigrants, but, most interestingly, there is no question that Canadians are anti-immigration. It has now become a fact and common sense. Further, it appears that Chinese people and the 'rainbow of other ethnic and immigrant groups' are defined, with politicians, as on the outside of what is now 'ordinary Canadian'.

Journalist John Haslett Cuff discussed a Yes advertisement that featured a group of children preparing for a class photo. The voice-over stated that they would be told 'No 27,000 times before they are 13'. Therefore 'Vote Yes for Canada'. He argues that:

> The visible minority population of Canada is something less than 10 percent, yet the advertisement shows a predominance of coloured faces, and this propaganda reminds us that the accord has been severely criticised for reflecting the views of too many minorities (Quebec and aboriginal people for instance) to the detriment of a strong federal government. The advertisement simply bolsters this notion.
>
> (Haslett Cuff 1992)

Ordinary Canadians – increasingly defined as white, 'non-political' Canadians – began to be a primary focus in the coverage and in the campaigns. Similar to the situation with the Canada 125 celebrations, the definition of 'ordinary Canadians' implicitly excluded groups defined as 'special interest groups': immigrants, people of colour, lesbians and gays, and even women.

'The people' at the Wallaceford Pumpkinfestival

Wallaceford is a quiet town of about 2,500 people, located in a tobacco farming area. It has a central core with many old and beautifully kept houses. The town is populated mainly by people of British and French background, as well as

Belgians and Ukrainians (many of whom came to the area to grow tobacco). It has few 'visible minorities' (government terminology for racial minorities). The Pumpkin festival I attended had begun ten years earlier, and in 1992, in combination with Canada 125, was the biggest they had ever had. It was estimated that over 40,000 people attended the festival over the course of the weekend.

The pumpkin theme of the festival was woven together to create an environment of 'old-fashioned family fun' – a nostalgic sense of the long-lost ideal small town at Halloween in autumn. When I entered the town at dusk on the Friday evening, houses and shops and streetlights were all decorated with corn stalks and jack o'lanterns. It even smelled like autumn and falling leaves, and it glowed with oranges and harvest colours. Most of the houses were decorated (some in an outrageous manner), reaffirming the sense that these were 'authentic' and 'genuine' celebrations, and not simply commercial and tourist-oriented: this was the authentic and non-alienated *gemeinschaft* of community.

The festival featured no ceremonies with politicians and national anthems, and no 'multicultural' tables, even at the craft fair. The fireworks had a Canada 125 theme, with the new national multicultural version of the anthem playing while colours filled the sky. The parade included a number of floats sponsored by local and national businesses such as Bell Canada, and a Canada 125 float that played theme music from the 1967 centennial celebrations. The only 'ethnic' float, sponsored by local Ukrainian-Canadians, celebrated Canada 125 and 100 years of Ukrainian settlement in Canada.

The idea of 'the local' as the site of non-political patriotism was central to the Canada 125 policy. They thought that erasing government involvement and highlighting businesses and local festivals would again make the celebrations appear non-political. In fact, as in the Wallaceford Pumpkinfest, many of the local festivals were not focused on celebrating the 'multicultural' nation, but became primarily celebrations of unmarked and yet normative local white identity, seen as *Canadian*-Canadian identity. Further, at the Wallaceford Canada 125 Pumpkinfestival, the idea of authentic and unified locality and the opposition between activities seen as political and non- political were mobilised by the organisers to exclude some community members from the festival itself.

Sounding exactly like a Canada 125 advertising brochure, one of the organisers of the festival, Donald, had told me innumerable times over the course of the weekend festival how his town was 'old-fashioned', and 'friendly', and how 'everyone worked together'. Like many other people in Wallaceford and other small towns, he suggested that it was the small size and friendliness of the town that made it possible for them to have such a successful and pleasant festival. Painting a picture of community respect and consensus, he told me that in Wallaceford 'nobody interferes or forces anybody else's opinion. Everyone's opinion is respected.' He mentioned that there had been a small problem in town recently, but that he wasn't sure he wanted to talk about it.

As well as describing the lack of conflict in the town, he also detailed some of

the decision-making and policy-making processes of the festival organising committee.

> The Pumpkinfest committee has maintained an attitude [that] we want to be totally *politically unbiased*. We don't want to, for example, put something in our parade that would be for the Yes or No vote. We are looking for total *impartiality*. We actually a couple of meetings ago issued a *policy*, 'we need a policy here, there's bound to be an issue come up at some time in the future, maybe this year or next year, some controversial type issue'. We [had a] discussion at great length, and we ended up passing the motion...that there should be nothing in the parade or any other event in the festival which would be in *bad taste...We went through the wording*...we didn't want anyone to express any *political* views...we ended up settling on wording that said *'in bad taste'* which would be up to the *discretion of the committee*, which would give *us* a little more *flexibility*, and *that's just the attitude of Wallaceford*, more *flexibility*, more *understanding*. For example, if somebody came with a float for the parade that said something we didn't like, that we thought was a controversial statement they would be politely asked to...[stay out or change the message].

> (emphasis mine)

Donald continued, 'We want *everyone's* opinion respected...We don't want our Pumpkinfestival used as a venue for any *controversial* issues of any sort.'

We return here to the notion of the 'non-political' as a model of consensus, and the institutionalisation of this axiom in policy. Paradoxically, the exclusion of politics and controversy (both phenomena resulting from differences of *opinion*) is presented as a result of the committee and Wallaceford having respect and understanding for different opinions. Embedded within this ratio- nale is the assumption that the community is, or should be, non-political. More importantly, *policy-making* at the local level of the Pumpkinfest parade, in a similar way to policy-making regarding national identity at the federal level in the Canada 125 Corporation, *institutionalised* the exclusion of 'politics' and controversy in order to create and defend a particular version of 'community'. This version of community also defines and limits norms of behaviour, which then become requirements of 'belonging'.

In fact, the 'controversy' that Donald had not wanted to talk with me about was the reason the festival committee made the new policy which outlawed 'bad taste' and controversy. Recently a woman from Wallaceford had charged one of the 'respectable men' of the town with raping her at a school picnic twenty years earlier. A women's shelter in a larger town close to Wallaceford had been supporting the woman in her court case. In response, some townspeople had set up an anonymous fund to defend this man. At this point, the fund contained contributions of over 20,000 dollars. The women's shelter had wanted to have

a float in the parade. The festival committee refused them on the basis of 'politics' and 'bad taste' after the policy meeting Donald described. People in the town were apparently still worried that the women from the shelter would show up and disturb the Pumpkinfestival.

When I asked Donald about the controversy, he said the fact that the town set up the support fund for the accused rapist was an indication of the kind of positive community spirit they have in Wallaceford. 'Even though the man was sentenced by a court', he said, 'Wallaceford stands up for its community members' He added that this was unique and wonderful and showed what a great community Wallaceford is. 'No matter what happens, we stick up for our community members,' Donald assured me.

Donald's expression of local 'community logic' reflects, in microcosm, the opposition between 'the people' and politics in the policy of Canada 125 and the coexisting discourses in the referendum campaigns. This form of identity construction excludes people seen as divisive and political (lesbians and gays, Oka warriors, people who raise 'women's issues'). It reifies a set of norms (*pace* Foucault) which act to categorise and isolate social deviants.

Donald expressed pride in his community's defence of 'its own', in the way it 'stuck together', no matter what. However, the woman who created the 'problem' had also lived in Wallaceford her whole life. In one fell swoop, however, she was effectively constructed as outside the community because of her 'politics', and not deemed deserving of the defence, respect, or community spirit which the accused rapist received. As in notions of 'tolerance' to difference at a national level, difference is not allowed if it threatens the imagined community's non-political *gemeinschaft*. Repeatedly, people who embody forms of political difference perceived to threaten community consensus, are cast outside the boundaries of 'community', and nation. Those left inside the 'community', like Donald, (the political nature of their actions erased in a bubble of self-congratulatory 'non-political' authenticity), may feel pride in the supposedly natural and authentic solidarity and consensus that remain in the community. The notion of the non-political as the model of community consensus draws on key modern liberal frameworks such as civil society, which, when embedded in policy at local and national levels, allows both the exclusion of difference (based on gender, race, ethnicity, or other criteria) and the construction of innocence.

Populism and localism

The conceptual opposition between political and non-political patriotism also had great weight in the town of Brookside, at a Raise-the-Flag Day ceremony held on 26 September 1992, a month before the referendum on the Charlottetown Accord. This opposition was at the centre of a conflict between the mayor and members of the women's service club that had organised the event.

Brookside is a small town approximately one hour outside of a large urban centre. Similar to many other small towns of its kind, its population is mostly white English-speaking Canadian. There are a few Francophones, Native people, people of colour, or groups who explicitly define themselves as 'ethnic', in a politicised sense. At the Raise-the-Flag Day the mayor of Brookside had wanted to use the ceremony for speeches promoting the Yes side in the referendum. Mary, one of the organisers, protested, arguing that patriotism should not be enmeshed with politics. She wanted the occasion to be without political speeches and to focus on the children of the town. She was already concerned that the ceremony would be interpreted as 'political', because, in a ceremony they had had a few weeks earlier, there had been heckling from passers-by on that theme.

When I interviewed her about the Brookside event, Mary interpreted the government as a 'political machine' trying to 'brainwash' and 'ram' the constitutional agreement 'down people's throats'. She also proposed a naturalised division between politicians and the 'real' Canadian people. Although Mary had organised the Raise-the-Flag Day and was planning to vote Yes in the referendum, she explained that there was a big difference between 'the government' and 'the community'. She commented on her feelings about the referendum and the way the government had handled it.

> I just think it's really sad that people...are making it a *government issue*. And it's the country. It has *nothing to do with the government*. You can't let a government...the *government has nothing to do with the country*. We are *a nation* and we are making this a *political issue*...and it's *not* a political issue.

These phrases of Mary's – 'the government has nothing to do with the country', and 'We are a nation...and it's not a political issue' – are strikingly similar to the recurring themes of the Canada 125 strategy and the co-existing discourses. Indeed, Mary's statements draw on the idea of the nation and its people (civil society) existing outside of and in opposition to the manipulative realm of government and party politics. Mary argues for a more natural and less manipulative understanding of the nation and its problems. As with the Canada 125 policy and advertising, the idea of 'non-political' patriotism was linked to naturalised images of 'ordinary people': families, mothers, children, and communities. Mary discusses Canada's crisis:

> To me [Canada] feels like it's an ailing mother who's dying and the kids are all there fighting over what they are going to get out of it...They have the strength to help her, and bring her back. They have that power to help her and they're not doing anything. That's what it feels like to me. And if they would just stop fighting and nurture this ailing mother back to health...It just scares me.

135

Mary's metaphor of the ailing mother in need of nurturing while the children bicker is compelling. It makes her critique of the government and what she calls 'special interest groups' common-sensical and very powerful. It would be difficult to argue that it is morally acceptable for children to argue while their mother dies. It is an argument that defies disagreement if accepted on its own terms. Her naturalised images of Canada as a family continue:

> I've often felt that Quebec has been acting like a spoiled whiny brat. They want to leave home and they get to the point where the parents say 'just go, now you're on your own, if you need us call us, we'll always be here for you but go on out and give it a try, I hope you don't die'. There has to come a point where you can't tolerate it. Yeah I think Canada's pretty close to that...Politicians seem to ruin it. The issue is so much more grass rooted than the way they have approached it...
>
> I think if you actually got all the people in Canada together, if you got a mother of two children from Quebec to sit down with me in my living room, or a bunch of moms, or an aerobic class...Take that Quebec aerobic class and bring it together with an aerobic class in Toronto [and] you're gonna find out that a lot of people have a lot of things in common.

Mary's naturalised images of families, children and ordinary people transform the abstract, complex and distant project of national politics into an understandable and 'common-sense' language. It is significant that in the constitutional debates and coverage, the press also continually used these kinds of family metaphors. The coherence and mobilising power of these images emerge from naturalised understandings embedded within them. Yet such common-sense familial metaphors also delegitimate Québec and other groups demanding recognition in the constitutional discussions, and do so without even addressing the issues at hand. Simply by using the term 'whiny brat' for Québec, Mary makes their demands seem illegitimate, ridiculous, and childish. The image also infantilises Québec's aspirations for sovereignty, suggesting that the federal government should be like strong and knowing parents, parents who would discipline this unruly child.

More to the point, however, the government, politicians and 'interest groups' are constructed as a 'small number' of manipulators *dividing* the country, while the 'ordinary people' are seen to understand and know how to promote *unity*. Unity of all the differences, finding things in 'common', being able to 'get together and agree', is seen as natural and good, whereas division and disunity are seen as unnatural and bad. The naturalness of the unity of the nation is again created through a populist, familial, and highly gendered image: the group of mothers with children at an aerobic class. The 'people', *ordinary* people in families with children, *know* how to solve the problems of the

country, based on their experiences in families and communities. This is just plain 'common sense'. Indeed, these characteristics of the naturalised realm of 'the people' are similar to the definitions of 'civil society' I have discussed above. Civil society is seen as the source of the unified and *non-political* identity of society.

As previously discussed, the Canada 125 policy was also built around the notion of 'the local' as the site of authentic non-political patriotism. For some people at small-town festivals, notions of local place and community became the framework to express ideas of national belonging which limited and defined 'Canadian' to mean white small-town Canadians or others who do not 'create problems'. In Brookside I asked Ron (a man in his early forties, wearing a 'Proud to be Canadian' T-shirt) why his town seemed to be so patriotic. He answered:

> I think it's more a sense of pride and Canadianship in a smaller community, as opposed to a larger place like Toronto. I opened the [*Toronto*] *Sun* this morning and the first thing that caught my eye was a full page of a Greek Minister [doing something for Raise-the-Flag Day]. That's fine if you don't mind that – if you do it to yourselves – *but is that really Canadian?* Unfortunately I think it is in Toronto, I think that's what being Canadian is in Toronto. In a town the size of Brookside, *this* is Canada; getting kids to sign a flag.

Ron's striking comment about being 'really Canadian' was followed by similar descriptions of small-town life in opposition to the big city.

> In a place like Toronto there isn't that sense of being one big family, it's seventy-five different families. It's easier to get ourselves into a project like this because, given what we know, and are known around the community...There's something nice about walking along the street and being able to say 'Hi' to a few people or stand by a window and talk. In Toronto if you say 'Hi' to someone they wonder what's wrong with you.

Ron's romanticisation of small town life because of its face-to-face contact, could be interpreted as a defence against the increasing urbanisation and alienation of postmodern global living. This is the naturalised nation as *gemeinschaft* described by Anderson (1991). However, Ron's discourse is not simply positing the superiority of small-town life over city life. He is mobilising a notion of locality in a discourse of national inclusion and exclusion. The naturalising imagery of nationalism (the nation as family and local community) creates boundaries of exclusion. He suggests that in Brookside, because they know each other, they can be 'one big family', whereas in Toronto they are 'seventy-five different families'. Family, in this moment, means cultural sameness. Toronto is

implicitly set up as multicultural, and therefore, incapable of being 'really Canadian', whereas the small town is more Canadian. Here, concepts and images embedded in Canada 125 policy – face-to-face contact, and the local as the site of authentic national identity – exclude 'multicultural' others from belonging in the nation.

Finally, Ron thinks that the government is destroying the country because of its political motives and 'political correctness', especially their promotion of multiculturalism and other 'Balkanising' factors. The government, too, is opposed to the sincerity and authenticity of small-town non-political patriotism:

E.M: On some of the Canada 125 advertisements they have a lot of multicultural shots...

RON: Politically correct.

E.M.: What do you mean?

RON: That's not a good word in my vocabulary. I use it as sarcastically as possible. Remember when we were talking downtown and I was talking about little events put on by a community. I was saying that small was more sincere than the big scale stuff and the million dollars spent on fireworks. Well that's how those advertisements come across to me. Politically correct scenarios where everyone is singing smacks to me of political statements. Whereas a bunch of people giving out a cake in downtown with friends and neighbours walking by, we are here because we want to, making fools of ourselves because we want to, not because we want to be politically correct.

In this passage, multiculturalism is equated with a manipulative and 'political' large-scale government campaign, and opposed to the sincerity of his local and all white Raise-the-Flag day. In discussing the referendum, Mary also made a series of oppositions in which the government and the politicians, 'brainwash' and 'ram through deals'. For Mary, it was also 'special interest groups' who inhabited the divisive political universe of manipulation, machination, and bickering.

Ron's and Mary' sense of locality – their non-urban, non-multicultural homes and their defence of the *gemeinschaft* of knowing and being known, – is also the secure and authentic jumping off point which allows them to propose that their identities are, or should be, *the* authoritative and authentic national identity. Their communities become a point of opposition to the political and manipulative patriotism of the government, and the un-Canadianness of urban multiculturalism. Further, both see themselves rejecting and even resisting the manipulations of politicians and the government. However, their discourses of belonging use strikingly similar frameworks to those of the government, at least in terms of definitions of authentic Canadianness. Paradoxically, the opposition between political and non-political patriotism allowed Mary and Ron to construct themselves as rebels against the very politicians and the government that used the same populist images in order to influence them.

Legitimacy and 'common sense'

The paradox inherent in the 'rebellion' of the 'local people' against the Conservative government (while using similar conceptual frameworks), raises an important point. If we assess the Conservative celebratory policy in terms of its success, in the short term, to help legitimate the government and their constitutional initiatives, it was a miserable failure. The Charlottetown Accord failed in the referendum, Prime Minister Brian Mulroney resigned as a result of that failure, and the Conservative Party was virtually voted out of existence in the next election. Yet, in the long term, they may have had a different kind of success, because many of their key frameworks have gained legitimacy and greater social space. The press spoke (and still speaks) of the rejection of the Charlottetown Accord and the Conservatives as a 'populist' rebellion, even a new and unprecedented form of Canadian 'anti-elite' consciousness. The idea of 'the people' resisting the Conservative party may be exciting to those of us who don't support their agenda. Yet, it is important to note that while the Conservatives may have been ousted, the even more extreme right and 'populist' Reform Party has increasingly gained power, and in that election were only a few seats short of becoming the official opposition. Further, the programme of the governing federal Liberals has shifted to the right (later, in 1996 they became the official opposition). Ontario, the province in which the festivals took place, elected a Progressive Conservative provincial government that is now slashing social services and fighting unions in the name of 'the people'.

Indeed, the kinds of 'local people' central to Canada 125 discourses have become a defined, marked, and increasingly powerful political force. Recently the telephone area codes in such small-town, mostly white, communities which surround Toronto have been changed to 905, in order to accommodate increased population. The press, accounting for the political clout of this population, has begun to speak of 'The 905 Revolution' (Delacourt 1995). The term 'revolution' also plays on the election slogan of Mike Harris, the Progressive Conservative Premier of Ontario, who described his election platform as a 'common-sense revolution'. Harris was elected, according to results, primarily because of his ability to mobilise and speak to the concerns of voters such as these. Thus, as in the Canada 125 policy, white small-town Canadians have become a defined and politically powerful population of voters, a specific 'public' which is addressed and responded to by political parties. The '905 revolution' is based on anti-government sentiment, opposition to taxes, replacement of the word 'citizen' with 'taxpayer', a belief in individual rights, and anti-immigrant and anti-minority sentiments (Delacourt 1995). Further, people such as these are increasingly, in political discourse and electoral politics, considered the 'ordinary Canadians', the democratic majority, whereas other groups are increasingly defined as 'special interest groups'.

This chapter has shown that the key term 'the people' is a site of political and

discursive contest and that political actors in multiple sites manipulate these terms for their own ends, thereby institutionalising particular notions of identity and belonging. Concepts of the nation and the community as a non-political and natural 'people' draw on notions of 'civil society' and 'the popular' that are fundamental to Western modernity and the development of 'the nation'. Significantly, it is through these liberal categories that the Right has been successful in appropriating the conceptual ground of left and liberal democratic discourse, as they have in Britain (Hyatt 1997) and in India (see Chatterjee 1995). These key assumptions are mobilised in Conservative policy to re-define citizenship and to naturalise the exclusion of some citizens from notions of national belonging without direct reference to culture, race, sexual preference and gender. The conception of 'Canada in crisis' is central to all of these processes, as it is in local peoples' expressions of 'the bottom line', discussed in the next chapter.

7

THE 'BOTTOM LINE'

'Canada first' and the limits of liberalism

In December 1995, the book review page of *The Globe and Mail* announced, 'Political tomes reflect national malaise: Pundits zero in on issues clouding Canada's identity'. Thomas Walkom's review of nine recently published books about Canadian issues of identity begins by declaring that 'Canada is in crisis' (Walkom 1995). The sheer number of books produced on Canadian identity indicate that 'problems' and 'crises' of identity – and demands for solutions to such problems – are persistent features of life in Canada. Increasingly, however, writers who see cultural pluralism as the source of Canada's identity problems are being granted legitimacy. Both Neil Bissoondath's *Selling Illusions: The Cult of Multiculturalism in Canada* (1994), and Richard Gwyn's *Nationalism Without Walls* proclaim that multiculturalism weakens national identity. Gwyn argues that if Canada continues to laud the cultures of others – meanwhile discarding the British Canadian symbols that have historically defined the nation – the nation is in danger, because if the core element of Canada is obliterated, there may be nothing left (Simpson 1995). Although there is in reality no imminent risk of this 'obliteration' occurring, the sense of impending 'crisis' gives these arguments for the defence of 'core culture' (and one might say the obliteration of multiculturalism) a sense of urgent necessity and increasing legitimacy.

These arguments are illustrative of a broader trend of white backlash against the gains made by minorities in Western nations such as the USA, the UK and Australia. Trying to comprehend this backlash, analysts often point to the anxiety and sense of 'crisis' that is used to rationalise it. Winant argues that white US racial identity is now contradictory, confused, and anxiety-ridden as a result of post-war challenges to white supremacy such as the civil rights movement. The sense of crisis has resulted in a series of political projects aimed at wresting back the gains made by minorities, projects in which whites construct themselves as *disadvantaged*. Winant contends that 'imaginary white disadvantage – for which there is almost no evidence at the empirical level – has achieved popular credence, and provides the cultural and political "glue" that holds together a wide variety of reactionary racial politics' (1997: 42). What is at stake in these debates about multiculturalism? In the Australian

context, Johnson suggests that the white backlash, or 'revenge of the main-stream' is not so much a response to the fragmentation of identity, but rather 'involves a retrospective challenge to the attempted incorporation of marginalised groups into "mainstream" identity' (1997: 422). Hage argues that the 'discourse of decline' in Australia results from a previously powerful Anglo-Celtic group, defined by anti-British ideals of egalitarianism and 'mate-ship', struggling to maintain/reclaim its legitimacy during the ascendancy of a new middle-class, urban, Anglo-Celtic elite defined by 'Cosmo-multicultur-alism' (1994b).

This chapter examines what I call 'bottom line' statements from local white people in multiple sites in order to question what was at stake for them in terms of Canadian identity and cultural difference during the 'crisis' of 1992. I use the term 'bottom line' because during interviews there often came a moment when people would use phrases such as 'when it comes right down to it' or 'when it comes down to the crunch', and then proceed to articulate their fundamental beliefs about what Canadian identity *should* be. So far, I have argued that specific forms of Canadian pluralism bolster 'unmarked whiteness' and help to affirm a dominant white Anglophone '*Canadian*-Canadian' culture and nation-alist programme. However, during the 'identity crisis' of 1992, many white Canadians saw multiculturalism as disempowering them, and as a threat to the unity, national identity and progress of Canada. A sense of insecurity, uncer-tainty and crisis fed a backlash to the gains made by minorities, a backlash which was not framed as an overt defence of *whiteness*, but rather, like the books described above, as a defence of national identity and unity. Many believed that cultural pluralism weakened an already crisis-ridden and insecure national iden-tity, and that to bolster itself Canada should be defined on the basis of *Canadian*-Canadian culture, and 'Canada first'.

In this final chapter, I explore how people make sense of the idea of 'Canada first', and show that within the perceived 'crisis' of national identity, liberal discourses of equality, rationality, tolerance and progress are used to make *intol-*erance and hierarchy logical and rational. Further, the conceptual frameworks that made multiculturalism a logical part of the nation-building project in earlier decades are now used to rationalise the desire for a more overtly exclu-sionary national identity. The final sections of the chapter draw together the strands of the book and contextualise the Canadian material within wider debates about Western power, nationalism and globalisation in anthropology and cultural studies.

The logic of 'Canada first'

In September 1992, at a local community festival in Fernwood, a small town in Southern Ontario, I stood on a small bridge overlooking a river, watching a rubber duck race. I began a conversation with two women who were standing beside me. Rachel, a white woman in her early fifties, and Jennifer, her

daughter, in her late twenties, own the local general store. Our discussion demonstrates how the idea that Canada should 'be first' emerges as the logical conclusion to a series of concerns, worries and axiomatic assumptions.

E.M.: I just wondered if you think it's important to celebrate Canada?
RACHEL: We don't do enough of it. I wish we did more of it. We're too split up this country. Like we don't have enough patriotic spirit and it's sad that we are such neighbours to the States and it hasn't rubbed off on us.

Consistent with long-standing patterns of identity construction, Rachel immediately compares Canada with the United States. As in my discussion with the people on the stage in Rockville (Chapter 5), Canada is seen as 'split up', and by implication the patriotism of the USA is seen as unifying.

E.M.: So they are really patriotic...?
RACHEL: We don't have...even just a little bit more. There's just so much difference. Like BC [British Columbia] doesn't even seem to be part of us. Everything just seems so segregated. Now this Québec thing, which is just ridiculous.
E.M: You think it's ridiculous?
RACHEL: Well, I don't know a whole lot about it, it's just sad when you see the country splitting up. Like, so many things, the *politicians* will do one thing, from what I've heard, *the people* so different. Dad was in Montreal for a while just a few weeks ago. He was doing some business and he said the people are fine. It's just the *politicians*. The *ordinary people*, he said they all want a united Canada.

Like the populist patriotism discussed in the previous chapter, Rachel perceives 'the ordinary people' as naturally unified, their patriotism more authentic than that of the politicians who separate and divide the country. But the *content* of Canadianness is still unclear.

E.M.: What are the things about Canada that you think should be celebrated?
JENNIFER: Well, that's just it. What are we up here, other than the beavers, the North? That's about all that's been brainwashed into our heads other than that we are all so multicultural up here. But down in the States they are too.
RACHEL: We need to *amalgamate* all the different cultures a little more. It's good to have the separate ones but we have to all come together. We don't have anything really that says 'we are Canadians'. When you say Scotland you think of kilts, but Canada doesn't have anything like that. *I guess you can say Indians and totem poles*, I suppose.

Jennifer and Rachel refer to quintessential nationalist images – the north, Indians, multiculturalism – but see them as failing to provide an authentic, identifiable and compelling Canadian identity. This failure emerges to bolster anti-government sentiment: the government has attempted to *brainwash* people into multiculturalism. Rachel and Jennifer want an identifiable and authentic identity, represented by what they see as real cultural symbols such as Scottish kilts. There is a telling irony here because, as Hugh Trevor-Roper shows in a seminal article, the emergence of the kilt and the idea of a distinct Highland tradition were *invented* traditions (1983: 15–41). Rachel and Jennifer see the Canadian symbols of the north, Indians and multiculturalism – no less invented as national symbols than kilts – as unsuccessful. Perhaps the fact that that they are invented is too obvious, or perhaps it is not their *invention* that is the problem, but that such invented traditions of Canadian identity are based on symbols that highlight *minority*, and not dominant, Canadian culture.

Indeed, as we see below, the key to an authentic and unified identity is framed in terms of the national 'Canadian culture', and Canadian 'first'.

JENNIFER: When people from Mexico or whatever come up to America...they say 'now we are Americans', whereas when they come over here they make a point of saying 'we are Pakistanians' [sic]. Well, Canadian should be first...How can you stand strong if you're all separate, right? It's almost like we're all these different little countries within a country. But...you can't expect to be a strong country as far as unity. It'd be great if Canada was first and then you still keep your culture.

The logic here is that America is strong because American culture is *first*; America and its culture are the *primary* loyalty of all citizens. Logically, then, the answer to Canada's problems is that 'Canada should be first'. People can still keep their cultures, but for the country to be strong, some form of unified core Canadian culture should be primary.

E.M. So you think Canada should be first. But what are the things that we...?
RACHEL: Yeah, what do we have? We seem to have lost it. Because it used to be like the Royal Family and everything...but even English-speaking people do not support the monarchy anymore...
JENNIFER: I think we cow down to too many of these different groups who say 'we want to have this done in the schools, we want this out here, we want to support our own'. Well you can have that as long as you have *something to fall back on*...
RACHEL: ...Like, this is our *Canadian law*, this is our *Canadian school system*. This is what you accept *if you want to come to the country, you accept it the way it is. You don't try and change it.*

Rachel and Jennifer attribute the disunity in the country to the lack of fixed and identifiable symbols of nationhood and national belonging, blaming people from 'different groups', those we have seen repeatedly described as 'special interest groups'. Finally, for Jennifer the core of Canadianness is a set of laws and institutions, something to 'fall back on'. It is these institutions and laws that outsider 'others' should not be allowed to change.

Rachel's desire for 'amalgamation', and 'Canada first', echoes a body of similar sentiments expressed to me during fieldwork, a recurring sequential 'logic of identity' which usually began with the statement that Canada was 'too divided' or had no (or at least an extremely problematic and weak) cultural identity. One common explanation for this weakness was that Canadian culture was not singular, and therefore unified, but rather plural, and therefore frag-mented. Implicit in this judgement was the *a priori* assumption that a nation, by its nature, should have a unified identity and culture. The solution to this dilemma was often that Canada needed 'one system' or 'one set of rules', or that Canada should 'be first'. These statements were always articulated as part of a sequential logic, embedded in a series of statements and assertions in which the conclusion was that 'other' cultures in Canada should be secondary to 'Canadian culture'. Below I explore how people use concepts such as 'Canadian culture', 'other cultures', 'one set of rules' and 'Canadian first', and trace their links with historically constituted patterns of identity construction.

Demonising and admiring the USA

The constant attempt to construct an authentic, differentiated, and bounded identity has been central to the project of Canadian nation-building, and is often shaped through comparison with, and demonisation of, the United States. The USA has been used as an important external 'other' many times in Canadian history. Early versions of history defined Canadians as kinder to Native people than their American counterparts, and the Canada First Movement as well as the Group of Seven used Canada's Northernness to claim superiority over and difference from the USA. Ironically, while one of Canada's defining and supposedly essential characteristics is tolerance to difference, one of the major socially acceptable forms of overt *in*tolerance has been that directed at the United States.

In my discussions with local white people on the problem of Canadian iden-tity, there was constant reference to the United States, shifting back and forth between demonisation and admiration. The USA might be described as lawless and less tolerant, and Americans as jingoistic 'flag-wavers'; however, as in my discussion with Pam, Jan, and Marcia on the bandstand in Rockville (discussed in Chapter 5), American patriotism and secure identity also inspired envy. To many interviewees, a more American pluralist model was desirable as a solution to the problem of Canada's fragmented and even non-existent identity. Several

people told stories to illustrate their experiences. Donald from Wallaceford argued that:

> [W]e are not a patriotic nation. Compared to the United States for example, which is a very valid comparison. We're not nearly as patriotic. I've been to festivals and fairs and different events on both sides of the border and you can feel the patriotism at every event down there. Whatever it is, it seems to filter into their entire society, right from childhood to senior citizens. And Canadians don't have that...We are just not spontaneously patriotic.

Continuing to describe one small example of spontaneous patriotism in Canada, he argued that scenes like this 'might help' Canada. His almost stereotypical description and demonisation of Americans, indoctrinated into patriotism from the cradle to the grave, shifts to desire for and envy of their strength in their secure identity. The USA emerges as a model to 'help' Canada, with the 'problem' of Canadian identity.

Ron, a participant in the Raise-the-Flag Day in Brookside, also felt that Canadians needed more nationalism, again in comparison to the United States. He saw patriotism as more American, yet also expressed longing for Canadian versions of patriotism.

> Canadians have this reputation of being almost anti-nationalist. If you cheer for the flag or something like that, everybody thinks there's something wrong with you. I think that's got to stop. You don't have to go whole hog like the Americans to the point where the flag is everything, but geez, somewhere there has to be a happy medium.

Although people wanted to carve out a Canadian version of patriotism, being too pro-American, however, was still not really acceptable. Jean, in Brookside, began by comparing Canada to the United States:

> If you move to the States for instance and you are American you may be Greek-American, Anglo-American, or whatever, but you are American first – you are not Greek and then American. Whereas it seems in Canada it's 'I'm French and then maybe Canadian'.

Jean, was, however, careful to pronounce 'I'm not *pro*-American. I'd much rather live in Canada than the States.' Yet she continued to use the USA as a model to solve Canada's problems. For Jean, even if you are not 'pro-American', it is possible to see that their patriotism, and their resulting version of pluralism, in which America is 'first', has benefits. All of the above comparisons of strong American and weak Canadian patriotism took place in the context of discussions on Canada's 'identity crisis'. People used comparison

146

with the United States to argue that pluralism was the problem and that Canada should be 'first'.

'Canada first': many cultures, one set of rules

I met Trevor in a queue at a chip stand the day before the referendum at a Canada 125/Pumpkinfest in Wallaceford. Trevor was white, about 45 years old, dressed casually, and sported a Blue Jays baseball cap. He described himself as a small businessman and, as we ate our chips while shivering in the near-freezing weather, we discussed the Pumpkinfest, the referendum, and Canadian identity. I asked him whether he'd seen the Canada 125 advertisements that present Canada as multicultural, and if that was how *he* saw Canada. Trevor answered that:

> Within Canada, yes, there is a lot of multi...people. I have nothing against that. If you want to live here, then you must feel that it's a great country to live. But it's like the old saying...if you want to live here, then *do like the Canadians do*. If you want to practice *your own culture*, and things like that, then I think you do it *within yourselves*, and *within the group*, and you *shouldn't impose* on anyone else. I think it's great for Canada...*not to discriminate* against anyone. But when you want to *come here*, [if] you want say your *individual church* here, or your *individual school* here...you may have it, but *your culture* and *your people should have to pay* for this. It shouldn't be publicly paid for.

For Trevor 'multi...' people are foreign outsiders who *come* to Canada. They are not, by definition, born here and not, by definition, 'Canadian'. Like official multicultural discourse, while 'it is great' for Canada 'not to *discriminate* against anyone', the *limits* of diversity are clearly defined. People who are 'multicultural' should not 'impose' on Canadians.

Most important for Trevor though, is that *their* cultural activities, if different from 'Canadian', should not be supported through public (Canadian) funds, as if 'multi' people did not pay taxes in Canada. Regarding funding Trevor argued that:

> Well...it's OK to a point because they do it with *Canadians*, but, to a point. But let's not forget what country you're in, and if you want to live here you should be *Canadian first, and whatever you are second*...But this is the way we're going, we're gonna let people do what they want to do and I guess the Canadian government and the Canadian people, they are gonna have to pay for that. And I don't agree...When it *comes right down to the crunch*, are you *Chinese or are you Canadian* living in a Canadian society?

Trevor here comes 'down to the crunch' and answers his own question. One must be a Canadian living in Canadian society. Canadian must be first. But what is Canadian?

> . It's mixed, but it's like anything else, *you have to set the morals,* you have to…there's where you have to, to me, it's the way to run a, well, it's, the *majority,* that, ah, get together. We should have more say within our government, instead of, you know…And that's the way it should go. Like you say, they make a decision and it's wrong, then it should be…Let's try to correct it.

Coming up with a precise definition of 'Canadian' is much more difficult than defining *non*-Canadian. Trevor became confused, hesitant and very angry. He had a hard time explaining just what he meant. He had strong anti-government feelings – somehow 'they' hadn't set the morals. Finally he got down to his 'bottom line'.

> It's just what I said before. If you want to live in Canada then, yes, you are Canadian. If you are living in Canada and you are a different religion and stuff like that, that's your right to do that, and that's what *Canadians allow* you to do. But when it *comes right down to it,* and you say what you *are,* you should be a Canadian if you live here. *Canadian first,* and *whatever you came from before,* and your *culture,* yes, it *comes with you.*

It's important to note here that when it comes 'down to the crunch', Trevor can't actually define 'Canadian', except for something about morals and the majority. Further, Trevor says that difference in terms of culture is acceptable ('your culture…comes with you'), as long as you are 'Canadian' first.

As we have seen throughout the book, the project of Canadian nation-building has not been based on the erasure of difference but on controlling and managing it. Difference is allowed – in defined and carefully limited ways – as long as the *project* of Canadian nation-building comes *first.* In this structure of difference and Canadianness, those defined as the 'real' and 'true' Canadians are the ones who define the appropriate *limits* of difference. As Trevor says, 'Canadians *allow*' 'multi' Canadians to have their religions and cultures as long as they don't '*impose*'. For Trevor, the most important bottom line seems to be the cost of difference. He said he would vote No on the Charlottetown Accord because

> *We* don't want to pay any more to come out of the *actual* Canadian pocket, Canadian pockets, for other people that come in that want their own culture, you know. I mean, why should *we* pay for the school for another…[group] that just want their own culture, and take it out

of the taxpayers that are paying for...actually have *lived here, born and raised here*, pay taxes on their school, and turn around and pay taxes out for somebody that wants a separate school?

Trevor overtly distinguishes between multicultural groups and ['We'] *real* Canadians by speaking of the '*actual* Canadian pocket', which we must assume belongs to 'actual Canadians', who, according to Trevor, are 'born and raised' in Canada.

Trevor said he decided to vote No in the referendum because he did not want to pay for multiculturalism, special schools and other religions. Yet it is important to note that the constitutional changes did not promise a strengthening of multiculturalism, and certainly did not promise separate schools for groups defined as 'ethnic'. Indeed, many of the critics of the Accord argued it might *weaken* Canada's commitment to multiculturalism (see Chapter 6, note 5). In this moment of crisis, however, Trevor felt victimised by the government and 'special interest groups'. In creating a space of white victimisation, those defined as 'multicultural' outsiders emerged to take the role of hated 'other'.

One of the organisers of the Flag Day in Brookside also presented her 'bottom line'. Jean had come from England in her early twenties, over twenty-five years earlier. She felt that the idea of different rights for different groups was simply too 'confusing'.

JEAN: To me you should just keep it quite simple – have *one system* and go with it. We could negotiate ourselves into the grave. Get into an economic slump...

E.M.: But if we were to say we have one culture here...?

JEAN: I'm *not* saying *one culture*, I'm saying *one set of rules*. For me to try and *take away* somebody's *cultural background*, that's asking for trouble. And why should you? It just adds to the *flavour* of everything. But to say that we will *give preferential treatment* to this one and that one...

Jean said that the main issue was not *culture*. The 'bottom line' boiled down to *rules*. It is necessary to have '*one* system'. All must be treated the same. Pam, the organiser of the Flag ceremony in Rockville, distinguished between celebrations of cultural difference, and the granting of special rights:

Somewhere there is a *fine line* between acknowledging our uniqueness, and it's nice to acknowledge and celebrate those differences because, the festivals, especially with the food and the culture and the traditional dancing, is a wonderful way to celebrate, where we're from. But when you start into...granting *special privileges* and *special rights to special groups* that is no way to promote *national unity*. Because then somebody feels left out. Someone's better than they are.

149

For Pam, the multicultural version of culture as 'saris, samosas, and steel bands' (Mullard 1982) was acceptable, but the issue of political *rights* was where she drew the line.

As we have seen, the idea that Canada's 'core culture' should 'be first' is ambiguous and contradictory. Sometimes it means the common denominator of what all Canadians share, sometimes it means the culture of the English-Canadian majority to which others should adapt as the standard, and sometimes it means the rules, regulations and institutions which define the single sovereign nation–state. The project works precisely through this ambiguity and flexibility, as different meanings are stressed at different times.[1] At the same time several important themes emerge in these statements of the 'bottom line'. Below, I have grouped them into three clusters and analyse them in the context of the book's broader argument about the Canadian version of the Western project of nation-building. The first section concerns ideas about core cultures and other cultures and the issue of managing diversity. The second analyses notions of core culture as a set of rights, laws, and rules necessary for progress. The third explores the limits, flexibility, and ambiguity of liberal 'tolerance'.

Core culture versus 'other' cultures: managing, limiting, and tolerating diversity

Despite assertions that Canada should be 'first', most people I spoke with were very careful to maintain the self-conception that they were tolerant of different cultures. In general, people did not suggest that minority groups should reject their cultures, or that Canada should have only one culture, but that Canadian culture should be first, it should be the primary loyalty. Rachel said, 'It'd be great if Canada was first and then you still get to *keep your culture.*' Ron said, 'Canadian first, and whatever you came from before, and *your culture*, yes it *comes with you.*' Jennifer argued that you could have *many different cultures* 'as long as you have something to fall back on'. Jean said, 'I'm *not saying one culture*, or that Canada should "take away somebody's cultural background".' People, therefore, did not see cultural difference *per se* as the problem, only *specific forms* of difference that threaten the unity of the nation.

Some contemporary critics such as Gilroy and Bhabha suggest that dominant power functions through the erasure of difference and the production of fictive national cultural homogeneity, and that symbolic violence and racism are expressed and reproduced through the twin factors of singularity and erasure. However, while the conceptual framework of national belonging discussed above offers clear examples of desires for the subordination of other cultures to a dominant norm, and is an expression of symbolic violence against cultural 'others', this bid for dominance does not function, as Bhabha and Gilroy might suggest, through the erasure of other cultures and the construction of a singular model of culture. Instead it functions within a framework of *plural cultures*, and by mobilising specific definitions of culture. The major process here is not the

erasure of cultural difference but the proper management of cultures – a hierarchy of cultures – within a *unified project*.

Focusing on pluralism and hierarchy, rather than simply erasure and homogeneity, allows for an analysis that does not reproduce the liberal idea that issues of power can be ameliorated simply through inclusion of difference and a non-homogenising notion of culture. While modern capitalist enterprises now include cultural diversity and feed upon the cultural heterogeneity of the global marketplace (see Stuart Hall 1991a, 1991b, 1992b), my approach allows for an analysis which accounts for the power and flexibility of less overtly racialised and apparently more liberal nationalist discourses. Indeed, the recurring paradox of multiculturalism and core culture in Canada is that the proliferation and *plurality* of *other* cultures should add up to the bounded and identifiable core culture of the nation.

The concept of plural cultures resulting in core culture is not new. Rachel argues that Canada needs to '*amalgamate* all the cultures a little more'. The concept of amalgamation was important for the management of cultures in the colonies of the British Empire. Asad suggests that the idea of amalgamating and coordinating the relationship between dominant European cultures (seen as progressive) and subordinate native cultures (seen as less progressive) was an 'attempt to conceptualise the problem of multiculturalism in colonial settings' (1993: 252). In the statements of 'Canada first', above, the central issue is not the erasure of culture, but the proper management of dominant and subordinate cultures, the relationship *between* cultures.

Pluralist amalgamation functions through the making of a conceptual distinction between definitions of culture used for national core culture and for the cultures of 'others'. Official multiculturalism as a basis for national identity mobilises the idea that the 'multi-cultures' are made up of identifiable and commodifiable fragments of culture, a defined range of traditional practices, cultural possessions or lifestyle choices. These are seen as 'folk' practices, as hangovers from original, older, *traditions*. Raymond Williams suggests that definitions of 'folk', in the nineteenth century, tended to consider folk cultural forms 'survivals' following Tylor's 1871 definition in *Primitive Culture*. 'Survivals' are elements surviving 'by force of habit into a new state of society' and have often been described specifically as pre-urban, pre-industrial, and often in contrast with modern popular forms of culture (Williams 1983: 136–7). In colonial settings, however, what mattered in dealing with emergent cultural identities was to manage what had survived of native cultures *in combination* with the new European elements absorbed by them: this totality would be 'controlled, improved, protected, and developed' (Asad 1993: 251). Managing the emergent cultural identity in Canada means the proper coordination of these subordinate cultures, defined as less progressive folk *survivals*, within the totality of a *normative* national culture and the project of nation-building.

National culture, on the other hand, is seen as a whole and integrated way of life with shared and universal values, laws, education, institutions, and a state

that should reflect that national culture. The conceptualisation of 'culture' as a whole national culture and 'the common way of life of a whole people' (as conceptualised by Raymond Williams) developed in Britain in the late nineteenth and early twentieth century. This particular concept of culture was possible because of the development of a 'totalising project' that involved the entire adult population in the electoral process of parliamentary democracy, and the 'growing articulation...of civil society', a situation in which 'all aspects of life...were now to be politicised' (Asad 1993: 249). This project also involved the development of integrating and improving institutions such as those for education, the arts, and local government. These institutions should not, argues Asad, be thought of as expressing a 'single, essential social logic' for they 'certainly did not create a "common life" (in the sense of work and leisure, of worship and sensibility, of commitments and aspirations) for all classes in Britain'. Rather, it was the political ideology of new liberalism that enabled these activities 'to be conceptualised in relation to a normalising project', which made it possible to think of culture as a 'whole way of life' in Williams' sense (Asad 1993: 249). The normalising project in Britain resulted in the conception of a core shared *national* culture coinciding with political boundaries: the ideal conception of a nation–state (Gellner 1983).

In Canada, as in Britain, there exists no common culture for all classes, regions, or cultural groups. However, the *ideal* of, and the work to *create* a common core culture through flexible strategies, has been integral to the project of nation-building in Canada. This book has documented the slow, contested, conflicted, and partial development of that ideal of a national cultural identity, a central practice in the project of nation-building. Government, intellectuals, elites, artists, and a multitude of others, including people in small towns at Canada 125 festivals, have all participated in desiring and articulating that national culture. The attempt to construct a Canadian national core culture has not necessarily entailed the erasure of difference. More important to the project has been the proper management, coordination, and amalgamation of living cultures to create a national core culture.

Although the characteristics of that desired and emergent core culture – its content – have changed over time, and have been worked out anew in distinct political, economic and social contexts, the project of identity construction has some essential and constant features. First, a shared assumption of those who carry out the project has been that a nation, to be a strong and sovereign nation, must have a bounded identity which differentiates it from all others. Second, to create the nation, internal differentiation and cultural diversity will be managed – whether through assimilation, institutionalisation, appropriation, or erasure – in the service of the construction of that core national culture. The particular ways governments and individuals deal with cultural diversity vary in different social, political and economic contexts, and in response to the 'flexible strategies' (Asad 1993: 12) elaborated to respond to those contexts. Yet, historically and in the present, even the proliferation and institutionalisation of

diversity in liberal ideologies such as 'multiculturalism', limit authorised forms of difference to those which do not threaten the project of nation-building and the making of national identity. Further, 'multiculturalism' constructs a dominant and supposedly unified, white, unmarked core culture through the proliferation of forms of limited difference. This process has entailed the construction of a hierarchy of core culture (as a whole way of life) which encompasses fragments of folk 'multicultures'. The 'multicultures' are by definition subordinate, and the unmarked core Canadian culture is, by definition, dominant. Also, the particular forms of pluralism which have emerged have created a situation in which those who share in the white unmarked core culture conceive of themselves as 'real' and 'authentic' Canadians, who tolerate and even celebrate the 'colour' and 'flavour' of multicultural 'others'.

'Bottom line' articulations were often framed as populist resistance to multiculturalism and a government that promoted a non-unifying version of Canada. Yet despite the language of opposition and resistance, the discourses of 'Canada first' and the historical construction of multicultural national identity share basic parameters and precepts. These include the desire for an identifiable, differentiated, bounded and whole identity; the willingness to manage difference to create this whole culture; and the distinction between the whole common culture and the fragments of other cultures. Rather than see 'Canada first' as a form of resistance, I propose the conflict between these views is actually a struggle within a *shared project*. It is a battle over *which* flexible strategies – to manage populations (the nation) in the name of progress – are the most rational and useful in this particular context. These debates can be seen as framed within a particular tradition, and a particular project. In Thomas' elaboration of the notion of 'project', people who share projects may have diverse interests and objectives, intentions and aims. However, they all share and 'presuppose a particular imagination of the situation, with its history and projected future, and a diagnosis of what is lacking' (Thomas 1994: 106). In Canada, the solution to what is lacking (a unified identity and culture, in this case) may be a source of debate and contest, but that a solution must be found in order for the nation to progress, is not.

Desires for 'Canada first' emerged at a particular moment in national and global history. While Canadian identity was proclaimed as 'in crisis', new forms of global capitalism filled the world's stage, economic recession took its toll, forms of right-wing populism emerged, and the federal Progressive Conservative government was seen to have mishandled the job of managing the country. Local white people felt victimised by the government, by special interest groups, and by other forces beyond their control. I suggest that what is at stake in the 'bottom line' statements is not simply homogeneity versus diversity, or assimilation versus multiculturalism. What is at stake is the fact that cultural differences, when mobilised *politically* by minorities, are seen to threaten and fragment the unity and progress of the nation. Demands for 'Canada first' are demands for *loyalty* to the project of nation-building, as it has

been historically defined. In addition, these (unnatural, disloyal, and fragmenting) *political* challenges by minorities threaten the historically constituted *authority* of those who share the unmarked core culture to define and manage both 'crucial homogeneities *and* differences' (Asad 1993: 267). Rather than cultural homogeneity versus diversity, the issue at stake here is the *authority* to define the project. The government and the institutions that have historically had the job of managing diversity, are accused of not handling their managerial authority well. The proliferation of divisions in society (and the fragmentation of the idealised nation and national culture as a 'whole way of life') are seen as evidence of that. The populist and naturalised discourse of 'the people' in opposition to the government creates an authorised space for this struggle for authority. By the 'democratic will of the people', it is 'the people' (historically defined as white assimilated 'Canadian-Canadians'), who should have the authority to define the limits of difference and the project of nation-building.

Many studies of nationalism and the problem of cultural difference have focused on extreme and violent forms of 'ethnic nationalism' which create a model of the nation as culturally and racially homogeneous. A common distinction in literature on nationalism is that made between 'civic' and 'ethnic' nationalism (Ignatieff 1993; Smith 1991). The Western or 'civic' model of nationalism is primarily territorial or spatial: nations must possess territories, and people and territory belong to each other. Civic nationalism is characterised by what Smith calls 'patria': a 'community of laws and institutions with a single political will', a 'sense of legal equality among the members of that community', and a sense of 'citizenship' including civil and legal rights, political rights and duties, and socio-economic rights. Finally, the civic model implies some measure of 'common values and traditions among the population, or at any rate its 'core' community' (1991: 11). Smith argues that in the Western model nations are seen as 'culture communities, whose members were united, if not made homogeneous, by common historical memories, myths, symbols and traditions'. In summary, the components of Smith's 'standard, Western model of the nation' are 'historic territory, legal-political community, and common civic culture and ideology' (ibid.: 10–11).

The 'non-Western' or 'ethnic' model has, as its distinguishing feature, an emphasis on 'a community of birth and native culture'; in other words, 'common descent'. The nation is seen as a fictive 'super-family' whose population can trace its roots to an ascribed common ancestry. Therefore its members are seen to be brothers and sisters differentiated by this descent from outsiders. Concurrent with this, according to Smith, is that 'ethnic' nationalism displays strong popular elements.

> Of course 'the people' figure in the Western model too. But there they are seen as a political community subject to common laws and institutions. In the ethnic model, the people, even where they are not mobilised for political action, nevertheless provide the object of

nationalist aspirations and the final rhetorical court of appeal. Leaders can justify their actions and unite disparate classes and groups only through an appeal to the 'will of the people'.

(Smith 1991: 12)

Finally, the binding role of law in the Western model is fulfilled, in the 'ethnic' model, by 'vernacular culture', usually languages and 'customs'. To summarise, then, the main elements of 'ethnic' nationalism are 'genealogy and presumed descent ties, popular mobilisation, and vernacular languages, customs and traditions' (ibid.: 11–12).

These characterisations of different forms of nationalism are deeply value-laden. I am quite sure that readers, so far, would be able to pick out which is the 'good' and which is the 'bad' form of nationalism. 'Civic' nationalism is often seen as universal and inclusive, whereas 'ethnic' nationalism is viewed as dark, primordial, and exclusionary. But more than that, the Western civic model is seen by some as more democratic, more rational, and even more realistic. For example, in a recent popular study of ethnic nationalism, accompanied by BBC documentaries, Michael Ignatieff suggests that the civic model is 'necessarily democratic' and further, between the two models of nationalism, 'the civic has the greater claim to sociological realism' (1993). Ignatieff opposes the rational and scientific superiority of 'the West' and its individualistic democratic law (characterised by civic nationalism) to the irrational and authoritarian 'Rest', where the community has power over the individual (characterised by ethnic nationalism). He also draws on older discourses that oppose savage human nature to modern civilisation when he admits that he can't help thinking that:

liberal civilisation – the rule of laws not men, of argument in place of force, of compromise in place of violence – runs deeply against the human grain and is only achieved and sustained through the most unremitting struggle against human nature...

What's wrong with the world is not nationalism itself. Every people must have a home, every such hunger must be assuaged. What's wrong is the kind of nation, the kind of home that nationalists want to create and the means they use to seek their ends. A struggle is going on wherever I went between those who still believe that a nation should be a home to all, and that race, colour, religion and creed should be no bar to belonging, and those that want their nation to be home only to their own. It's the battle between the civic and the ethnic nation. I know which side I'm on. I also know which side, right now, happens to be winning.

(Ignatieff 1993: 189)

Ignatieff sees liberal nations as having progressed from the violent, unreasonable, exclusionary state of 'human nature' that the ethnic nations are still mired

within. This approach to examining violent nationalism (as kick-backs to 'human nature') is flawed because it fails to account for the ways in which the particular ethnic nationalisms he examines are the result of processes associated with modernity, 'civilisation', and Western colonialism. Further, when he argues that civic nationalists 'still believe that a nation should be a home to all, and that race, colour, religion and creed should be no bar to belonging', he forgets that civic nations have elaborate immigration programmes carefully planned to prevent the rise of 'social tensions' between the majority and minority, and protect the 'social cohesion' of society. The categorisation of nations into ethnic and civic models, emerging out of Western paradigms, also obscures the ways in which *Western liberal values* can also be mobilised to construct difference and dominance.

Canada could be seen as a classic example of Western civic nationalism. However, the recent rise of populism has resulted in an exclusionary notion of 'the people' as the 'final rhetorical court of appeal', one of Smith's characteristics of 'ethnic' nationalism. Certain categories of people consider that they, as real and authentic Canadians, represent the 'democratic will of the people'. It is those 'people', historically defined as white unmarked *Canadian*-Canadians, who claim the final authority to define inclusions and exclusions in this civic nation. This sounds surprisingly like the 'demotic' elements of *ethnic* nationalism described by Smith.

Significantly, the claim for authority to define crucial homogeneities and differences is not represented through rhetorical appeals to primordial ties of *descent* or *blood* as in ethnic nationalism, or even directly through the idea of a *homogeneous* culture. Rather, as I discuss below, these claims for authority, which in this case propose that unmarked white Canadian culture should be dominant, are often made through appeals to liberal Western universal principles such as rationality, equal rights, progress, and common laws and institutions: the key features of *civic* nationalism.

Core culture and Western universal principles

For many of the people interviewed, the unity of the country was paramount, and maintaining this unity meant having 'Canada first'. But what exactly is Canada? What does it consist of? Many interviewees found it easier to define Canada by what it is not. However, some definitions of the content of Canadianness did emerge. For Jennifer and Rachel, 'special interest groups' who want their own schools are fine as 'long as you have *something to fall back on*'. This 'something' is 'Canadian law' and 'the Canadian school system'. The limit for Jean is that Canada needs 'one set of rules'. For Pam unity is threatened when 'special privileges and special rights' are granted to '*special groups*'. The core culture of Canada (which others should have as their primary loyalty), is not framed as a primordial, essential and homogeneous culture. The content of 'Canada', rather, is based on respect for common institutions and universal

rules, rights and laws. This fits with Smith's conception of 'the people' in the civic Western model of nationalism as a 'political community subject to common laws and institutions' (Smith 1991: 12). In this case, however, rules, rights and laws – all state projects, and all key Western liberal concepts deemed central to civic nationalism – serve as both the content of Canadianness, and a mode of defending one increasingly exclusionary '*Canadian*-Canadian' (some might say 'ethnic') version of it.

In an earlier version of this book I argued, drawing on Catherine Hall's (1992b) and Stuart Hall's (1991a, 1992b) formulations of Englishness as a form of 'ethnicity', that the 'Canadian-Canadians' I interviewed were defending an unmarked and normative white Canadian *ethnicity*. Yet to call white Canadianness an ethnicity does not capture its specificity. While the notion of '*Canadian*-Canadians' as a dominant *ethnic* group enacts a powerful and compelling reversal, forcing us to ask why it is that in Canada the English and French are not considered 'ethnic' but other groups are (see Greenhill 1994 for an exception), it does not capture the combination of the *dominant* and *unmarked* nature of this form of identity. In a similar vein could we call 'Western identity' an 'ethnicity'? The point about these categories of identity – could we think of them as 'dominant and unmarked ethnicities'? – is that people in them do not think of themselves as 'ethnic', but rather, see their customs, beliefs, practices, morals and values as normative and universal. As Richard Dyer puts it regarding 'whiteness', 'at the level of racial representation...whites are not of a certain race, they're just the human race' (1997:3). He also argues that a focus on specific forms of white ethnicity takes away from the important task of studying 'whiteness *qua* whiteness' (ibid.: 4).

The *Canadian*-Canadian model of nationhood, which has 'citizenship', civil and legal rights, political rights and duties, and socioeconomic rights as ideals, is a Western liberal model that places the notion of equality at its centre. Liberal thinkers, despite differences between them, share a body of ideas that Goldberg suggests they used to place themselves in the centre of modernity. Professing themselves as the rational and liberal centre, they constructed other movements such as Marxism, fascism, and anarchism as extreme and marginal. Concepts of individualism, equality, rationality, universality and progress are central to this liberal body of ideas. As Goldberg argues:

> What unites liberals, in spite of their deep differences, then, is the core set of general ideas...ideas taken at once as basic presuppositions and as ideals. Liberalism is committed to *individualism* for it takes as basic the moral, political and legal claims of the individual over and against those of the collective. It seeks *foundations* in *universal* principles applicable to *all human beings* or *rational* agents in virtue of their humanity or rationality. In this liberalism seeks to transcend particular historical social and cultural differences: it is concerned with broad *identities* which it insists *unite* persons on moral grounds, rather than

with those *identities which divide*, politically, culturally, geographically, or temporally. The philosophical basis of this broad human identity, of an essentially human nature, is taken to lie in a common rational core within each individual, in the (potential) capacity to be moved by *Reason*. In keeping with this commitment to the force of reason, liberalism presupposes that all social arrangements may be ameliorated by rational *reform*. Moral, political, economic and cultural *progress* is to be brought about by and reflected in carefully planned institutional improvement...Finally, and for the concern at hand perhaps most significantly, liberalism takes itself to be committed to *equality*. This commitment is open to a wide range of liberal interpretations the particular nature of which distinguishes one form of liberalism from another. Nevertheless, the egalitarian core on which all liberals agree consists in the recognition of a common moral standing, no matter individual differences.

<div style="text-align: right">(Goldberg 1993: 5, emphasis mine)</div>

It was precisely such notions of equality, rationality, universality and progress that emerged in my discussions with people. These liberal concepts were mobilised to make the subordination of 'other cultures' to 'Canadian culture' ('Canada first') rational, reasonable and logical. Indeed, these examples can be seen as supporting Goldberg's claim that the 'irony of modernity, the liberal paradox comes down to this: As modernity commits itself progressively to idealised principles of liberty, equality, and fraternity...there is a multiplication of...the sets of exclusions they prompt and rationalise, enable and sustain' (ibid.: 6).

In discussions with Donald and Ron, a notion of equality based on recognising *unifying sameness* rather than *divisive difference* was linked to rationality, and was used as an argument against cultural pluralism.

RON: I think we've got a country, but I think when Mr. Trudeau came out and started his bilingualism types of cultural programmes...he *Balkanised* the country, instead of trying to play up that *we are all equal* and we are *all Canadian*. We've lost that; we need to get back to that.

DONALD: I've always personally felt that the multiculturalist aspect of Canada was great, everybody living together in *harmony*...great. Unfortunately...it's almost *like a dream that may never happen*. Because no matter what you do or what you say or no matter what happens you can't please everyone all the time. It's *human nature*...So, where do you *draw the line*? The underlying issue is as long as people are treated *fairly, equitably*, I think that those are the key elements. *Equitable in the most emphatic way*.

These two positions locate the principle of equality in opposition to pluralism. Both argue that equality is the ultimate goal, but clearly their notion of it differs from the definition of equality used to legitimate, bilingualism, Native self-government, or the recognition of Québec as a distinct society.[2] The notion of equality is used as a way of 'drawing the line' (Donald's words) between irrational and destructive divisiveness and rational equity/fairness. For example, Ron sees 'Balkanisation' as the inevitable, violent and destructive result of the implementation of programmes that promote cultural diversity and thus inequality. Donald suggests that 'human nature' dictates that if you start giving people different rights, they will fight and anarchy will ensue. The answer, again, is equality. But equality, in these definitions, means sameness. The term Balkanisation triggers rather powerful images of ethnic cleansing and violence, as does the spectre of 'human natures' battling out differences. Equality, then, is part of a discourse that opposes rational civilisation to irrational savagery, as in the opposition between ethnic and civic nationalism.

Further, people mobilised notions of equality, of rationality versus chaos, and finally progress, when discussing the relationship between the cultures in Canada. Jean, after comparing Canada to the United States, suggests:

> [W]e get hung up, we extend so much of our energy and time on this one issue. And the economy is going down the tubes, and all kinds of other issues are being ignored while we spend all our time, energy and efforts on whether one group should be treated differently than another. To me it should be a *non-issue*. You know I just don't see why it is such a major issue. *They're French, they speak French, that's great*. It just *adds to the colour* of the country. Because I speak *French* does that mean I should have *something that the rest of the country doesn't have*? Why? I speak *Romanian*...do I get...? Sure they [the French] were one of the founding cultures of this country but...I just think it creates too much tension or dissension...I don't know I guess it goes back to when the country was established...There were two distinct cultures...but there are so many cultures, there aren't just two cultures, *you cannot give everyone the same equal recognition*. I mean, that's just asking for *chaos*. To me you should just keep it quite *simple – have one system* and go with it. We could negotiate ourselves into the grave. Get into an economic slump.

For Jean, the recognition of all cultures as equal can create 'chaos'. Also, when discussing Québec culture and language and the culture and language of an immigrant group such as Romanians, she plays one minority group off against the other. In the process she erases the specificities of the groups and their histories, and thereby discounts the potential claims of either group. By making all others equal in their difference (and equal in that they are a problem), we return to the idea of the unmarked core Western culture – 'One set of rules' –

as the most rational way to avoid 'chaos'. According to this argument, civic core culture is universal and rational, whereas other cultures are marked, and all equal in their difference from the unmarked and rational norm. They should therefore adjust to this rational norm, in order to ensure the harmony of the nation.

Jean proposes another form of rationalism, arguing that while the nation argues about group rights, 'the economy is going down the tubes'. Canada could negotiate itself 'into the grave' and 'get into an economic slump'. Jean's fears suggest specific ideas about national progress. The commitment to progress is central to modernity and to nation-building, since a nation is, ideally, a 'unified totality defined according to principles of progress' (Asad 1993: 17). Desires for 'Canada first' are seen as necessary for building a unified and secure identity – a kind of moral progress that will contribute to other forms of progress. Here the language of economic rationality and progress rationalises the subordination of other cultures to unmarked core Canadian culture. For Jean, culture should be more unified because it wastes time, and puts economic progress at risk.[3]

Ideas of rationality, efficiency, equality and economic progress were also mobilised to argue against government support of French language programmes. In Rockville, Marcia, Pam and I sat on the stage after the flag raising ceremony, discussing bilingualism. Marcia commented that Québec is a problem, because although she has no objection to anybody speaking 'any language they please in their home', or paying for education in any language, she doesn't think Canada 'as a nation…can provide education and training to everyone…in *two languages*'. Pam suggested that if the government were to support a second language for people it should not necessarily be French but should be selected according to their particular area and region.

PAM: For example, in this particular area, being largely Italian, why would they particularly want to learn German? There's a large Amish and Mennonite population. Why would they particularly want to learn Italian?

MARCIA: In Montpelier French makes perfectly good sense, there is a large population…that still speaks French…But then to turn around and say 'we are going to have a *forced bilingualism* where the second language must be French', is like saying…and the reason it has to be French is that they were here first…

PAM: Oh no, the actual Inuits were, if you want to get really picky…

MARCIA: Yeah, I know, but you see the actual argument is that the second language has to be French because they were one of the founding peoples. That argument won't work because of the Ojibway, the Onondaga, the Seneca, and Iroquioan languages. I mean it just doesn't fly.

The part that really disturbs me…is that…the direction in the rest of the world is to find a common language and use English. India has 200 and some odd different dialects; they have to find a *common language*. Your

first question always should be what language are the air traffic controllers speaking. Whatever language they are speaking will control international commerce...

In this discussion, economic rationality and equality are invoked in such a manner that 'ethno-cultural minorities' (to use government terminology) can discount Québec's claims to bilingual status. Then Native people (as *First* Nations) are brought in to discount Québec (as a *Founding* Nation). Finally, multicultural groups, Native people, and Québec are all equally discounted because English, as the most progressive and efficient language (not just of Canada but of the entire world), should naturally be dominant. It is the common, core language, and the rational progressive choice.

We return here to the Western project of nation-building as 'the continuous physical and moral improvement of an entire governable population through flexible strategies' (Asad 1993: 12). The debates here are about *which* flexible strategies are most effective for bringing about the progress of the nation. However, the necessity of the progress of the nation, and the management of populations for that goal, is taken for granted. In some cases progress is defined as economic and material progress (as in Jean's 'economic slump' and the women in Brookside not wanting to pay for language programmes). In other cases, progress is defined as moral progress (a nation, to be a nation, must have a strong and unified identity, and to ensure this other cultures must be subordinate to core culture). The goal of progress, and the ideologies that inform it, could be seen as one of the main contents of a dominant liberal Western culture defined on supposedly universal principles of rationality and equality. A key to this form of cultural dominance is the presumption of its natural and universal authority – its entitlement – to define all others as 'cultural', marginal, and subordinate to its unmarked centre, and to authorise *which* differences *and* which similarities are allowed within its projects. It is their historically constituted authority to define when and how others may be similar *or* different that people defended with the discourses of reason, rationality, equality and progress.

Liberal tolerance and power

Canadian civic nationalism does not create exclusions through concepts of descent and blood as in ethnic nationalism. Rather, unmarked and supposedly universal Western liberal categories (without the overt goal of erasing difference or constructing cultural homogeneity) are utilised. Here liberal universal principles do not simply allow or ignore intolerance, but are the very language and conceptual framework through which intolerance and exclusion are enabled, reinforced, defined and defended.

Tolerance and equality, both central concepts in liberal discourse, have immensely flexible meanings, and can inform projects in a multitude of ways.

The celebration of (limited, managed, institutionalised) difference, as in Canadian multiculturalism, can, in a moment of crisis, such as the 'crisis' of Canadian identity in 1992, turn into its denial. As Goldberg points out, liberal modernity's response to difference emerges in two forms.

> The first is to deny otherness, the otherness it has been instrumental in creating, or at least to deny its relevance. The second seems less extreme, but the effect is identical. Liberals may admit the other's difference, may be moved to *tolerate* it. Yet tolerance, as Susan Mendus makes clear, presupposes that its object is morally repugnant, that it really needs to be reformed, that is, altered. Thus, liberals are moved to overcome the racial differences they tolerate and have been so instrumental in fabricating by diluting them, by bleaching them out through assimilation or integration. The liberal would assume away the difference in otherness, maintaining thereby the dominance of presumed sameness, the universally imposed similarity in identity. The paradox is perpetuated: The commitment to tolerance turns only on modernity's 'natural inclination' to *in*tolerance: acceptance of otherness presupposes and at once necessitates 'delegitimation of the other'.
>
> (Goldberg 1993: 7)

This kind of 'tolerance' based on liberal values, can be bestowed, rationalised, and used in the project of nation-building, as we saw in the creation of a 'multi-cultural' Canada. However, it can also – using similar liberal frameworks of equality, rationality and progress – turn to intolerance, when it appears the project of nation-building is threatened. This shift, as I have argued, is not necessarily framed in an overt language of cultural erasure or cultural homo-geneity. Multiple cultures – as long as they are properly managed, institutionalised, and heirarchised – are not a problem so long as these cultures are loyal to the Western project of nation-building, a project which entails creating unified totalities of governable populations according to progressive principles (Asad 1993: 12, 17). This project gains its authority and reinforces its power through its ability to construct itself as *not cultural* (in that it is not presented as the project of one cultural or ethnic group), but as *universal* and *rational*. Intolerance of those who are viewed as a threat to the project – as it changes, develops, and adapts to new demands and challenges – therefore does not need to be hinged on overt demands for the erasure of difference and cultural homogeneity. The liberal language of loyalty – loyalty to supposedly neutral and universal concepts of equality and progress, and to laws and institu-tions (the key features of the Western civic nation) – is sufficiently flexible and ambiguous for this task.

Western projects and cultural hybridity: concluding thoughts

Stuart Hall, in an article on cultures, communities and nations within globalisation, says that in his view, 'the capacity to *live with difference*' is the 'coming question of the twenty-first century' (Hall 1993: 359). I agree, but also think it is central to critically question what forms of 'living with difference' we speak of. The Canadian nation-building project has lived 'with difference' from the outset, and has done so through flexible strategies of managing, appropriating, controlling, subsuming, and often highlighting it. This process has shown that the recognition of difference, in and of itself, is not necessarily the solution, just as the erasure of difference *per se* has not always been the main problem. Throughout this book I have sought to expand formulations of Western power which posit that dominance functions and reproduces itself through erasing difference, through the construction of cultural singularity and homogeneity. In saying that the erasure of difference and the construction of homogeneity is not how 'multiculturalism' as a national identity functions, I do not intend to deny its power, construct it as innocent of injustice, nor suggest that minorities are thereby full subjects and citizens. Rather, my purpose has been to explore how liberal values and goals of inclusion and pluralism are an integral part of the project of building and maintaining dominant power, and reinforcing Western cultural hegemony. I suggest that containing analysis at the level of inclusions, exclusions, and the opposition between cultural homogeneity and heterogeneity is not an adequate approach if we hope to understand important features and processes of power in the global culture of the late twentieth century.

If some critics claim that Western culture is about homogenisation and erasure, they also claim that its opposite – a notion of a more fluid, syncretic, less bounded, more *hybrid* notion of culture – is an alternative, and even resistant, mode of imagining cultures and communities. Stuart Hall, in a discussion of the cultural politics of globalisation, suggests that along with cultural homogenisation, globalisation has brought about a dialectic of identities – a shifting between what Robins calls 'Tradition' and 'Translation'. Hall writes, 'Some identities gravitate towards...Tradition', as they attempt 'to restore their former purity and recover the unities and certainties which are felt as being lost' (1992b: 309). Hall's examples of the retreat to 'Tradition' are Muslim fundamentalism, and forms of 'ethnic absolutism' engaged in by some dominant majorities and some minority communities in Western nation–states. The alternative, suggests Hall, are people who 'accept that identity is subject to the play of history, politics, representation and difference, so that they are unlikely ever again to be unitary or 'pure'. These people consequently gravitate towards what Homi Bhabha calls 'Translation' (Hall 1992b: 309). These might be people identified with communities of diaspora, people who can neither return to 'tradition', nor are willing or able to assimilate into dominant cultures and lose their identities. They are 'irrevocably the product of several interlocking histo-

ries and cultures', and they belong 'at one and the same time to several "homes" (and to no one particular "home")' (Hall 1992b: 310). These cultures of 'Translation' are also often described as 'cultures of hybridity'.

For Hall and Bhabha the notion of 'cultures of hybridity' and 'Translation' is epitomised in the model of culture described in Salman Rushdie's controversial *Satanic Verses*. Rushdie himself argues that the book

> celebrates hybridity, impurity, intermingling, the transformation that comes out of new and unexpected combinations of human being, cultures, ideas, politics, movies, songs. It rejoices in mongrelization and fears the absolutism of the pure. *Melange*, hotch-potch, a bit of this and that, is how *newness enters the world*. It is the great possibility that mass migration gives the world and I have tried to embrace it. *The Satanic Verses* is for change-by-fusion, change-by co-joining. It is a love-song to our mongrel selves.
>
> (cited in Hall 1993: 361)

It is important to point out that these identities based on cultural 'hybridity' and 'Translation' are not offered simply as one form of identity emerging from globalisation. They are also posited as alternative or *resistant* models of culture.

The location of identity in the spaces between homogeneous cultures through 'hybridity' and 'Translation' create Bhabha's radical 'Third space of enunciations'. This space, he argues, is the 'precondition for the articulation of cultural difference' (1994: 38). Further, he argues that the recognition of 'the split-space of enunciation' may open the way to conceptualising an '*interna*-tional culture', based not on the 'exoticism of multiculturalism', but rather on the 'inscription and articulation of culture's *hybridity*'. To recognise this space, he argues, 'makes it possible to begin envisaging national, *anti-nationalist histo-ries* of the "people". And by exploring this Third Space, we may elude the politics of polarity and emerge as the others of our selves' (1994: 38–9, emphasis mine). In this view, cultural hybridity is a form of radicalism, an alternative and better way of conceiving culture.

Yet, as Asad points out, 'neither the invention of an expressive youth culture (music, dance, street fashions, etc.), as Gilroy seems to think, nor the making of hybrid cultural forms, as Bhabha supposes, holds any anxieties for the holders of the status quo'. In fact, if one looks closely, such cultural forms are 'comfortably accommodated by urban consumer capitalism' (Asad 1993: 266). They are also comfortably embraced and transformed, as I have shown, by the liberal multi-cultural tradition which sees cultural differences (hybrid or not) as colourful contributions to national culture and tradition. While there is nothing of course wrong with these forms of cultural expression, I agree with Asad when he says that 'the claim to their having revolutionary potential is absurd' (ibid.: 266).

The language of newness and invention, in opposition to 'Tradition' is misguided, because the Imperial project also produced 'syncretic' and 'amalga-

mated' cultures in the colonies (Asad 1993). The colonial tradition of constructing cultures was not only a matter of constructing homogeneity, but also a matter of creative and institutionalised cultural hybridity, indicating that the radical potential – and the idea of the *novelty* of these forms – deserve interrogation. Moreover, the focus on the 'new' can also be seen as participation in an Enlightenment discourse which privileges progress and creation (civilisation) in opposition to backward-looking and primitive 'tradition'.

Stuart Hall, in his discussion of the cultural politics of globalisation, discusses what I see as a more pernicious and frightening form of cultural 'hybridity' and 'Translation', although he does not call it that. He identifies two characteristics of global mass culture. The first is that it is always centred in the West, in the sense that the technology, the concentration of capital and labour, and the images and stories produced of Western societies, are 'the driving powerhouse of this global mass culture. In that sense, it is centred in the West and it always speaks English' (Hall 1991b: 28). However, as Hall points out, this particular form [of global mass culture] 'does not speak the Queen's English any longer'.

> It speaks English as an *inter*national language which is quite a different thing. It speaks a variety of *broken* forms of English; English as it has been *invaded,* and as it has *hegemonized* a variety of other *languages without being able to exclude* them from it. It speaks Anglo-Japanese, Anglo-French, Anglo-German or Anglo-English indeed. It is a new form of *inter*national language.
>
> (Hall 1991b: 28, emphasis mine)

This description of global mass culture as 'Western centred' sounds surprisingly like Bhabha's *hybrid* model of culture. It is *inter*national, as in Bhabha's formulation, and it is made up of 'broken' (or what Rushdie calls 'mongrel' or 'hotch-potch') elements. However, Hall suggests that what we have, despite transgressions and ruptures, is still a situation in which the West has 'hegemonized' global mass culture.

Although global mass culture, according to Hall, enacts a 'peculiar form of homogenisation' which is 'enormously absorptive of things', he points out that the process of homogenisation is 'never absolutely complete'. He argues that 'it does not work for completeness', nor does it attempt to 'produce little mini-versions' of Englishness or American-ness everywhere (1991b: 28–9). Hall argues that globalisation is able to '*recognise and absorb*' differences '*within the larger, overarching framework* of what is essentially an American conception of the world'.

My analysis of pluralist national culture in Canada has argued that cultural difference has been recognised within the context of the overarching framework of the Western project of nation-building, as worked out in the specific context of Canada. The Western project of globalisation, in a similar way, and as formulated by Hall, does not require homogeneity of cultures or the obliteration of

difference. The forms of power associated with globalisation, Hall points out, *'rule alongside and in partnership with'* other economic and political elites. They do *'not attempt to obliterate them'* but rather operate *'through them'*. As in the institutionalisation of cultural difference within the official policy of multiculturalism in Canada, globalisation, according to Hall, must 'hold the whole framework of globalisation in place and simultaneously police that system'. It *'stage manages independence'* within it (1991b: 28–9). Canadian multiculturalism also 'stage manages' independence and cultural diversity within the 'whole framework' of the nation and the Western project.

Hall's fascinating characterisation of global mass culture, describes, I suggest, not a strategy of cultural *homogenisation*, but a strategy of flexibility, of creating and using cultural hybridity within a Western project. Hall argues that to understand globalisation 'You have to think about...how those forms which are different, which have their own specificity, can nevertheless be *penetrated, absorbed, reshaped, negotiated, without* absolutely *destroying* what is specific and particular to them (1991b: 28–9, emphasis mine). Like cultural pluralism in Canada, globalisation is based on the ability to recognise, utilise, absorb and negotiate differences, and the capacity to construct and manage new forms of identity and subjectivity – of both homogeneous *and* hybrid forms. The *recognition* of difference, and the *mixing* of cultures, are necessary and beneficial to globalisation, as it has been necessary for the project of nation-building and the creation of national identity in Canada. In that case, then, 'hybridity' and 'Translation', not unlike 'multiculturalism', are enmeshed with, and are reflections of, particular forms of power, forms that reflect, and also 'translate', a much older flexible Western project.

Western projects attempt to construct cultural *hegemony* without the production of cultural *homogeneity*. Television screens in Western nations in the late 1990s are often full of advertisements for Microsoft Corporation and various brands of personal computers with on-line communications systems. These advertisements promise instant access to all corners and cultures of the world. They also show colourful images of people in India, South America, Africa and Italy, effortlessly jumping into cyberspace – an international space of ideal equality and access. We know, in fact, that this technological equality is not even remotely a representation of reality: e-mail and Internet hook-ups, if you can find them in South Asia, Latin America and Africa, are prohibitively expensive. However, these advertisements exemplify the ways in which Western forms of power happily construct a world (increasingly corporatist and economically driven) in which we have *many cultures, one project*.

Indeed, one of the most important features of Western cultural power is that it is unmarked as culturally specific. As I have shown, regarding the project of nation-building in Canada, it constructs its dominance through culturally *unmarked* and supposedly *universal* notions of rationality, progress and equality. These Western liberal notions helped to construct 'multiculturalism' as a rational, progressive, and equal form of national life in one social and political

context. Yet, these flexible, unmarked and ambiguous Western liberal categories are now mobilised to make more populist and overtly hierarchical forms of identity (such as 'Canada first') rational and reasonable. As Bauman (1989) and Goldberg (1993) have argued, racism and intolerance are not contradictory to, but enabled by, definitions of 'the rational' and 'the reasonable' as they have been defined throughout modernity.[4]

This study of cultural politics and identity in the project of nation-building in Canada identifies Western power as a project that is immensely totalising and also immensely flexible, ambiguous, and mobile. Indeed, mobility is a key characteristic of Western modernity, and has enabled a particularly modern form of power to 'insert itself into pre-existing structures' (Asad 1993: 12). New or old, in colonial history or in the present-day 'new world order' of globalisation, power does not manifest itself in one easily readable and homogeneous form. For this reason it is more useful to examine the flexibility and ambiguity of projects, as I have done in this book, rather than place one's epistemic security in the dialectical opposition between repressive homogeneity (the erasure of difference) and revolutionary hybridity.

NOTES

1 INTRODUCTION: UNSETTLING DIFFERENCES

1 This particular version of nationhood is also configured differently depending on *who*, within Canada, tells the story. For example, an Aboriginal painter, George Littlechild, has a painting that, like the Mountie postcard, is called 'Mountie and Indian Chief'. His version, however, is a painting rather than a photo. The image is cartoon-like, perhaps a comment on the false nature of the supposed photographic 'truth' of the original image (and of dominant versions of history). Further, the Mountie and the Chief are not shaking hands, as they are in the original photo. Between them Littlechild has painted a fence which divides the two worlds, reinforcing Littlechild's caption which says that the image 'brings the viewer face to face with two very diverse cultures'. While Littlechild's painting stresses the uneasy confrontation between different cultures and criticises dominant versions of historical 'truth', the Mountie and Indian Chief photo-postcard stresses the benevolence and tolerance of the Mountie as a symbol of 'Canada's glorious past'.

2 On nationalism see, for example, Balibar and Wallerstein (1991); Bhabha (1994); Foster (1991); Chatterjee (1986, 1993); Gellner (1983); Gilroy (1987); Greenfeld (1996); Kapferer (1988); Kedourie (1960); Kymlika (1995); Nairn (1981); Renan (1990); Smith (1986, 1991).

3 On 'whiteness' see Allen (1994); Delgado and Stefancic (1997); Dyer (1988, 1997); Fine *et al.* (1997); Frankenberg (1993); Roediger (1991, 1994).

4 A few examples of a dense field are Clifford (1983); Clifford and Marcus (1986); Marcus and Cushman (1982); Marcus and Fisher (1986).

5 This includes work by work Allen (1994); Asad (1973, 1979, 1987, 1991, 1993); Asad and Dixon (1984); Chakrabarty (1992); Dyer (1988, 1997); Frankenberg (1993); C. Hall (1992a, 1992b); S. Hall (1978, 1992a, 1993); Martin and Mohanty (1986); Mohanty (1987, 1990, 1991); Morrison (1993); Pratt (1984); Reinhold (1993); Roediger (1991, 1994); Said (1979, 1984, 1989, 1994); Ware (1992).

6 Of course the terms 'modernity' and 'Western' must be used carefully. While there exists no integrated Western culture or monolithic Western identity, the terms 'modernity' and 'the West' indicate a range of historically constructed and powerful concepts, discourses and beliefs which inform practices in complex and systematic ways (Asad 1993).

7 On modernity and nationalism see Asad (1993); Chakrabarty (1992); Chatterjee (1986); Goldberg (1993); S. Hall (1992b); Handler (1988).

8 Berland makes an important point when she admits that she and other feminists have contributed to these Canadian metaphors and discourses of marginalisation, images

which are compelling despite the fact that they contribute to the idea of a common identity (albeit one of shared victimhood) (1995: 523–4).

9 An exception is *The Globe and Mail* journalist Ray Conlogue who criticises this trend (1995a, 1995b). He argues that the one consistent feature of Canadian identity is its racism toward the French-speaking minority.

10 Thomas suggests that if the notion of project was elevated to the level of a central anthropological concept it could be problematic, because it might imply that all social action is always oriented towards innovation or transformation (1994: 105), an implication about intentionality that would not always hold true. Yet clearly this definition of project as a *transformative endeavour* has particular salience when we are talking about activities inspired by a Western view of progress. So the term may be problematic as a universal tenet but in the case of colonialism and nationalism the interest in creating something new and progressive is widespread (Thomas 1994: 105–6).

11 One important variable is regional identity, and how people perceive of their region in relation to the nation as a whole indicates complex power relations. The people who saw themselves as 'ordinary Canadians' were from Southern Ontario, the perceived centre of the nation to those who live there. Historically Canadian nationalism and its symbols have come from this power centre of Ontario and Québec, and defining oneself as simply 'Canadian' reflects a regional nationalist conceit that comes from having a position of power and thus conceiving of one's region as the geographical and conceptual centre of the nation. People from out West call themselves '*Western* Canadian', and from the East, 'Maritime' or '*Eastern*' Canadians, whereas many from Southern Ontario have the privilege of simply calling themselves 'Canadian'. If I had done the work in other regions of Canada, I am sure that many of the debates about nationalism would have focused on *marginalisation*. For this reason, in terms of the research, interviewing white Ontarians is legitimate because as with whiteness and *Canadian*-Canadianness, conceiving of oneself as unmarked and 'normal' is a sign of privilege. It is the very process through which a particular version of identity comes to be seen as normal, and how it constructs difference, that this research explores.

2 SETTLING DIFFERENCES

1 Apparently the British supported the idea of unification because they hoped it would mean that the colonials could then organise their own military defence and 'become sufficiently strong militarily to discourage the Americans from adventurism in the north'. This was in tandem with their desires for less colonial responsibility and expense (Bumsted 1992a: 328–9). Kilbourne suggests the British public was thoroughly bored with the idea of Canada and has been ever since. The House of Commons was only one quarter full when it passed the British North America Act, 'though it filled up immediately after for a debate on the dog-tax bill' (Kilbourne 1989: 13).

2 Berger's discussion of the Canada First Movement does not detail their conceptualisation of Native people and northernness. It does refer to the fact that the Canada First philosophy was frequently explained in the language of a popularised social Darwinism that claimed an evolutionary hierarchy of races, placing 'Negros' at the least developed stage, the Nordic or 'northern man' at the top, and the 'Red Indians', Peruvians, Chinese and Japanese, in the middle (Berger 1966: 19–20).

3 It is important to point out that Canada as a nation was built upon immigrant labour. It was, and still is, stratified in terms of race/ethnicity, and as Roxana Ng points out, gender.

> A review of the history of Canada shows case after case of the use of immigrant labour; Scandinavian and Ukranian labour was brought in to open the frontier, the Chinese to build the railway, etc. Indeed immigration is *the* process through which the stratification of the labour market is produced in the first place, and how it is maintained in the second place; ethnicity is thus an integral part of the composition of the labour market. By the same token, in order to protect themselves from exploitation by employers, men have organized themselves against capital by excluding women, children, and ethnic minorities, thereby contributing to the gender and ethnically segregated character of the labour market.
>
> <div align="right">(Ng 1987: 474 footnote 6)</div>

4 A note on terminology: Following Francis (1992), I use the term 'Indians' when I am discussing *images* of Native people, and the terms Native people, First Nations people, or Aboriginal people when discussing real people.

5 The appropriation of the work of the Group of Seven into a *national* iconography was also problematic because their images of the Pre-Cambrian shield, Algonquin, and 'north of superior' were seen by some Canadians as an imposition of 'one set of foreign images by another equally removed, emanating from metropolitan Toronto, an "Uppity Canada"' (Osborne 1988: 173). The paintings are 'centralist' in that they reflect a vision of central Canada – not the East or the West – as if the centre represented the whole.

6 Landscape imagery has been the subject of debate and critique in the disciplines of Art History, English and Geography. On nature and landscape see Cosgrove and Daniels (1988); Cronon (1995); Daniels (1993); Merchant (1994, 1995); Oelschlaeger (1992); Plumwood (1993); Schama (1995); Turner (1980).

7 More recently Atwood writes that:

> surely the search for the fabled Canadian identity is like a dog chasing its own tail. Round about and round about it goes, with the tail whisking out of sight; whereupon it proclaims the tail elusive, fragile, threatened or absent. And yet, as everyone can plainly see, there is the tail as firmly attached to the dog as ever, continuing to drag, or on the contrary to droop, according to the climate – climate is very important in Canada – or the climate of opinion.
>
> <div align="right">(1995: 8)</div>

8 Recently there have been attempts to add Aboriginal people's and 'multicultural' writing to the canon of Canadian literature – see Hutcheon and Richmond (1990) for example.

3 MANAGING THE HOUSE OF DIFFERENCE: OFFICIAL MULTICULTURALISM

1 These kinds of contradictions also existed on a global scale. Banton points out that after the Second World War, UNESCO, on the one hand, aimed to correct mistaken beliefs about race as permanent type that informed the Nazis. Yet on the other hand, they still used the terminology 'racial type' (Banton 1987:42).

2 Despite all the funding put into protecting Canadian culture, almost twenty years later the story had not changed. In 1977, Alan W. Johnson, head of the Canadian Broadcasting Corporation, suggested:

> We are in a fight for our *soul*, for our cultural heritage and our *nationhood*. *Without a culture* there is no political survival and we are *not a nation*. It is

impossible to calculate, or even describe, the devastating, cumulative effects of the self-invited *cultural invasion* of Canada by American[s]...The timeless objective of surviving has been given a new imperative by the sudden awakening of the contemporary version of our *Canadian crisis of identity and nationhood'*.

(cited in Lehr 1983: 361, emphasis mine)

3 Many of the observations in this section on the flag debate come from analysing a Canadian Broadcasting Corporation special on the flag debate which was originally aired in 1964 at the peak of the debate. It was re-broadcast on 25 July 1993 on the CBC program A Sense of History (Canadian Broadcasting Corporation 1993).

4 I have less than quadrupled the amount, a low estimate. Aykroyd's 1992 figures on the celebration's costs resulted from more than quadrupling the 1967 figures. 'An inflation factor of 4.2% as provided by Statistics Canada was applied to the 1967 cost' (1992: 197). I have loosely followed his lead.

5 The recognition and management of cultural difference does not necessarily mean the recognition of collective rights. In 1969, two years after the centennial celebrations, the federal government brought out its controversial White Paper on Aboriginal peoples. It proposed, among other things, the abolition of Aboriginal status. Allan Smith suggest that it viewed Indians as 'candidates for assimilation into the White mainstream, built on the notion that group characteristics associated with race and visible difference were to be treated as of virtually no consequence' (1992: 241). Prime Minister Trudeau defended the policy as an enlightened one, saying 'the time is now to decide whether Indians will be a race apart in Canada or whether they will be Canadians of full status' (in Bumsted 1992b: 338). It proposed the 'advancement of individual rights of Indians rather than the collective rights of native peoples' (ibid.: 336). In any case the White Paper caused immense controversy and incited protest by Aboriginal people. Opposition to the paper galvanised Native People's political organising.

4 BECOMING INDIGENOUS

1 Recent analyses of 'nature', 'landscape' and 'the environment', see them as social constructs that help to create identities. Mitchell suggests that we should examine nature, landscape and environments not in terms of what they 'are' – as self-explanatory material entities. Nor should we attempt to discover what their essential 'meanings' are by reading them as 'texts'. Rather, one seeks to explore what these concepts do, how they work and how they are instrumental in human cultural practice (Mitchell 1994). This approach to environment and nature draws on similar frameworks developing within anthropology and sociology which also see culture as 'a verb' (Street 1993). On nature and landscape also see Bunce (1994); Carter *et al.* (1993); Cosgrove and Daniels (1988); Cronon (1995); Daniels (1993); Merchant (1994, 1995); Oelschlaeger (1992); Plumwood (1993); Schama (1995); Turner (1980); Wilson (1991).

2 The issue of transnationalism and its effect on fixed notions of culture has been discussed by Appadurai (1991, 1993), Clifford (1992) and Gupta (1992a, 1992b). Critics such as Bhabha (1994), Gilroy (1987), S. Hall (1991a, 1992b) celebrate the 'diasporic' and 'hybrid' forms these identities take. Critics include Asad (1993), McClintock (1995), Mitchell (1996), Srivastava (1996), Thomas (1994), Wilson and Dissanayake (1996).

3 The controversies included the 'The Spirit Sings' exhibit at the Glenbow museum (Assembly of First Nations and Canadian Museums Association 1992; Harrison

1988; Trigger 1988), and the 'Into the Heart of Africa' exhibit at the Royal Ontario Museum (Hutcheon 1994; Mackey 1995; Schildkrout 1991). In response to these challenges and controversies, several museums and galleries implemented programmes to include minority communities (Assembly of First Nations and Canadian Museums Association 1992). Others began to ensure that exhibits about specific minority communities were organised by or curated by members of those communities.

4 In the final report of the project to Canada 125 Corporation, 'Experience Canada', the producers of *Spirit of a Nation*, suggest that:

> A nation's culture is the adhesive which bonds its people. Canada does have a proud heritage and a positive outlook for the future. Canadians need to be allowed to share and celebrate their pride. They need to be encouraged to project that pride and confidence to the rest of the world. Therefore projects like EXPERIENCE CANADA must be funded and made readily accessible to the public. EXPERIENCE CANADA must continue to lead Canadians toward common goals and strengthened bonding as we continue to progress as one nation, proud and strong and free.
>
> (Canadian Heritage Arts Society 1992b: 3)

5 For interesting perspectives on the centrality of Aboriginal people in Australian nationalism see Lattas (1990). On liberal images of Indians in the Hollywood film *Dancing with Wolves* see Thomas (1994: Chapter 6) and on Australian Aboriginal art and the art market see Morphy (1994).

6 I thank Talal Asad for comments on an earlier version of this argument in Mackey (1996).

7 A 1992 exhibit at the Royal Ontario Museum used Native self-representation to try to legitimate itself as a cultural institution after it had been faced with controversy over the 'Into the Heart of Africa' exhibit in 1989–90 (see Mackey 1995). One of the main criticisms made by the opponents of the IHA exhibit was that it had not been curated by African-Canadians. The ROM knew that representing others was a potentially dangerous exercise. As a result, *Fluffs and Feathers: An Exhibit on the Symbols of Indianness* designed by Deborah Doxtater and Tom Hill for Woodland, a cultural centre and museum on the Six Nations Reserve in Brantford, was brought in during the year of the Columbus Quincentennary. There was a sense that even if there were protests, they had 'covered themselves' because Native peoples were representing themselves in the exhibit. However, the exhibit became transformed in its new site in very interesting ways, indicating the resilience of museum visitors and large institutions to change. The exhibit highlighted many 'kitsch' objects that use images of Native people, such as ashtrays, tobacco tins, cheap novel covers, and souvenirs. In its original site in the Woodland Cultural centre, the exhibit had a crowded and casual feel and objects were not, for the most part, in glass cases. The exhibit therefore encouraged a reading of the objects as familiar and ubiquitous (an important point) rather than as sacred artefacts to be venerated. The exhibit space in the ROM was much larger, and objects were in glass cases, thereby calling up a reading of them as artefacts. Further, the Woodland exhibit, for some of the reasons mentioned, encouraged a sense of casualness, which promoted interaction between the objects and the viewers (Interviews Nos, 57, 58, 60). For example, at one point in the exhibit, visitors were encouraged to dress in a buckskin vest and head-dress (provided), and see themselves on a video screen, an activity which worked well in the casual environment at Woodland Cultural Centre. In the ROM, however, visitors seemed to feel that touching the objects was taboo. I watched for over two hours and not one person tried on the clothes, although they did stand and admire these

cheap imitations as if they were works of art. Finally two students from a school tour read the sign inviting them to try the clothes on, and began to do so with great pleasure. Their teacher intervened and told them to stop, saying, 'Do not touch anything in the museum!'

8 Other feminists have also addressed this question of 'voice' and reception. See Lazreg (1988); Mackey (1991); Mani (1990); Mohanty (1990).

9 I do not in any way intend to devalue the importance of self-representation for Aboriginal people or other minorities. As Metis filmmaker Loretta Todd points out, 'Cultural autonomy signifies a right to cultural specificity, a right to one's origins and histories as told from within the culture and not as mediated from without' (cited in Townsend-Gault 1995: 99). I only raise questions about reception.

5 LOCALISING STRATEGIES: CELEBRATING CANADA

1 The names of all towns have been changed and all informants have been given pseudonyms.

2 The Council offers services designed to help newcomers (Immigrants and Refugees) to 'settle and integrate into Canada', including language training, translation and interpreting services, and education and citizenship information.

3 See Julie Marcus (1997) for an analysis of the cultural appropriation of Ayer's Rock into New Age movements and Australian national identity. See Wright (1995) for an examination of the appropriation of Afro-Caribbean symbols in a north-eastern English carnival.

4 Ernie gave me a copy of his speech. I present it here as he gave it to me.

5 In 1992 there was a highly publicised 'random shooting' of a white woman by a black man in a Toronto restaurant. The discourses about this shooting were often framed in terms of comparison with the United States, often including statements along the lines of 'This doesn't happen here – it happens south of the border.' This event – the 'Just Desserts shooting' – fed into a moral panic about immigration. The criminal was an illegal immigrant who apparently should have been deported a year or two earlier. The immigration department was accused of negligence. The result was that immigration laws became even tighter, as if, by definition, because one black illegal immigrant was a killer, all were.

6 Shortly before this interview, after the Rodney King verdict in the United States, Toronto had had a night of 'riots'. In the press these 'riots' were often described as an anomaly because the 'Canadian way' of dealing with difference is usually more gentle and less violent than the America way. In one, the riots were described as part of 'An American Disease' (*The Economist*, 30 May 1992).

6 CRISIS IN THE HOUSE

1 The 'people' and the 'popular' are discursive devices, contested in terrains of struggle. Stuart Hall suggests that popular culture, especially, is organised 'around the contradiction: the popular forces versus the power-bloc'. He suggests that the term 'popular', and 'even more, the collective subject to which it must refer – "the people" – is highly problematic', and made so by the ability of someone such as 'Margaret Thatcher to pronounce a sentence such as "We have to limit the power of the trade unions because this is what the people want".' Hall argues that the 'capacity to *constitute* classes and individuals as a popular force – that is the nature of popular and political struggle' (Hall 1981: 239).

2 A throne speech, given the first day of the opening of Parliament after an election, usually describes the mandate of the government and announces their plans. It is

called a 'Throne Speech' because the speech formally comes from the reigning sovereign of Britain, Canada's head of state.

3 The final report of the Canada 125 Corporation to the federal government points out that 'the constitutional, political and economic climate at the time did not lend itself to these celebrations' (Canada 125 Corporation 1995: 14).

4 For a more in-depth discussion of the Charlottetown Accord, the referendum campaigns and the Canada 125 celebrations, see Mackey (1996).

5 The only generally agreed upon positive aspects of the Accord (at least in the beginning) were the agreements regarding Aboriginal self-government (Jhappan 1992: 15). However, a major objection to the Aboriginal self-government proposals was that made by the Native Women's Association of Canada and supported by the National Action Committee on the Status of Women (NAC). They argued the Accord could exempt Aboriginal governments from the Charter of Rights and Freedoms, and that the equality rights of Native women would therefore not be guaranteed. Judy Rebick (President of NAC) argued that the Charlottetown Accord

> takes back rights won by women and minorities in the 1982 Constitution, it provides no guarantee of equity for Aboriginal women, it threatens new and existing social programmes vital to all Canadians, and it ignores demands for gender equity and minority representation in the senate.
>
> (Rebick 1992: 14)

Of particular concern to the NAC, Pierre Trudeau, and other groups were the changes in the Canada clause, the preamble of the constitution which 'expresses fundamental Canadian values' and which guides the courts in 'their future interpretation of the entire constitution' (Government of Canada 1992a). According to Shelagh Day, the new Canada clause 'modifies the existing rights in the Charter of Rights and Freedoms' (Day 1992: 21). Further, whereas in the current Charter, multiculturalism is asserted with the phrase that the Charter 'shall be interpreted in a manner consistent with preservation and enhancement of the multicultural heritage of Canadians', in the new Canada clause this commitment becomes fuzzy and vague. It is only 'Canadians' and not governments who are committed to 'racial and ethnic equality in a society that includes citizens from many lands who have contributed, and continue to contribute to the building of a strong Canada that reflects its cultural and racial diversity'. There is no protection or promotion mechanism in the new clause. The clause has a similar approach to gender equity. Day suggested that these absences in the clause may have a 'negative impact on the interpretation of these rights' in court, and 'make limits on rights easier to justify' (ibid.: 22).

Finally, Shelagh Day, NAC, Pierre Trudeau, and others suggested that the clause set up a hierarchy of rights. The right to equality and legal protection from other forms of discrimination specifically mentioned in the 1982 Charter are simply not mentioned at all (Day 1992: 22). Indeed, as Andrew Cardozo suggested, in an article about the repercussions of the Accord for ethnic and racial minorities, 'The new Accord is riddled with quotas, affirmative action and special treatment – but it's not for minorities or even women' (Cardozo 1992: 24). Apparently minority groups feared that if they protested about the accord they would be called traitors (Harper 1992). At the same time the government and supporters of the Accord presented it as a solution to all of Canada's constitutional and unity problems.

6 Feature stories in *Maclean's* magazine on 12 and 19 October and 2 November all examine this issue (see, for example, Wilson-Smith 1992). 'Breaking down the vote' (2 November), a report of the voting after the referendum, says that the failure of the Accord 'amounted, in effect to a massive repudiation by Canadian voters of the

country's political and economic elites, the vast majority of which supported the agreement'. An article in the 2 November 1992 *Maclean's*, entitled 'A fury that found its voice', implies the rejection was a decision to 'rebel' (Fotheringham 1992). See also Goar (1992); Newman (1992); Salutin (1992a, 1992b); Walker (1992). For a more detailed discussion of the Charlottetown Accord and the Referendum campaigns, see Mackey (1996).

7 THE 'BOTTOM LINE'

1 I thank Talal Asad for his comments regarding the ambiguity and flexibility of the idea of 'core culture'.
2 Different definitions of 'equal rights' are a matter of different liberal traditions (see Goldberg 1993: 20).
3 In a broader way, in 1990s' Canada, servicing the deficit has become the rationale for the full-scale devastation of the welfare state, cultural institutions, and other social programmes (McQuaig 1995). Often critics of deficit cutting (done in the name of *material* progress), defend social programmes, including multiculturalism, in the language of the historic morality and benevolence of the Canadian state (in terms, we could say, of defending *moral* progress).
4 For both of these writers, racial thinking and intolerance are not aberrant to modernity, but emerge from it. Goldberg argues that 'racial thinking' emerges from transforming categories and conceptions of social subjectivity throughout modernity (1993). Bauman argues that modern conceptions, categories and practices (particularly rationality and reason) were a necessary, although not a sufficient condition, for the Holocaust to occur (1989: 13).

BIBLIOGRAPHY

Abu-Lughod, Lila (1990) 'The romance of resistance: tracing transformations of power through Bedouin women', *American Ethnologist*, 17(1): 41–55.
—— (1991) 'Writing against culture', in Richard Fox (ed.) *Recapturing Anthropology: Working in the Present*, Santa Fe: School of American Research Press, 137–62.
Aerospace Industries Association of Ontario (1992) 'It's time to look up. Say "yes" on Monday', (1/4 page advertisement), *The Toronto Star*, 24 October 1992.
Allen, Theodore (1994) *The Invention of the White Race*, London: Verso.
Allor, Martin (1987) 'Projective readings: cultural studies from here',*Canadian Journal of Political and Social Theory/Revue Canadienne de théorie politique et sociale*, Vol. XI (1–2): 134–8.
Allor, Martin, Daniel Juteau and John Sheppard (1994) 'Contingencies of culture: the space of culture in Canada and Quebec', *Culture and Policy*, 6(1): http://www.gu.edu.au/gwis/akccmp/6_1_03.html
Anderson, B. (1991) *Imagined Communities: Reflections on the Origin and Spread of Nationalism*, (revised edition) London: Verso.
Ang, Ien and John Stratton (1996) 'Asianing Australia: notes toward a critical transnationalism in cultural studies', *Cultural Studies*, 10(1): 16–36.
Angel, Sumayya (1988) 'The Multiculturalism Act of 1988', *Multiculturalism*, 11(3): 25–7.
Appaduria, Arjun (1991) 'Global ethnoscapes: notes and queries for a transnational anthropology', in Richard Fox (ed.) *Recapturing Anthropology: Working in the Present*, Santa Fe: School of American Research Press, 191–210.
—— (1993) 'Patriotism and its futures', *Public Culture*, 5(3): 411–30.
Armstrong, Jeanette (1990) 'The disempowerment of First North American Native Peoples and empowerment through their writings', *Gatherings: the En'owkin Journal of First North American Peoples*, 1(1): 143–5.
Asad, Talal (1973) *Anthropology and the Colonial Encounter*, New York: Humanities Press.
—— (1979) 'Anthropology and the analysis of ideology', *Man*, 14: 607–27.
—— (1987) 'Are there histories of people without Europe?', *Society for Comparative Study of Society and History*, 29(3): 594–607.
—— (1991) 'Afterword: from the history of colonial anthropology to the anthropology of western hegemony', in George W. Stocking, Jr (ed.) *Colonial Situations: Essays on*

the Contextualization of Ethnographic Knowledge, Madison: University of Wisconsin Press, 314–24.

—— (1993) *Genealogies of Religion: Discipline and Reasons of Power in Christianity and Islam*, Baltimore: Johns Hopkins University Press.

Asad, Talal and John Dixon (1984) 'Translating Europe's others', in Francis Barker (ed.) *Europe and Its Others*, volume 1, Colchester: Essex University Press, 170–7.

Assembly of First Nations and the Canadian Museums Association (1992) *Task Force Report on Museums and First Peoples*, Ottawa: AFN and CMA.

Atwood, Margaret (1972) *Survival: A Thematic Guide to Canadian Literature*, Toronto: Anansi.

—— (1991) *Wildnerness Tips*, Toronto: McClelland and Stewart Inc.

—— (1995) *Strange Things: The Malevolent North in Canadian Literature*, Oxford: Clarendon Press.

Aykroyd, Peter H. (1992) *The Anniversary Compulsion: Canada's Centennial Celebrations; A Model Mega-Anniversary*, Toronto: Dundurn Press.

Badone, Ellen (1992) 'The construction of national identity in Brittany and Quebec', *American Ethnologist*, 19(4): 806–17.

Bagley, C. (1986) 'Multiculturalism, class and ideology: a European Canadian comparison', in S. Modgil, V. Gajendra, K. Mallick and C. Modgil (eds) *Multicultural Education: The Interminable Debate*, Lewes: The Falmer Press.

Balfour Bowen, Lisa (1992) 'Native spirit', *The Sunday Sun*, 18 October 1992.

Balibar, Etienne and Immanuel Wallerstein (1991) *Race, Nation, Class: Ambiguous Identities*, London: Verso.

Bank of Montreal (1992) 'A portrait of Canada', advertisement insert for newspapers, June/July 1992.

Bannerji, Himani (1996) 'On the dark side of the nation: politics of multiculturalism in Canada', *Journal of Canadian Studies*, 31(3): 103–28.

Banton, Michael (1967) *Race Relations*, London: Tavistock.

—— (1987) *Racial Theories*, Cambridge: Cambridge University Press.

Barker, M. (1981) *The New Racism*, London: Junction Books.

Bashevkin, Sylvia B. (1991) *True Patriot Love: The Politics of Canadian Nationalism*, Toronto: Oxford University Press.

Bauman, Zigmunt (1989) *Modernity and the Holocaust*, Cambridge: Polity and Basil Blackwell.

—— (1992) *Intimations of Postmodernity*, London: Routledge.

Beaudoin, Gerald and Dorothy Dobbie (1992) *Report of the Special Joint Committee on a Renewed Canada*, 28 February 1992, Ottawa: Supply and Services Canada.

Bell Canada (1992) 'Canadians have always looked upon obstacles as challenges', *The Globe and Mail*, 1 July 1992.

Bennett, Tony, Graeme Turner and Michael Volkerling (1994) 'Introduction: post-colonial formations', *Culture and Policy* 6(1) http://www.gu.edu.au/gwis/akccmp/6_1_Introduction.html#intro

Berger, Carl (1966) 'The true north strong and free', in Peter Russell (ed.) *Nationalism in Canada*, Toronto: McGraw-Hill, 3–26

—— (1970) *The Sense of Power: Studies in the Ideas of Canadian Imperialism 1867–1914*, Toronto: University of Toronto Press.

Berkhofer, Robert F. (1978) *The White Man's Indian: Images of the American Indian from Columbus to the Present*, New York: Alfred A. Knopf.

Berland, Jody (1994) 'On reading "The Weather"', *Cultural Studies*, 8(1): 99–114.

—— (1995) 'Marginal notes on cultural studies in Canada', *University of Toronto Quarterly*, 64(4): 514–25.

Berlant, Lauren (1993) 'The theory of infantile citizenship', *Public Culture*, 5(3): 395–410.

Bhabha, Homi K. (ed.) (1990) *Nation and Narration*, London: Routledge, 291–322.

—— (1994) *The Location of Culture*, London: Routledge.

Bissoondath, Neil (1994) *Selling Illusions: The Cult of Multiculturalism in Canada*, Toronto: Penguin Books.

Blundell, Valda, John Shepherd and Ian Taylor (1993) *Relocating Cultural Studies*, London: Routledge.

Boddy, Trevor (1989) 'Cardinal of hull', *Canadian Forum*, October, 15–19.

Bordo, Jonathan (1992) 'Jack Pine – wilderness sublime, or the erasure of the aboriginal presence from the landscape', *Journal of Canadian Studies*, 27(4): 98–128.

Bothwell, Robert (1995) *Canada and Quebec: One Country, Two Histories*, Vancouver, UBC Press.

Breckenridge, Caro. A. (1989) 'The aesthetics and politics of colonial collecting: India at world fairs', *Society for the Comparative Study of Society and History*, 31: 195–216.

Breton, Raymond (1988) 'The evolution of the Canadian multicultural society: the significance of government intervention', in A.J. Fry and Charles Forceville (eds) *Canada: Canadian Mosaic. Essays on Multiculturalism*, Amsterdam: Free University Press, 27–44.

Brodie, Janine (1995) *Politics on the Margins*, Halifax: Fernwood Publishing.

Bumsted, J.M. (1992a) *The Peoples of Canada: A Pre-Confederation History*, Toronto: Oxford University Press.

—— (1992b) *The Peoples of Canada: A Post-Confederation History*, Toronto: Oxford University Press.

Bunce, Michael (1994) *The Countryside Ideal: Anglo-American Images of Landscape*, London: Routledge.

Cairns, H. Alan C. (1965) *Prelude to Imperialism: British Reactions to Central African Society 1840–1890*, London: Routledge and Kegan Paul.

—— (1991) *Disruptions: Constitutional Struggles, from the Charter to Meech Lake*, Toronto: McLelland and Stewart.

Cameron, Duncan and Miriam Smith (eds) (1992) *Constitutional Politics*, Toronto: James Lorimer.

Canada 125 Corporation (1992a) 'We're looking for some big ideas', first pamphlet looking for events to register.

—— (1992b) 'Canadians say it loud and clear!', Canada 125 tabloid April 1992.

—— (1992c) 'Wow! Canadians have taken off with Canada 125', Canada 125 tabloid June 1992.

—— (1992d) 'Happy Birthday Canada!', Canada 125 tabloid July 1992.

—— (1992e) 'The Celebrations Continue!', Canada 125 tabloid August 1992.

—— (1992f) 'Event Planners Guide'.

—— (1992g) 'Great ideas for celebrating Canada in 1992'.

—— (1992h) 'Let's celebrate: what's going on coast to coast for Canada's 125th Anniversary?', advertising pamphlet.

—— (1992i) 'Canada 125', pamphlet advertising Canada 125 merchandise.

—— (1992j) 'Canada 125: Info 125', August.

—— (1995) *Canada 125: Canadians Say it Loud and Clear – Les Canadiens ont parlé haut et forte*, Final Report of the Canada 125 Corporation. Attained through Heritage Canada, Canadian Identity Directorate.

Canadian Broadcasting Corporation (1993) 'A sense of history' (footage of Pearson's speech to legionaires regarding the flag – 1964). Broadcast July 25, 1993. 30 min.

Canadian Council of Christians and Jews (1993) *Canadians' Attitudes toward Race and Ethnic Relations in Canada*, Toronto: Poll and Report Prepared by Decima Research.

Canadian Heritage Arts Society (1992a) '*Spirit of a Nation* advertising pamphlet', Victoria: Canadian Heritage Arts Society.

—— (1992b) *Experience Canada: Project Report* (and script of *Spirit of a Nation*), Victoria: Canadian Heritage Arts Society.

Canadian Imperial Bank of Commerce (1992) 'The constitutional debate: a straight talking guide for Canadians', *Maclean's*, 6 July 1992.

Canadian Multiculturalism Act (1988) *Chapter 24, an Act for the Preservation and Enhancement of Multiculturalism in Canada*, Ottawa: Queen's Printer.

Carby, Hazel (1989) 'The canon: civil war and reconstruction', *Michigan Quarterly Review*, 28(1): 26–51.

Cardinal, Douglas (1989) 'Museum of Man proposal, 1983: From earth creatures to star creatures', *Canadian Forum*, October, p.17.

Cardozo, Andrew (1992) 'Minorities and the tough choice', *Canadian Forum*, 24 October, 24.

Carter, Erica, James Donald and Judith Squires (eds) (1993) *Space and Place: Theories of Identity and Location*, London: Lawrence and Wishart.

Chabram, Angie, and Rosa Linda Fregoso (1990) 'Chicana/o cultural representations: reframing alternative critical discourses', Introduction in Special Issue, *Cultural Studies*, 4(3): 203–12

Chakrabarty, Dipesh (1992) 'Provincializing Europe: postcoloniality and the critique of history', *Cultural Studies*, 6(3): 337–57.

Chatterjee, Partha (1986) *National Thought and the Colonial World: A Derivative Discourse?*, London: Zed Press.

—— (1993) *The Nation and Its Fragments: Colonial and Postcolonial Histories*, Princeton, NJ: Princeton University Press.

—— (1995) 'Religious Minorities and the Secular State: Reflections on an Indian Impasse', *Public Culture*, 8(1): 11–39.

Clifford, James (1983) 'On ethnographic authority', *Representations*, 1: 118–46.

—— (1988) *The Predicament of Culture*, Cambridge, MA: Harvard University Press.

—— (1992) 'Traveling Cultures', in Lawrence Grossberg, Cary Nelson and Paula Treichler (eds) *Cultural Studies*, New York: Routledge, 96–111.

Clifford, James and George E. Marcus (1986) *Writing Culture: The Poetics and Politics of Ethnography*, Berkeley and Los Angeles: University of California Press.

Coates, Colin M. (1993) 'Like "The Thames towards Putney": the appropriation of landscape in lower Canada', *Canadian Historical Review*, LXXIV(3): 317–43.

Cohen, A.P. (1975) *The Management of Myths: The Politics of Legitimation in a Newfoundland Community*, Manchester: Manchester University Press.

Conlogue, Ray (1995a) 'Is Canada willing to face the reality of Quebec's distinctness?', *The Globe and Mail*, 18 November.

—— (1995b) 'Media howl gives impression of culturally intolerant Quebec', *The Globe and Mail*, 18 February.

Cook, Ramsay (1963) *Canada: A Modern Study*, Toronto: Irwin Publishing.

Corrigan, Phillip (1990) *Social Forms/Human Capacities*, London: Routledge.

Cosgrove, Dennis and Stephen Daniels (eds) (1988) *The Iconography of Landscape*, Cambridge: Cambridge University Press

Courmier, A.J. (1964) 'Participation in Canada's centennial by people of Indian ancestry – some policy considerations', policy document attained through the National Archives of Canada.

Cronon, William (ed.) (1995) *Uncommon Ground: Toward Reinventing Nature*, New York: W.W. Norton

Curtin, Phillip D. (1964) *The Image of Africa: British Ideas and Action, 1780–1850*, Madison: University of Wisconsin Press.

Daniels, Stephen (1993) *Fields of Vision: Landscape Imagery and National Identity in England and the United States*, Princeton, NJ: Princeton University Press.

Day, Shelagh (1992) 'What's wrong with the Canada clause?', *Canadian Forum*, 21–3 October.

Delacourt, Susan (1992a) 'Loss of faith: the referendum campaign has exposed a great divide in Canada's political system', *The Globe and Mail*, 24 October 1992.

—— (1992b) 'No appears stronger over long haul', *The Globe and Mail*, 19 October 1992.

—— (1995) 'The 905 revolution', *The Globe and Mail*, 25 November.

Delgado, Richard and Jean Stefancic (1997) *Critical White Studies: Looking Behind the Mirror*, Philadelphia: Temple University Press.

Dippie, Brian W. (1992) 'Representing the other: the North American Indian', in Elizabeth Edwards (ed.) *Anthropology and Photography 1860–1920*, London: Yale University Press and Royal Anthropological Institute, 132–6.

Dyer, Richard (1988) 'White', *Screen*, 29(4): 44–64.

—— (1997) *White*, London: Routledge.

Ellen, R.F. (ed.) (1984) *Ethnographic Research: A Guide to General Conduct*, London: Academic Press.

Feaver, George (1993) 'Inventing Canada in the Mulroney years', *Government and Opposition*, 28(4): 463–78.

Fine, Michelle, L. Weiss, L.C. Powell, and L.M. Wong (eds) (1997) *Off White: Readings on Race, Power and Society*, London: Routledge.

Finley, J.L. and D.N. Sprague (1979) *The Structure of Canadian History*, Scarborough: Prentice-Hall of Canada.

Foster, Robert J. (1991) 'Making national cultures in a global ecumene', *Annual Review of Anthropology*, 20: 235–60.

Fotheringham, Allan (1992) 'A fury that found its voice', *Maclean's*, 2 November: 76.

Foucault, Michel (1986) 'Disciplinary power and subjection', in Steven Lukes (ed.) *Power*, London: Basil Blackwell, 229–42.

—— (1991) 'Governmentality', in Graham Burchell, Colin Gordon and Peter Miller (eds) *The Foucault Effect*, London: Harvester Wheatsheaf, 87–104.

Fox, Richard (ed.) (1991) *Recapturing Anthropology: Working in the Present*, Santa Fe: School of American Research.

Francis, Daniel (1992) *The Imaginary Indian: The Image of the Indian in Canadian Culture*, Vancouver: Arsenal Pulp Press.

Frankenberg, Ruth (1993) *White Women. Race Matters: The Social Construction of Whiteness*, Minneapolis: University of Minnesota Press .

Frankenberg, Ruth and Lata Mani (1993) 'Crosscurrents, Crosstalk: Race, "Postcoloniality" and the Politics of Location', *Cultural Studies*, 7(2): 292–310.

Fraser, Alistair B. (1990–91) 'A Canadian flag for Canada', *Journal of Canadian Studies*, 25(5): 64–80.

Fraser, Blair (1967) 'The great flag debate: maple leaf rampant', in Blair Fraser *The Search for Identity: Canada 1945–1967*, Toronto: Doubleday, 234–47.

Frye, Northrop (1971) *The Bush Garden: Essays on the Canadian Imagination*, Toronto: Anansi.

Geddes, John and Brenda Branswell (1998) 'A ticking time bomb', *Maclean's*, 2 March 1998.

Gellner, Ernest (1983) *Nations and Nationalism*, London: Cornell University Press.

Gibbon, John Murray (1941) *The New Canadian Loyalists*, Macmillan War Pamphlets Canadian Series. Toronto: Macmillan Canada.

Gilroy, Paul (1987) *There Ain't no Black in the Union Jack*, London: Routledge.

—— (1990) 'The end of anti-racism', in Wendy Ball and John Solomos (eds) *Race and Local Politics*, London: MacMillan, 191–210.

—— (1992) 'Cultural studies and ethnic absolutism', in Lawrence Grossberg, Cary Nelson and Paula Treichler (eds) *Cultural Studies*, New York: Routledge, 187–198.

Goar, Carol (1992) 'Canadians do find unity – in rejecting leaders' vision', *The Toronto Star*, 27 October.

Goldberg, David Theo (1993) *Racist Culture: Philosophy and the Politics of Meaning*, Oxford and Cambridge: Blackwell.

Gollner, Andrew and Daniel Salee (eds) (1988) 'Introduction: a turn to the right? Canada in the Post-Trudeau era', in Andrew B. Gollner and Daniel Salee (eds) *Canada Under Mulroney*, Montreal: Vehicule Press, 9–22.

Gordon, Colin (1991) 'Government rationality: an introduction', in Graham Burchell, Colin Gordon and Peter Miller (eds) *The Foucault Effect: Studies in Governmentality*, London: Harvester Wheatsheaf, 1–51.

Government of Canada (1992a) 'Your Guide to Canada's Proposed Constitutional Changes'.

—— (1992b) 'Does the Charlottetown Agreement give Canadians...?' (full double page advertisement), *The Globe and Mail*, 21 October.

—— (1992c) 'Were Canadians consulted about the Constitution?' (full double page advertisement), *The Globe and Mail*, 24 October.

Greenfeld, Liah (1996) 'Nationalism and Modernity', *Social Research*, 63(1): 3–40.

Greenhill, Pauline (1994) *Ethnicity in the Mainstream: Three Studies of English Canadian Culture in Ontario*, Montreal: McGill-Queen's University Press.

Gupta, Akhil (1992a) 'Beyond "culture": space, identity, and the politics of difference', *Cultural Anthropology*, 7(1): 6–23.

—— (1992b) 'The song of the nonaligned world: transnational identities and the rein-scription of space in late capitalism', *Cultural Anthropology*, 7(1): 63–79.

Gwyn, Richard (1992) 'No to accord was also no to old-style politics', *The Toronto Star*, 27 October 1992.

Hage, Ghassan (1994a) Locating multiculturalism's other: a critique of practical toler-ance', *New Formations*, 24: 19–34.

—— (1994b) 'Anglo-Celtics today: cosmo-multiculturalism and the phase of the fading phallus', *Communal/Plural*, 4: 41–7.

—— (1996) 'Nationalist anxiety or the fear of losing your other', *The Australian Journal of Anthropology*, 7(2): 121–40.

Hall, Catherine (1992a) *White, Male and Middle-Class: Explorations in Feminism and History*, Cambridge: Polity.

—— (1992b) 'Missionary stories: gender and ethnicity in England in the 1830s and 1840s', in Lawrence Grossberg, Cary Nelson and Paula Treichler (eds) *Cultural Studies*, New York: Routledge, 240–70.

Hall, Stuart (1978) *Policing the Crisis*, Oxford: Polity.

—— (1981) 'Notes on deconstructing "the popular"', in Raphael Samuel (ed.) *People's History and Socialist Theory*, London: Routledge and Kegan Paul, 227–40.

—— (1991a) 'Old and new identities, old and new ethnicities', in Anthony D. King (ed.) *Culture, Globalisation and the World System*, London: Macmillan, 41–8.

—— (1991b) 'The local and the global: globalisation and ethnicity', in Anthony D. King (ed.) *Culture, Globalisation and the World System*, London: Macmillan, 19–39.

—— (1992a) 'The west and the rest: discourse and power', in Stuart Hall and Bram Gieben (eds) *Formations of Modernity*, Cambridge: Polity Press in Association with the Open University, 275–332.

—— (1992b) 'The question of cultural identity', in Stuart Hall, David Held and Tony McGrew (eds) *Modernity and its Futures*, Cambridge: Polity Press in Association with the Open University, 273–326.

—— (1992c) 'New Ethnicities', in James Donald and Ali Ratansi (eds) *'Race,' Culture and Difference*, London: Sage, 252–59.

—— (1993) 'Culture, community, nation', *Cultural Studies*, 7(3) 349–63.

Handler, R. (1988) *Nationalism and the Politics of Culture in Quebec*, Madison: Univer-sity of Wisconsin Press.

—— (1991) 'Who owns the past?: History, cultural property, and the logic of possessive individualism', in Brett Williams (ed.) *The Politics of Culture*, Washington, DC: Smithsonian University Press, 63–74.

Harcourt, Peter (1993) 'The Canadian nation – an unfinished text', *Canadian Journal of Film Studies*, 2(2–3): 5–26.

Harney, Robert F. (1989) ' "So Great a Heritage as Ours": immigration and the survival of the Canadian polity', in Stephen R. Graubard (ed.) *In Search of Canada*, New Jersey: Transaction Publishers, 51–98.

Harper, Tim (1992) 'Minorities fear "traitor" taunts if they protest', *The Toronto Star*, 4 September 1992.

Harris, Cole (1966) 'The myth of the land in Canadian nationalism', in Peter Russell (ed.) *Nationalism in Canada*, Toronto: McGraw-Hill Ryerson Co., 27–43.

Harrison, Julia (1988) ' "The Spirit Sings" and the future of anthropology', *Anthropology Today*, 4(6): 6–9.

Harvey, Penelope (1992) '1992: discovering native America', *Anthropology Today*, 8(1): 1–2.

Haslett Cuff, John (1992) 'Some feel-good messages are better than others', *The Globe and Mail*, 20 June 1992.

Hawkins, Freda (1989) *Critical Years in Immigration: Canada and Australia Compared*, Kensington: McGill-Queens University Press.

Held, David (1992) 'The development of the modern state', in Stuart Hall and Bram Gieben (eds) *Formations of Modernity*, Cambridge: Polity Press in Association with the Open University, 71–125.

Hinsley, Curtis (1991) 'The world as marketplace: commodification of the exotic at the world's Columbian Exhibition, Chicago, 1893', in Ivan Karp and Steven Lavine (eds) *Exhibiting Cultures*, Washington, DC: Smithsonian Institution Press, 344–65.

Hobsbawm, Eric (1983) 'Introduction: inventing traditions', in Eric Hobsbawm and Terence Ranger, *The Invention of Tradition*, Cambridge: Cambridge University Press, 1–14.

—— (1990) *Nations and Nationalism since 1780: Programme, Myth, Reality*, 2nd edition, Cambridge: Cambridge University Press.

Hutcheon, Linda (1994) 'The post always rings twice: the postmodern and the postcolonial', *Textual Practice*, 8(2): 205–38.

Hutcheon, Linda and Marion Richmond (eds) (1990) *Other Solitudes: Canadian Multicultural Fictions*, Toronto: Oxford University Press.

Hyatt, Susan Brin (1997) 'Poverty in a "post-welfare" landscape: tenant management policies, self-government and the democratisation of knowledge in Great Britain', in Cris Shore and Susan Wright (eds) *Anthropology of Policy*, London: Routledge, 217–31.

Ignatieff, Michael (1993) *Blood and Belonging: Journeys Into the New Nationalism*, Toronto: Viking.

Imperial Oil (Esso) (1992) 'Nation building…an exercise of the heart', *The Globe and Mail*, 1 May.

Investors Group (1992) 'Son of immigrants', *Maclean's*, 6 July 1992.

Janigan, Mary (1998) 'The meat of the matter', *Maclean's*, 16 February 1998.

Jeffrey, Brooke (1992) *Breaking Faith: The Mulroney Legacy of Deceit, Destruction and Disunity*, Toronto: Key Porter Books.

—— (1993) *Strange Bedfellows, Trying Times*, Toronto: Key Porter Books.

Jhappan, Radha (1992) 'Aboriginal Self-Government', *Canadian Forum*, 15–16 October.

Johnson, Carol (1997) 'John Howard and the revenge of the mainstream: some implications for concepts of identity', *Australasian Political Studies 1997: Proceedings of the 1997 APSA Conference*, 409–31.

Kapferer, Bruce (1988) *Legends of People, Myths of State*, Washington, DC: Smithsonian Institution Press.

Kedourie, Elie (1960) *Nationalism*, New York: Frederick A. Praeger.

Kilbourne, William (1989) 'The peaceable kingdom still', in Stephen R. Graubard (ed.) *In Search of Canada*, New Jersey: Transaction Publishers, 1–30.

Kymlica, Wil. (1995) 'Misunderstanding nationalism', *Dissent*, Winter, 130–7.

Lattas, Andrew (1990) 'Aborigines and contemporary Australian nationalism: primordiality and the cultural politics of otherness', *Social Analysis*, 27: 50–69.

Lavenda, Robert H. (1983) 'Family and corporation: two styles of celebration in central Minnesota', in Frank Manning (ed.) *The Celebration of Society: Perspectives on Contemporary Cultural Performance*, Bowling Green, Ohio: Bowling Green University Popular Press, 51–64.

Lazreg, Marnia (1988) 'Feminism and difference: the perils of writing as a woman on women in Algeria', *Feminist Studies*, 14(1), 81–107.

Lehr, John (1983) 'Texas (When I Die): national identity and images of place in Canadian Country Music broadcasts', *Canadian Geographer*, 27(4): 361–70.

Lewycky, Laverne (1992) 'Multiculturalism in the 1990s and into the twenty-first century: beyond ideology and Utopia', in Vic Satchewich (ed.) *Deconstructing a Nation: Immigration, Multiculturalism and Racism in '90s Canada*, Halifax: Fernwood Publishing, 359–97.

Little, Kenneth (1991) 'On safari: the visual politics of a tourist representation' in David Howes (ed.) *The Varieties of Sensory Experience*, Toronto: University of Toronto Press.

London Life Insurance Company (1992) 'Canada is too big for small minds', (full page advertisement) *The Toronto Star*, 30 June 1992.

McBride, Stephen (1993) 'Renewed federalism as an instrument of competitiveness: liberal political economy and the Canadian constitution', *International Journal of Canadian Studies*, 7–8: 187–205.

McClintock, Anne (1995) *Imperial Leather: Race, Gender and Sexuality in the Colonial Contest*, New York: Routledge.

MacDonald, George F. and Stephen Alsford (1989) *Museum for the Global Village*, Hull: Canadian Museum of Civilization.

Mackey, Eva (1991) 'Revisioning "Home"work: feminism and the politics of voice and representation', MA term paper, University of Sussex.

—— (1995) 'Postmodernism and cultural politics in a multicultural nation: contests over truth in the "Into the Heart of Africa" controversy', *Public Culture*, 7(2): 403–32.

—— (1996) 'Managing and imagining diversity: multiculturalism and the construction of national identity in Canada', D. Phil thesis in Social Anthropology, University of Sussex.

—— (1997) 'The cultural politics of populism: celebrating Canadian national identity', in Cris Shore and Susan Wright (eds) *Anthropology of Policy*, London: Routledge, 136–59.

Maclean, Hunter (1992) 'We believe in one Canada', *Maclean's*, 6 July, 1992.

Maclean's (1992a) 'Breaking down the vote', 2 November: 18–19.

—— (1992b) 'The storied land: discovering the heroes, villians, myths and legends that shape the nation', (Special Canada Day Edition), 6 July.

McNaught, Kenneth (1970) *The Pelican History of Canada*, London: Penguin.

Macpherson, C.B. (1962) *The Political Theory of Possessive Individualism*, Oxford: Oxford University Press.

McQuaig, Linda (1992) *The Quick and the Dead*, Toronto: Penguin.

—— (1995) *Shooting the Hippo: Death by Deficit and Other Canadian Myths*, Toronto: Viking.

Mani, Lata (1990) 'Multiple mediations: feminist scholarship in the age of multinational reception', *Feminist Review*, 35: 24–41.

Manning, Preston (1992) *The New Canada*, Toronto: Macmillan.

Marcus, George (1989) 'Imagining the whole: ethnography's contemporary efforts to situate itself', *Critique of Anthropology*, 9(3): 7–30.

—— (1992) 'Past, present, and emergent identities: requirements for ethnographies of late twentieth-century modernity worldwide', in Scott Lash and Jonathan Friedman (eds) *Modernity and Identity*, Oxford: Basil Blackwell, 309–30.

Marcus, George E. and Dick Cushman (1982) 'Ethnographies as texts', *Annual Review of Anthropology*, 11: 25–69.

Marcus, George E. and Michael M.J. Fischer (1986) *Anthropology as Cultural Critique: An Experimental Moment in the Human Sciences*, Chicago and London: University of Chicago Press.

Marcus, Julie (1990) 'Anthropology, culture and post-modernity', *Social Analysis*, 27: 3–16.

—— (1996) 'The erotics of the museum', paper given at Sussex March 1996, manuscript in author's possession.

—— (1997) 'The journey out of the centre', in Gillian Cowlishaw and Barry Morris (eds) *Race Matters*, Canberra: Aboriginal Studies Press, 29–51.

Martin, Biddy and Chandra Talpade Mohanty (1986) 'Feminist encounters: what's home got to do with it?', in Teresa de Lauretis (ed.) *Feminist Studies/Critical Studies*, Bloomington: Indiana University Press, 191–212.

Martin, Ged (1993) 'Constitution and national identity in contemporary Canada: a historian's view', in Vivien Hart and Shannon C. Stimson (eds) *Writing a National Identity: Political, Economic and Cultural Perspectives on the Written Constitution*, Manchester: Manchester University Press in Association with the Fulbright Commission, 199–239.

Massey, Doreen (1994) *Space, Place and Gender*, Cambridge: Polity Press.

Matheson, John Ross (1980) *Canada's Flag: A Search for a Country*, Boston: G.K. Hall and Co.

Mendus, Susan (1993) 'The tigers of wrath and the horses of instruction', in John Horton (ed.) *Liberalism, Multiculturalism and Toleration*, London: Macmillan, 193–206.

Merchant, Carolyn (ed.) (1994) *Ecology: Key Concepts in Critical Theory*, New Jersey: Humanities Press.

—— (1995) *Earthcare: Women and the Environment*, New York: Routledge.

Milne, David (1991) *The Canadian Constitution*, Toronto: James Lorimer.

Minh-ha, Trinh T. (1987) 'Of other People's: beyond the "salvage paradigm"', *Discussions in Contemporary Culture*, Seattle: Bay Press.

Mitchell, Clyde (1984) 'Typicality and the case study', in R.F. Ellen (ed.) *Ethnographic Research: A Guide to General Conduct*, London: Academic Press, 239–41.

Mitchell, Katharyne (1996) 'In whose interest? Transnational capital and the production of multiculturalism in Canada', in Rob Wilson, Wimal Dissayanake (eds) *Global/Local: Cultural Production and the Transnational Imaginary*, Durham: Duke University Press.

Mitchell, W.J.T. (ed.) (1994) *Landscape and Power*, Chicago: University of Chicago Press.

Mohanty, Chandra Talpade (1987) 'Feminist encounters: locating the politics of experience', *Copyright*, 1: 30–44.

—— (1990) 'On race and voice: challenges for liberal education in the 1990s', *Cultural Critique*, 14: 179–208.

—— (1991) 'Under western eyes: feminist scholarship and colonial discourses', in Chandra Talpade Mohanty, Ann Russo and Lourdes Torres (eds) *Third World Women and the Politics of Feminism*, Bloomington: University of Indiana Press, 51–80.

Moodley, Kogila (1983) 'Canadian multiculturalism as ideology', *Ethnic and Racial Studies*, 6(3): 320–31.

Morphy, Howard (1994) 'Aboriginal art in a global context', paper presented at Sussex Social Anthropology Subject Group Seminar, manuscript in possession of author.

Morrison, Toni (1993) *Playing in the Dark: Whiteness and the Literary Imagination*, New York: Vintage.

Mullard, C. (1982) 'Multiracial education in Britain: from assimilation to cultural pluralism', in John Tierney (ed.) *Race, Migration and Schooling*, London: Holt, Rinehart and Winston.

Multiculturalism and Citizenship Canada (1985) *Education: Cultural Pluralism in Canada*, Ottawa: Supply and Services Canada.

—— (1991) 'Multiculturalism: what is it really about?', Ottawa: Minister of Supply and Services Canada.

Multiculturalism and Citizenship Corporate Policy Branch (1987) 'Multiculturalism policy strategy document: a proposal', unpublished document released under Access to Information Act.

—— (1988) 'Canadian Multiculturalism Act briefing book: clause by clause analysis', unpublished document released under Access to Information Act.

Nairn, T. (1981) 'The modern Janus', in Tom Nairn *The Break-up of Britain: Crisis and Neo-Nationalism*, London: Verso, 329–63.

National Committee on the Centennial (1961) 'Press Release: National Committee on the Centennial', document obtained through National Archives of Canada.

Nemiroff, Diana (1992) 'Modernism, nationalism, and beyond: a critical history of exhibitions of First Nations art', in Diana Nemiroff, Robert Houle and Charlotte Townsend-Gault (eds) *Land, Spirit, Power: First Nations at the National Gallery of Canada*, Ottawa: National Gallery of Canada, 16–41.

Nemiroff, Diana, Robert Houle and Charlotte Townsend-Gault (eds) (1992) *Land, Spirit, Power: First Nations at the National Gallery of Canada*, Ottawa: National Gallery of Canada.

Newman, Peter C. (1992) 'How the Yes side lost its marbles: the No forces were able to tap into the underground rivers of prejudice, racism and loathing for the political process', *Maclean's*, 2 November 1992: 22.

Ng, Roxana (1987) 'The social construction of "Immigrant Women" in Canada', in M. Barrett and R. Hamilton, *The Politics of Diversity*, London: Verso, 269–86.

—— (1993) 'Sexism, racism, Canadian nationalism', in Himani Bannerji (ed.) *Returning the Gaze: Essays on Racism, Feminism and Politics*, Toronto: Sister Vision Press, 182–96.

Noranda (1992) 'Canadian unity: everyone's responsibility', *Maclean's*, 6 July 1992.

Nourbese Philip, Marlene (1992) *Frontiers: Essays and Writings on Racism and Culture*, Stratford: Mercury Press.

Oelschlaeger, Max (ed.) (1992) *The Wilderness Condition: Essays on Environment and Civilization*, Washington, DC: Island Press.

Osborne, Brian S. (1988) 'The iconography of nationhood in Canadian art', in Dennis Cosgrove and Stephen Daniels (eds) *The Iconography of Landscape*, Cambridge: Cambridge University Press, 162–78.

—— (1992) 'Interpreting a nation's identity: artists as creators of national consciousness', in Alan R.H. Baker and Gideon Biger (eds) *Ideology and Landscape in Historical Perspective: Essays on the Meanings of Some Places in the Past*, Cambridge: Cambridge University Press, 230–54.

Palmer, Howard (1991) *Ethnicity and Politics in Canada Since Confederation*, Saint John, NB: Canadian Historical Association.

Parliament Buildings Guide Manual (active document – in state of continual update), used by tour guides of the Parliament Buildings; obtained from the Public Information Office, House of Commons, Ottawa, April 1994.

Picard, André (1992) 'Yes side in Quebec injects more "Canada" into message', *The Globe and Mail*, 19 October 1992.

Plumwood, Val (1993) *Feminism and the Mastery of Nature*, London: Routledge.

Pratt, Minnie Bruce (1984) 'Identity: skin, blood, heart', in Elly Bulkin, Minnie Bruce Pratt and Barbara Smith (eds) *Yours In Struggle: Three Feminist Perspectives on Anti-Semitism and Racism*, New York: Long Haul Press, 11–13.

Probyn, Elspeth (1996) *Outside Belongings*, London: Routledge.

Rebick, Judy (1992) 'Why not women?', *Canadian Forum*, 24 October, 14.

Regroupment de Solidarité avec les Autochtones (1992) *The Mohawk Trial: Not Guilty*, Montreal: CIDMAAA.

Reinhold, Susan (1993) 'Local conflict and ideological struggle: positive images and section 28', D. Phil dissertation in Social Anthropology, University of Sussex.

Renan, E. (1990) 'What is a nation?', in Homi Bhabha (ed.) *Nation and Narration*, London: Routledge, 8–22.

Roediger, David R. (1991) *The Wages of Whiteness*, London: Verso.

—— (1994) *Towards the Abolition of Whiteness*, London: Verso.

Rosaldo, Renato (1989) 'Imperialist nostalgia', in Renato Rosaldo *Culture and Truth*, Boston: Beacon Press.

Royal Bank of Canada (1992) 'Unity or disunity: the benefits and the costs', information pamphlet, September 1992.

Said, Edward (1979) *Orientalism*, Toronto: Vintage.

—— (1984) 'Orientalism reconsidered', in Francis Barker (ed.) *Europe and its Others*, Volume 1, Colchester: Essex University Press, 14–27.

—— (1989) 'Representing the colonized: anthropology's interlocutors', *Critical Inquiry*, 15: 205–25.

—— (1994) *Culture and Imperialism*, London: Vintage.

Salutin, Rick (1992a) 'To know the no', *The Globe and Mail*, 9 October.

—— (1992b) 'Memorable moments from Rick Salutin's referendum bulletin board', *The Globe and Mail*, 16 October.

Samuda, R. (1986) 'The Canadian brand of multiculturalism: social and educational implications', in S. Modgil, V. Gajendra, K. Mallick, and C. Modgil (eds) *Multicultural Education: The Interminable Debate*, Lewes: The Falmer Press.

Satchewich, Vic (1992) 'Introduction', in Vic Satchewich (ed.) *Deconstructing a Nation: Immigration, Multiculturalism and Racism in '90s Canada*, Halifax: Fernwood Publishing, 13–18.

Schama, Simon (1995) *Landscape and Memory*, Toronto: Random House.

Schildkrout, Enid (1991) 'Ambiguous messages and ironic twists: into the heart of Africa and the other museum', *Museum Anthropology*, 15(2): 16–23.

Scott, David (1995) 'A note on the demand of criticism', *Public Culture*, 8(1): 41–50.

Seidel, Gill. (1987) 'The white discursive order: the British new right's discourse on cultural racism with particular reference to the Salisbury Review', in Iris M. Zavala, Teun A. van Dijk, and Myriam Diaz-Diocaretz (eds) *Approaches to Discourse, Poetics, and Psychiatry*, Amsterdam: John Benjamins Publishing Company, 39–66.

Shore, Cris and Susan Wright (1997) 'Policy: a new field of anthropology', in Cris Shore and Susan Wright (eds) *Anthropology of Policy*, London: Routledge, 3–39.

Simeon, Richard (1988) 'National reconciliation: the Mulroney Government and federalism', in Andrew B. Gollner and Daniel Salee (eds) *Canada Under Mulroney*, Montreal: Vehicule Press, 25–47.

Simpson, Jeffrey (1995) 'A call for a new Canadian community', *The Globe and Mail*, 2 December.

Smith, Allan (1992) 'First Nations, race and the idea of a plural community: defining Canada in the postmodern age', in Stella Hryniuk (ed.) *20 Years of Multiculturalism: Successes and Failures*, Winnipeg: St. John's College Press, 233–54.

Smith, Anthony D. (1986) *The Ethnic Origins of Nations*, London: Basil Blackwell.

—— (1991) *National Identity*, London: Penguin.

Smith, Bernard (1960) *European Vision and the South Pacific: 1768–1850*, London: Oxford University Press at Clarendon.

Smith, Susan (1993) 'Immigration and nation-building in Canada and the United Kingdom', in Peter Jackson and Jan Penrose (eds) *Constructions of Race, Place and Nation*, Minneapolis: University of Minnesota Press, 50–77.

Smolicz, J.J. (1985) 'Multiculturalism in Australia: rhetoric or reality?', *New Community*, 12(3): 450–63.

Special Committee (1989) 'Report to the Minister of State, Multiculturalism and Citizenship', (Special Committee on Canadian Participation in the 1992 International Anniversary of Christopher Columbus' First Voyage to the Americas), unpublished document obtained from the Secretary of State.

Spicer, Keith (1991) *Citizen's Forum on Canada's Future: Report to the People and Government of Canada*, Ottawa: Supply and Services Canada.

Spivak, Gayetry Chakravorty (1990) *The Post-Colonial Critic*, London: Routledge.

Srivastava, Sanjay (1996) 'Postcoloniality, national identity, globalisation and the simulacra of the real', *The Australian Journal of Anthropology*, 7(2): 166–90.

Stocking, George W. Jr (1968) *Race, Culture, and Evolution: Essays in the History of Anthropology*, New York: The Free Press.

—— (1987) *Victorian Anthropology*, New York: The Free Press.

Stoler, Ann Laura (1989) 'Rethinking colonial categories: European communities and the boundaries of rule', *Society for the Comparative Study of Society and History*, 31: 134–61.

—— (1995) *Race and the Education of Desire*, Durham: Duke University Press.

Stott, Rebecca (1989) 'The Dark Continent: Africa as female body in Haggard's Adventure Fiction', *Feminist Review*, 32: 69–89.

Street, Brian (1992) 'British popular anthropology: exhibiting and photographing the other', in Elizabeth Edwards (ed.) *Anthropology and Photography*, London: Yale University Press in Association with The Royal Anthropological Institute, 122–31.

—— (1993) 'Culture is a verb: anthropological aspects of language as cultural process', in David Graddol, Linda Thompson and Mike Byram (eds) *Language and Culture*, Clevedon, PA and Adelaide: B.A.A.L in association with Multilingual Matters Inc., 23–43.

Swainson, Gail (1992) 'Poodles win Canada 125 logo rights but gays don't', *The Toronto Star*, 9 August 1992.

Taylor, Charles (1990) 'Modes of civil society', *Public Culture*, 3(1): 95–118.

The Constitution Act (1982) (Including the Canadian Charter of Rights and Freedoms) Ottawa: Minister of Supply and Services Canada.

The Economist (1992) 'Canada's American Disease', 30 May.

The Globe and Mail (editorial) (1995) 'Giving voice to the Canadian idea', *The Globe and Mail*, 4 November.

The Toronto Star (1992) 'Acadien singer furious over ad', 30 June 1992.

Thomas, Nicholas (1994) *Colonialism's Culture: Anthropology, Travel and Government*, Cambridge: Polity Press.

Tim, Donuts (1992) 'We've been building this road for 125 years', *The Globe and Mail*, 21 October.

Todd, Loretta (1992) 'What more do they want?', in Gerald McMaster and Lee-Ann Martin (eds) *Indigena: Contemporary Native Perspectives*, Toronto: Douglas and McIntyre, 71–9.

Todorov, Tzvetan (1984) *The Conquest of America*, New York: HarperPerennial.

Townsend-Gault, Charlotte (1992) 'Kinds of knowing', in Diana Nemiroff, Robert Houle and Charlotte Townsend-Gault (eds) *Land, Spirit, Power: First Nations at the National Gallery of Canada*, Ottawa: National Gallery of Canada, 76–101.

—— (1995) 'Translation or perversion?: showing First Nation's art in Canada, *Cultural Studies*, 9(1): 91–105.

Trevor-Roper, Hugh (1983) 'The invention of tradition: the highland tradition of Scotland', in Eric Hobsbawm and Terence Ranger (eds) *The Invention of Tradition*, Cambridge: Cambridge University Press, 15–41.

Trigger, Bruce G. (1986) 'The historian's Indian: native Americans in Canadian historical writing from Charlevoix to the present', *Canadian Historical Review*, LXVII (3): 315–42.

—— (1988) 'Reply by Bruce Trigger' (to Julia Harrison's ' "The Spirit Sings" and the Future of Anthropology'), *Anthropology Today*, 4(6): 9–10.

Trudeau, Pierre Elliot (1971) 'Announcement of "Federal Multicultural Policy",' *House of Commons Debates, 8 October 1971*, pp. 8545–8.

Turner, Frederick (1980) *Beyond Geography: The Western Spirit Against the Wilderness*, New York: The Viking Press.

Underwood, Nora (1992) 'The psychology of anger: Canadians are lashing out at the elites', *Maclean's*, 12 October: 21.

Van Kirk, Sylvia (1980) *'Many Tender Ties': Women in Fur-Trade Society in Western Canada, 1670–1870*, Winnipeg: Watson and Dwyer Publishers.

Vipond, Robert C. (1993) 'Constitution making in Canada: writing a national identity or preparing for national disintegration?', in Vivien Hart and Shannon C. Stimson (eds)

Writing a National Identity: Political, Economic and Cultural Perspectives on the Written Constitution, Manchester: Manchester University Press in Association with the Fulbright Commission, 231–39.

Walcott, Rinaldo (1996) 'Lament for a nation: the racial geography of "The OH! Canada Project"', *Fuse*, 19(4):15–23.

Walker, William (1992) 'Outcome a "message": "No" voters rebuked PM and elites: Manning', *The Toronto Star*, 27 October 1992.

Walkom, Thomas (1995) 'Political tomes reflect national malaise', *The Globe and Mail*, 2 December.

Ware, Vron (1992) *Beyond the Pale: White Women, Racism and History*, London: Verso.

Webber, Jeremy (1994) *Reimagining Canada: Language, Culture, Community, and the Canadian Constitution*, Kingston and Montreal: McGill-Queen's University Press.

Whitaker, Reg (1991) *Canadian Immigration Policy Since Confederation*, Saint John, NB: Canadian Historical Association.

Whitelaw, Ann (1997) 'Statistical imperatives: representing the nation in exibitions of contemporary art', *Topia*, 1(1): 22–41.

Williams, Raymond (1980) *Problems in Materialism and Culture: Selected Essays*, London: Verso.

—— (1983) [1976] *Keywords: A Vocabulary of Culture and Society*, London: Collins.

Wilson, Alexander (1991) *The Culture of Nature: North American Landscape from Disney to the Exxon Valdez*, Toronto: Between the Lines.

Wilson, Rob and Wimal Dissanayake (eds) (1996) *Global/Local: Cultural Production and the Transnational Imaginary*, Durham: Duke University Press.

Wilson-Smith, Anthony (1992) 'What happens next?', *Maclean's*, 2 November.

Winant, Howard (1997) 'Behind blue eyes: whiteness and contemporary US racial politics', in Michelle Fine, Lois Weis, Linda C. Powell and L. Mun Wong (eds) *Off White: Readings on Race, Power and Society*, New York and London: Routledge.

Winsor, Hugh (1992a) 'Bidding to quicken the patriotic heart beat', *The Globe and Mail*, 28 May 1992.

—— (1992b) 'The high cost of feeling better', *The Globe and Mail*, 26 May 1992.

Wright, Susan (1995) 'The Caribbean in Cleveland: making a difference through carnival in North-East England', unpublished manuscript in possession of author.

—— (1998) 'Politicisation of "culture"', *Anthropology Today*, 14(1): 7–15.

Wright, Susan and Cris Shore (1995) 'Towards an anthropology of policy: morality, power and the art of government', *Anthropology in Action*, 2(2): 27–31.

INDEX

ANTHROPOLOGICAL HORIZONS

Editor: Michael Lambek, University of Toronto

Published to date: